CUBISM:
A HISTORY AND AN ANALYSIS
1907-1914

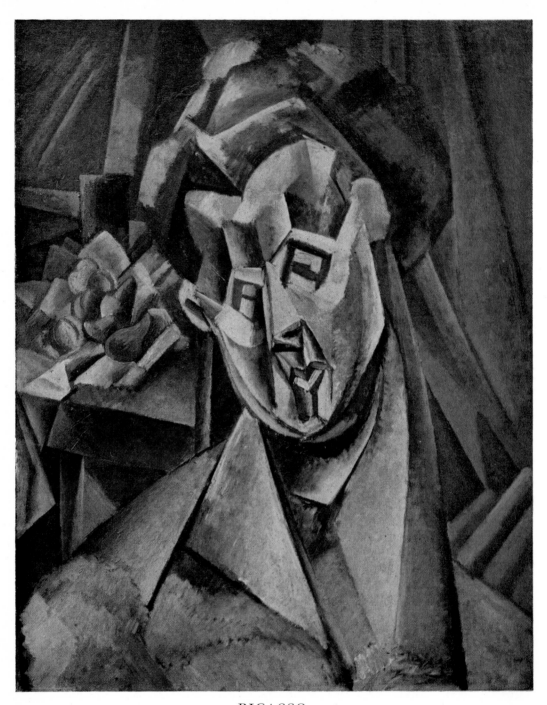

PICASSO

A. La Femme aux Poires, 1909. Oil, $36\frac{1}{2}'' \times 24\frac{1}{4}''$.
Collection Mr. and Mrs. Samuel A. Marx, Chicago

CUBISM:

A HISTORY AND AN ANALYSIS

1907-1914

by

JOHN GOLDING

FABER AND FABER LIMITED
24 Russell Square
London

*First published in mcmlix
by Faber and Faber Limited
24 Russell Square London WC*1
*Printed in Great Britain by
R. MacLehose and Company Limited
The University Press Glasgow*

CONTENTS

ACKNOWLEDGEMENTS

In its original form this book was written as a doctoral thesis for the Courtauld Institute of Art, and I am deeply indebted to my two supervisors, Prof. Sir Anthony Blunt and Prof. Douglas Cooper, for all their help and advice. While I was writing the thesis my researches were aided by a grant from the Research Fund of the University of London. The many private collectors in Europe and America who allowed me to see Cubist works in their possession are too numerous to mention; I am particularly grateful to those who have given me permission to reproduce paintings from their collections. Of the officials of the libraries, museums and galleries who have helped me, I should like especially to mention Mr. Alfred Barr, Jr. and Mr. William S. Lieberman of the Museum of Modern Art, New York. I am extremely grateful, too, to M. Daniel H. Kahnweiler, to Mme. Juliette Roche Gleizes and to Mme. Sonia Terk Delaunay for all the time they spared me, and for letting me see unpublished and generally inaccessible documents in their possession. I would also like to thank Mr. John Richardson for calling my attention to many important points, in particular to the discovery of the very rare 'mathematical' drawings by Gris. Finally I should like to thank Mr. James Joll for the advice and encouragement he has given me at every stage of the work.

ABBREVIATION

Z refers to C. Zervos, *Picasso*, Vols 1–6, Paris 1932–54.

ILLUSTRATIONS

COLOUR PLATES

MONOCHROMES

at the end of the book

PICASSO

Plates 1 to 22 are copyright by SPADEM, Paris

19A *Bouteille et Guitare,* 1913. Construction. No longer in existence.

19B *L'Etudiant à la Pipe,* 1913–14. Oil, 28¼″ × 24″. Collection the Heirs of Gertrude Stein.

20A *Femme en Chemise assise dans un Fauteuil,* 1913. Oil, 51″ × 39″. Collection Dr. Ingeborg Pudelko Eichmann, Zurich.

20B *Seated Woman (Portrait de Jeune Fille),* 1914. Oil, 51″ × 36¼″. Collection Monsieur Georges Salles, Paris.

21A *Le Violon,* 1914. Oil, 32¾″ × 28″. Musée National d'art Moderne, Paris.

21B *Green Still Life,* 1914. Oil, 23½″ × 31¼″. The Museum of Modern Art, New York.

22 *Homme Assis au Verre,* 1914. Oil, 94¼″ × 65½″. Private Collection Milan.

<div align="center">BRAQUE</div>

23 *Grand Nu,* 1908. Oil, 55¾″ × 40″. Collection Madame Cuttoli, Paris.

24A *View from the Hotel Mistral,* 1907. Oil, 31½″ × 23½″. Collection Mr. and Mrs. Werner E. Josten, New York.

24B *Still Life with Musical Instruments,* 1908. Oil, 19¾″ × 24″. Collection of the Artist.

25 *Maison à L'Estaque,* 1908. Oil, 28¾″ × 23¾″. Collection Mr. Hermann Rupf, Berne.

26A *Le Port (Harbour in Normandy),* 1909. Oil, 32″ × 32″. Collection Mr. Walter P. Chrysler, Jr., New York.

26B *Still Life with Fruit Dish,* 1908–9. Oil, 20¾″ × 25¼″. Collection Mr. Rolf de Maré, Stockholm.

27A *Landscape, La Roche Guyon,* 1909. Oil, Collection Monsieur Jean Masurel, Roubaix.

27B *Landscape, Carrières Saint-Denis,* 1909. Oil, Private Collection, New York.

28 *Violon et Cruche,* 1910. Oil, 46½″ × 8¾″. Kunstmuseum, Basle.

29A *Glass on a Table,* 1910. Oil, 13¾″ × 15¼″. Collection Anthony Hornby Esq., London.

15

INTRODUCTION

Cubism was, if not necessarily the most important, at least the most complete and radical artistic revolution since the Renaissance. New forms of society, changing patronage, varying geographic conditions, all these things have gone to produce over the past five hundred years a succession of different schools, different styles, different pictorial idioms. But none of these has so altered the principles, so shaken the foundations of Western painting as did Cubism. Indeed, from a visual point of view it is easier to bridge the three hundred and fifty years separating Impressionism from the High Renaissance than it is to bridge the fifty years that lie between Impressionism and Cubism. If social and historical factors can for a moment be forgotten, a portrait by Renoir will seem closer to a portrait by Raphael than it does to a Cubist portrait by Picasso.

Despite its revolutionary quality, and the sudden, explosive way in which it seemed, almost overnight, to come into being, Cubism owed, of course, much to the art of the preceding fifty years. While the Cubists reacted against the passion and expressionistic violence of Van Gogh and the impressionistic 'intimisme' and pretentious symbolism of the Nabis, they admired Seurat for his intellectual objectivity, his classical detachment and formal purity; several of the future Cubists began their artistic careers as Divisionists, that is to say as his successors. Gauguin, in an indirect fashion, was a powerful influence in the formation of Cubism, in so far as it was he, in the eyes of the young painters working in Paris in the early years of the twentieth century, who had been the true discoverer of the aesthetic worth of primitive art. A form of 'primitive' art, Negro sculpture, was, it will be seen, one of the main influences in the birth of Cubism in that it encouraged Picasso, both on an intellectual level and by its formal, abstract properties, to take stock afresh of traditional pictorial values. In a more general way primitive art—and here one can extend the term to include the work of that great 'primitive' painter, the Douanier Rousseau—supported the Cubists in their determination to shake themselves free of what Braque has called 'la fausse tradition', the conventions that had governed Western painting for the preceding five centuries. Only one nineteenth-century artist, however, played a

15

positive, direct role in the formation of the style. This was Cézanne. His importance cannot be too much stressed, and in a study of the development of Cubism one finds oneself returning to him again and again. It was Cézanne, more than any other painter, who provided a link between twentieth-century painting and traditional Western art.

Many of the contemporary historians and critics of Cubism agreed in seeing a direct connection between Cubism and Fauvism, the other important style born in Paris during the first decade of the century. This existed only in the most limited sense; a move towards greater abstraction, the tendency to take greater liberties with visual appearances, was the only very concrete way in which Fauvism foreshadowed Cubism. Even so, the abstract element in Cubism was the result of an entirely different approach from that of the Fauves. For while Fauve painting at its most typical sprang from a free, spontaneous and often highly subjective response to the external world, and for this reason seemed occasionally to be so far removed from conventional appearances, the Cubists, on the other hand, were led to still greater abstraction by the fact that their vision was conceptual and intellectual rather than physical and sensory. The Fauves, and particularly Matisse, admired Cézanne, and Braque may well have been led to an appreciation of him through their example; but the ends to which he put his study of Cézanne were, once again, totally different. In the same way Picasso's attitude to primitive art had little or nothing to do with that of Matisse, Derain or Vlaminck.

Indeed, viewed in retrospect, Fauvism seems to have belonged as much to the nineteenth century as to the twentieth. For in so far as Fauvism existed as a style or movement—that is to say when, between 1904 and 1906, the works of Matisse, Derain and Vlaminck all resembled each other to a certain extent and had clearly-defined characteristics in common—it was a synthesis of elements drawn from the art of the past fifty years: Impressionism, Divisionism, the decorative rhythms of Gauguin and the expressionism of Van Gogh, all contributed equally to its appearance. And since Fauvism evolved no really consistent technique of its own and was not governed by any very clearly-defined aesthetic, it was not a style that could have anything more than a very fleeting existence. It could well be interpreted as a sort of final paroxysm of post-Impressionist painting. All this does not apply, of course, to much of Matisse, and certainly not to most of the Matisse of 1906 onwards. But the *Joie de Vivre*, while it is generally considered to be one of the key-works of Fauvism, and while it incontestably represents a summary of Matisse's work of the previous years, shows him in fact taking the decisive step towards the formation of his

16

own, individual, mature style. Apart from a few isolated sketches of Derain's done under the direct influence of the painting, there are really no Fauve works quite like it. The refined, undulating outlines, the subtle blending of colour, the whole feeling of carefully calculated formal precision and intellectual control, even the arcadian symbolism, all these factors are at variance with the immediacy, the sporadic, broken or violent contours and the deliberately loose, occasionally even disorganized appearance of Fauve paintings done by Vlaminck and Derain at Chatou and in London, the Collioure landscapes of Derain and Matisse, and Matisse's portraits of his wife painted in 1905—the sort of painting that originally earned the movement its name.

The formation of Cubism was in sharp contrast to that of Fauvism. Where the Fauves drew from a wide variety of sources, the development of Cubism, except for the joint influences of Cézanne and Negro sculpture, was remarkably self-contained. And whereas the Fauves borrowed restlessly from the art of their predecessors, the Cubists reverted to fundamental principles; they began, so to speak, from the bottom upwards. Feeling that traditional painting was exhausted, they took each of the elements that comprise the vocabulary of painting—form, space, colour, and technique—and substituted for the traditional use of every one of them a new interpretation of their own. In short Cubism was a completely new pictorial language, a completely new way of looking at the outside world, a clearly-defined aesthetic. As such it has shaped the course of almost all twentieth-century painting.

The effects of Cubism are still with us. They can be seen in much of the art of to-day. In as much as Cubism has conditioned the development of architecture and the applied arts it has become part of our daily lives. For this reason it will, perhaps, be some time before it is possible to put Cubism in its proper historical perspective, to evaluate it with complete assurance. But to-day it is possible to define the characteristics of the style, to illustrate how, from one year to the other, even from one painting to the next, the painters evolved, step by step, the means of expressing their new pictorial concepts. What these concepts were, an examination of the paintings themselves will best serve to define; but it is of value, too, to reconstruct as far as possible the attitude of the painters to their own works, to tell what they said, thought and did, to see, in other words, what were the aesthetic principles that guided them. Finally, from an historical point of view it is of interest to record what their contemporaries thought of them, how Cubism was greeted by the public and critics of its day. These are the aims of this book.

Cubism, in its first stages, was the creation of two artists, Picasso and Braque,

and the first chapter of the book begins in 1907 with their meeting. This chapter is devoted to an historical survey of the rise and spread of the movement. The second chapter is dedicated to an investigation of the early Cubism of Picasso and Braque: to a study of how a new concept of pictorial form and space came into being. In 1912 Picasso and Braque were joined in their creation of Cubism by a third artist, Juan Gris (Gris was a Cubist by 1911 but his real historical importance dates from the following year). 1912 was also the year in which the new Cubist techniques, *collage* and *papier collé*, were invented. The works of Gris and the use made of the new media by all three artists between 1912 and 1914 are the subject of the third chapter. The fourth and final chapter is an account of the dissemination of the style in France and comprises a stylistic survey of the development of individual artists such as Léger and Delaunay who were temporarily attracted to Cubism and developed individual variants of the style. The book ends with the outbreak of war in 1914, when the painters were physically separated by the war and the school, as such, was dissolved.

THE HISTORY AND CHRONOLOGY
OF CUBISM

When Apollinaire introduced Braque to Picasso towards the end of 1907 he initiated what was to prove one of the most unusual and intensive collaborations in the history of art.

At the time of their meeting, Picasso and Braque had very different positions in the Paris art world. Picasso had already acquired a considerable reputation for himself as an original and independent figure. The works of his so-called 'pink' and 'blue' periods were being bought by important collectors, and the fact that an established dealer like Vollard was interested in his work gave him additional prestige. With the *Demoiselles d'Avignon* (Pl. 1), finished shortly before he met Braque, he had produced a painting that was to become one of the cornerstones of twentieth-century art. Braque, on the other hand, although he was only six months younger than Picasso, was slower in his development and had not yet established himself as a particularly original or significant painter; indeed, Braque subsequently came to feel that the paintings he executed in Antwerp during the summer of 1906 were his first creative works.[1] Braque enjoyed his first success only in 1907, when the German dealer Wilhelm Uhde bought the Fauve pictures which he exhibited at the *Salon des Indépendants*.

When he was shown the *Demoiselles d'Avignon*, Braque appears at first to have been bewildered by it,[2] though he realized that it marked an important new departure. Fauvism had by now largely spent itself, and Braque's search during the following years for a more solid foundation for his painting drew him increasingly closer to Picasso. In 1907 Picasso and Braque had been living near each other in Montmartre for some time, and after 1908 began meeting daily to talk, visit the galleries and museums, and to examine each other's

[1] Douglas Cooper, notes to the Catalogue for the Braque exhibition at the Tate Gallery, London 1956, p. 26.
[2] Fernande Olivier, *Picasso et ses Amis*, Paris 1933, p. 120. Braque's remark, quoted by Fernande Olivier, is said to have been made in connection with the *Demoiselles*.

work. Picasso had never exhibited at the large *Salons* or taken part in any group manifestations, and after the *Indépendants* of 1909, Braque joined him in this particular kind of artistic isolation. While both painters, and Picasso in particular, led active social lives and mixed with a wide circle of literary and artistic figures, their friendship seems to have rendered them self-sufficient. This is probably what Braque meant when he said recently, 'nous étions surtout très concentrés'.[1] In 1911, the year in which their intimacy was at its greatest and their work so close as to be often almost indistinguishable, Picasso and Braque spent the summer months together at Céret, in the Pyrenees. In the summer of 1912 they were again together at Céret and then at Sorgues, a village near Avignon where Braque rented a house. During the brief periods in which they were separated they corresponded. Later, in the autumn of 1912, Picasso moved to Montparnasse, and during the following years the differences in their work began to become apparent, but the same friendly relations were maintained. At the time of Picasso's removal to the Left Bank he accompanied Braque on a short trip to Le Havre, and in the early summer of the next year they were together again at Céret. In the summer of 1914 Braque was once more at Sorgues, while Picasso spent his time between Sorgues and Avignon, where he worked in the company of André Derain. When war was declared and Braque and Derain returned to join their regiments in Paris, Picasso escorted them to the station in Avignon. The outbreak of war naturally marked the end of the collaboration of Picasso and Braque, but the unprecedented closeness of their artistic careers over the preceding years makes it impossible to separate completely the contribution made by each to Cubism during the most vital years of its development.

Contemporary critics and writers (except those who acknowledged no relationship between the work of Picasso and Braque and that of the other figures of the movement), however, were almost unanimous in proclaiming Picasso as founder and leader of the movement. Sometimes the name of Braque is coupled with that of Picasso, but when mentioned, Braque is almost invariably referred to as a follower of Picasso. This neglect of Braque is strange, since his were the first Cubist paintings (e.g. Pl. 25) and since, as opposed to Picasso, he actually showed Cubist works in a public *salon*. Louis Vauxcelles already spoke of 'cubes' in his review of the exhibition which Braque gave at Kahnweiler's gallery in November 1908,[2] and the same critic referred to the paintings which Braque exhibited at the *Salon des Indépendants* of the following year as 'bizarreries cubiques',[3]

[1] Dora Vallier, *Braque, La Peinture et Nous* in *Cahiers d'Art*, 1954, no. 1, p. 14.
[2] *Gil Blas*, 14 Nov. 1908.
[3] *Gil Blas*, 25 May 1909.

from which the style derived its name (Pl. 26a). Braque had submitted some paintings to the *Salon d'Automne* in 1908 (a few of the same paintings which he later showed at Kahnweiler's), and Matisse, who was on the jury, is also said to have described these works as being composed of 'petits cubes'.[1]

The reasons for Picasso's primacy, however, are obvious. In the years before 1907 Braque was almost unknown, whereas many people already saw Picasso and Matisse as leaders of *avant-garde* painting. Moreover, Picasso obviously had a more forceful and dynamic personality than Braque, and this had impressed itself strongly on influential critics such as Apollinaire, Salmon and Vauxcelles, with whom he was more friendly than was Braque. Then, although neither painter was exhibiting publicly in Paris after 1909, by 1914 Picasso had held one-man exhibitions in England, Germany, Spain and America,[2] while Braque exhibited abroad more rarely, and then only in group shows. Finally, the *Hommage à Picasso* (Pl. 43) with which Gris made his sensational début at the *Salon des Indépendants* of 1912, must have had the character of a tribute to the *chef d'école*.

The importance of Braque's contribution to Cubism and his stature as an artist began to be seen and acknowledged only after the war. Kahnweiler linked the names of Picasso and Braque together seriously in *Der Weg zum Kubismus*, written in 1915 though not published until 1920, but general recognition of their collaboration dates from the Kahnweiler and Uhde sales of the early 1920's when their pre-war Cubism could be seen together in large quantities for the first time. Uhde, a young collector and dealer who had been on friendly terms with both painters since the early pre-Cubist days, in a book entitled *Picasso et la Tradition Française*, which appeared in both French and German in 1928, stressed the cardinal part played by Braque in his formation of Cubism. Uhde writes: 'La définition stylistique (du Cubisme) doit beaucoup à Braque', and summing up the differences in their characters, 'le tempérament de Braque était clair, mesuré, bourgeois; celui de Picasso, sombre, excessif, révolutionnaire. Dans le mariage spirituel qu'ils conclurent alors, l'un apportait une grande sensibilité, l'autre un grand don plastique'.[3]

Vauxcelles's attack on Braque's first Cubist paintings serves to emphasize

[1] Matisse later denied ever having said this, but the story is probably true since it is recorded as early as 30 September 1911, in *L'Intransigeant*. The story is repeated again in the June 1912 issue of *La Revue Française*.

[2] These were in 1909 at the Thannhauser Gallery in Munich; in 1911 at the Thannhauser Gallery and at the Photo-Secession Gallery, New York; in 1912 at the Stafford Gallery in London and the Dalmau Gallery in Barcelona; in 1913 at the Neue Galerie in Berlin. A second Berlin exhibition in 1914 was described by *Gil Blas* on the 5th April as 'la plus complète qui puisse être faite des oeuvres de ce prodigieux créateur'.

[3] *Picasso et la Tradition Française. Notes sur la Peinture Actuelle*, p. 39.

the new and radical use to which he had put his studies of Cézanne, for in 1908 Cézanne had already been an important influence on advanced painting for some time. Indeed, Vauxcelles, in a review of the *Salon des Indépendants* of 1907, notes with satisfaction that 'L'influence de Cézanne décroît', and adds, 'certains des salons antérieurs, ceux de 1904 et 1905 surtout, auraient pu porter comme enseigne . . . " hommage à Cézanne " '.[1] The main influences seen by Vauxcelles in the work of the younger painters were those of Gauguin, Derain and Matisse, to which in 1910 he adds the influence of Picasso.[2] During these years the most important of the established exhibitors at the *Indépendants* and the *Salon d'Automne* were Bonnard, Vuillard and Denis, while the small group of Neo-Impressionist painters under the leadership of Signac were also established and admired; by 1909 Vauxcelles was able to comment on the fact that it was no longer necessary to fight for the painters that he had christened the Fauves.[3] After the large Cézanne retrospective exhibiton at the *Salon d'Automne* of 1907, his influence once again became paramount,[4] although after 1909, following the lead of Braque, certain painters began to interpret Cézanne from a more formal and intellectual, and less immediately visual point of view. Vauxcelles refers to some of the painters of the *Indépendants* of 1910 who were working under the influence of Cézanne as 'géomètres ignares, réduisant le corps humain, le site, à des cubes blafards'.[5]

But by far the greater number of paintings to be seen at both these *Salons* in the first ten years of the century were still sub-Impressionist in character, and it was as part of the final and conclusive reaction against Impressionism that the Cubist and pre-Cubist works exhibited in 1910 were greeted. Apollinaire in a review of the *Salon des Indépendants* of that year wrote: 'Si nous devions traduire le sens général de cette exposition, nous dirions volontiers—et avec quelle joie—qu'elle signifie: déroute de l'impressionnisme'.[6] And to prove his point he cited beside the names of Matisse and two or three other painters who had been Fauves those of Robert Delaunay, Henri Le Fauconnier, Jean Metzinger, André Lhote and Marie Laurencin, all of whom were at some time or another involved in the Cubist movement. Reviewing the *Salon d'Automne*, Allard grouped together the work of Metzinger, Le Fauconnier and Gleizes, and using one of the paintings shown by Metzinger as an example, stated: 'ainsi naît

[1] *Gil Blas*, 30 March 1907.
[2] *Gil Blas*, 18 March 1910.
[3] *Gil Blas*, 25 March 1909.
[4] References to the renewed influence of Cézanne and its continuance are frequent, e.g. *Gil Blas*, 25 March 1909, *Mercure de France*, March 1912, *Paris Journal*, 30 Sept. 1912.
[5] *Gil Blas*, 18 March 1910.
[6] *L'Intransigeant*, 18 March 1910.

aux antipodes de l'impressionnisme, un art qui, peu soucieux de copier un épisode cosmique occasionnel, offre dans leur plénitude picturale à l'intelligence du spectateur les élements essentiels d'une synthèse située dans la durée'.[1] Of Gleizes' work he said: 'J'ai eu l'impression très nette à regarder sa toile d'une cure de sobriété après la débauche impressionniste'. Allard seems to have realized that the work of these painters was a reaction against Fauvism as well: 'assez d'affiches, de visions "qui s'imposent violemment", de "tranches de vie frémissante", assez de notations et d'anecdotes. Un beau tableau n'est qu'un juste équilibre, c'est à dire un accord de poids et un rapport de nombres. Que l'oeil du peintre soit sensible, mais non pas son pinceau'. *La Presse*, although hostile to the future Cubists, seems to have realized that something new was afoot when it referred to 'les folies géométriques de Mm. Le Fauconnier, Gleizes et Metzinger'.[2] Shortly afterwards Metzinger published an article in the literary review *Pan* on the work of Picasso, Braque, Le Fauconnier and Delaunay in which he proclaimed a new type of painting which for the first time broke with hellenic traditions.[3]

1910 is the year in which the Cubist painters, other than Picasso and Braque, came together as a conscious group, although many of them had known each other earlier. Metzinger and Delaunay had exhibited portraits of each other at the *Salon d'Automne* of 1906, when both were working in a Neo-Impressionist idiom, and by 1907 Delaunay had met Léger and Le Fauconnier as well.[4] Gleizes and Le Fauconnier became friendly in 1909 after a meeting at the home of a young socialist writer named Alexandre Mercereau,[5] where Gleizes also met Metzinger and Delaunay for the first time in the following year, although these meetings did not lead to immediate friendship, and Gleizes knew little about their work.[6] Léger appears to have joined the circle at Mercereau's later in the same year, probably introduced by Delaunay with whom he was becoming very friendly at this period. The painters also met at the Tuesday evenings held by the review *Vers et Prose* at the *Closerie des Lilas*. This café was the stronghold of the older generation of literary Symbolists, writers like Paul Fort,

[1] *Au Salon d'Automne de Paris, l'Art Libre*, Lyons, Nov. 1910. The two following quotations are from the same article.
[2] *La Presse*, 1–2 Oct. 1910.
[3] *Note sur la Peinture. Pan*, Paris, Oct.–Nov. 1910.
[4] Unpublished biographical data on Delaunay, compiled by Sonia Terk Delaunay, definitive version 1950.
[5] Mercereau, a journalist and writer of short stories dealing with supernatural happenings, had founded, some years earlier, the *Abbaye de Creteil*, a communal artistic settlement. Gleizes had also participated in this scheme. The *Abbaye* closed down after a few years, and Mercereau busied himself in trying to bring together young Parisian painters and writers.
[6] Gleizes, *Souvenirs*, unpublished, written in the years before 1953.

Stuart Merrill and Verhaeren, but many of the younger literary figures such as Apollinaire, Allard, Salmon and Mercereau (the last two on the staff of *Vers et Prose*) were to be seen there too. Allard had arrived in Paris from Lille in the spring of 1910 and his first contacts were with the future Cubists; because of this, his criticism is doubly interesting as representing their ideas unclouded by outside opinion. Older, more established painters like Signac and Sérusier also frequented these gatherings at the *Closerie* so that the atmosphere, though stimulating, was not particularly radical. Gustave Kahn, art-critic of the *Mercure de France*, entertained privately the same group of painters and authors.[1]

The works of Metzinger, Gleizes and Le Fauconnier had been hung together by chance at the *Salon d'Automne* of 1910, but the common characteristics which the critics saw in their styles, and the excitement expressed by the poets and authors at Mercereau's and at the *Closerie des Lilas* over the possibilities of a new school of painting, seem to have made the painters aware of each other. Apollinaire and Salmon in particular, although both were in many ways insensitive to painting, realized that Picasso's latest style contained the elements of a new art, and felt that the work of several other painters was evolving in a similar direction. Gleizes writes, 'c'est à partir de ce moment, octobre 1910, que nous découvrîmes sérieusement les uns les autres, y compris Robert Delaunay . . . et que nous comprîmes quelles affinités nous rapprochaient. L'intérêt de faire bloc, de nous fréquenter, d'échanger des idées, nous apparut impérieux.'[2] Besides the meetings at Mercereau's and the *Closerie*, the painters began meeting regularly at Le Fauconnier's studio in the rue Visconti as well, where during the closing months of the year they watched with interest the development through successive stages of his *Abondance*, a painting that all appear to have regarded as an important, revolutionary work. Early in the following year Gleizes instituted weekly *soirées* at his studio in Courbevoie. Neither Picasso nor Braque, the true creators of the movement, were present at any of these gatherings.

The first Cubist manifestation took place at the *Salon des Indépendants* of 1911. Largely at the instigation of Apollinaire, Salmon and Allard, the painters had decided to show together as a group. 'Metzinger, Le Fauconnier, Delaunay, Léger et moi,' writes Gleizes, 'étions décidés à envoyer au prochain Salon des Indépendants . . . mais . . . nous devions être groupés, c'était l'avis de tous.' They feared that if their paintings were not all shown together most of the impact would be lost; but to ensure that they were hung together, the rules of the *Salon* had to be modified. Usually the committee of the *Salon* appointed a

[1] Ibid.
[2] Ibid, on which the following account is based.

hanging committee which was automatically and unanimously approved by the general assembly at its annual meeting held a few weeks before the opening of the exhibition. With the aid of their literary friends, the painters drew up a pamphlet to distribute to the general assembly, protesting against the chaotic hanging in previous exhibitions, and urging that the hanging committee proposed by the committee of the *Salon* be overthrown. They proposed instead a new list of candidates which included themselves 'et d'autres peintres que nous connaissions plus ou moins . . . qui nous paraissaient plus ou moins susceptibles de représenter sinon une tendance, du moins une valeur'. These included Lhote, Segonzac, La Fresnaye and Marchand.

The manoeuvre proved successful and Metzinger in particular received a very large number of votes. Le Fauconnier, Léger, Delaunay, Metzinger and Gleizes chose for themselves *Salle 41* and accepted a few other painters to be shown with them, among them, at the request of Apollinaire, Marie Laurencin. A neighbouring gallery contained the entries of Lhote, la Fresnaye, Segonzac, Luc Albert Moreau and André Mare. The dramatic 'coup' at the general meeting, coupled with the publicity made by the writers of the circle, sufficed to provoke an exceptional amount of interest in the contents of these rooms even before the *Vernissage*. On the opening day it was almost impossible to get into *Salle 41* owing to the crowds. Next day a violent storm of criticism and derision was let loose in the press,[1] while the long review by Apollinaire in *L'Intransigeant* served to establish him as the champion of the group.[2] The painters themselves, despite the highly organized aspect of the demonstration, appear to have been surprised at the sensation caused by their works and at the sudden notoriety which they acquired overnight. Even without the works of Picasso and Braque the public saw in this manifestation a new departure in art; yet in many ways the *succès de scandale* of the *Indépendants* was due as much to the poets as to the painters.

Shortly after the *Salon des Indépendants*, the *Société des Artistes Indépendants* of Brussels invited the French painters to join them in their yearly show, which was to open in June. The catalogue lists Archipenko, Delaunay, Segonzac, Gleizes, Le Fauconnier, Léger, Marchand, Moreau and Jean Plumet; Metzinger for some reason abstained. In his preface to the catalogue, Apollinaire wrote: 'Les peintres nouveaux qui ont manifesté ensemble cette année, au Salon des Artistes Indépendants de Paris, leur idéal artistique, acceptent le nom de

[1] *Gil Blas*, 20–21 April 1911, and in *Comoedia*, *Excelsior*, *Action*, *L'Oeuvre* and *Cri de Paris* (quoted in Gleizes).
[2] *L'Intransigeant*, 20 April 1911.

cubistes qu'on leur a donné. Cependant le cubisme n'est pas un système, et les différences qui caractérisent non seulement le talent, mais la manière de ces artistes en sont une preuve manifeste.'[1]

The term 'Cubism' had become common usage in the press after the opening of the *Salon des Indépendants*, although Apollinaire himself had referred to Metzinger, who had shown a painting directly influenced by Picasso, as 'le seul adepte du cubisme proprement dit'.[2] Applied to the artists showing at Brussels, the term could have no very definite meaning, and Apollinaire found it hard to identify many specific characteristics shared by the painters, or even to distinguish Cubism from Fauvism: 'Un trait les unit, toutefois si les peintres que l'on a appelé les fauves ont eu comme principal mérite de revenir aux principes en ce qui concerne la couleur et la composition, les cubistes pour élargir encore le domaine d'un art ainsi renouvelé, ont voulu retourner aux principes en ce qui concerne le dessin et l'inspiration. Si j'ajoute que la plupart des cubistes ont été jadis comptés parmi les fauves, je montrerai l'étendue du chemin parcouru en peu de temps par ces jeunes artistes et la logique de leurs conceptions.

'De ces deux mouvements qui se succèdent en se combinant si bien, il est sorti un art simple et noble, expressif et mesuré, ardent à la recherche de la beauté, et tout prêt à aborder ces vastes sujets que les peintres d'hier n'osaient entreprendre, les abandonnant aux barbouilleurs présomptueux, démodés et ennuyeux des Salons officiels'.

Apollinaire concludes: 'Je crois avoir donné en peu de mots le sens véritable du cubisme: manifestation nouvelle et très élevée de l'art, mais non pas un système contraignant les talents.'

The exhibits in the Brussels exhibition seem to have had in common only a concentration on clearly defined simple forms and a corresponding limitation of colour, and very few of them had anything at all in common with the work of Picasso and Braque. Certain critics like Hourcade and Allard, who did not realize the importance of what Picasso and Braque were doing, continued to take a broad view of Cubism as simply a return to a more sober, classical form of art, and thus to include within the movement a large number of artists who were not strictly speaking Cubist but had been slightly influenced by Cubism. In October 1912 Hourcade wrote: 'Le mot "cubisme" . . . n'a pas de sens si vous le prenez en tant qu'épithète d'école: il n'y a pas d'école cubiste. Et il est absurde de croire que tous les peintres de la Section d'Or[3] et d'autres, disséminés au

[1] *Les Indépendants, Cercle d'Art*, VIIIème Salon, 10 June–3 July 1911.
[2] *L'Intransigeant*, 21 April 1911.
[3] For the *Section d'Or* see pp. 30–32 below.

Salon d'Automne, ont entre eux un seul principe commun si ce n'est le désir de réagir contre la décadence négligente de l'impressionnisme. La vraie définition du Cubisme me paraît être: *Le retour au style par une vision plus subjective de la nature* (et qui se traduira quelquefois par une plus ferme écriture des masses). L'intérêt premier du cubisme est la différence absolue des peintres entre eux.'[1] However, Vauxcelles's original references to the 'cubes' in Braque's work and to his 'bizarreries cubiques' had been intended disparagingly, and the term 'Cubism' continued to be applied by hostile critics to the work of the more advanced painters whom they could not understand or appreciate, and by perceptive critics to these same artists whom they considered to be pioneers in a new movement. But as the pictorial innovations of Picasso and Braque—the construction of a painting in terms of a linear grid or framework, the fusion of objects with their surroundings, the combination of several views of an object in a single image, and of abstract and representational elements in the same picture—began to influence a widening circle of artists, the style became distinguishable by virtue of these features.

Although until late in 1912 Picasso and Braque lived in Montmartre and had relatively little contact with the other Cubists who lived mostly on the Left Bank or in the suburbs, they did not live in isolation. Picasso had never shown publicly at the big *Salons*, but Braque's Cubist works exhibited at the *Salon des Indépendants* of 1909 were widely discussed and were undoubtedly an influence on some painters, while they must have helped others to interpret Cézanne in a more intellectual, objective way. The work of both painters could be seen at Kahnweiler's gallery in the rue Vignon and at the small private gallery run by Uhde.[2] Delaunay used to meet Picasso at the gatherings at the Douanier Rousseau's,[3] while Metzinger was a frequent visitor to Picasso's studio in the *Bateau Lavoir*[4] during the early years of Cubism, and was an important agent in transmitting the first discoveries of Picasso and Braque. It was Metzinger who, in his *Note sur la Peinture* of 1910, was the first to write of the fact that Picasso and Braque had dismissed traditional perspective and felt free to move around their subjects, studying them from various points of view. Discussing

[1] *Paris Journal*, 23 Oct. 1912.

[2] There was also a Picasso exhibition at Vollard's in the winter months of 1910–11. Vollard continued to buy Picasso's work until the summer of 1910, although his purchases became fewer, and this exhibition may not have included Cubist work. There appears to have been no catalogue; M. Kahnweiler cannot remember the exhibition at all.

[3] *Picasso et ses Amis*, p. 77.

[4] The *Bateau Lavoir* was the studio building in the rue Ravignan (to-day known as the place Emile-Goudeau), where Picasso lived from 1904 until 1909; the name seems to have arisen from its resemblance to the washing-boats on the Seine. The building was originally a piano factory, and was known to Picasso and his friends also as *la maison du trappeur*.

the painting of Picasso and Braque, he added to some general remarks about the return to a more formal and intellectual art his view that a painting by Picasso was 'l'équivalent sensible et vivant d'une idée, l'image totale . . . Cézanne nous montre les formes vivantes dans la réalité de la lumière, Picasso apporte un compte-rendu matériel de leur vie réelle dans l'esprit, il fond une perspective libre, mobile . . . Aux perceptions visibles il joint les perceptions tactiles'. And of Braque he wrote: 'Qu'il peigne un visage, un fruit, l'image totale rayonne dans la durée; le tableau n'est plus une portion morte des masses concurrentes.' Léger was shown the works of Picasso and Braque in 1910 by Kahnweiler and met them later the same year.[1] Le Fauconnier and Gleizes did not meet Picasso until late in 1911, and Gleizes does not record having met Braque at all.

The poets and writers who had been instrumental in organizing the younger painters at the *Indépendants* also played a large part in uniting the different aspects of Cubism. Apollinaire and Raynal in particular moved freely in all artistic circles. Apollinaire, however, remained personally most intimate with Picasso, and it is certain that the literary circle which surrounded Picasso, and which included Max Jacob and Pierre Reverdy, was more advanced than that around Gleizes and Metzinger, whose closest friends, men like Mercereau and Nayral, belonged to the circle of Paul Fort and the older generation of Symbolists.

During 1911 and 1912 the group formed by Gleizes, Metzinger, Léger, Le Fauconnier and Delaunay was expanded to include several new figures. Archipenko and La Fresnaye, who had been unknown to Gleizes before the *Salon des Indépendants* of 1911, began to frequent the Mondays at Courbevoie.[2] Picabia was drawn into the circle, probably by Apollinaire with whom he had recently become friendly. Apollinaire himself was usually accompanied by Marie Laurencin. But most important was the contact established with the Duchamp brothers who exhibited under the names of Jacques Villon, Marcel Duchamp and Duchamp-Villon. Duchamp-Villon, although at that time not personally in touch with the group, was on the committee of the *Salon d'Automne* of 1911 and together with La Fresnaye, Desvallières and one or two others, was largely responsible for persuading the hostile jury to include the paintings submitted by the Cubists. Duchamp-Villon and La Fresnaye were also members of the hanging committee, so that the Cubist painters were able to exhibit for the second time that year as a group. Marcel Duchamp and Jacques Villon had been influenced by the demonstration at the *Indépendants*, and were included in the

[1] Douglas Cooper, *Fernand Léger et le nouvel Espace*, Geneva 1949, p. 36.
[2] *Souvenirs*.

Cubist room at the *Salon d'Automne*. After this their studio at Puteaux became another meeting place. Franz Kupka, a Czech painter who had come to Paris in 1894 or 1895, and who lived in an adjacent studio, was also drawn into contact with the Cubists. Le Fauconnier and Mercereau continued to entertain weekly, so that the painters and writers were meeting constantly. Metzinger, Gleizes, and Le Fauconnier even planned to publish a review dedicated to the plastic arts, with the collaboration of Jacques Nayral and Mercereau.[1] The participation of many of these painters in the formation of *Les Artistes de Passy* in October 1912, an attempt to transform that district of Paris into yet another art-centre, is a further sign of the continual emphasis on communal activity.[2] Lhote, who had already established a certain independent reputation, mixed cautiously in Cubist circles, but from 1911 onwards was generally referred to as a Cubist, although his somewhat academic style often gained his exemption from the unfavourable criticism directed at the other painters.

The most significant new figure to join the group, however, was undoubtedly Juan Gris. A Spaniard like Picasso, Gris had arrived in Paris in 1906 and had moved into a studio adjacent to Picasso's in the *Bateau Lavoir*. Although he did not begin painting seriously until 1911, Gris had thus been in a position to watch at first hand the birth and development of Picasso's Cubism. Within an amazingly short time he developed into a highly accomplished and individual painter. As he was a very intellectual artist, he was the ideal figure to take over from Metzinger the task of transmitting the principles of Cubism to the other painters; and since he joined the group at a moment when the movement was striving for greater definition, his influence and importance cannot be over-estimated. Marcoussis and Herbin, whose work began to be noticed during 1912 and 1913, had also approached Cubism directly through Picasso and Braque.

The influence of Cubism seems to have been immediate and extensive. One reviewer of the *Salon des Indépendants* of 1912 writes: 'Leurs oeuvres remplissent maintenant plusieurs salles et se manifestent dans plusieurs salons, puisqu'ils font école',[3] and another: 'les cubistes, on les rencontre en force'.[4] Reviewing this same exhibition, both Allard and Apollinaire noticed that for the first time in several years the influence of Matisse and Fauvism was

[1] The plans for this review are discussed in *Paris Journal*, 17 Oct.–30 Oct. 1911.
[2] The formation of this group is discussed in an article entitled *Passy, Nouveau Centre d'Art*, in *Poème et Drame*, Paris, January 1913. The painters involved were Gleizes, Metzinger, Laurencin, Jacques Villon, Duchamp-Villon, Picabia, La Fresnaye and Tobeen. Auguste and Claude Perret were also present at the meetings in the *Maison de Balzac*. At one of these meetings La Fresnaye read a paper on Cézanne.
[3] J. Laran, in *Bulletin de la Société de l'Histoire de l'Art Français*, 1er fascicule, 1912.
[4] Mourey, in *Journal*, 22 March 1912.

slight.[1] Gustave Kahn wrote: 'L'exposition est bonne pour les cubistes'.[2] To add to the general impact of their work, many of the Cubists had, at the suggestion of Apollinaire, submitted very large canvases—Delaunay's *Ville de Paris* was the largest painting in the exhibition.

That same year (1912) the Cubists also exhibited in Rouen at the *Salon de Juin*, and the movement was rapidly becoming known outside France as well. As early as 1910, Mercereau had sent to Russia an exhibition of works by Gleizes, Metzinger and Le Fauconnier, and a few artists whose aims he felt to be similar.[3] Apollinaire was able to write that the *Salon d'Automne* of 1912 had been persuaded to show the Cubists because of their influence and prestige abroad;[4] the most important and sensational feature in the *Salon* was certainly the *maison cubiste*, for which André Mare and Duchamp-Villon were responsible. Indeed, a painter-critic named Lecomte had resigned from membership of the *Salon* because he felt the Cubists were too numerous and their work too well hung.[5] Finally the storm and controversy raised by the Cubists reached its climax on the 3rd of December 1912 when they became the subject of an *interpellation* in the *Chambre des Députés*. Following the lead of a municipal councillor and amateur photographer named Lampué, who had written an open letter to Monsieur Bérard, Under-Secretary in the Ministry of Fine Arts, in the *Mercure de France*,[6] a Socialist deputy, Monsieur Jean Louis Breton, demanded that measures be taken to prevent the Cubists from exhibiting at the *Salon d'Automne*: 'Il est absolument inadmissible que nos palais nationaux puissent servir à des manifestations d'un caractère aussi nettement antiartistique et antinational.' The attack was answered by Marcel Sembat, another Socialist, and a leading member of the party, who was himself keenly interested in modern painting. 'Quand un tableau vous semble mauvais,' he declared, 'Vous avez un incontestable droit: celui de ne pas le regarder et d'aller en voir d'autres. Mais on n'appelle pas les gendarmes.'[7] So the matter rested there; but it is a sign of the intense feeling aroused by the new school.

The most important single Cubist exhibition was that of the *Section d'Or* at the *Galerie de la Boétie* in October 1912. In the previous year the Cubists and a large number of their friends had exhibited at the *Galerie de l'Art Contemporain* in the rue Tronchet, under the auspices of the *Société Normande de Peinture*

[1] *L'Intransigeant*, 19–22 March 1912; *Côte*, 19 March 1912.
[2] *Mercure de France*, 1 April 1912.
[3] Gleizes, *Souvenirs*.
[4] *L'Intransigeant*, 30 Sept. 1912.
[5] *Le Temps*, 12 Oct. 1912.
[6] 16 Oct. 1912.
[7] *Journal Officiel de la Chambre des Députés*, 1ère Séance du 3 déc. 1912.

Moderne.[1] This exhibition had received little attention in the press, though *l'Autorité* and *Paris Journal* had referred to it as an 'exposition des fauves et cubistes',[2] no doubt through a confusion of terms, but also partly because this seemed the only way of describing the manifold tendencies represented, which were as divergent as at Brussels.[3] The *Section d'Or*, on the other hand, was generally accepted as being Cubist in character. Over 200 works were shown, and the fact that all the artists showed paintings representative of their development during the previous three years gave the exhibition an added air of being a Cubist demonstration.[4] Since Picasso and Braque had not exhibited for some time, and since they had not taken part in the manifestations at the *Salon des Indépendants* and the *Salon d'Automne*, the public were not in a position to realize that their abstention deprived the *Section d'Or* of much of its meaning. The idea of the *Section d'Or* seems to have originated in the course of conversations between Gleizes, Metzinger and Jacques Villon at Puteaux and Courbevoie. Jacques Villon, who was older than the others and seems on that account to have enjoyed a certain authority, is generally credited with having suggested the title.[5] On the 2nd of September 1912 *Gil Blas* announced that Marcel Duchamp was planning to send to the forthcoming *Salon d'Automne* a painting which was also to be called *La Section d'Or*.[6] All the Duchamp brothers were at this time passionately interested in mathematics; Jacques Villon was engaged in reading Leonardo's *Trattato della Pittura*,[7] while Marcel Duchamp was a close friend of an amateur mathematician named Maurice Princet, so that it is not surprising that they should have been responsible for introducing a more scientific note into Cubist discussions. The choice of *La Section d'Or* as a title for the exhibition of the group of painters who appeared at the *Galerie de la Boétie* seems to indicate some dissatisfaction with the term Cubism as applied to their work, and was probably intended to imply that the paintings shown had a more profound and rational basis. Perhaps it was felt also to have a wider, more general

[1] This is presumably the same body as originated the exhibition at Rouen the following summer (1912), see p. 30 above, although Apollinaire calls it *Société des Artistes Normands* (*Les Peintres Cubistes*, p. 13).

[2] *Paris Journal*, 13 Nov.; *l'Autorité*, 27 Nov. 1911.

[3] The following painters exhibited at the *Galerie d'Art contemporain*: Metzinger, Le Fauconnier, Gleizes, Léger, Dufy, Marcel Duchamp, La Fresnaye, Lhote, Laurencin, Picabia, Friesz, Segonzac, Jacques Villon, Mare, le Beau, Zak, Verdilhan, Dumont, Lotiron, Marchand, Luc Albert Moreau, Vera, Tobeen, Bracque, Girieud, Ribbemont-Dessaignes, Texier, Saint-Deles; and the following sculptors: Archipenko, Duchamp-Villon, Jermant, Nadelman and Halau.

[4] *Paris Journal*, 15 Sept. 1912.

[5] This was confirmed verbally to the writer by M. Marcel Duchamp.

[6] *Gil Blas*, 2 Sept. 1912.

[7] Jacques Lassaigne, *Jacques Villon*, Paris 1950, p. 4. The *Trattato della Pittura* appeared in a French translation by Péladan in 1910.

meaning. The three organizers, however, and many of the painters most directly concerned, were at this period working in a Cubist idiom.[1]

If the Cubists had been surprised by the violent reactions which they had aroused previously, they seem to have been anxious to attract as much attention as possible with this exhibition. The *Vernissage* was held from nine until midnight, for which the only precedent was the initial opening of the *Salon d'Automne* in 1903.[2] Invitations were issued to vast numbers of people, and many of the guests had to be turned away. Lectures by Apollinaire, Hourcade and Raynal were advertised, and a review, *La Section d'Or*, was published to coincide with the opening; it was edited by Pierre Dumont and numbered Apollinaire, Reverdy, Max Jacob, Maurice Raynal, Salmon, Warnod and Hourcade among its contributors.

As in previous exhibitions, artists like Alcide le Beau, Segonzac and Luc Albert Moreau, whose paintings were related to Cubism only in a most general way, were invited to show, and the title may have been chosen partly to allow for this. But as opposed to the exhibition of the *Société Normande de Peinture Moderne* of the previous year, the majority of the artists showing at the *Section d'Or* were Cubists or painters directly influenced by the movement, and the effect made must have been concentrated. Furthermore, the fact that the exhibition was organized to show the successive stages through which Cubism had passed indicates that the painters were attempting to make their work as comprehensible as possible to the public, and their purpose must have been further served by the demonstration of the affinities between Cubism and the more readily understandable paintings of other artists who shared only a few of their pictorial concerns. The exhibition was undoubtedly a great success, and it put Cubism on the map more than any other exhibition that preceded it.

This same desire to render Cubism more intelligible to the general public, and to define and clarify the movement generally, led Gleizes and Metzinger in the autumn of 1911 to collaborate in writing the book *Du Cubisme*, which appeared in August 1912. Salmon's *La Jeune Peinture Contemporaine*, which contained an *Histoire anécdotique du Cubisme*, was published in the following month. Earlier in 1912 Apollinaire had written a series of articles for *Les Soirées de Paris* and these were gathered together with some additional material to form the bulk of his *Les Peintres Cubistes* which was issued in March of the

[1] The exhibitors were: Metzinger, Gleizes, Villon, Duchamp, Duchamp-Villon, Picabia, Gris, Lhote, La Fresnaye, Marcoussis, Archipenko, Agero, Marchand, Segonzac, Luc Albert Moreau, Vera, Léger, Pierre Dumont, Tobeen, Glanis, Le Beau, Laurencin, Hassenberg, Lewitzka, Tivnet, Ribbemont-Dessaignes, Gav, Dexter, Girieud and Valensi.
[2] *Paris Journal*, 9 Oct. 1912.

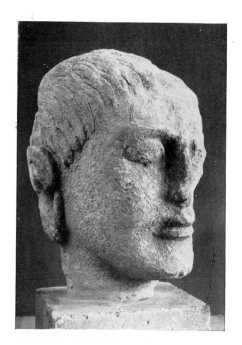 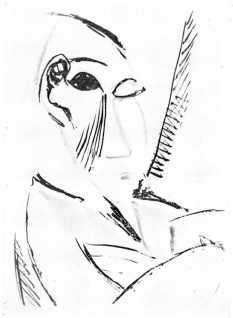

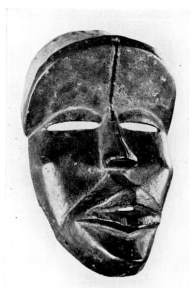 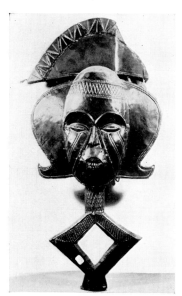 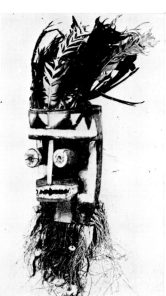

80A. Head of a Man (three-quarter view). Iberian Sculpture. Musée du Louvre

PICASSO

80B. Male Head, 1907. Ink and watercolour. The Museum of Modern Art, New York

80C. Wooden Mask, Dan, Ivory Coast. Musée de l'Homme, Paris

80D. Bronze ancestral figure from the French Congo, British Museum, London

80E. Wobé Ceremonial Mask, Sassandra, Ivory Coast. Musée d l'Homme, Paris

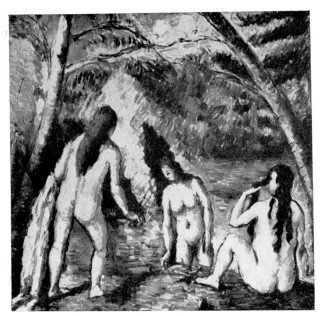

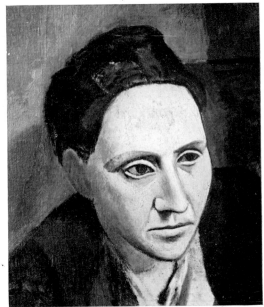

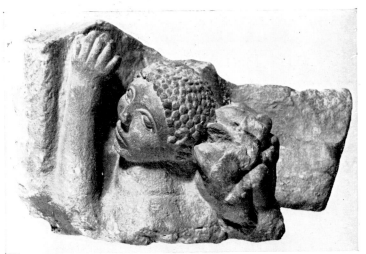

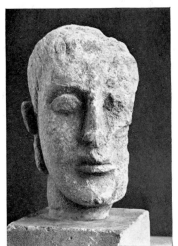

CÉZANNE
79A. Trois Baigneuses. Petit Palais, Paris

PICASSO
79B. Portrait of Gertrude Stein, 1906 (detail of head).
Metropolitan Museum of Art, New York

79C. Hunting Scene. Iberian Sculpture (Osuna). Museo Arqueológico, Madrid

79D. Head of a Man (full face view). Iberian Sculpture. Musée du Louvre

following year. In February and June 1912 Hourcade published articles entitled respectively *La Tendance de la Peinture Contemporaine* and *Le Mouvement Pictural vers une école française de peinture*,[1] in which he attempted to reassess the achievements of the preceding year. Raynal's first significant essay *Qu'est-ce que le Cubisme?* did not appear until late in 1913.[2] All these writings had certain points in common. All emphasized that Cubism was an art of realism, although natural appearances were playing an ever-diminishing part. Painting was to become intellectual, and the painters would depict the world not as they saw it, but as they knew it to be. Apollinaire and Hourcade added that this conceptual or intellectual approach led naturally to a selection of simple geometric forms. The right of the painter to move around an object and combine various views of it into a single image, first stated in writing by Metzinger in 1910[3] and elaborated a few months later by Allard,[4] was quickly adopted by most critics as a central feature of the style, and became related to the conceptual or intellectual aspect. Thus Hourcade felt that an artist could convey more clearly the real nature of an object by showing as many aspects of it as possible, and guided by intelligence rather than by his eye, would resort to geometric forms. Knowing that the opening of a cup is round, it is false to depict it simply as an ellipse; ideally the object is shown as a combination of plan, section and elevation. Emphasizing the intellectual approach, Hourcade was the first of the many writers to relate Cubist painting to Kantian aesthetics, and in one of his articles includes a quotation from Schopenhauer: 'Le plus grand service que Kant ait rendu c'est la distinction entre le phénomène et la chose en soi; et il a montré qu'entre la chose et nous il y a toujours l'intelligence'.[5] Hourcade also saw as a second feature of Cubist painting the organization of the whole surface in terms of interpenetrating or interacting planes: 'Pour tout dire, l'intérêt des toiles ne réside pas seulement dans la présentation des objets principaux, mais dans le dynamisme qui se dégage de la composition des toiles, dynamisme bizarre, inquiétant mais strictement exact'. In *Du Cubisme*, this feature was discussed as deriving from Cézanne: 'Il nous apprend à dominer le dynamisme universel. Il nous révèle les modifications qui s'infligent réciproquement des objets crus inanimés. . . . Il prophétise que l'étude des volumes primordiaux ouvrira des horizons inouïs. Son oeuvre, bloc homogène, se meut sous le regard, se contracte, s'étire, fond ou s'allume et prouve irrécusablement que la peinture n'est pas—ou n'est

[1] In *La Revue de France et des Pays Français No. 1*, Feb. 1912. *Revue Française*, June 1912.
[2] In *Comoedia Illustré*, Dec. 1912.
[3] *Note sur la Peinture.*
[4] In *Sur Quelques Peintres, Les Marches du Sud-Ouest*, June 1911.
[5] *La Tendance de la Peinture Contemporaine.*

plus—l'art d'imiter un objet par des lignes et des couleurs, mais de donner une conscience plastique à notre instinct.'[1]

On the subject of the abstract tendencies inherent in Cubist painting, however, the writers differed sharply. Apollinaire appeared to see complete abstraction as the goal. In the second section of *Les Peintres Cubistes*[2] he stated: 'Le sujet ne compte plus, ou s'il compte c'est à peine.[3] . . . Les jeunes artistes-peintres des écoles extrêmes ont pour but secret de faire de la peinture pure. C'est un art plastique entièrement nouveau. Il n'est qu'à son commencement et n'est pas aussi abstrait qu'il voudrait l'être'.[4] Gleizes and Metzinger, themselves painters, and fascinated by purely formal pictorial problems, also began by seeing abstraction as the logical end, although they rapidly retreated and admitted the need, for the moment at least, of a certain coefficient of realism: '. . . le tableau n'imite rien et . . . il présente nûment sa raison d'être. . . . Néanmoins avouons que la réminiscence des formes naturelles ne saurait être absolument bannie, du moins actuellement. On ne hausse pas d'emblée un art jusqu'à l'effusion pure.'[5] Allard and Hourcade rigorously opposed any suggestion of abstraction in Cubist painting. Hourcade condemned it as un-French: 'notre tradition profonde veut un sujet, et l'originalité de l'école cubiste ne peut être qu'en rejetant l'anecdote pour retrouver le sujet';[6] and he repudiated the idea that all the painters of the *Section d'Or* had renounced natural appearances: '. . . il est absolument faux de dire que tous ces peintres ont pour but unique de faire de la peinture pure et qu'ils tournent le dos à la nature.'[7] None of the writers realized that the Cubism of this date relied on a balance between abstraction and representation to achieve its effects, and that it was this balance that gave each work a significance on more levels than one. It was only natural that the two artist-writers, Gleizes and Metzinger, should have been the ones who were forced into a position of compromise between the two poles of abstraction and representation.

But while the *Section d'Or* represented the high point of the Cubist movement as it was presented to the public, and while the influence of Cubism daily became more powerful and widespread, many painters who had been Cubist, or had moved in Cubist circles, were already abandoning the style or using certain

[1] *Du Cubisme*, pp. 8, 9.
[2] This section appeared originally in the Feb. 1912 edition of *Les Soirées de Paris* as *Du Sujet dans la Peinture Moderne.*
[3] *Les Peintres Cubistes*, p. 11.
[4] Ibid., pp. 13–14.
[5] *Du Cubisme*, p. 17.
[6] *La Tendance de la Peinture Contemporaine.*
[7] *Paris Journal*, 23 Oct. 1912.

aspects of it as points of departure for developing completely new art forms. Delaunay, who earlier in the year had held an important exhibition together with Marie Laurencin at the *Galerie Barbazanges*, did not show at the *Section d'Or*, and wrote an open letter to Vauxcelles: 'je tiens à vous dire que je ne rallie pas à l'opinion qui est injustement basée de Monsieur Hourcade qui me proclame créateur du cubisme avec quatre de mes confrères et amis. C'est à mon insu que quelques jeunes peintres se sont servis de mes anciennes études. Ils ont exposé dernièrement des toiles qu'ils appellent toiles cubistes. Je n'expose pas.'[1] And in the reviews of the *Section d'Or* and the progressive *Salons* of 1912, there are indications that the works of Kupka, Picabia and Marcel Duchamp were generally recognized as having gone in some way beyond those of the original Cubists in daring and novelty. One critic of the *Salon d'Automne* wrote: 'Le record de la haute folie est détenu cette anneé par M. Picabia ... M. Kupka a tourné, lui, au sphéricisme,'[2] while Hourcade felt that Picabia had 'poussé jusqu'-au bout une théorie mauvaise.'[3] Allard had referred to the work of Kupka at the *Salon des Indépendants* as 'fantaisies post-cubistes',[4] while at the *Section d'Or* Vauxcelles singled out as representative of the worst and most outrageous tendencies Duchamp's *Le Roi et la Reine entourés de nus vites*.[5]

Both Delaunay and Le Fauconnier, who did not exhibit at the *Galerie de la Boétie* either, were at this point on less friendly terms with the other members of the movement, and for this reason their works were not illustrated in *Du Cubisme*.[6] The differences between the painters appear to have been purely personal, but Delaunay had also moved away from the other Cubists in his works of 1912, and, using his Cubist researches as a point of departure, was developing a much more purely abstract kind of painting with colour as its principal element.

Delaunay was himself profoundly aware that he had evolved a new kind of painting and he communicated his discoveries to Apollinaire with whom he had become very friendly. Apollinaire, always ready to welcome and encourage any form of artistic novelty, christened this development 'Orphism'. Apollinaire had recently finished writing *Le Bestiaire au Cortège d'Orphée*[7] and felt the name to be applicable to Delaunay's work, partly because it was more lyrical and sensuous than the rather austere Cubism of the period, and also because he saw it as

[1] *Gil Blas*, 25 Oct. 1912.
[2] Jean Claude, in *Petit Parisien*, 30 Oct. 1912.
[3] *Paris Journal*, 30 Sept. 1912.
[4] *Revue de France*, March 1912.
[5] *Gil Blas*, 14 Oct. 1912.
[6] Gleizes, *Souvenirs*.
[7] Paris 1911.

a form of 'peinture pure' which had analogies with music. In the nineteenth century music had come to be regarded as queen of the arts because of its non-imitative qualities, and throughout the Cubist period musical analogies become increasingly frequent. With the emergence of abstract painting many felt that painting had become completely 'musicalized'. In his article *Du Sujet dans la Peinture Moderne* (which became the second section of *Les Peintres Cubistes*) Apollinaire had written: 'On s'achemine ainsi vers un art entièrement nouveau, qui sera à la peinture, telle qu'on l'avait envisageé jusqu'ici ce que la musique est à la littérature pure.'[1] Arthur Eddy, an American critic who in 1914 produced the first book in English on Cubism, *Cubists and Post-Impressionism*, wrote that 'the comparison that Picabia is fondest of making is that of absolute music'.[2] Valensi, who had shown at the *Section d'Or* in 1912, in a lecture given late in the following year asked: 'Pourquoi ne pas concevoir alors une peinture pure? De même que le musicien a ses notes, pourquoi ne pas supposer que la couleur par sa force intrinsèque puisse exprimer la pensée du peintre?'[3] In his lecture *Le Cubisme écartelé* given at the *Section d'Or* on the 11th of October and later added to *Les Peintres Cubistes* when the book was already in proof, Apollinaire divided Cubism into four categories, Orphism being the most advanced: 'C'est l'art de peindre des ensembles nouveaux avec des éléments empruntés non à la réalité visuelle, mais entièrement créés par l'artiste et doués par lui d'une puissante réalité. Les oeuvres des artistes orphiques doivent présenter simultanément un agrément esthétique pur, une construction qui tombe sous les sens et une signification sublime, c'est-à-dire le sujet. C'est de l'art pur.'[4]

While waiting to move into a new apartment in the Boulevard Saint Germain, Apollinaire lived with the Delaunays for almost two months during the autumn of 1912, and at this time the Delaunays' studio became the meeting-place of a new group.[5] The poet Blaise Cendrars was drawn into the circle, and he, together with Apollinaire, Chagall, and the American painters Bruce and Frost, joined the Delaunays during the summer of 1913 at the house they had rented at Louveciennes. Early in 1913 Canudo, another friend of Apollinaire's, founded a review called *Montjoie* which was recognized to be an Orphist mouthpiece, while Apollinaire expanded and developed his ideas on the new style in *L'Intransigeant* and particularly in *Les Soirées de Paris*. Archipenko, who had been a friend of Delaunay for some time, now also denied being a Cubist; the Art

[1] *Les Peintres Cubistes*, p. 12.
[2] A. J. Eddy, *Cubists and Post-Impressionism*, New York 1914, p. 91.
[3] This lecture was published in *Montjoie*, Nov.–Dec. 1913.
[4] *Les Peintres Cubistes*, p. 25.
[5] The bulk of this paragraph is reconstructed from the Delaunay biographical data.

column of *Gil Blas* reported on the 14th of December 1912: 'M. Archipenko a déclaré formellement qu'il s'était détaché de la façon la plus absolue du groupe cubiste dont il rejette les principes.'[1] The group used also to frequent the Bal Bullier, a popular Parisian dance hall. There they were sometimes joined by Arp and Arthur Cravan.

Delaunay felt that the basis of his art was 'simultaneous' contrasts of colour, a concept which he adoped from Chevreul, whose colour theory had interested him for some time. He meant by this that the areas of colour in his painting were not to be blended by the eye but were to be seen as acting on each other reciprocally, thus producing pictorial form and space. Sonia Delaunay later expressed this theory in its simplest form: 'Les couleurs pures devenant plans et s'opposant par contrastes simultanés créent pour la première fois la forme nouvelle construite non par le clair-obscur, mais par la profondeur des rapports des couleurs mêmes.'[2] In March 1913, writing on the *Salon des Indépendants* in *Montjoie*, Apollinaire referred to 'L'Orphisme, peinture pure, Simultanéité', and the two terms thus became largely synonymous.

The poets and critics had played a considerable part in stimulating and organizing the first manifestations of the Cubists, but the connections between Orphism and contemporary literature were stronger and more direct. Apollinaire, who at the time was fascinated by the interrelation of the arts, and was exploring the visual possibilities of poetry in his *Calligrammes* (for which one of the original titles was *Moi aussi je suis peintre*), was inspired by Delaunay's painting *Les Fenêtres* to compose, late in 1912, his poem of the same name, in which the means are to a certain extent analogous. This poem, written in free verse, was one of the first in which Apollinaire eliminated punctuation, and was composed of seemingly disconnected, partially self-sufficient phrases and ideas, which by their placing and interaction serve to evoke both form and atmosphere. Early in 1913 Cendrars published the first 'simultaneous' book, *La Prose du Transsibérien et de la petite Jehanne de France*, a poem over six feet in length, which was printed in letters of different colours and sizes on an abstract coloured background designed by Sonia Delaunay. The avowed programme of *Montjoie* was to find the link between various arts and to investigate their common tendencies, and Canudo invented the term 'cérébrisme' to describe this attitude: 'Montjoie est l'organe de l'art cérébriste, car le cérébrisme, selon sa définition même, comprend et explique toute l'évolution artistique de notre époque depuis quarante ans, dans le sens le plus vaste d'une esthétique

[1] *Gil Blas*, 14 Dec. 1912.
[2] In a preface to the programme of the *Comédie des Champs Elysées, Saison 1926–27*.

indissolublement cérébrale et sensuelle—contre tout sentimentalisme dans l'art et dans la vie.'[1] Writing about Stravinsky, Canudo gave a practical demonstration of his outlook when he claimed that: 'Il participe de notre esthétique, du cubisme, du synchronisme, du simultanisme des uns, et de la toute nerveuse onyrythme prosaïque des autres.' An author named Henri Martin, who wrote under the name of Barzun, published a *Manifeste sur le simultanisme poétique*,[2] and disputed with Apollinaire the invention of what he called literary Simultaneism. Apollinaire felt that he had achieved simultaneity in his 'poèmes conversations, où le poète au centre de la vie enrégistre en quelque sorte le lyrisme ambiant'.[3] Later in the same article *Simultanisme-Librettisme* in which he expounded these views, Apollinaire, using Picasso's work as an example, extended the idea of Simultaneity to cover the combination of various view-points of objects in a single image.

Orphism appeared before the public at the *Salon des Indépendants* of 1913. As in the case of Cubism, Apollinaire tried to give the word as much of an all-inclusive meaning as possible: 'On a déjà beaucoup parlé de l'Orphisme. C'est la première fois que cette tendance se manifeste. Elle réunit des peintres de caractères assez différents qui tous, dans leurs recherches, sont animés par une vision plus intérieure, plus populaire, plus poétique de l'univers et de la vie. Cette tendance n'est pas une invention subite; elle est l'évolution lente et logique de l'impressionnisme, du divisionnisme, de l'école des fauves, et du cubisme. Le mot seul est nouveau.'[4] Generally speaking, however, although Orphism was regarded as a new school its derivation from Cubism was acknowledged. This had, of course, been made clear at the *Salon des Indépendants* by Delaunay's *L'Equipe de Cardiff* which, by comparison with his more abstract works, appeared simply as a highly coloured and more *mouvementé* Cubist painting. Warnod noted in *Comoedia* that 'le cubisme et l'Orphisme sont de la même famille. Tandis que le cubisme vise au dessin intégral, l'orphisme est une recherche de peinture "pure", non pas qu'il soit question de couleurs pures, c'est-à-dire comme elles sortent du tube, mais de peinture considérée en dehors de tout autre chose'.[5] Apollinaire, who in *Les Peintres Cubistes* had defined Orphic Cubism as being represented only by Delaunay, Léger, Picabia, Duchamp and Picasso in so far as his use of light was significant, now saw Orphic tendencies in Laurencin, Gleizes and Metzinger,[6] and later (more understand-

[1] Issue of April–May–June 1914.
[2] *Paris Journal*, 27 June 1913.
[3] *Soirées de Paris*, June 1914.
[4] *L'Intransigeant*, 25 March 1913.
[5] 18 March 1913.
[6] *L'Intransigeant*, 18 and 25 March 1913.

ably) in La Fresnaye.[1] More often, however, the term was reserved for Delaunay and his disciples, Bruce, Frost, Sonia Delaunay and Alice Bailly, and for painters such as Picabia, Kupka and Duchamp who had all been originally classified as Cubists but whose work was becoming more abstract, although it had little or nothing to do with that of Delaunay. Léger, whose researches had always been more highly personal than those of the other Cubists with whom he showed, and whose art was now becoming more obviously divergent, is also sometimes referred to as an Orphist; this, however, is understandable since his work did have something in common with Delaunay's. At the *Salon des Indépendants* all these artists were grouped together in *Salle 45*, together with the work of Morgan Russel and MacDonald Wright, who called themselves 'Synchromists' and somewhat pretentiously purported to be representatives of a new school which was to be the culmination of all European painting; they were, in fact, rapidly absorbed into the more vital Orphist movement. The Cubists were hung in the adjacent *Salle 46*.

During 1912 many of the critics, and in particular Hourcade and Allard, had been anxious to point out that the work of the Cubists was becoming more individual and less austere and didactic. Colour had begun to reappear, particularly in the work of Léger, who had only seriously restricted his palette in 1910. Now, under the influence of Orphism, the tendency to reinstate the more sensuous aspects of painting grew stronger. At the *Salon d'Automne* of 1913 Salmon was struck by 'L'infinité des couleurs inscrites en tant de toiles', but added 'néanmoins le Salon de 1913 est un salon nettement cubiste'.[2] The Orphists were not adequately represented at this *Salon*, since Delaunay himself refused to show there, but at the *Indépendants* of 1914 the Orphist canvases were so numerous and of such large dimensions that they had to be placed in the largest and most important hall on the ground floor. The Cubists had gained new recruits also, but the impact of the Orphist section caused Salmon to write, 'Orphisme et Simultanisme m'apparaissent périlleux, quant à l'avenir de la forme miraculeusement retrouvée.'[3] A few months earlier La Fresnaye, a member of the jury of the *Salon d'Automne* of 1913, had written, 'la peinture devient nettement plus abstraite'.[4] Even allowing for the fact that Orphism, as the most recent artistic novelty, was attracting the attention of a press and public made restless and sensation-hungry by the numerous artistic upheavals which the twentieth century had already witnessed, the fact is that by 1914 the abstract

[1] *Soirées de Paris*, Nov. 1914.
[2] *Montjoie*, Nov.–Dec. 1913 (nos. 11 and 12 appeared as a single issue).
[3] *Montjoie*, March 1914.
[4] Ibid., Nov.–Dec. 1913.

tendencies in European painting were already assuming an importance second only to that of Cubism from which they had largely sprung.

Mondrian, who had felt the impact of Cubism even before reaching Paris, had first exhibited at the *Indépendants* in 1911, submitting his painting from an address in Amsterdam. At the same *Salon* in the following year, after he had come to Paris, his entries were included in the Cubist room, and by 1913 his work was beginning to attract special attention. In one review Apollinaire referred to 'la peinture très abstraite de Mondrian',[1] and added in another, 'ses arbres et son portrait de femme offrent un grand intérêt.'[2] Apollinaire was furthermore at pains to stress that while the work of Mondrian derived from that of Picasso and Braque, it was completely different in appearance (cf. Pl. 77b). This came about through the fact that although Mondrian made use of the Cubist grid-system of composition, he had already begun to develop a new form of painting which finally culminated during the war in the purely abstract idiom of *De Stijl* and Neo-Plasticism. In Russia, too, the abstract possibilities of Cubism were being explored and developed. Cubism was known there largely through the exhibitions organized by the painter Larionov, who kept in touch with all the most recent developments in Paris and Italy. Larionov had in 1911 invented Rayonism, a movement which had a strong abstract bias, although it was closer in many ways to contemporary Futurism than to Cubism. In 1913 Malevitch, whose work at this period showed traces of both Cubist and Futurist influence, launched the Suprematist movement which stood for a more purely abstract style than anything yet seen.

Writing of the *Salon des Indépendants* of 1914, Apollinaire saw another influence at work: 'Cette année le futurisme a commencé à envahir le Salon, et tandis que les futuristes italiens paraissent d'après les reproductions qu'ils publient, subir de plus en plus l'influence des novateurs (Picasso et Braque) de Paris, il semble qu'un certain nombre des artistes parisiens se soient laissés influencer par les théories futuristes.'[3] This may to a certain extent have been true. Unlike the Cubists, the Futurists had never limited the colours on their palettes and were concerned with a wide range of subject matter, so that they may have contributed to the general 'loosening-up' process that Cubism was undergoing. Certainly pictorial Futurism owed a great deal to Cubism and was even considered by some to be, like Orphism, an off-shoot of it, although its development was exactly the converse of that of Orphism. Most of the Orphists

[1] *L'Intransigeant*, 18 March 1913.
[2] *Montjoie*, Special Supplement on the *Salon des Indépendants*, March 1913.
[3] *Soirées de Paris*, March 1914.

were Cubists who had broken away and formulated new stylistic and aesthetic principles. The Futurists, on the other hand, were men who started from violent ideological principles of their own but looked to Cubism for guidance as to how they could best express themselves. Marinetti, the organizer of the movement, who launched the first Futurist manifesto in 1909, had spent much time in France and was in touch with the most advanced French thought. He had been connected with the *Théâtre de l'Oeuvre* at the height of its activity, was a friend and admirer of Jarry, and a regular visitor to the Tuesday gatherings at the *Closerie des Lilas*.[1] By 1910 both Boccioni and Russolo knew Marinetti well,[2] and were undoubtedly excited at the prospect of creating a new form of painting to correspond to his novel ideas. But when the Futurist painting manifestoes appeared early in 1910 the work of the painters themselves still lacked a sense of direction. Of the five painters who had signed the manifesto only Severini, who had been in Paris since 1905, had any claim to be considered *avant-garde*, whereas the others were mostly working in a debased divisionist technique and relied for novelty on the rather obvious imagery of their subject-matter.[3] At that same moment the Cubist painters, other than Picasso and Braque, were making contact with each other on the basis of common pictorial interests, while the Italians were banded together with an elaborate programme but no adequate means of expressing it. They were, however, aware of the developments in France. In 1914 Boccioni wrote: 'Noi conosciamo il Cubismo quale ci fu contrapposto in Francia negli articoli e nei libri quando apparimmo col manifesto tecnico della pittura futurista (11 Aprile 1910) e con la nostra prima esposizione, Galerie Bernheim (6 Febbraio 1912).'[4] In actual fact little had been written about Cubism by April 1910, but Boccioni's work of 1911 shows some indirect Cubist influence, and he was certainly in correspondence with Severini, who, though as yet little touched by the movement, was a friend of both Picasso and Braque.[5]

The first Futurist exhibition in Italy (the exhibition Boccioni refers to is the first Paris exhibition) took place at the Intima Gallery in Milan in the Spring of 1911, and was succeeded in the summer of the same year by a second exhibition at the Ricordi pavilion.[6] The Futurists were severely criticised in *La Voce* by the painter-critic Ardengo Soffici,[7] for the triteness of their imagery and their lack

[1] Severini, *Tutta la Vita di un Pittore*, Italy 1946, p. 97 et seq.
[2] Benedetta Marinetti, *Marinetti, Cahiers d'Art*, Paris 1950.
[3] Severini, op. cit., describes some of the pre-Parisian canvases, pp. 124–5.
[4] Boccioni, *Pittura Scultura Futuriste*, Milan 1914, p. 148.
[5] *Tutta la Vita di un Pittore*, p. 115.
[6] There had also been a Boccioni exhibition at the Palazzo Pesaro in Venice in 1910.
[7] *Tutta la Vita di un Pittore*, pp. 118–19.

of technical control. A friend of Apollinaire, Soffici was possibly the only man in Italy at the time with a clear idea of Cubism and its aims, and in contrasting it with the work of the young Futurists no doubt felt that his strictures were justified. Severini, who had signed the manifestoes but was not exhibiting, had come to Milan to ask Marinetti for financial assistance, and he advised that the Italian painters should visit Paris before exhibiting there as they intended.[1] Boccioni convinced Marinetti of the necessity of the expedition, and accordingly Marinetti, accompanied by Boccioni, Carrà and Russolo, arrived in Paris in the autumn of 1911. Severini, who had not previously met Carrà and Russolo, now took all three Italian painters on a tour of the Paris studios and galleries. By the time that the Futurist exhibition opened at the Galerie Bernheim in February of the following year, Boccioni had reworked his *States of Mind*, a series of paintings which he felt held the key to a new range of subject-matter in painting, and Carrà and Russolo had abandoned or destroyed some of their largest pre-Parisian canvases.[2]

Futurism's debt to Cubism was universally recognized. Apollinaire pointed out that Boccioni's best works were those in which he came nearest to recent works by Picasso which he had seen in Paris.[3] Hourcade wrote of the Futurist exhibition in the *Revue de France*: 'L'on jurerait qu'un sage disciple des cubistes et un encore plus sage disciple de Signac les ont peintes en collaboration . . . Nos hôtes aux paroles rouges voudraient-ils brûler les musées pour détruire les preuves?'.[4] Even pictorial Futurism of course contained much that was new; as opposed to Cubism it was primarily an art of movement, concerned with treating large ambitious subjects, and with an aggressively contemporary aesthetic which expressed itself in its destructive attitude towards the past and a glorification of the machine; unlike Cubism it was a highly romantic and literary kind of painting. But the means by which the Futurists were expressing themselves at this point were largely borrowed from the Cubists, and occasionally in some less well-informed criticism, the two terms became synonymous.[5] The linear Cubist grid was adapted to become the Futurist 'lines of force' by which the representational elements are traversed. The fusion of the figure and its surroundings on which the Italians insisted was something that the Cubists had already achieved, and although the Futurists went further and added that the painting must be a synthesis of things seen and things remembered, visible and invisible, this had very little effect on the means employed. The interacting

[1] Ibid., p. 125.
[2] Ibid., p. 125 et seq. [3] *Petit Bleu*, Feb. 1912.
[4] March-April 1912.
[5] E.g. Jean Claude, in *Petit Parisien*, 19 March 1912.

transparent planes used by the Cubists to achieve this fusion and to explain and develop form, coincided with the Futurists' conception of the transparency of objects, and proved capable of adaptation to give a sense of dynamic balance or movement. Explaining one of the sections of their manifesto in the preface to the exhibition at Bernheim's, the Futurists, now aware of Cubist painting, talked for the first time of 'battaglie dei piani'; and Boccioni summarizes most concisely the debt of Futurism to Cubism when in *Pittura Scultura Futuriste*, published in 1914, he wrote under the heading *Compenetrazione dei Piani*: 'È il modo plastico di rendere possibile il movimento in un quadro facendo partecipare gli oggetti dell'ambiente alla costruzione dell'oggetto che vi è immerso.'[1] The end is purely Futurist but the means are Cubist.

But as the movement became more fiercely nationalistic, the Futurists began to complain that they in turn were being plagiarized in France. In articles in *Der Sturm* and *Lacerba*[2] Boccioni claimed that the Futurists had been the first to introduce the concept of Simultaneity into painting, and that Léger's article *Les Origines de la Peinture et sa Valeur Représentative*[3] was really a Futurist statement. Léger was certainly more in sympathy with Futurism than most of the other artists associated with the Cubist movement. Delaunay, for example, violently repudiated any analogy between his own art and that of the Futurists, both in an open letter to the press[4] and in a long essay written immediately after attending a lecture given by Marinetti at the time of the first Futurist exhibition in Paris.[5] Actually the quarrel was largely due to Apollinaire's careless use of terms and to a rather wilful misunderstanding on the part of Boccioni. The idea of Simultaneity first appeared in the preface to the Futurist exhibition at the Bernheim Gallery: it had its origin in Boccioni's series of *States of Mind*, and was primarily the rather literary concept that a picture must be a synthesis of what is remembered and what has been seen, a synthetic visual impression comprising not merely the various aspects of a single object, but any feature related to it, physically or psychologically. A painting by Carrà entitled *Simultaneità*, which shows a figure in a series of successive attitudes, indicates that Simultaneity had for the Futurists also the simpler meaning of the combination of different aspects of objects or people in motion into a single painting. For Delaunay and Léger the term had much more purely plastic connotations.

[1] *Pittura Scultura Futuriste*, p. 234.
[2] *Lacerba*, 1 Aug. 1913.
[3] The article was originally delivered as a lecture at the Académie Wassilief, and was published in *Montjoie*, 29 March, 14 and 29 June 1913.
[4] *L'Intransigeant*, 10 March 1913.
[5] Unpublished. Marinetti delivered two lectures, one on 9 Feb. at the *Maison des Etudiants* and one on 15 Feb. at the *Galerie Bernheim*.

For Delaunay it was the interaction of colours which produced a sense of form and space in a picture, whereas for Léger it meant the simultaneous presence in a painting of the three pictorial elements of line, form and colour, all used in a system of deliberate contrasts.

The Futurists, however, undoubtedly had an influence on the terminology of French painting and literature, and the bewildering mass of 'isms' springing up in 1913 and 1914 reflects also some of the spiritual restlessness which Futurism did so much to engender. The first Futurist manifesto was published originally in French in the *Figaro*, and the manifesto of the Futurist painters appeared in full in *Comoedia* shortly after its publication in Italy. Apollinaire, whose enthusiasm and readiness to support any new cause (often without any very deep understanding or sympathy with its aims) did much to add to the artistic confusion of the period, was himself persuaded to write a Futurist manifesto which appeared in Milan in June 1913—*L'Anti-tradizione Futurista*. Late in 1913 he wrote on a more factual note: 'Le futurisme n'est pas sans importance, et ses manifestes rédigés en France n'ont pas été sans influence sur la terminologie qu'on emploie aujourd'hui parmi les peintres les plus nouveaux.'[1]

The relations between the Cubists and the German painters with whom they came into contact were less stormy, although the internal situation in Germany was complex from an art-historical point of view owing to the fact that during the pre-war years Germany seemed to become the melting-pot for western-European painting. By 1912, however, the influence of Matisse and the Fauves, which the *Brücke* had grafted on to a more purely native form of Expressionism, was definitely on the wane, and German painters were feeling the influence of both Cubism and Futurism. Picasso's work was the first seen in Germany in 1909 at the Thannhauser Gallery in Munich, and paintings by many of the other painters subsequently known as Cubist were shown at the second exhibition of the *Neue Künstlervereinigung* in Munich in 1910. Throughout 1912 and 1913 the works of Picasso and Braque were to be seen at the Sturm Gallery in Berlin and in the *avant-garde* exhibitions in Cologne and Munich.

The most significant and direct connection with Germany, however, was that between Delaunay and the artists of the *Blaue Reiter*.[2] In 1911 the German painter Elizabeth Epstein, a friend of the Delaunays, drew the attention of Kandinsky to the works of Delaunay at the *Salon des Indépendants*, and later in the year Kandinsky wrote inviting Delaunay to join in the first exhibition of the reconstituted *Neue Künstlervereinigung*, now known as the *Blaue Reiter*, which

[1] *Soirées de Paris*, 15 Dec. 1913.
[2] Most of the information in this paragraph comes from the Delaunay biographical data.

was held in December at the Thannhauser Gallery in Munich. Delaunay was represented by three paintings, all of which were sold, and his reputation and influence in Germany increased steadily. In the spring of the following year (1912) Delaunay was visited in his studio in Paris by Paul Klee, and later on by Marc and Macke. While in Paris Klee saw and admired Cubist works at Uhde's, and he may have known the rapidly growing Rupf collection in Berne, but he remained most impressed by Delaunay's scientific approach to the handling of colour, which fitted in with his own ideas; in the autumn of 1912 he translated some of Delaunay's notes on light for the review *Der Sturm*. The climax of Delaunay's success in Germany came when he was given a large one-man show at the Walden Gallery in Berlin early in 1913; both Delaunay and Apollinaire travelled to Germany for the opening. Orphism appealed particularly to the Germans, since like so much of their own painting it was brightly coloured and was simultaneously a more theoretical and a more popular type of art than Cubism.

Although the influence of Cubism on the German painters was less direct than it had been in the development of Futurism (the work of Delaunay which the Germans most admired, for instance, was no longer really Cubist at all), unlike the Italians the Germans made no attempt to disguise their interest in the movement, and several of the artists of the *Blaue Reiter* actually thought of themselves as Cubist painters. This was in a sense strange, since not only was their art as far removed from true Cubism from a purely visual point of view, but their aims, though not as aggressively stated as those of the Futurists, were equally at variance with those of the French painters. The work of both Klee and Marc was tinged by a strong literary flavour, and, particularly in the case of Marc, by a strong underlying current of Germanic mysticism. In fact Marc's painting after 1911, with its intense, vibrant colour, and its sense of drama and dynamic tension, was in many ways closer to Futurism than to Cubism. In the work of Macke, even at its most controlled and classical, a jagged expressionistic feeling keeps breaking through, while his subject-matter at its most typical invites, once again, Futurist analogies. However, what all three painters learnt from Cubism, largely through Delaunay, was the means of organizing a canvas in terms of interacting and transparent facets or planes, which could be made to suggest movement and depth, while preserving the unity of the picture-plane; Chagall, another painter whose work was known and admired in Germany, and who had also flirted briefly with both Cubism and Orphism, acknowledged a similar debt to Cubist painting. But whereas Futurism had been to a large extent aimed at and against Paris and Parisian painting, the Germans were

content to remain on the receiving end of things and their work, in the pre-war years at least, had little or no influence back on French art.

With the declaration of war the Cubist painters, many of whom had begun to grow apart artistically, were physically separated, and the movement rapidly broke up. Cubism, however, had already won its most important battles. Though not appreciated by the public it certainly was accepted or at least recognized by all the significant critics and by several important dealers. It had temporarily reasserted the ascendancy of painting over other art forms by overshadowing any advances in literature or music. The style was constantly attracting new figures and had influenced, directly or indirectly, almost every significant young painter in Europe; even Matisse, whose art had always seemed at the opposite pole to Cubism, was introducing a hitherto unknown severity into his painting in preparation for Cubistic experiments in 1915. Whatever directions artists were to take after the war, it was already clear that painting could never be quite the same again.

CHAPTER II

PICASSO AND BRAQUE

1907-12

When Picasso painted the *Demoiselles d'Avignon* (Pl. 1), those of his friends who were allowed to see it seem to have felt that in some way he had let them down. In his *Histoire anecdotique du Cubisme* Salmon records their disappointment.[1] Gertrude Stein writes that 'Tschoukine who had so much admired the painting of Picasso was at my house and he said almost in tears, what a loss for French painting'.[2] Braque was frankly bewildered by it.

The *Demoiselles* is not, strictly speaking, a Cubist painting. Cubism was an art of realism and, in so far as it was concerned with re-interpreting the external world in a detached, objective way, a classical art. The first impression made by the *Demoiselles*, on the other hand, is one of violence and unrest. Indeed, the savagery of the two figures at the right-hand side of the painting (which is accentuated by the lack of expression in the faces of the other figures) would justify its classification as one of the most passionate products of twentieth-century Expressionism. But it is incontestable that the painting marks a turning point in the career of Picasso and, moreover, the beginning of a new phase in the history of art. It is, too, the logical point to begin a history of Cubism. For as an analysis of the painting will show, many of the problems that faced Picasso and Braque in their creation of the style are stated here, clumsily perhaps, but clearly for the first time. 'Ce sont des problèmes nus, des chiffres blancs au tableau noir,' Salmon has written of the figures in the *Demoiselles*. 'C'est le principe posé de la peinture-équation.'[3]

[1] In *La Jeune Peinture Française*, p. 43.

[2] Gertrude Stein, *Picasso*, Paris 1938. Eng. edit. New York, London 1939, p. 18. This statement of Gertrude Stein's is, however, slightly puzzling as Barr writes that it was not until 1908 that Matisse took Tschoukine to Picasso's studio. (*Matisse, his art and his public*, Museum of Modern Art, New York 1951, p. 85). At any rate, if Tschoukine did not say this to Gertrude Stein, someone else probably did.

[3] *La Jeune Peinture Française*, p. 43.

47

By the winter of 1906, when he began the preparatory sketches for the *Demoiselles*, Picasso was already establishing his reputation as one of the most outstanding of the younger figures in contemporary French painting. Since he did not exhibit at the big *Salons* his name may not have been as well known to the general public as those of Matisse and Derain, who in the previous years had emerged as the most important and controversial figures in the Fauve movement, but there were a large number of people who believed in his genius. There are even indications that many of Picasso's circle, the artists, writers and dealers who used to meet at his studio in the *Bateau Lavoir* and at the Steins' house in the rue Fleurus, already saw Picasso and Matisse as the two rival personalities most likely to influence the course of twentieth-century painting.[1] In the spring of 1906 Matisse had shown his painting *La Joie de Vivre* (Barnes Foundation, Merrion, Penn.) at the *Salon des Indépendants*, where it had received a great deal of attention, and during the latter part of this year Derain was engaged in painting a canvas of bathers (Private collec., Solothurn) (Pl. 76b) which he intended to show at the *Indépendants* of 1907, so that it is possible that the *Demoiselles* may have been prompted by a spirit of rivalry. At any rate Picasso seems to have realized, even before he began it, that it was to be no ordinary painting. Salmon, who was an intimate friend of Picasso's at this time, described a few years later his restless state of mind: 'Picasso connut l'inquiétude. Il retourna ses toiles et jeta ses pinceaux. . . . Durant de longs jours, et tant de nuits, il dessina, concrétisant l'abstrait et réduisant à l'essentiel le concret. Jamais labeur ne fut moins payé de joies, et c'est sans le juvénile enthousiasme de naguère que Picasso entreprit une grande toile qui devait être la première application de ses recherches.'[2]

Although the historical importance of the *Demoiselles* cannot be overestimated, it is not hard to understand why it disappointed Picasso's friends. It is in many ways an unsatisfactory painting. To begin with there are the obvious inconsistencies of style. Even a cursory glance is enough to show that Picasso had several changes of mind while he was working on the canvas; indeed, he himself considered it unfinished. The mood of the painting, too, is disturbing. Unlike the *Joie de Vivre*, which was intended to soothe and delight the eye, the *Demoiselles* can hardly have been calculated to please. Whereas Matisse's painting is, as the title suggests, wonderfully joyful and full of rich colour and sensuous rhythms, the *Demoiselles* is angular, harsh and grating. The charm and wistfulness of so

[1] In 1912, when he wrote *La Jeune Peinture Française*, Salmon certainly saw them in this light. And by 1906 they were the two painters who were most attracting the attention of the Steins and the circle around them.

[2] *La Jeune Peinture Française*, p. 42.

much of Picasso's earlier work has been deliberately suppressed. Derain's *Baigneuses* is in many ways closer in spirit to the *Demoiselles*, and it was regarded, by Vauxcelles at least,[1] as a revolutionary work, but it had the advantage that it could still be fitted into a traditional frame of reference. It looked, so to speak, like a lot of other painting. The *Demoiselles* did not.

Nevertheless, there are many things about the *Demoiselles* that serve to relate it to other painting of the period and, more particularly, to the contemporary work of Matisse and Derain. During the early years of the century the influence of Cézanne had become increasingly pronounced among the progressive young painters who showed at the *Salon des Indépendants*, and after its creation in 1903, the *Salon d'Automne*. Matisse, who was one of the first of the painters of his generation to appreciate the true genius of Cézanne, had been working under his influence since 1899, the year in which he bought Cézanne's *Three Bathers* (Pl. 79a now in the Petit Palais: Venturi no. 381) from Vollard, choosing it in preference to an *Arlésienne* by Van Gogh.[2] The Cézannesque features in the *Joie de Vivre* have, it is true, been overlaid by a variety of different influences, ranging from the decorative *'cloisonnist'* aspect of Gauguin's painting to the colouristic splendour of Persian illumination and the pure but voluptuous line of Ingres; but in the figure pieces of 1904 and 1905, that in a sense led up to it, the influence of Cézanne is immediately obvious.[3] Derain, although as early as 1904 he had executed a still life in which he seized in a more or less superficial way on some of the aspects of Cézanne's art which were later to fascinate and influence the Cubists, did not begin to look at Cézanne really seriously until 1906. The fruits of his study can, however, already be seen in the *Baigneuses* in the firm modelling of the figures and in the angular severity of their contours which recall in particular much of Cézanne's portraiture of the 1880s.[4] Now, looking for guidance in his construction of a monumental figure composition, Picasso too turned to Cézanne.

To begin with, the closest prototype for this kind of painting—a large composition of naked and partially draped women—is to be found in Cézanne's *Baigneuses*.[5] The first of the preliminary sketches for the *Demoiselles*, on the other hand, suggest that at first Picasso may have been more drawn to Cézanne's earlier, more romantic figure pieces. These sketches show that Picasso originally intended the composition to include seven figures, five women and two men,

[1] See p. 139 below.
[2] Alfred H. Barr, *Matisse, his art and his public*, the Museum of Modern Art, New York 1951, pp. 38–9.
[3] See e.g. *Luxe, Calme et Volupté* and almost all the succeeding figure pieces of 1905.
[4] See e.g. Venturi, nos. 516–553–555 etc.
[5] For similarities in composition see e.g. in particular Venturi no. 542.

grouped in a curtained interior around still lifes of fruit and flowers. Picasso later explained, in 1939, that the man seated in the centre of the composition was a sailor enjoying the company of the naked women.[1] The second man (who appears at the left hand side of the composition, drawing back a curtain) carries, in one of the earliest sketches, an object which Picasso identified as a skull. The entire picture was thus conceived as a kind of *memento mori* or moral allegory. The erotic implications of the subject, the *motif* of the figure holding back the curtain and the very prominent position of the still lifes, call to mind such works by Cézanne as *l'Eternel Féminin*, the various *Temptations of St. Anthony* and the *Après-Midi à Naples*. In the later sketches, which become cruder and less Cézannesque in style, Picasso abandoned the idea of including the two male figures in the composition. Some of the original significance of the painting was, however, preserved in its first title, *Le Bordel Philosophique*, suggested in a spirit of humour by Salmon, Max Jacob and Apollinaire.[2] The painting seems to have acquired its present name after the war, when it entered the possession of M. Jacques Doucet. Even so it is only a more oblique reference to the same theme, since the *Avignon* of the title refers to a street in the prostitutes' quarter of Barcelona.

In the last analysis, and in spite of the indoor setting, the *Demoiselles* is related more closely to Cézanne's canvases of bathing women than to his earlier, less structural figure pieces. Indeed, it would have been quite natural if, when Picasso became more interested in the purely pictorial problems involved in composing and unifying a picture the size of the *Demoiselles*, he had begun to look with greater concentration at Cézanne's later figure work. The differences between the *Demoiselles* and the late *Baigneuses* of Cézanne are, of course, much more obvious than their similarities—too obvious, indeed, to need much elaboration. Picasso's work is crude and direct both in colour and execution. Cézanne's is the reverse. There is a strong linear element about the *Demoiselles* and a lack of modelling in certain parts of it that Cézanne would never have tolerated. And any influence of Cézanne that there may be in the *Demoiselles* as it now appears is of the most general kind. Nevertheless, the liberties taken with the human body, the overall composition and the way in which the figures are closely grouped together in shallow depth and intimately related to their surroundings, all these things indicate a debt, however remote, to the Cézanne *Baigneuses*.

[1] Alfred H. Barr, *Picasso, Fifty Years of his Art*, New York 1946, p. 57.
[2] Salmon refers to it by this name in *La Jeune Peinture Française*. In *Propos d'Atelier*, Paris 1922, he writes of the *Demoiselles*: 'On a peu à peu oublié le titre premier, suggéré, revu et adopté par les familiers de Picasso: Guillaume Apollinaire, Max Jacob et moi-même: 'Le B . . . Philosophique'. Footnote to p. 16.

Furthermore, when one looks at these paintings by Cézanne one is often struck by the closeness between the poses of certain figures and those of the 'demoiselles'. This is a point which it would be useless to push too far; the pose of the second figure from the left in the *Demoiselles*, for instance, was one which Picasso had already used frequently in his earlier work. But in one case at least it is likely that this similarity is not simply fortuitous. The squatting 'demoiselle' with her broad back and splayed-out legs must surely be derived from the figure at the right of the *Three Bathers* owned by Matisse, a work which Picasso could well, indeed must almost certainly, have seen.[1] In a discussion of the general composition and appearance of the *Demoiselles* another possible influence should be mentioned: that of El Greco. The Spanish writer Gomez de la Serna, a friend of Picasso's at this time and an 'habitué' of the *Bateau Lavoir* during his visits to Paris, recalls that Picasso's walls there were decorated with reproductions of El Grecos.[2] Moreover, some of Picasso's painting of 1906 bears testimony in a very concrete way to his admiration for this Spanish master.[3] The angular, and in the case of the three women at the extreme left and right of the *Demoiselles*, rather 'faceted' appearance of the figures, and the heavy, chalky highlights found in certain parts of the drapery could well have come from a study of El Greco's work.

But on a more concrete level the *Demoiselles* owes most to Picasso's use of 'primitive' sources. In this respect, too, the *Demoiselles* was related to much of the most advanced painting of the period. The interest in primitive art had come about largely, of course, through the work of Gauguin. Developing certain of his ideas, the Fauves and the German painters of the *Brücke* undoubtedly saw primitive art as a liberating force, stimulating them in their attempts to achieve a more direct and spontaneous form of expression, although the Fauves, at least, were more immediately influenced in this respect by the passionate painting of Van Gogh than by primitive art.[4] By 1906 Picasso had

[1] Picasso and Matisse did not meet until 1905–6 but by 1907 they were certainly on friendly terms and must have visited each other in their studios. The first studies for the *Demoiselles* are almost certainly from the winter of 1906 but it is likely that by this time Picasso had seen the Cézanne. The radiographs of the *Demoiselles* in the Museum of Modern Art, New York, show that originally the squatting figure had a tress of hair falling down her back and that her forearm was not twisted around as it now is: this would make the similarities with Cézanne's figure even greater. The closeness of the poses of these two figures was originally pointed out to me by Mr. J. Richardson.

[2] Gomez de la Serna, *Picasso*, Turin 1945, pp. 6–7. G. Coquiot also mentions this in *Cubistes, Futuristes and Passéistes*, Paris 1914, p. 148.

[3] See e.g. the *Composition* now in the Barnes Foundation, Merion, Penn. Picasso was working on this painting in August 1906, some three weeks after his return from Gosol (Stein-Picasso correspondence, Yale University Library). In an undated letter to Leo Stein written from Horta de Ebro probably in May 1909 Picasso talks of a proposed trip to Toledo: 'Je veux revoir Greco'.

[4] Primitive sources are not used more directly by Matisse and Derain until late in 1906 (see e.g. some of Matisse's sculpture of this period and Derain's *Baigneuses*).

known the work of Gauguin for some time. But while the melancholy air and the mannered, somehow archaistic appearance of much of the work of his so-called 'Blue Period' remind one of some of Gauguin's painting, it was not until several years later, in the work executed during the year preceding the *Demoiselles*, that Picasso's work became bolder and more direct, in some cases one might justifiably say more primitive, in appearance.

In the spring of 1939, Picasso stated to Zervos that at the time when he was painting the *Demoiselles* his attention had been centred on Iberian sculpture in the Louvre.[1] Picasso had, it is true, for some time been frequenting the different galleries of the Louvre. Indeed, one gets the impresssion that his painting of 1906 is in some ways a synthesis of elements derived from a whole variety of different types of ancient art: the drawings on Greek white-ground vases, archaic Greek and Etruscan marbles and bronzes, and Cycladic and Mesopotamian figurines. As a Spaniard he must have been particularly interested in seeing the important series of Iberian reliefs from Osuna when they were put on show in the Louvre in the spring of 1906. Their installation was, furthermore, widely publicized. One of these reliefs, which shows a man being attacked by a lion, is, as Mr. J. J. Sweeney has pointed out, of obvious importance in relation to the work of Picasso (Pl. 79c).[2] It accounts in fact for the new facial type which begins to make its appearance in his work during this year,[3] and which reached its most precise definition in the work executed by Picasso on his return from Gosol (a village in the province of Lerida in Spain,[4] where he spent the early part of the summer of 1906), notably in the *Portrait of Gertrude Stein* (Metropolitan Museum, N.Y., Pl. 79b). After countless sittings during the early part of 1906 Picasso, unsatisfied with the face, wiped it out completely. Immediately on his return from Gosol, while Gertrude Stein was still in Italy, he repainted the face, using the conventions of Iberian sculpture, although, since he was anxious to achieve a likeness, they appear in a slightly modified form. The same facial type is adapted to his *Self-Portrait* (Philadelphia Museum of Art) of a few months later, and it is used again, in a more sculptural way, in the *Two Nudes* (collection Mr. Dave Thompson, Pittsburgh) also of late 1906. The *Two Nudes* represents in many ways the culmination of the 'Iberian' phase in Picasso's art.

[1] Zervos, *Picasso*, Paris 1942, p. 10.

[2] J. J. Sweeney, *Picasso and Iberian Sculpture*, Art Bulletin, 23, no. 3, 1941.

[3] During much of 1906 Picasso was, however, working simultaneously in a softer style more reminiscent of his earlier manner.

[4] It is perhaps worth noting that there is no Iberian sculpture that Picasso could have seen at Gosol; so any influence must come from the objects in the Louvre. The church and the castle at Gosol, which are in a state of almost total ruin, are mediaeval. No statuary survives.

The two central figures of the *Demoiselles* relate more closely than any other part of the picture to Picasso's work of 1906. They differ, however, in several respects from anything that had preceded them. The bodies are flatter, more distorted and more angular, and the heads more truly primitive in appearance. All this could be accounted for by the fact that Picasso was working on a very large scale and found it necessary to simplify his technique and adopt a bolder approach. But there are new elements in the treatment of the heads that cannot be so easily explained. A painting of a male head, which is almost certainly a study for the figure of the sailor that Picasso originally intended to place in the centre of the composition, while it is bolder and sketchier than a work like the *Self-Portrait*, has all the same facial characteristics. On the other hand in the heads of the two central 'demoiselles' the severe, regular ovals of the typically 'Iberian' faces of 1906 give way to new, asymmetric shapes. The jaws and chins become much heavier and the bulging eyes stare out vacantly at the spectator. The ears, previously almost always small and compact, reach fantastically large proportions.

All these new features are to be found in two Iberian stone heads of a different type, one of a man and one of a woman, which entered Picasso's possession in March 1907.[1] Both heads have the same staring expression, the same irregular contours and the same heavy jaws as the central figures in the *Demoiselles*, although the male head seems to have interested Picasso most. This head has the typically Iberian ear, with a scroll or shell-like shape at the top, but it is

[1] The history of the two stone heads is interesting. They were among the first discoveries at Cerro de Los Santos (serious excavation was begun there in 1871) and remained for some time in the possession of Don Juan de Dios Agaudo y Alarcón, the man responsible for the first excavations there. In 1903 the archaeologist Pierre Paris bought them, as a pair, for the Louvre. They were displayed there in the *Salle des Antiquités Ibériques* together with the other minor Iberian pieces. Four years later, in March of 1907, the two heads were stolen from the Louvre on successive days. The theft was committed by a man called Géry-Piéret, a Belgian adventurer whom Apollinaire had hired a year earlier as one of his secretaries and whom he was later to use as a model for the hero of *L'Hérésiarque*, which appeared in 1910. Piéret offered the heads to Apollinaire, who suggested that Picasso might be interested in them. Picasso bought them for a small sum, without realizing where they came from. Later, in 1911, after the disappearance of the *Mona Lisa*, the minor thefts from the Louvre assumed a new importance and were reported, for the first time, apparently, in the newspapers. Picasso realized that it was dangerous to retain the objects and, afraid of being implicated, he decided to dispose of them. Fernande Olivier in *Picasso et ses Amis* (pp. 182–8) tells of Picasso and Apollinaire setting out with the intention of dropping the heads in the Seine. They felt, however, that they were being followed and returned without having accomplished their mission. The restitution of the sculptures was finally made through the newspaper *Paris Journal* in September of 1911; Salmon, still a close friend of Picasso's, was working for the paper as art critic. The affair was unfortunately not over for Apollinaire. Géry-Piéret, now operating in Belgium under the name of Baron Ignace d'Ormessan, had written a letter to the Louvre, confessing to the theft of the *Mona Lisa* which he had in fact not committed. Apollinaire was arrested on the charge of complicity but released a few days later, on the 13th September, after Géry-Piéret had written the Louvre yet another letter clearing Apollinaire completely.

grotesquely exaggerated in size—a comparison of a side view of this head with a watercolour in the Museum of Modern Art in New York shows that Picasso found this feature of it particularly fascinating.[1] The Osuna reliefs were not in fact 'primitive' at all, but rather a perfectly valid reinterpretation of classical Greek sculpture. The two examples that Picasso owned on the other hand could certainly be called primitive, both in conception and execution. (Pls. 79d, 80a, b.)

If one is willing to discard the possibility of Picasso having focused his attention on these particular heads in the Louvre—and this is unlikely since they were not shown on the ground floor like the Osuna reliefs, the *Dama de Elche* and other important Iberian pieces, but in a small room in the basement together with some twenty other heads—his acquisition of them is useful in establishing a chronological sequence for the painting of the different sections of the *Demoiselles*.[2] For the evidence set out above suggests that the heads of the central figures, which still relate to a certain extent to the work of 1906 and which were almost certainly the first to be painted, were not executed until the Iberian stone heads came into Picasso's possession in March 1907, and that the painting did not really get under way until this month; there are no signs of any under-painting in either the heads or bodies of these two figures. On the 27th of March Picasso sent a post-card to Leo Stein which said: 'mes chers amis, voulez-vous venir demain, dimanche, voir le tableau.'[3] Picasso may have been referring to a painting that one of the Steins was contemplating buying, but it is tempting to suppose that he was inviting them to see the *Demoiselles* in its first state.

It cannot have been long, however, before the painting began to undergo a series of striking changes. The head of the figure at the extreme left, for instance, is different in colour from those of the central figures, and even different from the body to which it is attached; in it the pale pinks that had characterized so much of the work of 1906 have been mixed with black to produce a much more sombre effect. There is a more sculptural feeling about it, too. In this it is related to the heads of the *Two Nudes* painted a few months earlier, but as opposed to them, it is more completely mask-like, and every area or section of it is clearly defined and forms a self-contained unit. Thus there is a clear division between the forehead and the lower part of the face, and a lighter line running down the edge of it suggests that if more of the forehead were seen it would be

[1] Géry-Piéret, the man who stole the heads from the Louvre, said that he had chosen the male head because of the enormous ears, 'détail qui me séduisit,' *Paris Journal*, 6 Sept. 1911.

[2] For a more detailed discussion of the daring of the *Demoiselles* see J. Golding in *The Burlington Magazine*, London May 1, 1958.

[3] Picasso-Stein correspondence, Yale University Library.

divided down its central axis. The nose is a self-subsisting pyramid that could be lifted off the rest of the face, and so on. The heads of the two women at the right are different again. They are savagely distorted, and the long thin noses, which have a flat ridge running down the centre, are pulled into the side of the face by thick black lines. There are touches of green on the head of the standing figure, while the face of the squatting woman is orange, relieved by strokes of blue and yellow. The bodies of both these figures are even more angular than those of the other three women, and the planes that compose them are occasionally differentiated by touches of pure colour; the body of the squatting figure is in the same darker tonalities of the head. The area behind the two central figures is a pale, chalky grey, while the curtains on the right are a bright blue with strong highlights. The still life is painted in the same direct, rather violent technique. Radiographs of the various individual heads taken for the Museum of Modern Art show that originally the faces of the figures at the right were painted in the same idiom as that of the figure at the left.[1] Since the head of the standing figure represents an intermediate stage between that of the figure at the left and the one directly below it, it follows that the squatting figure, the still life and the drapery at the right were the last parts of the picture to be painted. The *Demoiselles* was abandoned by Picasso, in its present condition, probably in the early autumn of 1907.[2]

These abrupt changes of style in the *Demoiselles* are due to the fact that while he was working on it Picasso came into contact with Negro art. Negro sculpture had been 'discovered' several years earlier by Vlaminck,[3] and it is certain that by 1906 Matisse and Derain were familiar with it. Indeed, it is strange to think that Picasso, who was always alert to the latest discoveries in contemporary painting, did not know Negro sculpture when he began the *Demoiselles*, and Salmon goes so far as to say that he did.[4] Gertrude Stein, too, wrote in her book on Picasso: 'Upon his return from Gosol he became acquainted with Matisse through whom he came to know African sculpture.'[5] In the autobiography of Alice B. Toklas she insists that this was 'just after Picasso finished painting

[1] The standing figure was originally almost in pure profile, while the lower head was seen in a three-quarter view. The picture seems at one point to have corresponded almost exactly to the sketch in the Gallatin Collection in the Philadelphia Museum of Art. Z II, 21.

[2] Describing the evolution of the picture Salmon states that Picasso at one point abandoned the painting, painted a series of other pictures, returned from a holiday, and took the painting up again. *La Jeune Peinture Française*, p. 46. There is no record of Picasso's having left Paris in the summer of 1907, but it seems likely that he took some sort of holiday or rest and finished the painting in the early autumn.

[3] See p. 139 below.

[4] *La Jeune Peinture Française*, p. 43.

[5] *Picasso*, p. 22.

Gertrude Stein's portrait'.[1] Matisse substantiated this story by his statement to Warnod that he had bought a Negro statuette in a curiosity shop in the rue de Rennes, on his way to Gertrude Stein's, and that Picasso saw it and became enthusiastic about it.[2] Picasso himself, on the other hand, said that he became familiar with Negro art only after having painted the *Demoiselles*, and that his introduction to it took place in the Trocadero.[3] In view of the appearance of certain heads in the *Demoiselles*, however, it is perhaps permissible to think that his recollections are not completely accurate. It is also possible that Matisse showed Picasso some Negro work in 1906 but that at that time Picasso did not take it very seriously, and only discovered it for himself later. The clue to the mystery may be held in a passage from Michel George-Michel's *Peintres et Sculpteurs que j'ai connus* 1900–1942. He writes: 'Il suffit d'une visite avec son ami Apollinaire à une exposition d'art nègre pour que Picasso, qui d'abord s'amusa énormément, s'éprit soudain violemment de ces formes rustiques et barbares.'[4] The 'exhibition' probably refers to Picasso's visit to the Trocadero, and the visual evidence goes to prove that this took place while he was actually working on the *Demoiselles*.

The new features in the head at the left can be accounted for by a characteristic form of Negro mask (Pl. 80c.), found on the Ivory Coast, in which the component parts of the face have exactly the same clarity of definition. The heads of the two right-hand side figures are the result of a second, more emotional reaction to Negro sculpture of a different type (Pl. 80d.). They resemble most closely the heads of bronze ancestral figures from certain parts of the French Congo, of which there were a large number in the Trocadero. These masks are generally slightly concave in shape, and are usually covered with striations or incised lines. The ears are almost always ignored, as they are in the standing figure at the right of the *Demoiselles*. The eyes are often represented by raised lozenge shapes, with a small dot in the centre. The eyebrows meet in the middle of the forehead and their contours are continued down into the noses. The mouths are small ovals and generally appear low in the face. In short, a prototype in Negro art can be found for almost every one of the features in the

[1] In the *Autobiography of Alice B. Toklas* (New York 1933) she writes: 'In any case it was Matisse who first was influenced, not so much in his painting as in his sculpture, by the African statues and it was Matisse who drew Picasso's attention to it just after Picasso had finished painting Gertrude Stein's portrait,' p. 68. Janneau, who knew Picasso at this time, states in his *L'Art Cubiste* (Paris 1929) that Picasso came to know Negro sculpture in 1906, but he says that it was through Derain, p. 12.

[2] André Warnod, 'Matisse est de retour,' *Arts*, no. 26, July 1945.

[3] Zervos, *Picasso* Vol. II (1), Paris 1942, p. 10. The Trocadero is what is now known as the Musée de l'Homme.

[4] New York 1942, p. 13.

last three heads of the *Demoiselles*. Nevertheless, it is dangerous, and indeed impossible, to push too far the analogies between these heads and any particular kind of Negro art. In the Trocadero large quantities of objects were displayed in a somewhat haphazard fashion,[1] and while he was undoubtedly deeply stirred by Negro sculpture, the first impression that Picasso carried away with him must have been of a very general, rather emotional kind. It was only in the series of paintings that followed the *Demoiselles* that he began to grasp the intellectual and aesthetic principles of particular types of masks and to relate Negro culture more thoroughly to Western art.

Negro sculpture and the painting of Cézanne, both of which were used extensively by Picasso as sources for the *Demoiselles*, were to be the two major influences in the creation of Cubism; in fact the constant inspiration which Picasso and Braque drew from the art of Cézanne and the stimulation which Negro sculpture provided for Picasso were the only important outside influences in the development of a style which was to be very self-contained. It is in the *Demoiselles* that these two influences first appear together in the art of Picasso, and it is this that in part makes the picture a natural starting-point for the history of Cubism. Cézanne and Negro art are not yet, it is true, interpreted in a Cubist way. However, their influence on the *Demoiselles* is not the only feature of this painting that gives some indication of what Cubism was to achieve. In the mask-like head of the figure on the extreme left, for instance, Picasso has shown an almost sculptural interest in reducing the forms of the face to their simplest component parts. This sort of dispassionate investigation of the nature of simple, solid forms in space was one of the starting-points of the Cubism of both Picasso and Braque. On a more general level, the treatment of the figures in terms of simple, angular shapes or planes arranged in shallow depth foreshadows some of the later techniques which Picasso and Braque evolved to suggest the forms of solid objects and their relationship to the space around them. There are several things in the *Demoiselles* that cannot be explained completely either by the influence of Cézanne or of Negro art and which point ahead to one of the most important and revolutionary features of Cubist painting: the combination of various views of a subject in a single image. In the three figures in the left-hand half of the painting this sort of optical synthesis is accomplished in a crude, rather schematic fashion. The noses of the two figures that are seen from in front are in profile, while the figure at the left, which is in strict profile, has a full-face eye. The bodies of all three figures, however, are seen as in normal vision, from a single (or stationary) viewpoint. In the squatting figure on the

[1] The Trocadero was reorganized in 1928.

right, on the other hand, all the canons of traditional linear perspective have been violated. The subject seems to be posed in what is basically a three-quarter view from the back, with the breast and the inner part of the thigh visible between the arm and leg, but the far leg and arm have been pulled around into the picture plane so that the spectator has the impression of seeing a simple back view, abnormally splayed out, as well. It is as if the painter had moved freely around his subject, gathering information from various angles and view-points. This dismissal of a system of perspective which had conditioned Western painting since the Rennaissance marks, more than any other single feature of the *Demoiselles*, the beginning of a new era in the history of art.

Picasso rapidly became familiar with a wide range of Negro sculpture, and in the years immediately following his discovery of it amassed a large collection of his own.[1] Gomez de la Serna remembers that Picasso's studio in the *Bateau Lavoir* was filled with African and Oceanic 'idols'.[2] *Paris Journal* referred in 1911 to the enthusiasm with which Picasso would show his collection to visitors to his studio in the Boulevard de Clichy.[3] Later, after Picasso had denied any knowledge of African art in the *Enquête sur l'Art Nègre* conducted by the review *Action* in 1920,[4] Paul Guillaume, the first Parisian art-dealer to become interested in African and other primitive sculptures as works of art, wrote: 'Picasso possède un certain nombre de pièces des origines les plus variés; il fait coquetterie de n'attacher aucune importance aux époques.' In fact this ignorance was not assumed. In the early part of the twentieth century very little was known about the chronology of Negro art (most of it was considered to be much older than it is), and the stylistic differences between the work of various regions had not been examined; Guillaume himself included Oceanic work under the term Negro art, and felt that it could be extended to include Alaskan art as well. Picasso's own collection included the most diverse assortment of objects, many of which were almost valueless; indeed, a profitable trade in forgeries had sprung up rapidly to meet the new demand for primitive art. Besides the large collections in the Trocadero, however, Picasso also knew the fine private collection of Negro objects owned by Frank Burty, who was a friend. Then he must have seen the objects bought by Matisse and Derain; Derain in particular amassed a large number of excellent

[1] Many of the first objects in Picasso's collection were acquired at the same shop in the rue de Rennes in which Matisse had found the example he claimed to have shown Picasso. Allard in *Le Nouveau Spectateur*, 25 May 1919, reviewing an exhibition of Negro sculpture at the Galerie Devakey.

[2] *Picasso*, pp. 6–7.

[3] 25 Sept. 1911.

[4] No. 30, April 1920.

pieces.[1] However, a study of the work of his 'Negroid' period shows that Picasso was influenced as much by the general characteristics of Negro sculpture as by the peculiarities of the individual pieces he owned or saw.

Salmon quotes Picasso as saying that he admired Negro sculptures because he found them 'raisonnables'.[2] In stressing the more 'reasonable' or rational character of African art, Picasso was underlining the quality that distinguishes it most fundamentally from Western art. As opposed to Western art, Negro art is more conceptual, much less conditioned by visual appearances. The Negro sculptor tends to depict what he knows about his subject rather than what he sees. Or, to put it differently, he tends to express his *idea* of it. This leads inevitably to great simplification or stylization, and, at the same time, to a clarification and accentuation of what are felt to be the significant features or details of the object depicted. The figures of the French Sudan, for instance (and this was naturally the provenance of a great many of the objects in the Musée de l'Homme) are characterized by their angular contours and the emphasis on the solid, simple forms of trunk and head. The navel, as the central feature of the body, is usually enlarged and emphasized and sometimes the entire stomach is thrust forward in a protruding shield-like form; the limbs are shortened and seen as simple tubular forms, or reduced to a few incisive, sharply differentiated planes. The features of the face are sometimes treated in the same simplified way, or else are so highly stylized that they become simply decorative signs. Ultimately the process of creation is one of intuitively balancing formal elements, and, in the case of the most abstract Negro sculpture, the finished product has the quality not of a representation but a symbol—a re-creation rather than a reinterpretation.

Picasso's instinctive appreciation of the aesthetic principles of Negro art was indicative of a new attitude towards primitive art. Gauguin's glorification of the art and life of the South Seas was part of a conscious revolt against what he felt was a corrupt society and the art which it inspired. Through him, more than through any other single force, the aesthetic worth of primitive art forms came to be recognized. His attitude was, however, coloured by a highly literary romanticism, and despite his efforts at identifying himself with a primitive culture, his outlook naturally remained that of a sophisticated European; he borrowed freely from primitive sources but reinterpreted them to suit his own decorative and symbolic purposes. The painters of the *Brücke*, who spiritually and intellectually were some of Gauguin's truest heirs, saw primitive art as a

[1] Derain is already referred to as a 'collector' of Negro art in *Paris Journal* of the 5th Oct. 1911. His collection was sold at the Hôtel Drouot in 1955.
[2] *La Jeune Peinture Française*, p. 42.

healthy outcry against rationalism which paralleled their own 'Nietzschean affirmation of life'. This attitude was, of course, purely subjective, and their appreciation of primitive art was almost entirely emotional. The Fauves, who owed more to Gauguin from a purely pictorial standpoint, inherited from him some of the spontaneity and decorative rhythms of Polynesian art; and by 1907 both Matisse and Derain had absorbed into their own work some of the formal properties of Negro sculpture. Primitive art may have confirmed them in their desire to achieve a greater directness of expression, but they remained interested in it from a visual point of view. Picasso, on the other hand, while he was undoubtedly fascinated by the formal and sculptural properties of Negro art, also admired it intuitively for a more fundamental reason: for its 'reasonable' or conceptual quality. This was the real link between Cubism and Negro art. For, like Negro art, the Cubism of Picasso and Braque was to be essentially conceptual. Even in the initial stages of the movement, when the painters still relied to a large extent on visual models, their paintings are not so much records of the sensory appearance of their subjects, as expressions in pictorial terms of their idea or knowledge of them. 'I paint objects as I think them, not as I see them,' Picasso said to Gomez de la Serna.[1] And it was the conceptual element of Cubism that enabled the painters at various times to detach themselves from visual appearances without losing touch with the material world around them.

In the *Demoiselles d'Avignon* Picasso was influenced by two main types of Negro masks, the one flatter, more abstract and remote from European art, in which the basic planes of the face are differentiated not by relief but by the directions of the striations or hatchings with which they are covered, the other more solid, sculptural, three-dimensional and naturalistic. Much of Picasso's work of 1907–8 falls into two complementary, though by no means exclusive categories, according to which of the general types of Negro masks inspired it. Indeed, Picasso's admiration for these two different kinds of masks is indicative of the instinctive pull which he was feeling between an increased interest in solid, sculptural forms and an awareness of the need to depict them in a manner that did not violate the flat, two-dimensional plane on which he was working. When Picasso's art became truly Cubist, in 1909, he had begun to see solid forms in a new pictorial way, without the aid of linear or mathematical perspective. A new treatment of volumes required, naturally, the invention or formulation of new techniques to reconcile it with the demands of the flat picture surface. In these pre-Cubist paintings of 1907 and 1908 it is as if Picasso were preparing himself for the difficulties involved in creating a new style by taking

[1] *Picasso*, p. 31.

stock afresh of some of the basic problems inherent in all painting since the invention of illusionistic perspective.

The first type of 'Negroid' painting is more purely pictorial and is represented by the sketches and series of heads which culminate in the *Nu à la Draperie*, a painting of late 1907 which is known also as the *Danseuse aux Voiles* (Museum of Modern Art, Moscow). In this painting the various forms of the body are distinguished from each other by heavy black outlines and, as in African bronzes, by the direction of the striations with which they are covered. The strong linear flavour emphasizes, of course, the flatness of the picture plane and this effect is further strengthened by the fact that the entire picture surface is broken down into angular forms of almost equal size, which are all dealt with in the same vigorous technique.[1] Later, when their work had become completely Cubist, Picasso and Braque devised a more elaborate and sophisticated method of dealing with solid forms but the means which they used to differentiate between the parts or planes or an object or figure and the devices they used to reconcile it to the picture plane were, it will be seen, not unlike those which Picasso used so boldly here. (Pl. 2a.)

Picasso approached Cubism, however, primarily through his interest in analysing and investigating the nature of solid forms. This more sculptural approach can be seen in the second kind of Negroid painting. In fact, some of the canvases of this type have almost the appearance of being paintings of sculptures and masks.[2] This intensive investigation of simple, solid forms culminates in the paintings of the late summer and autumn of 1908, although by this time Picasso's work was becoming less specifically Negroid. *La Paysanne* (Museum of Modern Art, Moscow), executed at La Rue-des-Bois (where Picasso spent most of August),[3] or shortly after Picasso's return to Paris, is one of the largest and most powerful of the group. Whereas before, in 1906, Picasso had simplified and reinterpreted the human form in a more empirical fashion under the influence of archaic sculpture, now he explains it rationally in terms of simple self-contained planes differentiated by the use of a consistent light source. These are paintings

[1] The treatment of the drapery and background in terms of the heavily outlined, angular planes may also relate to Negro work, since in some Sudanese bas-reliefs (doors) in the Musée de l'Homme the areas surrounding the figures are similarly divided into striated, triangular sections of almost equal size. Many of Picasso's paintings of this period are executed in gouache, a quick-drying medium which is particularly suited to this technique, where the forms and ultimately the entire picture surface are built up by a system of cross-hatchings or by a series of individual, parallel brush strokes.

[2] For an early example of this type, see the male head (Z II, 56) of the winter of 1907–8, which is a reinterpretation, in more incisive terms, of the head of the left-hand figure of the *Demoiselles*.

[3] Picasso-Stein correspondence.

of solid forms stripped of all their inessentials and reinterpreted with almost geometric exactitude. 'If a painter asked me what was the first step necessary for painting a table' Picasso remarked to a friend at this time, 'I should say, measure it.'[1] The subjects of [Picasso's paintings have just such a measured look. One is reminded, too, that this was in actual fact the practice of the Douanier Rousseau, a painter whom Picasso much admired. Indeed, it is at exactly this stage of Picasso's evolution that one senses behind his art the presence of this great 'primitive' who in his *naïveté* had unconsciously succeeded in ignoring the forces which had influenced French painting for the past fifty years, the forces against which Picasso and his friends were most immediately reacting. (Pl. 2b.)

* * *

Braque may have been at first bewildered by the *Demoiselles d'Avignon*, but he nevertheless responded to its stimulus. The result was the large *Baigneuse*[2] or *Nu* (coll. Mme. Cuttoli, Paris) finished in the spring of 1908, some five or six months after his meeting with Picasso. (Pl. 23.) Like the *Demoiselles* it is a milestone in the history of Cubism. The debt to Picasso is immediately obvious; the large canvas, the scale of the figure itself and the distortions within it, the muted pinks, buffs and greys (which, despite the brighter touches, are the predominant colours in the *Demoiselles*), the treatment of the background in terms of large angular planes—all these features are new in the work of Braque. But Braque's work contains none of the expressionistic violence of Picasso's. As opposed to the harsh angularity of the *Demoiselles*, the *Baigneuse* is dealt with in terms of free, curving rhythms which owe a lot to Fauvism and to the contemporary work of Matisse.[3] And, fundamentally, Braque's painting is much more thoughtful and reasoned; while the *Demoiselles* must have excited him by its immediacy and directness, it also posed for Braque various pictorial problems. For instance, in the squatting 'demoiselle' Picasso had dislocated and distended the various parts of the body in an attempt to explain it as fully as possible, without the limitations of viewing it from a single, stationary position. In the *Baigneuse* the far side of the figure is pulled round into the picture plane so that the body becomes unnaturally broad; and the *pentimenti* show that the figure was originally to have been even squatter and broader. One gets the impression

[1] Gomez de la Serna, *Picasso*, p. 30.
[2] The painting is referred to by this title in the catalogue for the third of the Kahnweiler Sales, on 4 July 1922.
[3] See e.g. the *Blue Nude*.

that Braque wanted to show the spectator as much of the figure as he possibly could. Braque sensed, too, that by dismissing the conventional, single view-point perspective it was possible to synthesize into the depiction of the head a variety of information; thus in a three-quarter view the knot of hair at the back of the head is seen clearly, as if from the side. Then Braque has capitalized on the element of ambiguity in the *Demoiselles* (it is not immediately clear for instance whether the leg of the 'demoiselle' on the left is the far leg or the near leg, and the lower part of the twisted forearm of the squatting figure is left un-defined) as a means of emphasizing the flatness of the canvas he was working on: the far buttock of the *Nu* is connected to the foremost leg and heightened in tone so that it appears to stand in front of the nearer part of the figure; if the outline of the neck were extended it would not join the shoulder naturalistically but pass by its outer edge, and the fact that the outline is deliberately broken allows the neck, shoulder and arm to flow into each other and fuse. Hitherto, as a minor Fauve, Braque had not been a painter of any great historical impor-tance. Now his awareness of the new pictorial possibilities which Picasso had instinctively hit upon in the *Demoiselles* and his study of the work of Cézanne (whose influence, indeed, can already be sensed in the *Baigneuse*) were to make him, within the space of a few months, a major force in twentieth-century painting.

By 1907, the year that preceded the painting of the *Baigneuse*, Fauvism had already lost much of its original impetus, and Braque, like the other Fauves, had for some time been searching for some more solid basis for his art. Matisse, as has been seen, had for the past years been turning to the work of Cézanne for inspiration, and by 1906 Derain was looking at his work also, so that it was only natural that Braque, who had discovered Fauvism through them, should once again follow their example. The influence of Cézanne becomes apparent in the landscapes of *La Ciotat* of the summer of 1907, which show Braque's work hanging in the balance between Fauvism and a much more structural kind of painting. The loose, undulating rhythms of trees and foliage are still of a kind seen in Fauve canvases by Matisse (and have their origin ultimately in the late work of Gauguin), while the colour is decorative and heightened to an unnatural degree. But the compositions, which are now built up of a series of flat planes mounting upwards behind each other in shallow depth, are clearly derived from Cézanne. In the *View from the Hotel Mistral* (Pl. 24a,) executed on Braque's return to Paris a few months later, the influence of Cézanne is even more marked. It has been put, too, to more obviously constructive ends. The compo-sition, in terms of vertical and horizontal elements, is stronger, even slightly

rigid, and there is an obvious concern with the definition of forms that is a new element in the work of Braque. The heavy, crude outlines are now no longer broken and sporadic as they were in some of his most characteristically Fauve works, and every shape is carefully and fully outlined; only a certain emphasis on the oval forms of the foliage, and a few touches of arbitrary colour retain any flavour of Fauvism. The radical simplification of forms which characterizes the painting can be accounted for by the fact that this was one of the first canvases in which Braque attempted to work from memory. This dismissal of a visual model marked a decisive break with Fauve procedure and an important step towards a new, more rational and intellectual kind of painting.

The influence of Cézanne on contemporary painting was renewed and strengthened by the retrospective exhibition of his work held at the *Salon d'Automne* during October 1907. Progressive young painters had been aware of Cézanne's importance for some time, and this exhibition, the largest and most comprehensive display of his work seen till then,[1] was greeted with enthusiasm. Also during the latter part of 1907 seventy-nine of Cézanne's watercolours were shown in the Galleries of Bernheim Jeune. Simultaneously the *Mercure de France* published in its October issues the letters of Cézanne to Emile Bernard, including the letter which contains the passage: 'Permettez-moi de vous répéter ce que je vous disais ici: traiter la nature par le cylindre, la sphère, le cône, le tout mis en perspective, soit que chaque côté d'un objet se dirige vers un point central. Les lignes parallèles à l'horizon donnent l'étendue, soit une section de la nature. Les lignes perpendiculaires à cet horizon donnent la profondeur. Or, la nature, pour nous hommes, est plus en profondeur qu'en surface. . . .'[2] As the influence of Cézanne grew, so that of Gauguin, who had hitherto been an important influence in the work of the Fauves, waned. In one of his articles Bernard quoted Cézanne as having said of Gauguin: 'Il ne m'a pas compris. Jamais je n'ai voulu et je n'accepterai jamais le manque de modelé ou de gradation, c'est un non-sens. Gauguin n'était pas peintre, il n'a fait que des images chinoises.'[3]

Cézanne died in 1906 with the feeling of only partially having achieved the end for which he had striven so long and hard. He seems to have realized, however, that there was a younger generation of artists who were to carry on his work. 'Je crois les jeunes peintres beaucoup plus intelligents que les autres, les vieux ne peuvent voir en moi qu'un rival désastreux,' he said to his son in a

[1] The catalogue lists 56 paintings and drawings. Cézanne had been represented, on a smaller scale, in the *Salons* of this society for the three preceding years.

[2] Letter of 15 April 1904. *Mercure de France*, 16 Oct. 1907, pp. 617–18.

[3] *Mercure de France*, 1 Oct. 1907, p. 400.

letter written only a few days before his death.[1] Certainly no other nineteenth century artist was so widely studied and so differently interpreted by the painters of the succeeding age. Cézanne's intensely 'painterly' art with its brilliant use of colour and its mysterious deformations, which suggested a range of new pictorial concepts, was a source of inspiration for almost all the significant young painters working in Europe during the first quarter of the twentieth century. And no other painter was such an important influence in the formation of Cubism. Indeed, in many ways, Cubism was more justified than any other movement in claiming Cézanne as its father. Even the Cubists, however, interpreted Cézanne in a variety of ways. Léger, for example, deliberately disregarded the complexities of his art, the irregularities and 'distortions', and seized on the element of definition and structural precision as a starting point for his own Cubist experiments.[2] Delaunay, on the other hand, eventually concentrated on his use of colour. Roger de la Fresnaye saw him as a classicist, trying to return to a tradition of painting lost by the Impressionists,[3] while Gleizes and Metzinger emphasized his importance as a revolutionary.[4] Even Picasso and Braque, who shared their discoveries so intimately that for a while they came to share a common vision, looked, it will be seen, at Cézanne in different ways.

All the Cubists, however, studied Cézanne in a more or less constructive fashion. That is to say, all seized on an element of structural and formal strength in his work, which they saw as a corrective to the formlessness which had characterized so much French painting since the Impressionists had insisted on the validity of an instantaneous form of vision, that had so often dissolved the solidity of the material world into a haze of atmospheric colour and light. The Cubists saw, too, in Cézanne's obvious concern with purely pictorial problems an antidote to the emotionalism and decorative symbolism of so much other post-Impressionist painting. In a sense his painting was, to use an expression current in Cubist circles, 'pure' painting. But while it is impossible to overstress the importance of Cézanne in the emergence of Cubism, it is wrong to see even the earliest Cubist painting simply as a direct continuation of him. Gleizes and Metzinger, carried away by their enthusiasm for his art, went so far as to suggest at one point in *Du Cubisme* that Cubism was simply a development of his work:

[1] Paul Cézanne, *Correspondance*, edited by J. Rewald, Paris 1937. Letter of 15 Oct. 1906, p. 298.

[2] The influence of Cézanne on Léger and the minor Cubists is discussed in detail in Chapter IV.

[3] See R. *de La Fresnaye, Paul Cézanne* in *Poème et Drame*, Paris, January 1913. This article was originally delivered as a lecture at a meeting of *Les artistes de Passy*. See p. 29 above.

[4] See *Du Cubisme*, pp. 8–10.

E

G.C.

'Qui comprend Cézanne pressent le Cubisme. Dès maintenant nous sommes fondés à dire qu'il n'est entre cette école (Cubiste) et les manifestations précédentes qu'une différence d'intensité. . . .'[1] Nothing could be further from the truth. Although Cézanne's painting was profoundly original, his ambition was to use his own intensive study of nature to revivify classical or traditional painting; the means he used, although they were highly personal, were founded on the optical discoveries of the Impressionists. His art remained deeply rooted in the nineteenth century. The true Cubists, on the other hand, while they made their discoveries intuitively, were nevertheless very conscious of the fact that they were the beginning of something completely new; in a sense they were anti-traditionalists. Their way of looking at the exterior world, the means they used of recording their ideas about it, even their concept of what a painting was, all these things were different from anything that had gone before them. And they were reacting not only against the art of the past fifty years but also against the techniques and traditions of vision that had shaped Western painting since the scientific discoveries of the early Renaisance. But it was Cézanne who formed the bridge between their art and the art of the preceding five centuries.

In the *View from the Hotel Mistral* Braque had been influenced decisively by Cézanne, and the meeting with Picasso, which must have taken place about the time at which the painting was completed, encouraged him to turn his back completely on Fauvism. The great *Nu* bears witness not only to the impact which Picasso's work had on Braque, but also to the fact that Braque realized the extent to which the *Demoiselles d'Avignon* was a revolutionary work. But in the *Baigneuse* Braque's vision exceeded his technical means. And unlike Picasso Braque did not see in African art an answer to some of the problems of contemporary painting. Although many years later Braque recalled how strong an impression Negro art made on him,[2] it is hard to see any direct reflection of this in the paintings executed at the time when Picasso was reacting so positively to African sculpture; even in a painting like the *Nu* any influence from Negro art seems to have come at second hand, through Picasso's *Demoiselles*. However, Braque was sufficiently unsettled by the example of Picasso to turn his studies of Cézanne to more revolutionary ends, and in the canvases executed during the summer of 1908 at l'Estaque, Braque produced a series of completely original works, the first group of truly Cubist paintings. These were the controversial paintings rejected by the Jury of the *Salon d'Automne* and later exhibited at

[1] Ibid., pp. 9–10.
[2] Dora Valier quotes Braque as saying '. . . les masques nègres aussi m'ont ouvert un horizon nouveau. Il m'ont permis de prendre contact avec des choses instinctives, des manifestations directes qui allaient contre la fausse tradition'. Op. cit., p. 14.

Kahnweiler's gallery in the rue Vignon. Reviewing the exhibition, Vauxcelles wrote: 'M. Braque est un jeune homme fort audacieux ... l'exemple déroutant de Picasso et de Derain l'a enhardi. Peut-être aussi le style de Cézanne et les ressouvenirs de l'art statique des Egyptiens l'obsèdent-ils outre mesure. Il construit des bonshommes métalliques et déformés et qui sont d'une simplification terrible. Il méprise la forme, réduit tout, sites et figures et maisons à des schémas géométriques, à des cubes.'[1] Apollinaire, on the other hand, although he did not entirely understand the nature of Braque's new development and failed to realize that even though Braque was beginning to paint largely from memory, his work was still often related directly to his models, instinctively realized that Braque had accomplished something important and original. In his preface to the catalogue he wrote: 'Il ne doit plus rien à ce qui l'entoure. Son esprit a provoqué volontairement le crépuscule de la réalité et voici que s'élabore plastiquement en lui-même une renaissance universelle.'

Maisons à l'Estaque (Rupf coll., Berne) is representative of the whole series of 1908 landscapes. In this painting all the sensuous elements of the previous years have been banished; colour has been reduced to a severe combination of browns, dull greens and greys, and the soft curving rhythms of Fauvism have been replaced by a rigid system of verticals and horizontals, broken only by the forty-five degree diagonals of roof-tops and trees. All details have been eliminated and the foliage of the trees reduced to a minimum to reveal the geometric severity of the houses. These are continued upwards almost to the top of the canvas so that the eye is allowed no escape beyond them. The picture plane is further emphasized by the complete lack of aerial perspective (the far houses are, if anything, darker and stronger in value than the foreground house), and by the fact that occasionally contours are broken and forms opened up into each other. There is no central vanishing point; indeed in many of the houses all the canons of traditional perspective are completely broken. (Pl. 25.)

The debt of this sort of painting to Cézanne is clearly visible. But it is almost immediately obvious that Braque had begun to study Cézanne in a much more intellectual and thoughtful way, and that this was resulting in the creation of an entirely new type of painting. In the first place Braque had detached himself from visual appearances to a much greater extent than Cézanne, who while he was obviously very much aware (if only instinctively) of the purely formal or abstract side of painting, relied nevertheless, in his still lifes and landscapes, on an exhaustive study of the 'motif' as his point of departure. At l'Estaque, Braque was working from nature but one feels that the forms in his painting have not

[1] *Gil Blas*, 14 Nov. 1908.

been suggested by those of particular landscapes but rather that he has imposed on the natural scene his own austere, angular, almost geometrical form of vision. In this sense Braque's painting is, like Picasso's 'Negroid' pictures, conceptual. The forms are more crudely simplified than in Cézanne, and while there is the same sensation of recession that one gets from Cézanne's paintings, as one's eye moves from one clearly defined plane to another, Braque's paintings are composed in such a way that the feeling of depth is very restricted. Moreover, Cézanne had felt he was respecting the laws of traditional, scientific perspective. When these are violated in his painting, it is because the pictorial theory involved conflicted with his intensely visual and empirical approach, and with his desire to reconstruct the three-dimensional form of his subjects as fully as possible. The irregularities of this kind in Braque's work of 1908 are much more conscious and deliberate. In the still lifes, which have the same general characteristics as the landscapes, the Cézannian device of tipping certain objects up on to the picture plane is exaggerated to the point that one realizes at once that the artist is no longer making use of scientific perspective. Finally, there is the question of colour. Cézanne worked with a full Impressionist palette, and it is evident, not only from a visual analysis of his painting, but also from his letters and from Emile Bernard's observations on his method of work, that Cézanne relied on the exactness of tonal relationships to produce a sensation of volume and recession; indeed, the necessity he felt to verify these relationships was one of the reasons why he was compelled to turn back continually to a study of nature. With the l'Estaque paintings, Braque, on the other hand, began to limit his use of colour severely, and in this respect his work was typical of most early Cubist painting. When colour was finally re-introduced into Braque's painting, it was to appear as a completely independent pictorial element, related to solid forms and the space surrounding them, but clearly distinguishable from them as a separate artistic factor. It was to be used, in other words, in exactly the reverse way to Cézanne.

When Picasso and Braque met, Picasso was already familiar with the work of Cézanne. He had used the figure pieces of Cézanne as a source for the *Demoiselles*, and from the middle of 1907 onwards he was executing simple still lifes of pots, bottles, glasses and fruit in which he used Cézanne's high, informative viewpoints. Indeed, some of the paintings of this type, notably the group that was most probably begun towards the middle of 1908, seem to be almost exercises employing the sphere, the cylinder and the cone. But it is only in the second half of 1908 that Picasso turned to a more concentrated study of Cézanne. The first group of paintings in which this new development is clearly visible are the

68

canvases executed during the few weeks spent at la Rue-des-Bois in the autumn and in Paris during the succeeding months. The period of great intimacy with Braque had not yet begun, and it is very unlikely that by the time he left Paris for la Rue-des-Bois Picasso had already seen Braque's paintings of l'Estaque. However, Braque was already working under the influence of Cézanne before he left Paris for the summer, and Uhde records having heard Max Jacob say to Picasso, 'n'as tu pas remarqué comment depuis quelque temps Braque introduit des cubes dans ses peintures?'[1] One is tempted to wonder whether it was not through Braque's enthusiasm and example that Picasso was led to a deeper appreciation of Cézanne.

It is perhaps hard to see what Picasso found to admire that was common to both Negro sculpture and the work of Cézanne, two arts which are in many ways diametrically opposed. For while the Negro sculptor is often not particularly concerned with natural appearances, Cézanne's painting is the result of the acutest kind of visual observation. It is obvious that Picasso, who had admired the formal, sculptural element in Negro art, also appreciated the abstract, structural side of Cézanne's work. But it has been seen that Picasso was also attracted to Negro sculpture because he admired its conceptual quality. Now Cézanne's art, despite its use of simple, often almost geometrical forms, could never be described as conceptual. He was not so much concerned, as the Negro sculptor was, with conveying his idea about an object, but rather with recording it or reinterpreting it in pictorial terms. Or to put it differently, he saw in nature a store-house of artistic forms. Nevertheless, Cézanne had intuitively evolved a means of explaining the nature of solid forms in a new, very thorough way. To start with, he generally studied the objects in his still-lifes from slightly above eye-level, so that the spectator sees them in their most informative aspect; this high viewpoint was probably assumed largely in order to limit the pictorial depth and ensure the unity of the picture surface in so far as that looking downwards on to the subject one's eye is not allowed to wander off into limitless space. However, Cézanne very often goes further and tilts up the top of an object even more towards the picture plane, so that it appears sometimes as if seen almost from directly above, while continuing to show the rest of the object from a more normal, slightly lower point of view. It is impossible to say to what extent Cézanne was aware of the fact that he was doing this, and in the process breaking the laws of scientific linear perspective, but it seems likely that it was part of a natural desire to emphasize the two-dimensional aspect of the canvas while continuing to explain the nature of objects and also

[1] Uhde, op. cit., p. 39.

insisting on their solidity by modelling them as fully as possible. Many of these 'deformations' may also owe something to the fact that, as Cézanne moved from one section of his canvas to another, he unconsciously altered the structure of objects in an effort to relate rhythmically each passage of painting to the areas around it.[1] But apart from emphasizing the aesthetic or two-dimensional plane on which he was working, the tipping forward of certain objects or parts of objects also gives the sensation that the painter has adopted variable or movable view-points and that he thus has been able to synthesize into a single image of an object a lot of information gathered from looking at it from a series of successive view-points.[2] The way in which the contours of objects are continually broken in Cézanne's painting reinforces the impression that he looked at his subject from more than one position. Picasso, who was anxious to paint an object as he 'thought' it, or to express his ideas about it, was naturally anxious to explain as fully as possible the nature of its formal composition. He thus seized on the concept of volume implicit in Cézanne as one of the means of doing so. This was a development which of course took place in Picasso's work over a period of many months.

However, when approaching Cézanne after an intensive analysis of the predominantly simple, sculptural forms of Negro art, Picasso was naturally most immediately drawn to the precise, solid treatment of volumes that is found in so much of Cézanne's portraiture and still-life painting. The aspect of definition in Cézanne's work, its 'measurable' quality, is well illustrated by the fact that in one of his later Cubist phases Gris was able to interpret one of Cézanne's portraits of his wife in terms of a few sharply defined, superimposed planes that capture much of the structural feeling of the original. Then the landscapes at La Rue-des-Bois which are influenced by Cézanne are still related in many ways to Picasso's more 'primitive' or 'Negroid' work; indeed, this series of paintings begun in La Rue-des-Bois is contemporary with other canvases which represent only a continuation of his earlier work; some of the simplest of the La Rue-des-Bois landscapes, with their almost naïve interpretation of houses and trees, remind one strongly of the art of the Douanier Rousseau. However, in the more elaborate and sophisticated paintings of the series, the influence of Cézanne can be sensed in the general construction, in the technique of small, flat, rhythmically

[1] I am indebted for some of my ideas about Cézanne's method of work to Mr. R. Radcliffe's studies of his technique.

[2] It is perhaps worth noting, too, that since Cézanne returned again and again to his visual subject for reference, he cannot always have taken up exactly the same position in front of it, so that he must have in fact actually shifted his view-point from time to time, even if only very slightly. His eye was, however, clearly so highly trained that this may well have affected his vision of his subject.

70

applied brush-strokes which build up the forms, and in the devices which Picasso has used to retain the picture plane. For example, besides assuming Cézanne's high view-point, Picasso now often continues the outlines of walls or buildings at slightly different levels or angles as they appear at intervals behind the objects in the foreground. This feature derived from Cézanne's work can be seen also in some of Braque's l'Estaque landscapes.

Indeed, the Rue-des-Bois landscapes (Pl. 3a) have much in common with Braque's contemporary works. In both there is a reinterpretation of Cézanne in thoughtful, more conceptual, terms. Both painters take slight liberties with conventional perspective; that is to say, in their canvases the angles of vision are no longer completely consistent. Further, neither painter relies completely on the use of a single, consistent light source to model forms. Both have begun to produce a sensation of relief by arbitrarily juxtaposing lights and darks rather than by using shading in a naturalistic way. This is a feature of Cubist painting that was soon to become very apparent. Like Braque, Picasso had restricted the range of colours on his palette to browns, greys and greens, though the greens he uses are brighter and tend to predominate. And if one is forced to use the terms 'geometrical' when talking about Braque's work, it is even more applicable to Picasso's. The forms are severely simplified: tubular tree-trunks, heavily stylized masses of foliage and 'cubic' houses. Picasso's approach is harder, more sculptural than Braque's. The contours of the objects are unbroken (although they are occasionally slightly dislocated as has been seen) and the modelling is more aggressively three-dimensional. Braque, on the other hand, has used Cézanne's technique of opening up the contours of objects, so that in his paintings the eye slips inwards and upwards from plane to plane without having to make a series of abrupt transitions or adjustments. This use of new spatial sensations was to become an increasingly important feature of Braque's work.

The still-lifes which Picasso executed during the winter of 1908-9 and the early spring of 1909, such as for example the *Compotier* in the Museum of Modern Art, New York (a work probably of the early spring), are more frankly Cézannesque than anything that preceded them. Once again the forms are more solid, more firmly drawn and roundly modelled than in Braque's contemporary work. Cézanne's method of building up form by a series of parallel hatchings or small overlapping brush strokes is used by Picasso in a severe and logical way; indeed, in the gouaches of early 1909 this method of work becomes almost a refinement of the earlier, cruder striations. The objects in Braque's paintings like the *Still Life with Fruit Dish* (coll. Mr. Rolph de Maré, Stockholm), which is roughly contemporary (winter 1908-9) with the *Compotier*, are more

faceted, and the whole surface is broken up in terms of the same angular but subtly modulated planes which carry the eye back into a limited depth and then forward again on to the picture plane in a series of gentle declivities and projections. In the work of both painters one becomes increasingly aware of the fact that they are making use of a variable viewpoint. One sees more of the bowl and stem of the Picasso *Compotier*, for instance, than one would in normal vision if one assumed the same high viewpoint when looking at the top of it; and the gourd behind is painted as though in silhouette or directly at eye level. The table top is tipped up into the picture plane more sharply even than in a painting by Cézanne. (Pls. 3b and 26b.)

The human figure has always played a much more important part in the work of Picasso than in that of Braque, and Picasso looked with particular interest at Cézanne's figure work. What seems to have fascinated Picasso about Cézanne's figure studies and portraits, besides his obvious interest in their structural formal properties, is the complete disregard of details, which is at times extended even to a disregard of the individual features of the face. This is combined in Cézanne with an extremely elaborate build-up of form in terms of small flat planes based on empirical observation, which, following countless adjustments, fuse into the whole and become inseparable from each other. Some of Picasso's studies of single heads executed during the autumn and winter of 1908 show the earlier, more sculptural, Negroid type reinterpreted in a new idiom. The severe outlines of the facial mask are retained and the noses are the same protruding, convex forms, usually flattened into a ridge along the top. But the treatment of the rest of the face is more complex, subtler and more empirical; it is no longer divided into a few clearly defined sections, and eyes and mouth are not so precisely stylized and deliberately emphasized as they had been before.

In many of the figure paintings of the winter of 1908 and the spring of 1909 the Negroid elements are eliminated (Pl. 4a.), and the empirical or experimental treatment of form is extended to whole or three-quarter length figures. Under the influence of Cézanne, Picasso's work becomes once again more purely painterly, and these figures, though still simple and often clumsy and awkward in appearance, never give the impression, as did so many of the paintings of the Negroid phase, of being the pictorial counterparts of wooden sculptures. Forms become much more generalized; and they are no longer thrown into relief by the use of a single, consistent light source as in most of the Negroid work. The limbs are generally thin, but there is a marked tendency to distend or inflate the trunks of the bodies so that they become unnaturally broad. Picasso's work is, of

72

course, by now totally different, both in spirit and appearance, from that of Cézanne. It is a great deal more abstract, and the deformations within it are much more radical. This was partly because Picasso, like Braque, was at this time working largely from memory; indeed he had been doing so for the past three years.[1] This partial detachment from natural appearances, which has already been seen in the landscapes of Picasso and Braque of 1908, is one of the factors that distinguish most clearly their approach from that of Cézanne and other nineteenth-century artists, and even from the Fauves, whose vision, with the occasional exception of Matisse, despite the liberties they took with their subjects, was still conditioned by their instantaneous reactions to their surroundings. Cézanne in particular had as a rule relied completely on visual models, and had looked at the subjects of his paintings with a concentration and intensity as great as that shown by the artists of the early Renaissance in their rediscovery of the natural world. Only in the figure compositions did he work largely from imagination and memory. The element of distortion and the handling of the space in these paintings relates them intimately to Cubism, although most Cubist painting is close, too, in feeling to the more constructive and austere portraits, still-lifes and landscapes. It was the deliberate disregard of the more sensuous and immediately appealing aspects of painting, and the temporary dismissal of all human and associational values, combined with the fact that they were working in a conceptual way, relying on memory as much as on visual models, that allowed the Cubists to distort and dislocate figures and objects to a degree hitherto unknown. This is particularly noticeable in Picasso's drastic treatment of the human body in the series of paintings under discussion; in some of them the subject's limbs are abruptly truncated. There is furthermore an atmosphere of harshness and unrest about them that makes one realize how much closer to the spirit of Cézanne Braque's contemporary work is. Some figure paintings, however, probably mostly from the spring of 1909, are, like many of the contemporary still-lifes, more purely Cézannesque.[2] Less extreme in deformation, quieter and less agitated in mood, these paintings form a prelude to the important work which was to be done by Picasso during the summer in Spain at Horta de San Juan.

Examined over a certain length of time, the course of Picasso's development,

[1] Leo Stein, *Appreciation*, New York 1947. Stein, who knew Picasso well during these years, recalls that Picasso did not use a model during the Iberian period (he refers to it as the 'rose' period) and implies that this had been Picasso's procedure for some time (p. 174).

[2] The rather puzzling costumes of these sitters, the fancy-dress-like quality, may perhaps be due to the fact that the paintings were executed from photographs, postcards or magazine illustrations; that Picasso occasionally worked from photographs at this time.

though often paradoxical and breathtaking in its rapidity, can be clearly charted. The discovery of new sources of inspiration, world events, emotional and intellectual disturbances, or the stimulus provided by new contacts in his personal life, mark starting points for various periods into which his artistic career can be divided. And in his later work the careful dating supplied by Picasso himself eliminates any chronological problem. But during the early Cubist period, when the pictures were unsigned and undated, and when the wealth of discovery and invention makes differences of months and even of weeks important, it is extremely difficult to establish an exact chronological sequence. Nearly all the signatures and dates on Cubist paintings executed by Picasso and Braque between 1907 and 1913 have been added much later. Often the paintings appear to be signed on the reverse and occasionally a date is inscribed there also. These 'signatures' were mostly added by an employee of Kahnweiler's when they reached his gallery; this was usually, though clearly not always, within a few weeks of being painted. Even in the case of Braque, whose development was more methodical than Picasso's, the dating of certain works is problematical, and Picasso's sporadic method of work makes it doubly hard. The approach of both Picasso and Braque was primarily intuitive, but Picasso's innovations and changes of style give the impression of being realized more suddenly and spontaneously. Then, after having taken the most daring steps forward he sometimes retreats a few paces, so that on comparing two paintings close in date the earlier example often seems more advanced and developed. The same themes, the same subjects and poses are reinterpreted over and over again, often in some completely original way, but sometimes also in a manner reminiscent of a previous phase; any novelty is eventually assimilated to what had preceded it; nothing is ever discarded. This overlapping of styles is seen throughout the entire pre-war period, and since every phase contains the seeds for future developments, one is forced to take as focal points works in which discoveries or innovations are fully realized, rather than those in which they are first suggested.

The problem of establishing a satisfactory chronology for Picasso's work between 1907 and 1914 is largely solved by the invaluable landmarks provided by the months, generally in the summer, spent outside Paris. Because of their subject matter and homogeneity of style, and often also because of photographic records,[1] the paintings of these periods are usually securely datable. Furthermore, these months were usually periods of synthesis and discovery. It is in some of the drawings and sketches executed at Gosol that the facial types begin

[1] Some paintings furthermore have the names of the towns and villages in which they were executed inscribed on the reverse. This often allows a fairly precise dating.

to harden towards the 'Iberian' style of the autumn. Another, contemporary, series of Gosol paintings is characterized by a gentle, pastoral mood that is quite distinctive. The influence of Cézanne is seen strongly and consistently in some of the paintings Picasso brought back from La Rue-des-Bois in the autumn of 1908. Now, at Horta de San Juan,[1] in the summer of 1909, Picasso consolidated the achievements of the past years to produce the most important single group of paintings of his early Cubist period. Picasso and Fernande Olivier arrived there in May and remained, with interruptions, until September.[2]

The Horta figure pieces in particular are of vital importance in the history of Cubism. In the more sculptural, formal, Negroid paintings the starting point for the investigation of form had been the logical or rational division of the human form and face into their component parts. Later, after he had been influenced by certain paintings by Cézanne, Picasso began to treat solid forms in a more arbitrary, empirical or experimental fashion and to explore the possibilities of representing them without the aid of traditional perspective. At Horta, Picasso fused the Negroid and the Cézannian types of painting. Looking at these canvases one gets the sensation that the time spent in Horta was a period of almost unequalled concentration in Picasso's art.

The series of Horta heads all have more or less the same basic subdivision into several clearly defined areas. That is to say, Picasso uses as a starting point the same logical or rational analysis of volume that he had evolved in his Negroid paintings. The forehead is usually divided by a central ridge or furrow as in much of the Negroid work. Two simple planes connect the sunken eye socket to the forehead, and a small disk extends below from cheekbone to the inside corner of the eye, while the jaw, the nose and the section from nose to mouth and from mouth to chin are each clearly defined. But these areas then become the starting point for further subdivision and countless small refinements conditioned by direct observation. The same approach is applied to the whole body of a three-quarter length figure, which is the culmination of the series. The basic pyramidal or shield-like form of the stomach still recalls Negro sculpture, but the deformation of the figure is at once more geometrical and less extreme than in most of the Cézannesque paintings and less rigid than in the Negroid paintings; forms are faceted or subdivided in a more elaborate fashion than hitherto, so that one's eye passes freely from one sculptural element to another. There is, too, an increased feeling of sensitivity and subtlety. Most

[1] Horta de San Juan was known to Picasso and his friends by its colloquial name, Horta de Ebro.
[2] Picasso-Stein correspondence.

important, in these heads and figures the Cubist concept of form is expressed in a fully developed way. The heads are viewed from slightly above or at eye level but the undersides of nose and jaw are clearly seen. The side of the neck is swung forward in a great curving plane that is the basis of the sculptural breakdown of the neck and throat. The knot of hair at the back of the neck is, in some of the paintings, incorporated in an almost full-face view, and the back of the shoulder is tipped up into the picture plane. In the three-quarter length figures the sides of the body are pulled or folded outwards to broaden and expand the trunk. In other words, in each image Picasso synthesizes information obtained from viewing the subject from various angles, and, relying on his knowledge and memory of the structure of the human figure, he gives a complete and detailed analysis of the nature of the forms that compose it. (Colour Pl. A.)

The problem of combining various aspects of an object into a single image was one which, it has been seen, had concerned Picasso and Braque for some time. Indeed, it should be emphasized that Picasso had been dissatisfied with the limitations imposed on pictorial volumes by a scientific or linear system of perspective for some time before he became aware of the fact that Cézanne's painting suggested a new concept of form and space. As early as 1906, in many of Picasso's paintings influenced by Iberian sculpture, forms are distended to the point of distortion, and because of this, in the heads of figures, the features, and particularly the mouths are unnaturally elongated. This is very obvious in the *Portrait of Gertrude Stein*, where in a three-quarter view the far side of the mouth is almost duplicated, while the disparity between the eyes further accentuates the sense of breadth. In other figures where both the bust and the head are expanded in this exaggerated way, the neck clearly presented a problem: by nature a slender form, it must now be used to connect convincingly two abnormally heavy masses. (A satisfactory solution was not to be reached until the work of Horta de San Juan, where, using the tendons as an axis, the back of the neck is swung around into the front of the shoulder.) Then, in the *Demoiselles*, a further step is taken. The noses of the full-face figures are in profile, and in the squatting figure, with its distended pose and dislocated head, the canons of traditional perspective are completely violated. Braque had stated the new concept of form more consciously in the *Baigneuse* or *Nu* of early 1908, where the unnaturally squat proportions of the figure are further exaggerated by the inclusion of certain aspects of it not visible from a single point of view. In a three-quarter view of the head the knot of hair at the back of the head is seen as in a profile view, and the double outline of the foremost shoulder gives the impression that the top of it has been tipped up into the picture plane.

76

Picasso's *Baigneuse*, a work of late 1908, or early 1909, shows the painter accomplishing the desired optical synthesis in a very thorough but slightly schematic way (Pl. 4b.). Here both buttocks and the far side of the back are visible in what is basically a simple three-quarter view of the figure; one leg is in strict profile, while the other is seen almost from a frontal position. The face, divided down the central axis, is a crude combination of a three-quarter and profile view, and the elongation of the mouth suggests even a purely frontal view-point. In Braque's *Still Life with Musical Instruments*, painted in the autumn of 1908, the top of the mandolin is bent round to an exaggerated degree, so that the top and underneath of it are visible simultaneously. And from the middle of this year onwards, both painters had adopted and accentuated Cézanne's device of lifting the tops of objects up towards the picture plane. This aspect of Cézanne's art, and the way in which he distended forms and continually opened up their contours as though in an effort to broaden them even further, must have appeared to the Cubists as an early manifestation of the simultaneous depiction of various views of an object in a single image, and as a justification for their deliberate dismissal of linear perspective. (Pl. 24b.)

The new concept of form reached its fullest expression to date in the work of Picasso done at Horta de San Juan, and some sheets of drawings which probably date from the early days of his return to Paris, show Picasso methodically applying the Cubist concept of form to objects of different kinds and shapes: to a human head, a box, an apple and so on. But even in these drawings, which have the character of a study or demonstration, there is nothing theoretical about Picasso's approach. There are in Cubism many seemingly contradictory features, and one of the most obvious is the fact that despite the strong intellectual and rational strain that characterizes the style, the painting of Picasso and Braque remained markedly unscientific. The method of work of both artists was throughout primarily intuitive. Traditional perspective was abandoned but no new system was substituted for it. On the contrary, the painter's liberty had become absolute. He was free to move around his subject and to incorporate into his depiction of it any information gained by this process or acquired through previous contacts or experiences. Memory, therefore, played an increasingly large part in the artist's new vision of the world around him, and this led at first to a great simplification of form. But at the same time the painter now felt compelled to give in every painting a multiplicity of information about the formal properties of his subject, and this in turn rendered his task in some ways more complex than it had been hitherto. No ready-made solutions were offered for the problems posed. If the mind or memory suggested new forms, the means of

expressing them were purely pictorial. Pierre Reverdy, a young friend and supporter of Picasso and Braque,[1] was quick to realize the fact that true Cubism had not been the product of pictorial doctrines and theories, and also that the search for the means of expressing a new concept of form and space had made Cubism a style of almost unequalled pictorial discipline. In the first issue of *Nord-Sud*, a periodical which appeared in 1917 with the purpose of reintegrating and stimulating artistic life in Paris, Reverdy, feeling that some kind of objective evaluation of Cubism was by this time possible, wrote: 'aujourd'hui pour quelques rares élus, la discipline est établie, et comme on n'a jamais rêvé d'un art froid, mathématique et antiplastique, uniquement cérébral, les oeuvres qu'ils nous donnent s'adressent directement à l'oeil et aux sens des amateurs de peinture.'[2]

Besides the figure work, Picasso also executed several landscapes at Horta de San Juan. Trees and natural forms are here almost completely eliminated, and the concern is with the relationships between the cubic, block-like buildings and the reconciliation of their obvious solidity with the picture plane. Colour is even more limited than before, and the palette for the succeeding years is established: some of the paintings are in umbers, greys and blacks, with a few touches of dull green, while others are in softer grey-blues and buffs. In all the paintings the deviations from traditional perspective, which in landscape painting had hitherto been only slight, are carried to new lengths. Not only is there no central vanishing point, but the perspective, rather than being convergent is actually divergent, so that the roof tops and sides of the buildings are often broadest at their furthest ends, and have the effect of opening up, fan-wise, on to the picture plane. Picasso's use of light is by now completely arbitrary: darks and lights are opposed to each other simply to accentuate the incisive quality of the outlines and to throw form more sharply into relief. Since atmospheric perspective is disregarded also, the furthest buildings appear to be placed above rather than behind the ones in the foreground. The picture plane is further stressed by the device of dropping the small doors or openings below the bases of the buildings, and by the way in which some of the forms are opened up into each other and fused. The sky, too, is treated as a series of planes continuing the composition up to the top of the canvas, so that there is very little suggestion of depth even behind the buildings and mountains on the horizon. (Pl. 8a.)

This particular feature in the landscapes at Horta de Ebro, the solid, almost tangible, treatment of the sky, had been developed first in Cubist painting by

[1] Reverdy, who was born in 1889, was the youngest of the contemporary writers on Cubism, but was already friendly with the painters before the outbreak of the war and lived at the *Bateau Lavoir*.

[2] *Nord-Sud* 1, 1–15 March 1917. Reverdy and Paul Dermée were the editors of this review.

Braque as a result of his new ideas about pictorial space. It is particularly notice-able in the *Port*, a work painted from memory in the spring of 1909. In the late landscapes of Cézanne the sky is often treated in much the same way—as a complicated system of small, thickly painted facets or planes inextricably fused, and having a quality of weight and material existence.[1] Despite the austerity of his early Cubism, Braque's interpretation of Cézanne was more painterly than that of Picasso, and he was undoubtedly fascinated by the surface quality and the actual technique of Cézanne; there is in the handling of the sky in the *Port*, and indeed throughout the whole picture, a much greater emphasis on the richness of the pigment itself than there is in contemporary works by Picasso. The forms of lighthouses and boats, while almost toy-like in their basic simplicity, are de-veloped internally in terms of a large number of planes or facets, and since the sky receives the same treatment, the painting resolves itself into a mass of small, shifting planes, jointed together or hanging behind each other in shallow depth. Out of this, forms emerge, solidify, and then disintegrate again as the spectator turns his attention back from the individual forms to the painting as a whole. In Braque's l'Estaque landscapes of the previous year, the two-dimensional surface of the picture is retained partly by allowing the eye no way of escape beyond the mountains, buildings and trees, and here the same effect is achieved by the concrete treatment of the sky, which is as elaborately and solidly painted as the rest of the canvas, and which is fused with the landscape below by the exten-sion into it of all the main compositional lines. A few years later, in 1912, La Fresnaye, attempting to describe a certain aspect of Cézanne's work and to assess his influence on contemporary painting said: 'Chaque objet, dans une des dernières toiles, a cessé de valoir uniquement par lui-même, et devient peu à peu un organe dans l'organisme complet du tableau. Voilà la partie vraiment féconde de l'oeuvre de Cézanne et le point par lequel elle se trouve à la base de toutes les tendances modernes.'[2] The first sentence describing Cézanne's late work, could equally well be applied to this kind of painting by Braque. (Pl. 26a.)

Something has already been said, in connection with the landscapes and still-lifes of 1908 and early 1909, about the emergence of a new spatial sensation in Braque's work. In the *Port* this has become very marked. The treatment of the sky and of the areas between the various landscape objects, the boats, light-houses and breakwaters, in terms of the same facets or pictorial units into which the objects themselves are dissolved, has the effect of making space seem as real, as material, one might almost say as 'pictorial' as the solid objects themselves.

[1] See e.g. Venturi nos. 798–9 etc.
[2] *Cézanne* in *Poème et Drame*, January 1913.

The whole picture surface is brought to life by the interaction of the angular, shaded planes. Some of these planes seem to recede away from the eye into shallow depth, but this sensation is always counteracted by a succeeding passage which will lead the eye forward again up on to the picture plane. The optical sensation produced is comparable to that of running one's hand over an immensely elaborate, subtly carved sculpture in low relief. It has been suggested that the *Port* was shown, together with another painting by Braque since destroyed, at the *Salon des Indépendants* of 1909.[1] If the *Port* is indeed the landscape listed in the catalogue, it is the first surviving Cubist painting to have been seen in a large public exhibition (the Braque exhibition in the previous year had been at Kahnweiler's gallery which was small and at that time known to relatively few people). Braque's entries in the *Salon des Indépendants* were hung in the Fauve room. Reviewing the exhibition for *Gil Blas*, Vauxcelles wrote: '— tout, jusqu'aux bizarreries cubiques et, je l'avoue, malaisément intelligibles de Bracke [*sic*] (en voilà un, eût dit Pascal, qui abuse de l'esprit géométrique!) confère à cette salle touffue un intérêt passionnant.'[2]

By 1909 then, Picasso and Braque had initiated the first phase of Cubism; the art which both painters were producing was the result of a new freedom which arose from their having discarded all scientific systems and theories. But despite the spirit of communal research which had begun to characterize their work, it had already become apparent that there was still a fundamental difference of approach between them. The similarity of subject matter between Picasso's Horta landscapes and those which Braque was executing at exactly the same time at La Roche Guyon (that is to say in mid 1909) (Pl. 27a.) enables one to appreciate with clarity the fact that, although they were reaching much the same conclusions, it was for different reasons. Braque's paintings show a continuation of the fragmentation of form and the elaborate surface treatment already seen in *Le Port*. The brush-strokes have become smaller and more numerous, and perspective is distorted to such an extent that the buildings occasionally appear to be composed of completely dislocated or dissociated walls and roofs. Picasso's landscapes are more incisive and linear, and the solidity of the forms is deliberately emphasized. The paint quality is less attractive and the technique itself less conscious. The Braques are softer, shapes and objects tend to fuse and merge more, and there is almost a suggestion of the atmospheric shimmer of light. Picasso has said, 'Cubism is an art dealing primarily with

[1] Henry R. Hope, *Braque*, Museum of Modern Art, New York, p. 37. This must have been the *Paysage*, Cat. no. 215. The exhibition opened on the 25th of March so that if the *Port* was shown there it must have been painted very early in the spring of 1909.
[2] *Gil Blas*, 25 March 1909.

forms.'[1] Braque, on the other hand, is quoted as saying, 'ce qui m'a beaucoup attiré—et qui fut la direction maîtresse du cubisme—c'est la matérialisation de cet espace nouveau que je sentais.'[2]

Picasso's dismissal of traditional perspective had been the result of his interest in investigating the nature of solid form and of a desire to express it in a new, more thorough and comprehensive, pictorial way. This accounts for the strong sculptural feeling that characterizes so much of his early Cubist painting; and, indeed, from the Negro period onwards, he was executing small experimental sculptures which relate directly to the contemporary paintings. In his bronze *Head*, for example (a more important work, which will be discussed below) he dealt in three dimensions with the problems he had faced in the figure paintings at Horta de San Juan. Because of his interest in the properties of pictorial volumes, the device of combining into a single image various views of an object, one of the fundamental features of Cubism, was worked out more consistently in Picasso's work than in Braque's. Furthermore, Picasso was anxious to present in each image as much essential information about the subject as he could. When he subdivides and facets form, it is in an attempt to break through to its inner structure. This is exactly the effect achieved, for example, by the treatment of the necks in the Horta figures. One gets the impression that Picasso is striving for some ultimate pictorial truth, some absolute representation of reality. Braque was dissatisfied with traditional perspective for many of the same reasons as Picasso. 'Mécanisée comme elle est, cette perspective ne donne jamais la pleine possession des choses,' he has said.[3] But while he was interested in giving as complete an idea as possible of the nature of his subjects, he was not so much interested in the formal, sculptural properties of individual objects as in their relationships to each other and to the space surrounding them. Linear, scientific perspective allows for a fairly accurate mental reconstruction of the distances separating objects. Thus, in front of a still-life by Chardin or Courbet, for example, one can say that one object must be separated from another behind it by so many inches, and so on. Braque, on the other hand, wanted to *paint* these distances or spaces, to make them as real and concrete for the spectator as the objects themselves. In order to accomplish this it was necessary to convey the sensation of having walked around his subjects, of having seen or 'felt' the spaces between them. Braque has said 'dans la nature il y a un espace tactile, je

[1] Statement by Picasso, made in 1923 to de Zayas. It was translated into English and published in *The Arts* under the title *Picasso Speaks*, New York 1923. The entire statement is reproduced by Barr in his *Picasso*, pp. 270–1.

[2] Dora Vallier, *Braque, la Peinture et Nous, Cahiers d'Art*, 1954, p. 15.

[3] Ibid., p. 14.

dirai presque manuel. . . . C'est cet espace qui m'attirait beaucoup, car c'était cela la première peinture cubiste, la recherche de l'espace.'[1] And Braque's early Cubist work gives exactly that impression of 'manual' space which he has talked about. Every object in these paintings is separated from those surrounding it by layers of tactile, visible space which enable the spectator's eye to reach from one part of the canvas to another, from one object to another, by a series of clearly defined pictorial passages. When he fragments and decomposes the objects in his still-lifes and landscapes, it is not in order to strip form bare or to disengage some essential quality, but it is rather as a means of creating a completely new kind of pictorial space. And it was probably because of his desire to 'touch' space that he began to abandon landscape painting and to devote himself increasingly to still-life, in which the depth was naturally more restricted and could be more easily controlled.[2] Braque's interest in space gives his work an 'overall' quality, which has ever since remained one of the main features of his style, whereas in Picasso's painting the attention is usually riveted on the subject while the background or surround is often treated in a simpler or more cursory fashion.

Before going on to discuss the stylistic changes in the Cubism of Picasso and Braque during 1910, it is necessary to interject a word about Picasso's bronze *Head*, the most important early Cubist sculpture. It might have been expected that the African masks and statuettes that had such a profound effect on Picasso's painting would have excited him to a new activity in the field of sculpture as they did Derain[3] and, to a certain extent, Matisse. And during 1907 and 1908 Picasso did produce a handful of wood-carvings (many of which have the appearance of being unfinished), a couple of small bronze heads and masks, and one or two incidental pieces in plaster. But most of these can be regarded as experimental works designed to clarify the problems that Picasso was facing in his painting. Picasso, it has been seen, was anxious to introduce into his paintings what might almost be called a 'sculptural completeness'. One of the things that he objected to about a tradition of painting that was governed by a scientific, single view-point system of perspective was that it gave the spectator an incomplete picture or idea about the subject. In other words, he wished to give his own canvases a dimension that in a sense already existed in sculpture, or at least in free-standing sculpture. For clearly one of the principal characteristics of sculpture in the round is that the spectator is able, and is indeed often encouraged or compelled, to walk around it and study it from all angles. In other

[1] Ibid., p. 16.

[2] Braque has also said: 'Quand une nature morte n'est plus à la portée de la main, elle cesse d'être une nature morte.' Requoted by Braque, ibid., p. 16.

[3] See p. 169 below.

words, he is free to do what Picasso was trying to do for him in his painting. This is probably why, even when a 'school' of Cubist painting came into existence, there was at first very little Cubist sculpture. On a more general level it is possible to say that since painting is in any case an art of illusion, in so far as it conveys sensation of volume and depth on a two-dimensional surface, it was easier for the Cubists to break with traditional conventions, to push the 'illusion' one step further, and to invent a new pictorial language, than it was to find a new way of dealing with the solid, tangible forms themselves (Pl. 6).

Nevertheless, Picasso's bronze *Head* is in many ways a revolutionary work. It is clearly related to the Horta figure work although it came a few months later, and it shows the same intensive analysis of the nature of solid forms. Picasso makes full use of the play of light across the rough, irregular texture of the bronze to accentuate the dissolution of the face into sharp, angular and incisive planes. Certain sections, when they fall into deep shadow, give the effect of having been gouged out in order to show the interior as well as the exterior structure of the head. This was something that Picasso had also conveyed in the necks of the Horta figures, where the area between the projecting tendons appears to have been cut back into a deep recess. Then the head is distorted in a sweeping spiral movement so that the spectator is obliged to move completely around it and thus gathers a very complete idea about it; and, owing to the element of distortion, from several positions one sees more of the head than would be possible in ordinary vision. But this sculpture remains an isolated example, emphasizing the fact that in its earliest stage Cubism was primarily a pictorial revolution. And it was not until several years later, after Picasso and Braque evolved new methods of dealing with solid forms in their paintings, through their *papiers collés* and constructions, that there emerged with the work of men like Laurens and Lipchitz a real school of Cubist sculpture.

During the latter part of 1909 and the early months of 1910 the work of Picasso and Braque became increasingly elaborate and complex. In Picasso's Horta work there had still been some reference to the earlier, simpler and more rational forms derived from Negro art, but in the paintings done on his return to Paris this aspect is completely abandoned, and in the figure work, the approach becomes once again less rational and more empirical (Pl. 5). To control the elaborate complex of facets or planes to which forms are now reduced, Picasso had to resort again to the use of a consistent light source, and there is in many of these paintings a new and strong sense of *chiaroscuro*. Inside the objects and figures the planes begin to be opened up into each other more fully and are less clearly differentiated than hitherto. And by the spring of 1910, in

works such as the *Portrait of Uhde* (coll. Roland Penrose, Esq., London) figures and objects have become partially fused with their surroundings or with the background. In the work of Cézanne, where the outlines of objects are stressed again and again, and then as often broken, the eye, while conscious of the limitations of normal vision, has the sensation of being carried around the object beyond its boundaries. Here, in the work of Picasso, the device of fusing or merging the subject with its surroundings allows the painter to insist on the surface unity of the picture but also has the same effect of allowing the spectator to reconstruct form beyond the boundaries stated. These works of Picasso's produce, too, some of the same spatial sensation that is conveyed by Braque's.

The move towards this more complex kind of painting reaches a climax in the still-lifes that Braque painted late in 1909 and early in the following year, for example *Violon et Cruche* (Pl. 28). These paintings give the sensation that Braque has felt his way visually around each object and examined its relationships with the other objects around it from several view-points. By rendering the areas between the objects in a tactile, material fashion, Braque succeeds in fusing objects and space into a spatial continuum composed of small, fluid, interpenetrating planes. It is this concrete rendering of the space around the highly fragmented objects that gives these paintings a sensation of almost unprecedented complexity. The intense visual concentration and the technical discipline underlying these paintings transmits itself to the spectator in a feeling of tension, almost of unrest. Although it has been seen that early Cubism was in no sense simply a continuation of Cézanne, the paintings of Picasso and Braque of this period represent, in many ways, the culmination of the investigation of form and pictorial space initiated by him thirty years earlier. They mark also the final phase of the first period in Cubist painting. Both painters, and Braque in particular, seem to have realized that the technique of Cubist painting must become more suggestive, more abstract.

Of the two painters Braque was the more 'painterly'. He was always more conscious than Picasso of the actual surface quality of his work, and moreover more consistently conscious of the need for respecting the demands of picture plane. It was therefore natural that it should have been Braque who solved the present problem, largely a technical one, of finding a new, easier means of representing the new concepts of pictorial form and space in all their fullness and complexity. In a couple of landscapes executed at Carrières Saint Denis (Pl. 27b), where he had spent a week or so working in the company of Derain, late in the autumn of 1909, Braque had already begun to transform the subtlety and

observational quality of the Roche Guyon landscapes into tighter, more arbitrary compositions, reminiscent in the emphasis on the vertical and horizontal structure broken by forty-five degree diagonals (and also in colour, which is once again darker and harsher) of the *Maisons à l'Estaque*. Next, in a few small still-lifes of early 1910, such as the *Glass on a Table* (Pl. 29a), the objects are blocked in in a much more direct manner than hitherto. The linear quality of the original idea or sketch is retained, and these outlines become the starting point for the breakdown of the entire surface in terms of flat or tilted planes, a few of which are quite arbitrary. Another still-life, *Les Poissons* (Pl. 29b), probably executed a few months later, during the summer, shows the new compositional methods carried a step further. The table top and the bottle provide the main compositional accents, while the remainder of the surface is broken down in secondary vertical and horizontal sections. Through these planes the bodies of the fish, fragmented and dislocated, can be traced in a series of subsidiary diagonals. Only their heads remain immediately legible, and these provide the spectator with a starting point for the reconstruction of the subject. A contemporary landscape, *Les Usines de Rio Tinto à l'Estaque* (Pl. 30a), though the subject is still quite recognizable, is markedly more abstract than anything Braque had painted before. By now the painting is virtually constructed in terms of a loose grid or framework of vertical and horizontal lines suggested by the outlines of the buildings. The buildings themselves are no longer self-contained or fully circumscribed forms but are opened up completely into the space around them to form a composition of interpenetrating, shifting planes, suggesting an extremely complicated transparent sculpture in low relief. Braque himself has best described his new method of work when he said, 'la fragmentation (des objets) me servait à établir l'espace et le mouvement dans l'espace, et je n'ai pu introduire l'objet qu'après avoir créé l'espace.'[1]

Picasso's *Jeune Fille à la Mandoline* (also known as the *Portrait de Fanny Tellier*) (Pl. 7), a work of early 1910, although parts of it are still very solidly painted, marks also a transition towards a simpler more two-dimensional kind of painting. The treatment of the areas around the breasts, shoulder and elbows (the underneath of the elbow is brought around into the picture plane to make convincing the jointing of upper arm and forearm) is still very elaborate and carefully worked out, giving the impression almost of an enormously complicated and fragile sculpture in cardboard or paper, but other sections are dealt with as large flat planes. This is particularly noticeable in the treatment of the head, where the problem of combining two views is resolved by flattening the

[1] *Braque, la Peinture et Nous*, p. 16.

far side of the face into a single plane and swinging it around on to the picture surface. The figure is not merged with its surroundings as much as in some of Picasso's work of the period, but even here the section underneath the right arm appears to belong to both figure and background.

In Picasso's subsequent move towards a more abstract kind of painting, the work of Braque may once again have been a stimulus, and Picasso's remark to Braque, quoted by Michel Georges-Michel, 'j'ai essayé tes moyens et il me semble qu'on peut en tirer des choses admirables'[1] was perhaps made in connection with the new kind of painting Braque had invented in his still-lifes of the first half of 1910. Always more extreme than Braque, Picasso, in his work at Cadaqués in the summer of 1910, used the same grid type of composition to produce some of the most abstract and hermetic of all Cubist paintings. At Horta Picasso had been concerned with the breakdown of the human figure into its sculptural units and the relationships between them. Now, working from sketches (often of a type relating to the work of 1909 and early 1910) Picasso uses the outlines or the main directional lines of the body and its limbs as the starting point for his compositions. Around this linear framework is built up a complex system of open and interacting planes, which sometimes seem to represent the forms of the body but which are often quite arbitrary compositional elements. This system of transparent, interpenetrating shapes or planes suggests form in shallow depth, and from it the figure re-emerges as the spectator studies the canvas. This new method of composition can be seen clearly by comparing an etching of a figure done as an illustration for Max Jacob's *Saint Matorel*[2] and securely dateable to Cadaqués, with a drawing done a few months earlier. The oil paintings of this period are considerably more abstract than the etchings and drawings, and many cannot be deciphered or reconstructed without the aid of preliminary sketches. Picasso had abandoned the use of a consistent light source a year earlier only to reinstate it a few months later in the paintings done in Paris during the winter. Now once again lights and darks are juxtaposed arbitrarily to create a sense of shallow relief, and are evenly scattered over the entire picture surface to maintain a compositional balance. (Pls. 8b, 9a, 9b.)

Kahnweiler, who was in continual contact with both Picasso and Braque at this time, realized at once that with the type of painting created by these artists in 1910 (and of which the Cadaqués paintings are the most extreme examples) Cubism was entering a new phase. In 1915 he wrote: 'Noch viel wichtiger aber,

[1] Michel Georges-Michel, *Peintres et sculpteurs que j'ai connus*, New York 1942, p. 225.
[2] Published by Kahnweiler, Paris, Feb. 1911. The engravings were printed by Delatre.

der entscheidende Schritt überhaupt, der den Kubismus loslöst von der bisherigen Sprache der Malerei, ist der Vorgang, der sich gleichzeitig in Cadaquès . . . vollzieht. Dort verbringt Picasso seinen Sommer. Wenig befriedigt kehrt er im Herbst nach Paris zurück, nach Wochen qualvollen Ringens, mit unvollendeten Werken. Aber der grosse Schritt ist getan. Picasso hat die geschlossene Form durchbrochen. Ein neues Werkzeug ist geschmiedet für den neuen Zweck.'[1]

If Picasso was dissatisfied with the Cadaquès paintings, this was probably because he felt them to be too hermetic and abstract. And it was at this time, in 1910, that Cubism entered its most 'difficult' or hermetic phase, which subsequently gave rise to so much misunderstanding. The ignorant, baffled by the appearance of Picasso's and Braque's paintings, tended, indeed, to classify them as complete abstractions. Even the critic Arthur Jerome Eddy, who was the author of the first English book on Cubism and a cautious supporter of the movement, was able to write: 'In short Picasso and a few followers have reached a degree of abstraction in the suppression of the real and the particular that their paintings represent the same degree of emotion as the demonstration of a difficult geometrical proposition.'[2] It is therefore perhaps necessary to pause here to re-affirm some of the intentions of the movement which have hitherto been suggested only in passing.

Cubism, despite the strong intellectual bias and obvious concern with purely formal pictorial values, was never at any stage an abstract art. In fact the painters themselves and the contemporary writers who were genuinely anxious to understand their work, claimed that Cubism was an art of realism. Even Apollinaire who, excited by the complete break that Cubism had effected with traditional painting, had tended to suggest that the ideal programme would be a move towards complete abstraction, could still insist that the Cubist was a realist, since his inspiration was drawn from some transcendental truth beyond the world of appearances. Maurice Raynal, although less extreme and volatile in his thought than Apollinaire, adopted much the same idealist view while realizing that abstraction was not the end or goal of Cubist painting. In 1913, in his first attempt to define the movement, he wrote: 'Les artistes sincères sentent aujourd'hui . . . le besoin de canaliser et de dompter leur inspiration, de tirer de leurs facultés le "summum" de rendement possible, et d'équilibrer chez eux la sensibilité et la raison. . . . Ils n'imitent donc plus les apparences erronées de la vision mais celles plus vraies de l'esprit.'[3]

[1] *Der Weg zum Kubismus*, p. 27.
[2] *Cubists and Post-Impressionism*, New York 1914, p. 101.
[3] Raynal, *Qu'est ce que . . . le Cubisme*, in *Comoedia Illustré*, Dec. 1913.

When writing on a less metaphysical level, and in face of the paintings them-selves, even Apollinaire had to admit that the subject played an important part, and that the realism of the movement lay in its attempt to make a totally new but nevertheless very concrete statement about the visual world. Apollinaire describes Picasso's method of work in this way: 'Imitant les plans pour représenter les volumes, Picasso donne des divers éléments qui composent les objets une énumération si complète et si aigue qu'ils ne prennent point figure d'objet grâce au travail des spectateurs, qui, par force, en perçoivent la simultanéité, mais en raison même de leur arrangement. Cet art est-il plus profond qu'élevé? Il ne se passe point de l'observation de la nature et agit sur nous aussi familière-ment qu'elle-même.'[1] Apollinaire further stresses the realistic character of the movement when he writes, simply and perhaps instinctively: 'Courbet est le père des nouveaux peintres.'[2] Gleizes and Metzinger also emphasize in the opening section of *Du Cubisme* that to evaluate Cubism it is necessary to go back to Courbet—'(il) inaugura une aspiration réaliste dont participent tous les efforts modernes.'[3] Two years earlier, in 1910, Metzinger had written: 'Picasso ne nie pas l'objet et l'illumine avec son intelligence et son sentiment,' and again, 'Picasso s'avoue franchement réaliste.'[4] Discussing Cubism, Picasso himself has said: 'in our subjects, we keep the joy of discovery, the pleasure of the un-expected; *our subjects must be a source of interest*.'[5] And Braque: 'Quand les objets fragmentés sont parus dans ma peinture vers 1910, c'était une manière de m'approcher le plus de l'objet dans la mesure que la peinture me l'a permis.'[6]

The iconography of Cubist painting in itself serves to confirm the realistic intentions of the painters. Picasso and Braque turned to the objects closest to hand for their subject matter, objects forming part of their daily lives and re-lating to their most immediate and obvious physical necessities and pleasures. The wine glasses, tumblers, pipes and so on were articles which each painter handled regularly in the course of day-to-day life. The fans and musical instru-ments which become recurrent themes in the still-lifes were part of the equip-ment or decoration of many typical advanced studios in Montmartre; Braque who had been responsible in 1908 for the introduction of musical iconography into Cubist painting was furthermore seriously interested in music. Picasso worked mostly from memory, but when he used models for his figure pieces they were usually people he knew well, his friends and mistresses. So even

[1] *Les Peintres Cubistes*, p. 36.
[2] Ibid., p. 26.
[3] *Du Cubisme*, p. 6.
[4] 'Note sur la peinture,' *Pan*, Oct.-Nov. 1910 (the article was written in Sept.).
[5] From the interview with de Zayas, in Barr's *Picasso*, p. 271 (the italics are my own).
[6] *Braque, la Peinture et Nous*, p. 16.

in the first exploratory or formative phase, when human values were largely suppressed, the Cubism of Picasso and Braque was in some ways an expression of the private life and experience of the painter. The early researches had required the acceptance of a severe discipline, and individualities and personal tastes had been sacrificed in a common urge. But after the new concepts of form and space had been clearly formulated Cubist painting at once became much more personal, more human. Through some of his paintings of 1912 Picasso went so far as to say candidly to the spectator, 'j'aime Eva'; at the same time he wrote to Kahnweiler of Eva, 'et je l'aime beaucoup et je l'écrirai sur mes tableaux.'[1] In 1913 and 1914, after all the most important discoveries had been made, Cubist painting naturally became freer and more decorative, but the same simple subject matter was retained. In a vein of intimacy the Cubists introduced into their compositions the names of popular songs,[2] the programmes of theatres they had visited, the packets of cigarettes they had smoked, or the headings of newspapers they read—elements which, as Apollinaire put it, were 'déjà imprégnés d'humanité'.[3] And yet, despite the extremely personal aspect of so much Cubist painting, the movement remained free from introspection, and the painters continued to view and record their ideas of the material world of their immediate experience in a detached and objective way. This seemingly contradictory combination of an extreme objectivity of vision with a strong vein of intimacy and personal humour emerges as one of the main characteristics of the classical and late Cubism of Picasso and Braque.

The desire of the Cubists to keep closely in touch with visual reality explains Picasso's uneasiness about his Cadaqués paintings: clearly he could not go back to his earlier, more laborious methods of dealing with form, and yet at a single stroke he had carried the new technique suggested in the work of Braque to something very near complete abstraction. The *Portrait of Kahnweiler* (Pl. 10), painted in Paris soon after Picasso's return from Cadaqués in the early autumn of 1910, may have helped Picasso towards a solution of his problem, since in dealing with a particular individual he was forced to find a less difficult and hermetic means of expression; in any case the portrait serves to illustrate what steps Picasso took to make his work once again more legible. The basic method of composition of this painting is the same as in the Cadaqués work, but the subject is made identifiable by the retention or introduction of 'keys' or 'signs' within the looser, more generalized, structure of the figure. Distinctive features

[1] Letter to Kahnweiler of 12 June 1912. 'Eva' was the name given to Marcelle Humbert Picasso's companion of the moment.
[2] These song-titles appear in paintings of 1912 as well.
[3] *Les Peintres Cubistes*, p. 35.

of the sitter, his eyes and hands for example, are rendered with a greater degree of naturalism, and these, together with the stimuli provided by other details such as a button on M. Kahnweiler's coat, a lock of hair, or the still-life to the side of him, permit a reconstruction of the subject and his surroundings; and these more realistic touches in turn forced the painter to restore or preserve the naturalistic proportions of the figure. The distortion of scale which had appeared in the Cadaquès paintings is not encountered again in the following year, and while all subsequent paintings are understandably not as easily legible as this portrait, almost all of them do contain some kind of clue or stimulus which serves to identify the subject, and which renders it immediately recognizable to anyone familiar with Cubist iconography. Kahnweiler, who himself often helped the painters to choose titles for their paintings, in *Der Weg zum Kubismus* emphasizes the importance of the descriptive titles attached to the works as further means of enabling the spectator to reconstruct fully the subjects.

Although Braque had been responsible for taking the first steps towards a more abstract type of painting, his own use of the new procedure was much more cautious than Picasso's. In a painting such as the *Female Figure* (Pl. 31), executed in the winter of 1910–11, the subject is still much more easily recognizable than it had been in Picasso's Cadaquès work, or even in the *Portrait of Kahnweiler*. When, a year later, with paintings such as *Man with Violin* (Pl. 33), Braque's Cubism reached a second climax of complexity and became also highly difficult to read or interpret, one senses that it was not owing to the excitement of working with a new, more abstract technique as it had been with Picasso, but because his interest in elaborately breaking up the picture surface so as to analyse the relationships between the objects and the space surrounding them, slowly and inevitably led him to this kind of painting. And whereas Picasso had been forced to reintroduce clues, small fragments of legibility, into his work to render it more accessible to the spectator, Braque, even at his most abstract, instinctively retained them as a link with reality.

The method of composition used by the painters brought with it a new element of ease and fluidity. Most important, since form was now largely suggested rather than clearly defined, and since a strong linear quality was retained in the finished painting, it became much easier to combine the various views of an object or to synthesize in its depiction a greater amount of information. For example (although the painters never worked in such an obvious and theoretical way), plan, section and elevation of an object could be laid or drawn over each other, and then adjusted and fused to form a single, legible and highly informative image. Secondly, it was now obviously much easier to fuse figure and

surroundings, thus emphasizing the 'materiality' of space and also ensuring the unity of the picture surface, while the greater complexity and concentration of the central areas generally serves to isolate and emphasize the subject. Thirdly, with this method of composition the lack of a fixed light source, the arbitrary juxtaposition of light and dark, becomes a consistent and, indeed, a salient feature of the style. In some ways the dismissal of a single light-source can be regarded as a natural consequence of the dismissal of a single view-point.

In the work of Cadaquès Picasso had moved ahead of Braque with characteristic impetuosity, and then late in 1911, when Picasso's painting is once again comparatively legible, Braque had in turn produced a series of unusually elaborate and highly personal paintings (of which the *Man with Violin* (discussed above) and the still-life *Soda* in the Museum of Modern Art in New York are good examples) which represent the most hermetic stage of his Cubism and which have no counterpart in the work of Picasso. But on the whole the canvases of 1911 show the painters at their closest point, and the year and a half from the autumn of 1910 until the spring of 1912 was the period during which Cubist painting of the pre-war period appeared to change least radically. Perhaps no pictorial revolution of the magnitude and depth of Cubism had been effected with such extreme rapidity, and during the years between 1907 and 1910 every few months had witnessed some radical change in the appearance of Cubist painting. Now the style reached a moment of poise and equilibrium. The series of figure compositions executed by Picasso during the summer of 1911 at Céret (Pl. 11) and in Paris on his return, represent the culmination and perfection of this particular phase in his Cubism. These paintings do not differ fundamentally from his work of the previous autumn and represent only a very gentle movement towards a softer, more lyrical kind of painting. Another *Man with Guitar* by Braque (the one now in the Museum of Modern Art, New York) (Pl. 30b) is a close parallel to Picasso's Céret work of 1911 (although it is slightly richer in the actual paint quality) and was probably executed in Céret also. Two etchings of early 1912, *Fox* by Braque and *Still Life with Bottle* by Picasso, would, if unsigned, present a problem of identification except to the highly trained eye. As a result of the feeling of greater ease, decorative touches and small colouristic accents begin to appear in the smaller canvases of both men. In the work of Picasso of early 1912 certain objects are discreetly tinted, while in many contemporary Braques small, rippling strokes begin to be applied in bright reds and greens. Both painters were by now introducing stylized, almost illusionistically painted strips of decorative roping or braiding. The oval format, too, is used frequently.

91

But if Cubist methods of composition did not change fundamentally between 1910 and 1912, in the spring of 1911 Braque introduced a new element into one of his paintings which was of vital significance. Across a painting entitled *Le Portugais* (Kunstmuseum, Basel)[1] Braque stencilled the letters BAL, and under them numerals (Pl. 32). Braque had first introduced letters into a still-life, probably of early 1910 (*Le Pyrogène et 'Le Quotidien'*), but they are blended into the composition and have no function other than that of identifying as a newspaper the object over which they are painted. More important was the introduction of illusionistic nails into three still-lifes of early 1910.[2] At a time when the Cubists were beginning to restrict severely their use of colour, when all details and incidentals had been suppressed and eliminated, when the objects in their paintings had been dislocated and fragmented to a degree where they are occasionally almost unrecognizable, there is an element of contradiction, almost of perversity in this inclusion of a 'trompe l'oeil' detail. But this particular device had a deep significance. Intensely concerned with retaining contact with external reality, Braque must have realized, unconsciously perhaps, that at this particular time Cubism's means of expression could become only more abstract, and the illusionistically painted nail may be regarded as an affirmation of the realistic intentions of the movement.

The stencilled letters and numbers are assertions of this also—'toujours dans le désir de m'approcher le plus possible d'une réalité, j'introduisis en 1911 des lettres dans mes tableaux,' Braque has said[3]—but the implications are wider. In *Le Portugais* they fulfil several obvious functions. In the first place, in a style in which one of the fundamental problems had always been the reconciliation of solid form with the picture plane, the letters written or stencilled across the surface are the most conclusive way of emphasizing its two-dimensional character; Braque has stressed this when he said of the letters: 'c'étaient des formes où il n'y avait rien à déformer parce que, étant des aplats, les lettres étaient hors l'espace et leur présence dans le tableau, par contraste, permettait de distinguer les objets qui se situaient dans l'espace de ceux qui étaient hors l'espace.'[4] Gertrude Stein expressed much the same idea when she wrote, 'Picasso in his early Cubist pictures used printed letters as did Juan Gris to force the painted

[1] Braque has stated that the subject is a musician he had seen in a bar in Marseilles—Notes to the Catalogue of the Braque exhibition at the Tate Gallery, Sept-Nov. 1956, p. 32.

[2] Kahnweiler claims that the illusionistically painted nail appears for the first time in the *Still Life with a Pitcher* (Kunstmuseum, Basel) where it is used quite arbitrarily. A nail also appears in two other still-lifes (one in the Guggenheim Museum, New York) supporting a palette hanging on the wall; and it seems likely that this more rational use of the device may precede its employment in an arbitrary fashion.

[3] *Braque, la Peinture et Nous*, p. 16.

[4] Ibid., p. 16.

surface to measure up to something rigid and the rigid thing was the printed letter.'[1] Secondly, the letters in Cubist painting always have some associative value; in Picasso's *Ma Jolie* series the words, taken from the title of a popular song, relate through their musical connotations to the still-lifes with musical instruments and paintings of figures playing them. Here the letters D and BAL (the D must be the last letter of the word GRAND) were probably suggested by a dance hall poster hanging in a bar, and help to convey a 'café' atmosphere. Then, in the *Portugais* the letters have a purely compositional value, providing a terminal note for a system of ascending horizontal elements. Fourthly, they have a certain decorative value.

But the stencilled letters and numbers have yet another effect on the paintings in that they serve to stress their quality as *objects*. When, during the first years of their friendship, at Braque's suggestion[2] he and Picasso stopped signing their works they were automatically emphasizing the autonomous existence of their creations. Now, the introduction of elements of reality, such as the stencilled letters and numerals in *Le Portugais*, affirms clearly the material existence of the painting as an object in its own right. For in the same way in which the number or title of a painting in an exhibition catalogue gives it an identity as a material object different from all others of the same type, so the letters and numbers on a Cubist painting serve to individualize it, to isolate it from all other paintings. Then, again, and in this they point ahead to the invention of collage, the letters and numerals stress the material existence of the painting in another way: by applying to a canvas or sheet of paper letters, other pieces of paper or fragments of glass and tin—elements generally considered to be foreign to the technique of painting or drawing—the artist makes the spectator conscious of the canvas, panel or paper as a material object capable of receiving and supporting other objects.

Kahnweiler recalls that the painters themselves talked a great deal about 'le tableau objet'. In their studios the canvases stood on the floors, on the chairs and other pieces of furniture, or hung high on the walls. It would obviously be dangerous to deduce too much from this, but at the same time the painters' attitude towards their work unconsciously mirrored a whole new concept of painting. Reacting against the momentary quality of Impressionism, which had been like a window suddenly opened out on to nature from a sheltered interior, against all forms of violent personal expression, against the decorative and symbolic element which had characterized the work of the Nabis and Gauguin

[1] *The Autobiography of Alice B. Toklas*, p. 102.
[2] *Braque, la Peinture et Nous*, p. 18.

and so much late nineteenth-century painting, and even against the Fauves (and the strong *fin de siècle* flavour of Fauvism has never been sufficiently acknowledged or stressed), the Cubists saw their paintings as constructed objects having their own independent existence, as small, self-contained worlds, not reflecting the outside world but recreating it in a completely new form. Gleizes and Metzinger stressed that Cubist painting had no specifically decorative function, and that it did not attain its full meaning only when hung on the wall at eye level. In *Du Cubisme* they wrote: 'L'oeuvre décorative n'existe que par sa *destination*, ne s'anime qu'en vertu des relations qui s'établissent entre elle et des objets déterminés. . . . Le tableau porte en soi sa raison d'être. On peut impunément le porter d'une église dans une salon, d'un musée dans une chambre. . . . Il ne s'accorde pas à tel ou tel ensemble, il s'accorde à l'ensemble des choses, à l'univers: c'est un organisme.'[1] Later, in 1925, Gleizes wrote again: '. . . ce qui sortira du Cubisme . . . sera le tableau devenu un fait émouvant en soi sans rien de descriptif, du même ordre qu'un objet et dans la même relation avec la nature.'[2] The cubist painters had claimed for themselves the right to move around their subject and incorporate aspects of it not visible from a single point of view, and they bestowed, in theory if not in actual practice, the same liberty on the spectator in relationship to their own work.[3]

During the war the Cubist concept of the work of art as an autonomous, constructed object became more and more widespread. In an article entitled *Quand le Symbolisme fut mort* which appeared in *Nord-Sud* in 1917, Paul Dermée attempted to sum up the new aesthetic trends. He proclaimed a classic revival in the arts in which the work of art was to be judged as whole and not on the merits of its parts or in relation to its creator: '. . . l'oeuvre d'art doit être conçue comme conçoit l'objet de sa fabrication l'ouvrier d'une pipe ou d'un chapeau; toutes les parties doivent avoir leur place strictement déterminée selon leur fonction et leur importance. L'objet importe ici et non tel ou tel de ses éléments.'[4] In the same periodical, Reverdy, who admitted that much contemporary literature at this time reflected an aesthetic first developed in Cubist painting, added: 'le but du poète est de créer une oeuvre qui vive en dehors de lui, de sa vie propre, qui soit située dans un ciel spécial.'[5] Max Jacob, who had been a friend of

[1] p. 11.

[2] 'Chez les Cubistes' in *Bulletin de la Vie Artistique*, 1924–5.

[3] This is implied in the painters' attitude to their works, although in actual fact the spectator's only really satisfactory view-point is, of course, from in front.

[4] *Nord-Sud*, 15 March 1917—Dermée had obviously been influenced by Gris and by the nascent ideals of Purism in *L'Elan*, on which Ozenfant worked during 1915 and 1916.

[5] Ibid.

the painters and in particular of Picasso, published in 1917 in *Le Cornet à Dés*
one of the most lucid definitions of contemporary aesthetic. After condemning
the 'Baudelairean' atmosphere of the nineteenth century ('c'est le triomphe du
désordre romantique'),[1] and its cult of individual genius, Jacob goes on to stress
the objectivity of modern poetry (which is by contrast 'une poésie mondiale')
and the fact that a work of art 'vaut par elle-même et non par les confrontations
qu'on peut faire avec la réalité'.[2] Discussing the prose poem—a form of litera-
ture which, as used by Jacob, provides one of the closest literary parallels to
Cubist painting in that it embodies simultaneously actions or events normally
separated by time and space, which are fused into formal, difficult but rational
and understandable creations—Jacob warns the poet and artist against 'les
pierres précieuses trop brillantes qui tirent l'oeil aux dépens de l'ensemble', and
adds 'Le Poème est un objet construit et non la devanture d'un bijoutier.
Rimbaud est la devanture du bijoutier, ce n'est pas le bijou; le poème en prose
est un bijou'.[3]

The stencilled letters and numerals in Braque's *Portugais* are the prelude to
the introduction of collage into Cubist painting, and collage was in many ways
the logical outcome of the Cubist aesthetic. In the work of Picasso and Braque it
ushered in a new phase of Cubist painting.

[1] p. 20. This was written some years before its publication, which was delayed by the outbreak
of the war. In the preface to the 1922 edition, Gabory wrote: '(le Cornet à Dés) donne naissance à
toute une partie de littérature dit Cubiste et plus récemment "dadaïste" '—p. 7.
[2] p. 21 (from the 1916 preface).
[3] Ibid., p. 21.

PICASSO, BRAQUE AND GRIS

1912-14

In 1911 Picasso and Braque were joined in their creation of Cubism by a third painter, the Spaniard Juan Gris. Gris has, in a sense, no real history before this. Younger than Picasso and Braque by some five years, Gris arrived in Paris in 1906 at the age of nineteen. Knowing no one there, he sought out Picasso, and soon he installed himself in the same studio building in the rue Ravignan. In Spain Gris had begun to work as a commercial illustrator, and he continued to do so for several years in Paris, but, finding himself in the midst of a creative and original circle of people, he soon began to take his work more seriously. Apart from the commercial work only a few examples of Gris' earliest works are known. These are drawings and gouaches executed in a tight, refined, highly decorative, *art nouveau* style. By 1910, however, he had begun to work simultaneously in a more straightforward, naturalistic way, and by 1911 he was painting in oils. On January 1st, 1912, *Paris Journal* announced that some fifteen of his pictures were on show at Clovis Sagot's gallery. A few months later, in March, Gris made his début at the *Salon des Indépendants* with three canvases, one of which was an *Hommage à Picasso* (Pl. 43), and during the year he contributed to three exhibitions of Cubist painting.[1] After showing at the *Section d'Or* he signed an exclusive contract with Kahnweiler and, like Picasso and Braque, stopped showing his work publicly.

Gris became familiar with the art of Picasso just as it was entering its most crucial stage, that is to say in the months before he began the *Demoiselles d'Avignon*. Gris was an intelligent and intensely serious and thoughtful young man, and must have followed the development of Picasso's Cubism step by step, so that when he began to paint seriously in 1911 he might have been expected

[1] At the Galeries Dalmau, Barcelona, 20 April–10 May 1912; Société de Peinture Moderne, Rouen, 15 June–15 July 1912. La Section d'Or, October 1912.

to join Picasso and Braque at the most recent stage of their development, for he was already a highly experienced draughtsman. His approach to Cubism, however, was fundamentally different from theirs. More intellectual and with a much more coldly analytical mind than either Picasso or Braque, Gris was more interested in the implications of the discoveries they had made than in the appearance of their paintings. And his methodical, more purely intellectual interpretation of Cubism formed in many ways the necessary complement to the more instinctive Cubism of Picasso and Braque. His work, therefore, was of the greatest importance in serving to define the aims of true Cubism for the public and the minor figures of the movement, for from the first his uncompromising approach served to concentrate attention on the bare mechanics of the style.

Because of their seriousness and obvious originality, the paintings shown by Gris at the *Salon des Indépendants* attracted a great deal of attention. Furthermore, they were hung in a room devoted mainly to Russian exhibitors and the *Hommage à Picasso* was placed next to an *Improvisation* of Kandinsky's, so that the freedom and spontaneity of Kandinsky's technique and the extravagance of his colour must have made Gris' canvas look particularly cold and forbidding. An anonymous reviewer in *Gil Blas* wrote: 'ce n'est pas la peinture de M. Juan Gris qui réchauffera les promeneurs. . . . Devant son *Hommage à Picasso*, burlesque assemblage de tuyaux, quelqu'un murmure "on dirait des fragments de fourneau"—"fragment" est aimable mais "fourneau" est dur.'[1] Allard, who had supported the Cubist manifestations of 1911, in his review of the exhibition referred to 'les fantaisies post-cubistes de Kupka et Juan Gris'.[2] Allard's contact with Cubism was through Gleizes and his circle, and he had probably seen very little of the work of Picasso and Braque, so that he was baffled by Gris' paintings and felt them to be fundamentally foreign to the style. Apollinaire, although the section dedicated to Gris in *Les Peintres Cubistes* indicates that he was not entirely in sympathy with Gris' painting, once again sensed instinctively what it was that Gris was striving for and what his position in the movement was to be. He wrote: 'Juan Gris expose un *Hommage à Picasso* où il faut louer surtout un grand effort et un grand désintéressement. L'envoi de Juan Gris pourrait s'appeler le cubisme intégral.'[3]

It is characteristic of Gris' painstaking and methodical approach that he should have felt that he could master Cubism only after a fresh study of Cézanne. In his first still-lifes of 1911, the influence of Cézanne is immediately apparent

[1] *Gil Blas*, 20 March 1912.
[2] 'Le Salon des Indépendants, 1912', in *Revue de France*, March 1912.
[3] *L'Intransigeant*, 20 March 1912.

in the simple forms, the high angles of vision and in the way in which the tops of the tables on which the objects stand are distorted and thrown up sharply on to the picture plane. A less immediately obvious feature of these paintings which also derives from the work of Cézanne is the treatment of the outlines of the table-edges, which, when broken by an object, are continued beyond it at a slightly different angle. This was a feature of Cézanne's style that Picasso and Braque had also seized on in some of their work of 1908 and 1909. All this early group of paintings, however, indicates a study of Cézanne by a painter whose vision was already Cubist. In many of Cézanne's still-lifes the angle of vision is not consistent, but Gris' distortion of perspective is much more obvious and deliberate. The outlines are rendered in an angular and incisive fashion, and then deliberately broken at intervals, to create areas in which forms fuse or merge with each other and with the backgrounds. Form is not laboriously built up by a system of closely-knit hatchings or small planes, as in the paintings of Cézanne, or, for that matter, in the works of Braque and Picasso influenced by him, but smoothly and simply modelled. But the simplicity and initial impression of directness given by these paintings is deceptive. With some of them one has the sensation that having started with a more naturalistic drawing, Gris then began slowly dislocating or distorting the objects, sharpening the outlines and arbitrarily breaking them, while introducing simultaneously a series of intellectual and pictorial refinements.[1] In *The Eggs*, for example, the upper, empty part of the bottle is defined by contrast against the darker background, and one side of it is smoothly rounded while the other is squared off in deliberate contrast. Below, the transparent glass of the bottle vanishes against the white cloth, so that the dark wine becomes a self-subsisting cylinder of liquid. The use of the flowered wall-paper or curtain in the background emphasizes in a very direct, concrete way that this sort of painting has its origins in the work of Cézanne. (Pl. 42a.)

The first and most obvious difference between the early Cubism of Gris and that of Picasso and Braque is that Gris never abandoned colour to the extent that they did. Some of the earliest paintings, such as the views of Paris, are in silvery, rather muted tones, but in others Gris uses a palette composed of a single bright colour, mixed with black and white to form a full range from dark to light. Sometimes a second or third colour is subsequently introduced, but the

[1] It is known that in connection with his later work Gris destroyed almost all the many preliminary calculations that went into the construction of each painting. See p. 130 below. It is possible that there originally existed drawings for the early paintings which would have illustrated the steps by which Gris reached the final incisive stage in which many of the objects are quite highly abstracted or distorted.

original monochromatic effect is retained. This schematization of colour, which can be seen for instance in the *Portrait of Picasso*, is accompanied by a corresponding move to a more abstract method of composition. In a series of paintings begun probably in the winter of 1911–12, of which the *Still Life with a Cylindrical Pot*, a small rectangular canvas in the Kröller-Müller Museum (Pl. 42b), is an example, the subjects are distorted as if by forces moving diagonally across the canvases, and the emphasis is on the organization of the picture surface in terms of clearly defined, carefully balanced shapes. The fusion of subject and background is more complete than hitherto in the work of Gris, and there is very little sense of depth, even in paintings, like the one referred to above, where the objects are arranged behind each other in successive layers. The forms, however, continue to be heavily modelled and are lit from a single light source. This is another distinctive feature of Gris' Cubism, for he remained preoccupied with the problem of light, and for a long time used it rationally or naturalistically to develop form, unlike Picasso and Braque who in 1909 were already using it in a purely arbitrary fashion. In many of the small still-lifes of the period the background is as incisively and elaborately treated as the subjects themselves, so that the subject appears to lose its sense of importance; while these paintings are more immediately legible than many contemporary still-lifes of Picasso and Braque, Gris' dispassionate and intellectual concern with the solution of purely pictorial problems renders them in a sense more abstract. Cold and formal, even these early paintings have no direct counterpart in the work of Picasso and Braque.

Nevertheless, it is from Picasso's work of 1909 that Gris' first truly Cubist paintings most directly derived, probably because it was in the works of Picasso of this period that Gris saw the essential features of the style most clearly stated; Gris knew Braque's work much less well and did not become really friendly with him until after 1912. In the still-lifes the debt to Picasso was largely intellectual, but *L'Homme à la Pipe* (a portrait of Gris' friend Legua), a work of 1911, shows a purely visual influence as well. (Pl. 41.) The division of the forehead down the centre and the treatment of the areas around the eyes point to a thorough knowledge of the Horta de San Juan figure work. And here Gris was preoccupied with solving exactly the same problems that had concerned Picasso two years earlier; the problem of combining various views of an object into a single image, and representing them on a two-dimensional surface. In a basically three-quarter view the far side of the face is pulled around into the picture plane, and the cleft in the forehead and the bisection of the chin imply a profile view as well. The *Portrait of Picasso* (Pl. 43), painted some months later (winter 1911–12), shows Gris dealing with the combination of different views of the

head in a much more stylized, intellectual fashion. Indeed, the way in which the face is divided down the central axis, suggesting simultaneously a profile and full-face view, is reminiscent of Picasso's *Baigneuse* of 1908, one of the first paintings in which the new concept of form was most clearly and deliberately stated. The abnormally long chin is typical of Gris' figure work, but the device of repeating the jaw line recalls again Picasso's heads in the Horta paintings, although in Picasso's work this had helped to convey a sculptural quality that is not present here. This portrait has a distinctly experimental quality, and naturally enough (for Gris was still a novice by comparison), it is not as accomplished as the works of Picasso to which it most closely corresponds. In the *Portrait of Picasso* the areas around the nose and mouth are not fully explained and in the work of a painter who was so obviously striving for a logical and clear pictorial expression, passages such as these are particularly disturbing. However, in his subsequent work of 1912 Gris emerges as a more completely assured painter.

Developing in the same direction as Picasso and Braque, Gris now evolved a more linear type of composition. In the work of Picasso and Braque the invention of a kind of grid or linear framework, which was suggested by the outlines or directional lines of the subject, had led to a looser, more fluid type of painting. Gris, on the other hand, used a similar procedure to achieve a greater precision and explicitness. Some of the still-lifes of the first half of 1912 show Gris taking the first steps towards this new method of composition. Many of the thick black outlines are retained (rather than being blended into the composition as they had been hitherto), and left unbroken while the curving shapes and receding ellipses of the past months are reduced to triangles and cones. The diagonal movement across the canvas is replaced by a more static composition in terms of verticals and horizontals. By the time that Gris painted the *Portrait of Germaine Raynal* (coll. Mme. Raynal, Paris), in the summer of 1912, the new technique was fully developed. A linear framework, like an irregularly constructed leaded window or a metal grille, is clamped down over the figure and its setting, and then within each of the sections or compartments the subject is studied from a different point of view. One eye, for instance, looks directly out, while the other, enclosed in a separate rectangular form, is tipped sideways, carrying with it a portion of the nose. A view of the nose, seen from underneath, is enclosed in an oval form and placed in the centre of the face, while below, by joining together two profile mouths the full-face image is reconstructed. The tops of the shoulders are lifted on to the picture plane, making one think, once again, of Picasso's figure work of 1909, and one of them is made transparent so that the bricks of the paving in the street behind are seen through it. But, unlike Picasso

and Braque, Gris never uses a complex of partially transparent, interpenetrating planes to suggest form, which is, on the contrary always clearly defined. The main parts of the face and torso are firmly painted and solidly modelled. In this kind of painting, the linear frame-work is thus fused to a solid, carefully painted image. This framework itself is of course to a large extent suggested by the contours and features of the subject, and, before the painting reaches its final state, undergoes a whole series of adjustments and modifications, so that the process is by no means as simple as it might at first appear. (Pl. 44b.)

This sort of painting of Gris' illustrates what is perhaps the fundamental difference between his early Cubism and that of Picasso and Braque, for whereas their painting gives the impression that they moved freely around their subjects, painting them from a variable view point, Gris, on the other hand, dissects his subjects, examines each part from a different, but single view point, and then reconstructs the total image from these various sections. In the painting of all three painters the result is a highly informative kind of optical synthesis. But at this point Gris is still really adapting and elaborating scientific perspective (by fusing a series of different but consistent view points in a single painting) to achieve the very effects for which Picasso and Braque had abandoned it.

Gris exploited the logical possibilities of this kind of painting to the full in the still-lifes of the second half of 1912, in which he used mostly man-made or manufactured objects with basically geometric forms which allowed for even greater precision. Never before had the possibilities of Cubist form been stated so fully or explicitly. In *Le Lavabo* (Private coll., Paris) the curtain and the shelf at the top establish a frontal view point, but the table-top, which forms a perfect rectangle, is seen directly from above. The plan, section and elevation of each object could be almost literally reconstructed. Having found a means of expressing very accurately all the essential information about his subjects, Gris began to widen his palette and the colour in these works becomes almost naturalistic. (Pl. 45a.)

Gris' intellectual approach to Cubism inevitably led him to an interest in its mathematical implications. During the war he became a serious student of the works of Poincaré and Einstein, and later, in 1921, he was able to write a letter to Ozenfant in which he claimed to be able to reduce any given composition to purely geometric terms.[1] But even if before 1914 Gris had not yet reached this point, he was always ready to discuss Cubism in intellectual language.[2] The

[1] *The Letters of Juan Gris*, compiled by D. H. Kahnweiler, edited by D. Cooper, London 1956, pp. 105–6 (the letter is of March 1921).
[2] D. H. Kahnweiler, *Juan Gris*, Eng. ed. translated by D. Cooper, London 1947, p. 8.

Spanish sculptor Manolo, a friend of Picasso and Gris, is reported to have said: 'the one who explained Cubism was poor Gris.'[1] In connection with the intellectual and theoretical side of Cubism much has been written about the influence of Maurice Princet; indeed many contemporary critics and writers saw him as an important force in the movement.[2] The employee of an insurance company and an amateur mathematician, Princet lived for a while in the *Bateau Lavoir* and was undoubtedly on terms of fairly close friendship with many of the Cubist painters. The pictorial revolution that Picasso and Braque effected was, it has been seen, primarily an intuitive one. Pictorial theory played very little, or perhaps even no part at all in their creation of Cubism. Gris, who as his later writings show, had a considerable capacity for original thought, was obviously capable of formulating for himself a more rational and intellectual interpretation of the style. But even if Princet had no influence on these three figures, his presence as one of their friends seems to show that there was a good deal of theoretical talk in Cubist circles, and that Gris contributed to it. Both he and Princet, it will be seen, were influential in encouraging many of the minor painters to approach Cubism in a more theoretical fashion. And then even if in fact the 'legendary' question that André Lhote tells us Princet posed to Picasso and Braque was never formulated so precisely, it suggests that he recognized the obvious implications of what the Cubists were doing. 'Vous représentez à l'aide d'un trapèze une table, telle que vous la voyez, déformée par la perspective, mais qu'arriverait-il s'il vous prenait fantaisie d'exprimer la table type? Il vous faudrait la redresser sur le plan de la toile, et, du trapèze, revenir au rectangle véridique. Si cette table est recouverte d'objets également déformés par la perspective, le même mouvement de redressement devra s'opérer pour chacun d'eux. C'est ainsi que l'ovale d'un verre deviendra le cercle exact. Mais ce n'est pas tout: ce verre et cette table considérés sous un autre angle ne sont plus, la table qu'un plateau horizontal, de quelques centimètres d'épaisseur, le verre, qu'un profil dont la base et le faîte sont horizontaux. D'où nécessité d'un autre déplacement. . . .'[3] While Picasso and Braque never planned a painting in such an intellectual and calculating way, this passage illustrates, in a crude and simplified way, the sort of problem with which Gris was preoccupied.

Gris' quick mind rapidly assimilated the most advanced Cubist techniques. Thus on to the canvas of *Le Lavabo* he glued a small fragment of mirror. It was

[1] Quoted by D. H. Kahnweiler, ibid., p. 8, from Josef Pla's *Vida de Manolo contada por ell mateix*, Sabadell 1928, p. 131.

[2] E.g. Warnod, *Les Berceaux de la Jeune Peinture*, Paris 1926, pp. 40, 87. Carco, *De Montmartre au Quartier Latin*, Paris, p. 30. There are also references to him in writings by Metzinger, Salmon, Janneau etc.

[3] 'La Naissance du Cubisme' in R. Huyghe's *Histoire de l'Art Contemporaine*, Paris 1935, p. 80.

only about half a year earlier that Picasso had inaugurated what was to be one of the most important stages of twentieth-century art by the invention of *collage*. Early in 1912 Picasso had painted a still-life, *Still-Life with Chair-Caning* (Pl. 14a) into which he incorporated a piece of oil cloth, overprinted to imitate chair-caning.[1] This was the first *collage*, that is to say the first painting in which extraneous objects or materials are applied to the picture surface. Then in another still-life of the period Picasso introduced a postage stamp[2] and by the early part of 1913 was working with strips of cloth, bits of paper and even, occasionally, small pieces of tin or zinc foil. In the meantime, in September of 1912, Braque had executed the first *papier collé*, a drawing entitled *Compotier et Verre* (now in Mr. Douglas Cooper's Collection, in France) on which three pieces of wall-paper, printed to imitate wooden panelling, are pasted. Picasso and Braque spent the early part of the summer together at Céret,[3] and then were together again at the end of the summer in Sorgues, a village near Avignon. Picasso was in Paris at the beginning of September for a fortnight, but soon returned to Sorgues, where he remained for several weeks.[4] It was during Picasso's absence in Paris that Braque bought in a shop in Avignon the piece of wall-paper, simulating wood graining, which inspired him with the idea for the first *papier collé*.[5]

The invention of *collage* struck the most violent blow yet at traditional painting, and particularly at the idealized and romantic conception of the 'work of art' as the expression not only of technical skill but also almost of some absolute beauty. Now the Cubist painters were constructing works of art from odd bits of material—one might almost say from bits of rubbish—generally considered to have no aesthetic value, and not even to serve any good or useful purpose. And the invention of *collage* was, to a large extent, a revolt against slickness of brushwork and other forms of technical facility. Sabartès quotes Picasso as saying, 'we sought to express reality with materials we did not know how to handle, and which we prized precisely because we knew their help was not indispensable to

[1] This painting is usually dated 1911–12, but on stylistic grounds it is hard to place it in 1911. A certain softness in the handling of some areas, the positive colouring of the lemon and the fact that several of the objects are left almost intact (e.g. lemon and shell) all point to a date in the first half of 1912.

[2] This painting could, on stylistic grounds, be placed in 1911. However, both Picasso and Kahnweiler insist that the *Still-Life with chair-caning* is the first *collage*, so that one is forced to assume that this other painting followed it.

[3] Picasso arrived in Céret in March. He returned there in December and again at intervals during the following year.

[4] From Picasso's correspondence with the Steins (Yale University) it is possible to reconstruct his movements during the period. He returned to Sorgues on 13 September.

[5] Braque has stated specifically to Mr. D. Cooper that he had seen this paper for some days in a shop window and that he waited to buy it till Picasso went away.

us, that they were neither the best nor the most adequate.'[1] Raynal, as became clear in some of his later writings, did not really understand or approve of Picasso's latest innovation,[2] but in his article on *collage* in the *Section d'Or* of 1912, the first written discussion of *collage*, he implies that its appearance was largely due to the artists' distaste for photographic illusionism in painting, and that they felt it preferable to substitute for an exact copy of an object (for example the label on a bottle), a portion of the object itself.

Salmon, in *La Jeune Sculpture Française*, which was written before the war but did not appear until 1919, gives an account of a discussion between the painters that must have taken place at about this time: 'Braque discutait un jour avec Picasso de l'inimitable en peinture, c'est un thème favori des artistes modernes. Faut-il, si l'on peint une gazette aux mains d'un personnage, s'appliquer à reproduire les mots *PETIT JOURNAL* ou réduire l'entreprise à coller proprement la gazette sur la toile. On en vint à vanter l'habileté des peintres en bâtiment qui tirent tant de marbre et tant de bois précieux de carrières et de forêts imaginaires.'[3] Thus the illusionism that Picasso and Braque condemned was not that of the artisan, producing rich and exciting effects with the minimum of means, but the elaborate and pretentious productions to be seen in the fashionable *Salons* and Galleries. Braque, as the son and grandson of house painters, 'peintres-décorateurs', naturally played an important part in the introduction of new methods hitherto considered to be beneath the dignity of a class of artists who in France traditionally referred to themselves as 'artistes-peintres'. Salmon goes on to tell how Braque initiated Picasso into the professional secrets of the humbler forms of commercial painting, by teaching him the use of the house-painters' 'comb', an instrument which drawn through wet brown pigment gives the effect of wood-graining. Picasso, characteristically, used it at once (according to Salmon) not for its obvious and traditional purpose, but to suggest some stylized locks of hair and the beard in a painting of a man's head (the particular painting referred to by Salmon may be the *Male Head*, now in the collection of Madame Sacher in Switzerland). Even if this is simply one of the characteristic legends which have grown up around Picasso at all periods of his career, it is certain that by the summer of 1912 he and Braque were using this means of reproducing wood-graining in their paintings.

Daring as *collage* must have seemed, many of the innovations of Picasso and Braque during the preceding years had pointed towards it. Braque, at a time

[1] Sabartès, *Picasso*, English edition, London 1949, p. 241.
[2] In *La Jeune Peinture en France*, Paris 1927, Raynal condemned *collage* and the incorporation of new textures (sand, etc.) into Cubist paintings as subversive tricks.
[3] Paris, p. 13.

when he seemed to be moving inevitably towards greater abstraction, had introduced—arbitrarily in several cases—*trompe l'oeil* nails into some of his still-lifes, partly at least as an assertion that he did not intend to lose contact with external reality. Picasso's use of illusionistically painted, or at least immediately legible details, coat-buttons, moustaches and so on, which help the spectator to identify his subjects, asserts in a more obvious way the realistic character of the style. Then the stencilled letters in Braque's *Le Portugais* and the words or titles written over his and Picasso's paintings, were in a sense also clues for the reconstruction of the subject. But these keys or clues did not only serve to make the painting more legible; they were also elements of reality, which as Braque himself put it, could not undergo pictorial distortion.[1] From the desire to evoke as concretely and immediately as possible fragments of external reality in their paintings to the insertion of the fragments themselves was a short step. Indeed, the painters' distaste for photographic kinds of painting and for the too obviously accomplished and showy techniques of illusionistic painters demanded it.

Furthermore, *collage* was the logical outcome of the Cubists' conception of their works as self-contained, constructed objects. For the Cubist *collages* and *papiers collés* are in a sense exactly that—objects built up of various different substances and materials, a protest against the conventional oil painting proudly displayed on an easel or elaborately framed on a wall (Picasso, for instance, framed the *Still-Life with Chair-caning* simply by surrounding it with a single thickness of ordinary rope). And the strips of paper, fragments of canvas and other materials that the painters applied to their pictures emphasized in a very concrete way their weight and solidity as material objects. The care required in the handling of the *collages* and *papiers collés* to-day, and the methods of restoration which will eventually have to be devised to preserve them, emphasize the fact that they form a new category of works of art, totally distinct from traditional painting.

The aesthetic implications of *collage* as a whole were vast, and its invention was to lead to a whole series of developments in twentieth-century art. The fragments of extraneous matter almost invariably undergo some kind of alteration or transmutation in their incorporation into Cubist pictures, but the curiosity in exploring unorthodox technical procedures and the ability to see aesthetic possibilities in objects and materials hitherto not thought to have any artistic value, relate this aspect of Cubism to the 'ready mades' and *objets trouvés* of Dada, and to the Surrealists' juxtaposition of incongruous materials to evoke new

[1] See p. 92 above.

sensations and images. Indeed, the 'ready made' aspect of *collage* is illustrated by the fact that Gris felt that the engraving incorporated in his *Violon et Gravure* (Museum of Modern Art, New York) could be replaced by something else, the owner's portrait for example, without upsetting the pictorial balance or the 'actual merits' of the painting.[1] It is, however, necessary to make a distinction between *collage* in general and the Cubists' use of a particular kind of collage, namely *papier collé*. It is characteristic that Picasso should have invented *collage*, which was subsequently to be used by Dadaists as a weapon to destroy all art, and by the Surrealists to achieve the most disconcerting and disturbing of psychological effects, while Braque should have been the author of the first *papier collé*, an innovation with fewer implications, but one which introduced a whole new pictorial technique and which had only positive results.

Braque's *Still Life with Guitar* (1912–13) illustrates some of the most immediately obvious possibilities of *papier collé* as a technique (Pl. 35). In the first place the two strips of paper have a purely pictorial function. They are broad, flat planes of colour (blue and brown) which serve to establish the basic composition of the picture and to which the subject is subsequently related by overdrawing. Then each strip here has a representational function, too. The strip of paper at the left, by the addition of a hole drawn over it, and by the cutting out of a second circular form above it (a second view of the hole in the sounding board), becomes the central part of the guitar; the imitation wood-graining informs us, by a sort of *trompe l'oeil*, of what material the guitar is made. Lastly the strips of paper have a pronounced aesthetic effect on the picture in that, like all fragments of Cubist *collage*, they make one conscious of it as a constructed or 'built-up' object or entity, which differs from most traditional drawings and paintings. To recapitulate: the fragments of *papier collé* here can be said to exist on three levels. They are flat, coloured, pictorial shapes. They represent or suggest certain objects in the picture by analogies of colour and texture or by the addition of keys or clues. Thirdly, and this is the aspect of *papier collé* that most relates it to other forms of Cubist *collage*, the pieces of paper exist as themselves, that is to say one is always conscious of them as solid, tactile pieces of extraneous matter incorporated into the picture and emphasizing its material existence. In this still life the small pencil marks around the fragments of paper (which are visible even in a photograph) indicate that the composition was worked out with care before the paper was finally pasted on.

In the work of Braque the strips of *papier collé*, while they are often made to represent objects, always fulfil a primarily pictorial or compositional function.

[1] The *Letters of Juan Gris*, p. 3. Letter to Kahnweiler, from Céret, 17 Sept. 1913.

Picasso, who adopted the medium almost at once, also uses *papier collé* in this same straightforward, relatively simple way; often a few strips of paper of different colours and textures establish what might be called a compositional substructure, over which an ordinary Cubist drawing is laid. But Picasso's attitude towards *papier collé* was also in a sense more intellectual than Braque's, and certainly more fanciful and imaginative. Salmon's story of Picasso immediately putting the house-painter's comb to new ends and producing with it something totally unexpected is symbolic of a whole aspect of Picasso's talent which was given for the first time full rein by the discovery of *collage* and *papier collé*.

Bouteille de Vieux Marc, Verre, Journal (coll. Mme. Cuttoli, Paris), (Pl. 14b) one of Picasso's earliest *papiers collés*, conveys at once a sense of greater richness and exuberance than Braque's *Still Life with Guitar*. For while Braque limited himself to the use of fragments of newspaper and imitation wood-graining, and to a few other black and soberly coloured types of paper, Picasso turned as well to more brightly coloured and elaborately patterned varieties of paper. Here one is more immediately aware of the representational aspect of the pieces of *papier collé* than of their purely pictorial or compositional value. The largest piece of wall-paper is the table cloth. But whereas in *Still Life with Guitar* Braque used the '*faux-bois*' paper as imitation wood, that is to say he used it to represent wood in his picture just as the interior decorator would have used it to represent or simulate wood-panelling on the wall of a room, the wall-paper in *Bouteille de Vieux Marc, Verre, Journal* undergoes a subsidiary transmutation in that it represents or becomes a flowered table-cloth. Or in other words, Braque's *faux-bois* remains *faux-bois*, whereas Picasso's wall-paper becomes '*faux-tissu*'. In the same way the strip below it becomes the ornate moulding along the edge of the table. The piece of newspaper represents itself, or to be more precise, represents the whole of the newspaper of which it was originally a part. The fourth and smallest fragment represents the wine in the glass. It is cut out to suggest the wine seen from above and also the curved rim of the glass. At the same time it is prolonged downwards so as to suggest the depth of the liquid, while the space around it gives an idea of the thickness of the goblet. And, as opposed to the *Still Life with Guitar*, where the drawing of the objects extends over the strips of paper, in this work the drawing is at several points actually continued on underneath the fragments of *paper collé*, although Picasso did subsequently draw the outline of the table over the 'cloth' and added the shading on the newspaper to integrate the pieces of paper into the picture. This implies that Braque saw more quickly than Picasso that *papier collé* could

be used as a means of establishing the basic composition of a picture in a simple and direct way, while Picasso was more interested in the possibilities of transforming the elements applied to his pictures by giving them a new and specific meaning.

A whole series of variations and intellectual refinements appear in the *papiers collés* almost at once, particularly in Picasso's. *The Violin* (Gallatin coll., Philadelphia Museum of Art) (Pl. 15), a highly complex example, probably of early 1913, illustrates a use of *papier collé*, in many ways more like the original use of *collage*. Five illusionistic colour reproductions of fruit are incorporated into the composition without any subsequent modification. Here, as in Gris' *Violin and Engraving* the pieces of paper are in a sense 'ready made' objects, used to represent only pieces of fruit in a fruit bowl, and transformed only in so far as they are assimilated into a new context. In *L'Etudiant à la Pipe* (Coll. Stein Heirs, Paris), a work executed towards the end of 1913 or early the following year, a piece of paper is cut out to represent the typical student beret and its crumpled appearance even suggests the texture of heavy cloth. It is obviously impossible to distinguish completely *papier collé* from *collage*, except in cases where the strips of paper involve a particular technique, that is to say when the effects could not be achieved by the use of materials other than paper. This is true for example of the *Compotier et Verre*, and generally speaking, of all the *papiers collés* of Braque. This, broadly speaking, could be said of Picasso's *Violin* also, although the paper fruits are not used primarily for their compositional or pictorial value as are the other fragments of paper in this same picture, and as the fragments are almost always in the work of Braque. They are used rather in a purely literal way to suggest the presence of the fruit. Neither are they the fruit itself in the way that the newspaper is itself in the *Bouteille de Vieux Marc*. One gets the feeling that if the fruits had been over-printed on cloth, or for that matter on any other material, they would have served Picasso's purpose equally well. It is on this somewhat abstract, metaphysical plane that the dividing line between *papier collé* and *collage* becomes confused. In the case of the *Etudiant à la Pipe* the fundamental pictorial property of the paper, its flatness, is deliberately destroyed so that one would be justified in classifying it simply as a *collage* rather than as a *papier collé*. (Pl. 19b.)

The deliberate casualness of many of Picasso's *papiers collés* and *collages* served to emphasize both the daring use of new, 'unsuitable' materials and the material existence of the pictures themselves: the student's cap, for example, is not evenly glued on to the canvas, and the loose edges give a sense of actual relief, while the overlapping of the layers of paper in *The Violin* gives a sen-

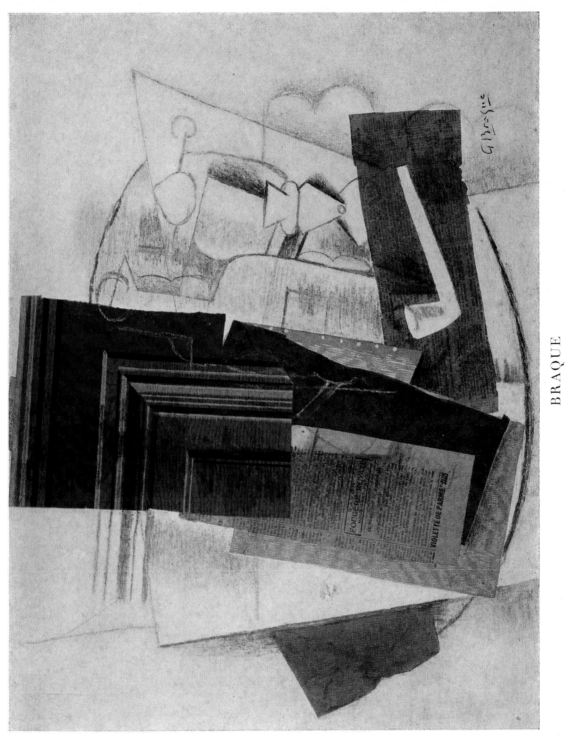

BRAQUE

B. Bottle, Glass and Pipe, 1913. *Papier collé*, $18\frac{7}{8}'' \times 25\frac{1}{8}''$.

Collection Lady Hulton, London

sation of density and weight. Braque, although he was working with the same humble materials, is always more consciously craftsman-like and respectful in his use of them; torn and ragged edges are rarely found in his *papiers collés*, and the strips of paper are smoothly applied so that their physical assimilation into the picture is more complete.

Although Braque's use of *papier collé* was less intellectual than Picasso's, he realized that, besides providing a new compositional technique, the pieces of paper could be made to play a part in rendering the spatial effects that continued to be one of the main preoccupations of his art. *The Clarinet* (Private collection, New York) (Pl. 36a), a work of 1913, despite its appearance of simplicity, is spatially extremely sophisticated. The four pieces of paper on the right, all of different colours, are pasted over each other to give a sensation of recession and depth. The large piece of black paper at the back, however, since it is darker in tone than the others seems to come forward again onto the picture surface. Its bottom end furthermore appears to stand on the front of the table. The flatness of the picture is also emphasized by the piece of black paper at the extreme left, which does not pass behind the long, horizontal strip of imitation wood graining but simply rests upon its upper edge. On the other hand it recedes, since it is smaller in size than the other piece of black paper. A series of spatial complications are also created by the relationship between the subject and the pieces of paper. Thus the clarinet is drawn over the newspaper, and the newspaper is in turn pasted over the brown wood-grained paper, which although it suggests the material of which the clarinet is made, nevertheless breaks up the drawing of it. In the same way the bowl of the wine-glass is drawn over the newspaper but its base disappears behind it. And although Braque's approach to *papier collé* was more purely pictorial than Picasso's he was not unaware of the intellectual refinements that the medium made possible. The pipe in *Bottle, Glass and Pipe* (Colour Plate B), another work of 1913, is simply an outline cut like a stencil from a piece of newspaper that is glued on to the paper, so that it becomes a 'negative' shape; since one is conscious of the physical, tactile existence of the newspaper, one might almost say that one is made aware of the pipe by its absence. In the *papiers collés* of both Picasso and Braque the simple, solid shapes cut out of paper occasionally cast shadows that do not echo or repeat their outlines, but rather reverse or complement them.

Gris' approach to *collage*, as one might expect, is perfectly straightforward and logical. In 1912 he glued a piece of mirror on to *Le Lavabo* and during the following years he incorporated an etching, playing cards and fragments of chair-caning into his still-lifes. The mirror in *Le Lavabo* is used in a purely

109

representational way, and as it is in a sense an inimitable material, its use seems completely rational. 'You want to know why I had to stick on a piece of mirror?' Gris asked a friend. 'Well, surfaces can be re-created and volumes reinterpreted in a picture, but what is one to do about a mirror whose surface is always changing and which should reflect even the spectator? There is nothing else to do but stick on a real piece.'[1] The elements of *collage* in his other paintings are generally used in the same literal way. In Picasso's *Still-Life with Chair-caning* the line representing the edge or moulding of the chair was added after the chair-caning had been incorporated into the painting, and the chair-caning appears below it so that it does not cover only the seat as it normally would in an actual chair. Although Gris frequently overpaints, too, the fragments of chair-caning in his paintings always give the impression of being 'tailored' or cut to fit exactly the seats of the chairs in his paintings.

Gris' *papiers collés*, however, are very different from those of Picasso and Braque. Kahnweiler has pointed out the basic distinctions in the three painters' use of the medium;[2] Picasso used it both in drawings and paintings, Braque only in drawings (although at least one of them is on canvas and many are very large), and Gris made use of it only in paintings. Unlike Picasso and Braque, who first painted *trompe l'oeil* details into their paintings and then progressed to incorporating into them the actual fragments of reality, Gris seems to have begun to use illusionistic detail and *collage* almost simultaneously, and in 1913, when he was painting sections of some of his canvases to represent wood-graining and wallpaper, he was already incorporating strips of paper into others. But is is only in 1914 that Gris began to use *papier collé* seriously as a means of expression. When this occurs, however, his use of the medium is a great deal more complex than that of either Picasso or Braque; indeed it almost constitutes a completely new technique. For the first time the entire surface of the canvas is covered with fragments of paper. It was now that Gris began to become fully aware of the abstract compositional possibilities of the medium. That is to say he began to realize that by adjusting or juggling the pieces of differently coloured paper he could achieve unusual compositional effects of great subtlety and of almost knife-like balance. This discovery was to affect all his subsequent work. But at this time the fragments of paper almost always continue to have some literal or representational value as well, and very often they still have (as opposed to many of the pieces of *papier collé* in the work of Picasso and Braque) the appearance of having been 'tailored' or cut out to fit some preconceived plan.

[1] Quoted by Kahnweiler in *Juan Gris*, pp. 87–8.
[2] Ibid., p. 87.

Sometimes the scraps of paper are cut out to correspond exactly to the shapes or contours of the objects which they represent, and each is subsequently carefully modelled or made more completely representational by the addition of over-drawn or over-painted detail. There is too, a great deal of over-drawing and over-painting of additional objects. The *papier collé* is thus assimilated into works that have the appearance of being immensely elaborate and complex paintings, and what distinguishes Gris' original approach to *papier collé* from that of Braque and Picasso is that he used it primarily to give his work a sense of definition and certainty, a precision and exactitude that he could not achieve by any other means. (Pl. 48.)

For some time before the invention of *papier collé* Picasso and Braque had been preoccupied by the problem of reintroducing colour into their painting. The initial limitation of colour in the work of Picasso, which began in his Negroid phase, was the natural result of his attitude towards form. The touches of primary colour in the right hand figures of the *Demoiselles* had served to give a certain sense of weight and form, but this empirical method of painting was soon abandoned for a more conceptual and rational approach, and colour thus be-came naturally, if not an inessential, at least a very secondary consideration. In the landscapes of the Rue-des-Bois and La Roche Guyon, Picasso and Braque had restricted themselves to browns, greys and one other colour (green) in order to control better the formal and spatial relationships which they were seeking to convey. Soon even the bright greens were suppressed, and towards the middle of 1910 Cubism entered what could almost be called a monochrome period. In other words, the discipline involved in creating a style which was revolutionizing traditional concepts of form and space forced both painters to discard the more immediately sensuous and appealing aspects of painting. Braque has said, 'j'ai senti que la couleur pouvait donner des sensations qui troublent un peu l'espace, et c'est pour cela que je l'ai abandonnée.'[1] However, in such a complete visual and pictorial revolution an important factor such as colour could not be ignored for ever. Furthermore, the austerity and asceticism of early Cubism was too intense to continue without a corresponding reaction towards a more highly coloured and decorative kind of painting.

As early as the spring of 1910, that is to say when he had been forced to adopt a nearly monochrome palette, Picasso was attempting to reintroduce areas of positive, bright colour into his paintings. However, he seems to have found that strong colour could not be satisfactorily combined with the complex rendering of volumes that characterized his work at that period, since he almost invariably

[1] *Braque, la Peinture et Nous*, p. 16.

painted it out again.[1] Towards the end of 1911 small colour accents began to appear in the work of both painters, but while they have a definite decorative value, they remained incidental to the formal and spatial effects and did not fundamentally alter the general sobriety of the paintings. During the first half of 1912 these small areas of colour become bolder and begin to assume more importance, and finally in *Le Modèle* (Pl. 13), a painting executed by Picasso at Sorgues in the early autumn of this year, the whole figure is painted in muted pinks. However, the use of naturalistic colour was probably felt to be at variance with a style that had developed a highly abstract means of expressing form. The head of the *Aficionado* (in the Kunstmuseum, Basel), a more complex painting from the same series as *Le Modèle*, was originally also painted in flesh pink, but was then reworked in the more usual early Cubist colour harmonies.[2] In many other paintings of the period small areas of brighter colour appear to have been over-painted.

Braque's remarks on colour in Cubist painting indicate that the painters wished to use it in a direct way, dissociating it from the modifications imposed on it by variations of light and the modelling of form. They wanted to find a way of using colour in a simple, direct, constructive way. That is to say they felt that it could exist as an independent pictorial entity, contributing to spatial and formal sensations but not conditioned by effects of atmospheric light and perspective or by the modelling of forms from lights to darks. This is borne out by an experiment of Picasso's that is described by Kahnweiler in his book on Gris.[3] In a painting called *The Piano* (dated 1909 by Kahnweiler), Picasso used ridges of plaster to achieve a sense of relief in order that colour might then be applied as an independent element, without any subsequent need for chiaroscuro or shading to convey a sense of form. Waldemar Georges, who was the author of what is perhaps the first serious article on Braque's work, saw his invention of *papier collé* as an experiment designed to solve the problem of reintroducing colour into Cubist painting: 'Soucieux jusqu'à l'excès de rendre non l'effet éphémère produit par la couleur, mais son essence même, Braque fait intervenir dans ses tableaux des matières extrapicturales. C'est ainsi qu'il entreprend d'ingénieuses compositions, dont les parties, jugées importantes, sont traitées en papier et ne figurent pas la réalité mais l'incarnent et se confondent avec elle.

[1] Kahnweiler describes these paintings in *Der Weg zum Kubismus*, p. 24. He recalls also that in one case the colour was not painted out. This painting, however, appears to have been since destroyed.

[2] Where the paint has cracked it reveals under the area of the face an under-painting of bright pink.

[3] p. 47.

Cette période du Cubisme marque déjà le désir que manifestent certains peintres d'objectiver leurs sensations.'[1]

Clearly *papier collé* was more than simply a colouristic experiment, but at the same time it solved the problems that were facing Picasso and Braque. '. . . la mise au point de la couleur est arrivée avec les *papiers collés*,' Braque has said.[2] It has already been seen how the strips of coloured paper could be used as an abstract compositional structure over which an ordinary Cubist drawing could be overlaid; form was thus preserved independently of the colour beneath it, although a subsidiary relation between colour and form is almost always established subsequently. In Picasso's *papiers collés*, and very occasionally in Braque's, the pieces of paper are cut out to represent specific objects, and in the work of both painters they often relate to objects in the pictures in a general way by analogies of shape or of texture, or are made actually to represent the objects by the addition of details or keys drawn over them. But in these cases the drawing conveys, in a kind of pictorial shorthand, all the necessary information about the form of the objects so that colour can exist, once again, free from modifications of light and modelling.

Besides the re-awakening interest in colour, there had been in Picasso's work of early 1912 a move towards a clearer, more explicit kind of painting. This becomes clear on comparing *Bottle and Glasses* (The Solomon Guggenheim Museum, New York), (Pl. 12a) a work of late 1911 and typical of the kind of painting that Picasso had been producing all that year, with the slightly later *Bouteille de Pernod* (Museum of Modern Art, Moscow) (Pl. 12b). In the former it is hard to detach any of the objects from its surroundings, or to reconstruct any one of them independently of the other objects around it. The second painting is by contrast much more immediately legible; the objects are kept more intact and stand apart from each other and from the background; they are more heavily painted and are even occasionally differentiated in colour. Whereas in the work of 1911 one has the impression of a complex of planes inextricably involved with each other, in the *Bouteille de Pernod* the glass and bottle are composed of a series of distinct planes, which seem to pass through and behind each other. In some of the still-lifes of the summer, the subjects are extended to include dead birds, and the shells which had appeared in a few earlier paintings become a recurrent theme. In keeping with the movement towards the more sensuous kind of painting, many of these canvases have a new quality of softness. The *Modèle*, painted at Sorgues in 1912, while it is still quite hermetic or hard to

[1] 'Braque' in *L'Esprit Nouveau*, 6 March 1921.
[2] *Braque, la Peinture et Nous*, p. 17.

read, is considerably less complex in handling than any of the Céret figures of the previous year. Braque's *Hommage à J. S. Bach* (coll. Monsieur H. P. Roché, Paris) shows that in the spring of 1912 he was moving along parallel lines to Picasso. The objects in this painting are, however, still more fully opened up into the planes surrounding them than those in the contemporary paintings of Picasso, and the simplification tends to give a sense of increased airiness or spaciousness rather than of solidity. (Pl. 34a.)

Later in 1912, after the invention of *papier collé* there was a much more radical change in the appearance of Cubist paintings by Picasso and Braque, and it has recently become usual for scholars to divide Cubism into two periods, an 'analytical' phase, which is generally acknowledged to end in 1912 or 1913, and a succeeding 'synthetic' phase. Kahnweiler, in *Der Weg zum Kubismus*, noted that the discoveries made by Picasso at Cadaqués in 1910 enabled him to combine or 'synthesize' a great deal of information about an object into a single image, and that the new method of work dispenses with the early 'analytical description' of objects.[1] Carl Einstein, a German writer and poet, uses the term 'synthesis' in the same way. In an article entitled *Notes sur le Cubisme*, which appeared in *Documents* in 1929, he distinguished three successive phases in Cubist painting: 'first a period of simplistic distortion, then a period of analysis and fragmentation, and finally a period of synthesis.' In actual fact, however, during the period of 'analyses' to which these writers refer, Picasso and Braque had already broken with traditional perspective and were combining or 'synthesizing' various views of an object into a single image. The development of a more abstract technique during 1910 only enabled them to effect this kind of synthesis in a freer, more suggestive manner. It was Ozenfant and Jeanneret in *La Peinture Moderne*, published in Paris in 1925, who were the first to see that if there was any real break in Cubism, it occurred in 1912. The early period from 1908 to 1912 they called 'hermetic' or 'collective' to differentiate it from the succeeding phase in which, according to them, the painters lost all sense of restraint and discipline, and indulged in excessive self-assertion. In his *Juan Gris* Kahnweiler refers to the fact that the years 1909–13 have been called the 'hermetic period' of Picasso and Braque;[2] that is to say that some people have seen a 'hermetic' phase coinciding with an 'analytical' one. Other critics have used the term 'hermetic' simply to describe the extremely complex, rather abstract appearance of Picasso's and Braque's paintings of 1911 and 1912. These paintings, it has been seen, were not different in kind from those of 1910.

[1] p. 34.　　　[2] p. 49.

But it was in the writings of Gris that the difference between an analytical and synthetic approach was elaborated. Gris, in a reply to a questionnaire, 'Chez les Cubistes', sent out by the *Bulletin de la Vie Artistique* in 1924 and published in January of the following year,[1] made a distinction between an early period of analysis in Cubist painting, which he felt to be purely descriptive and therefore of no real artistic value, and a later phase in which 'the analysis of yesterday has become a synthesis'. Three years earlier in *L'Esprit Nouveau* he had written: 'I work with the elements of the intellect, with the imagination. I try to make concrete that which is abstract. I proceed from the general to the particular, by which I mean that I start with an abstraction in order to arrive at a true fact. Mine is an art of synthesis and deduction, as Raynal has said.'[2] Kahnweiler records a conversation with Gris, which took place in 1920, in which Gris expressed himself even more explicitly: 'I begin by organizing my picture; then I qualify the objects. My aim is to create new objects which cannot be compared with any object in reality. The distinction between synthetic and analytical Cubism lies precisely in this. These new objects, therefore, avoid distortion. My *Violin*, being a creation, need fear no comparison.'[3]

For Gris, then, synthetic Cubism involved a clearly defined procedure. To describe it crudely: the composition of a painting was established in purely abstract, and in the case of his work, often mathematical terms. The subject then emerged from or was superimposed over this framework or substructure of flat coloured forms. As the subject-matter materialized in these paintings, as the flat, coloured shapes were converted into objects and figures, the rigidity of the underlying geometric frame-work was naturally softened, and by the time that the paintings reached completion, it is usually completely disguised. Sometimes while Gris was evolving this method of work the paintings were begun with specific subjects in mind (this was obviously true, for example, of the portrait of his wife and of the paintings executed after Cézanne and Corot, all works of 1916 and 1917), but even in these paintings Gris used two distinct approaches in that at a certain point the representational values were ignored while he established

[1] The text is given in full in Kahnweiler's *Juan Gris*, pp. 144–5.

[2] *L'Esprit Nouveau*, no. 5, 1921. Reprinted in *Juan Gris*, pp. 137–8. Gris refers to an article by Raynal in the same no. of this periodical. In his lecture *Quelques Intentions du Cubisme*, published in 1919, Raynal made the point that the Cubist painter first analysed the objects he wanted to depict, in order to extract their significance, and then, 'par un travail synthétique qu'il exécute à l'aide de tous ses moyens picturaux, il constitue un ensemble nouveau de tous ces éléments.' It is not clear, however, whether the process he describes is simply an extension of the original idea of 'synthesis' as Kahnweiler first saw it, or whether Raynal is trying to suggest some more radical difference of approach. He is a critic to whose terms it is often hard to give a precise meaning, and in this passage does not appear to resolve the formal contradiction between 'synthesis' and 'deduction'.

[3] *Juan Gris*, p. 104.

to his satisfaction the desired formal, abstract relationships between the flat, coloured shapes which he had come to see as the raw material of painting. (Pl. 50b.)

Applied to Gris' work the terms 'analytical' and 'synthetic' thus have a real and very precise meaning. On the other hand, they cannot be used in quite the same way in relation to Picasso and Braque. It will be seen that, in some of his painting executed in techniques influenced by *papier collé*, Braque really appears to have first established an abstract compositional framework on the canvas and to have only subsequently objectified the pictorial forms and given them a literal, representational value. And there is no doubt that *papier collé* made both Picasso and Braque much more aware of the possibilities of combining two distinct approaches, an abstract and a representational one, in a single painting, since they were working with pictorial elements, flat, coloured shapes which remained abstract until given a representational value by their incorporation into a picture. Previously Cubist paintings had owed their final appearance to the gradual fragmentation of forms and to the break-up of the space surrounding them; after the general composition had been established the pictures were obviously elaborated section by section until the composition was perfectly balanced. Now, in the *papiers collés*, the compositions, and the forms of objects themselves, could be built up rapidly by a few ready-made elements, while in the contemporary paintings the same effect could be achieved by a few, large, boldly painted planes or shapes. The process thus became that of adding together or combining compositional elements, which were subsequently made to play their part in the rendering of solid forms and the space around them. Painted objects and eventually the whole painting, even, one might say, pictorial reality itself, was 'built up to' rather than dissected or taken apart. To this extent it is possible to differentiate between an analytical and a synthetic approach in the Cubism of Picasso and Braque, but the terms cannot be used in an exclusive, categorical way as they can when talking about the work of Gris. There are very few paintings by Picasso and Braque of this more synthetic type that do not contain 'analytical' passages as well. Neither Picasso nor Braque ever evolved as completely as Gris a system of working from abstraction to representation. One feels that in their Cubist paintings the subject almost always continued to come first.

All this illustrates the danger of trying to make Cubist painting fit into hard and fast categories. If one accepts Gris' terminology, then the Cubism of Picasso and Braque was very seldom, indeed in the case of Picasso perhaps almost never, more than partially synthetic. Then, in so far as there is a definite break at all in their work it occurred in 1912 after the discovery of *papier collé*, whereas Gris

himself did not feel that he had achieved a synthetic kind of painting until long afterwards.[1] Gris was justified in distinguishing a series of different phases in his art, but if one tries to use these as the starting point for generalizing about the nature of Cubism, one is apt to succeed only in accentuating the differences between the approach of Picasso and Braque and that of Gris. Thus Kahnweiler rightly points out that it is in 1914 and 1915 that Gris took the first steps towards a more 'synthetic' kind of painting by attempting to convey the maximum information with the minimum means; that is to say by creating a series of generalized, significant images into each of which is synthesized all the painter's knowledge and experience of his subject. This was something that Picasso and Braque had been doing all along, or at least ever since they had adopted a variable view-point. Gris, on the other hand, as has been seen, originally dissected his subject, examined each part from a different angle and then reconstructed the total image again from the various parts. Then Kahnweiler tends to equate synthetic Cubism with a conceptual approach. The Cubism of Picasso and Braque was conceptual from the start, in that even when they were still relying to a certain extent on visual models, their paintings were more the depictions of ideas about types or categories of objects than representations of individual examples. The objects in Gris' pre-1914 paintings, on the contrary, often convey the impression of having been derived from particular models, or at least of having an exact counterpart in the material world. And even though during 1914 and 1915 Gris' art became more conceptual and to this extent more like that of Picasso and Braque, his approach remained very different and he continued to evolve towards a more mathematical, precise kind of painting. It was, however, his experiments with *papier collé* during 1914 that conditioned the development of his art, just as it was *papier collé* that affected the painting of Picasso and Braque when they began to use it extensively after Braque's discovery of it in the autumn of 1912.

But it should be emphasized that while *papier collé* involved new methods of work and initiated almost at once a new phase in the art of Picasso and Braque, it did not involve any fundamental change of aesthetic. *Papier collé* was, in part at any rate, an experiment designed to solve certain problems that the painters were concerned with in their creation of the style. It was not a fortuitous discovery that altered their view of the world around them, but rather a technical invention that conditioned the appearance of their paintings. Or, to put it

[1] By Gris' first definitions of synthetic painting it would seem that he had achieved it by 1918. Later, just before his death, he stated that he had only just entered a synthetic period, op. cit., p. 146.

differently, while *papier collé* affected their pictorial vision, the nature of the movement remained unchanged. Cubism contined to be an art of realism; its subject-matter remained the same, as did the interests and intentions of the painters. It has already been seen to what extent *collage* and *papier collé* were the natural result of the painters' aesthetic beliefs. As new techniques they speeded up the natural reaction from an austere, complex form of art towards a simpler, clearer kind of painting into which sensuous values could be re-introduced.

Braque's *Composition* (Pl. 34b) which belongs to the winter months of 1912–13, and Picasso's *Violon au Café* (Pl. 16) which is dated 1913 and is probably of the spring or early summer of this year, show at once the influence that the *papiers collés* had on their painting. The subjects of both paintings are treated in terms of long upright or slightly tilted planes that recall the strips of paper used in *papier collé*: both paintings are flatter than hitherto, and there is an element of directness and immediacy, particularly in the *Violon au Café*. The objects in Picasso's paintings of 1912 had been built up of overlapping and interlocking planes, and the method used here is basically the same. However, each of the planes that goes to compose the violin in this painting is a separate entity, clearly defined and differentiated from the others around it in colour and texture. The earlier effect of transparency has completely disappeared, and a work like *The Violin* (coll. The Kröller-Müller Foundation, Otterlo), executed some months earlier, looks almost fragile and insubstantial by comparison.[1] Braque's *Composition* is a more transitional work, although once again the forms are larger and bolder than in his earlier work. A slightly later painting by Braque, *Composition à l'As de Trèfle* (Pl. 37) relates directly to his first *papier collé*, *Compotier et Verre*. The painting is more elaborate and a few alterations have taken place, but apart from these, it is obviously developed from the *papier collé* in a perfectly straightforward manner, although, once again, the painting has become aggressively flattened. Braque had painted imitation wood-graining into his pictures before he began pasting pieces of paper on to them, but here a note of further sophistication is introduced into his work by the fact that in transposing the *papier collé* into a painting the wall-paper, printed to simulate wood grain-ing, is replaced by a painted imitation of it.

[1] This is a difficult painting to date exactly. The Catalogue of the Kröller-Müller Museum suggests Paris 1911–12. Barr places it *ca.* 1912 (*Cubism and Abstract Art*, p. 32). Zervos on the other hand says winter 1912–13. Because of the dislocation of the different parts, the fewer number of facets which compose it, and also because of the composition in basically vertical and horizontal accents, a date in the latter part of 1912 or very early in 1913 would seem to be most likely. However, this painting is a straightforward development of Picasso's earlier work and shows no real or direct influence of the *papiers collés*.

The technique of many of Braque's paintings of 1913 and 1914 was in fact developed directly from his experiments with *papier collé*. In a canvas such as *La Table du Musicien* (Pl. 36b), for example, a work of the summer of 1913, tack or pin marks can be seen in the corners of the planes or shapes that serve to establish the basic composition of the picture—and marks like these can be found on most of the canvases of this year. This suggests that before he actually began to paint or draw on the canvas, Braque experimented by laying strips of paper on it in various positions or combinations. Then, when he had decided upon the arrangement or composition that pleased him most, the pieces of paper were pinned to the canvas and lines were drawn around them, or their positions noted by pencil marks at the corners. After the papers were removed a drawing or blueprint was left behind, from which Braque began to work. A few of the shapes were solidly painted (a characteristic of Braque's work of the period is that much of the canvas shows through), some were made to represent specific objects, while others retained a purely pictorial function. The keys which enable the spectator to identify the objects (in the case of this particular painting the lines of music, the ace of spades and so on), are kept more intact and used more boldly than hitherto, so that the subject matter becomes more immediately obvious.

These paintings by Braque introduced a third, and totally new method of composition into Cubist painting. Originally the analysis or break-down of form and the break-up of space itself had been the starting-point for the break-up of the picture surface. Next, the linear grid suggested by the outlines or directional lines of the objects or figures had been the point of departure. Now the basic composition, worked out in terms of strips of paper, could exist independently of the subject, which was superimposed or laid over it. Waldemar Georges, after an interview with Braque, described his method of work in his article in *L'Esprit Nouveau* in 1921.[1] After discussing the early stages of Cubism and the part that Braque played in the creation of the style, Georges goes on to say, 'Il nous reste à étudier le processus créateur de Braque qui diffère sensiblement de celui des peintres antérieurs. Cet artiste peint sans modèle. Au lieu de disposer sur une table les éléments d'une nature morte et de travailler ensuite sur ce motif préétabli, il compose directement sur la toile et imagine des motifs pour n'obéir qu'aux lois du tableau. . . . Tandis qu'un Matisse ramène à l'état de taches de couleur les objets environnants, Braque transforme en objets les taches de couleur, qui s'imposent à sa vision. S'il confère par exemple à une tache blanche la forme d'une partition de musique, c'est qu'il imagine à tort ou à raison que

[1] *L'Esprit Nouveau*, no. 6, p. 644.

la mémoire visuelle intervenant, l'impression de blancheur produite par une simple tache serait moindre que celle offerte par le spectacle d'un livre ou d'un journal qu'on sait être blancs par habitude.' The insistence on colour implies that Georges is referring to Braque's post-war paintings, but the technique described is one which he developed during 1913. The process was not, of course, simply that of laying a subject over an abstract compositional background: a series of adjustments always take place that make objects and background inseparable from each other, and very often the shapes that establish the composition seem to have been suggested by specific objects. But, using Gris' definitions, these were perhaps the first synthetic Cubist paintings in so far as Braque was virtually working from abstraction to representation. Cubism had always been concerned with the balance between abstraction and representation, and now both approaches could be fused in a simple painting. It is this that makes Braque's work of the period enjoyable on so many different levels, both pictorial and intellectual; and an appreciation of these paintings provides the key to the understanding of all his subsequent work.

During 1913 Picasso's work also continued to evolve under the influence of *papier collé*, although not in quite the same way as Braque's. Most of Picasso's paintings are heavier and more solid than Braque's, and in a work like *Violin and Guitar* (Arensberg Coll., Philadelphia Museum of Art) (Pl. 17), probably dating from the middle of the year, the long slab-like shapes that build up the composition develop also the form of the objects depicted. The part of the violin which is a piece of paper painted in imitation wood-graining and then glued to the surface clearly belongs to an early stage of the composition, and this suggests that Picasso had a definite subject in mind when he actually began the painting. The pencil lines show that even the fragment of violin which is drawn into the central white shape was part of the original subject and was not simply added as an afterthought. In this painting and others like it the original compositional ideas may have been developed by the arrangement of a few abstract pictorial shapes, but the subject soon suggested itself, or was decided upon, and conditioned the subsequent development of the painting. There is thus never quite the same duality of approach in Picasso's work as there is in Braque's, and his work of this period is in a sense more straightforward and direct.

There is a fundamental difference, too, in the two painters' use of colour. This can be seen by comparing the *Violin and Guitar* with a more or less contemporary work by Braque, *Violin et Verre* (Pl. 38), similar in form. Each of the coloured planes or shapes that make up the central mass of Picasso's painting seems to belong in some way to the objects depicted; if any of these areas were re-

moved the objects would begin to disintegrate. In Braque's painting, however, although the large, irregular brown shape in the centre of the painting is clearly related to the violin, it is not inseparable from it, and gives indeed almost the effect of a plane passing through it. The violin and the glass are in fact drawn or painted over the composition of flat, coloured shapes in the same way in which objects were drawn over the fragments of paper in *papiers collés*, and their forms exist independently, although as in so many of the *papiers collés*, colour produces a subsidiary interaction between the objects and the shapes underneath them. Picasso, on the other hand, makes colour more an integral part of form. With Braque it exists autonomously, creating spatial relationships which are then made even more complex when the subject is superimposed. The colours in Braque's painting are browns, blacks and dull greens (imitation marbling begins to appear in this year). In other paintings of the period these more severe tones are relieved by brighter blues and by areas painted in pale colours in imitation of patterned wall-papers. Picasso's *Violin and Guitar* is painted mostly in slaty blues and grey-browns, but in other paintings of the same type the artist uses bright, rather acid greens and reds as well. By the end of the year he was working with a full palette, and his colour schemes were becoming increasingly light and decorative.

At the same time that Picasso and Braque were reintroducing colour into their paintings they began to experiment with a whole new range of materials to enhance the tactile qualities of their canvases and to give a sense of textural variety and richness. Certain areas in Picasso's *Violin and Guitar* are built up of plaster mixed with coarse sand, so that the effect given is almost that of a very low sculptural relief. In many of Braque's paintings of 1913, like the *Verre et Violon*, shapes are built up of gesso mixed with white oil paint. Both painters applied strips of paper dipped in paint on to their canvases. Braque, who early in 1912 had mixed sand and gravel into his paintings, was fascinated by the physical properties of different media, and by the way in which the quality of colour changed when it was blended with them: 'plus tard j'ai introduit dans mes tableaux du sable, de la sciure de bois, de la limaille de fer . . . je voyais combien la couleur dépend de la matière. . . . Et ce qui me plaisait beaucoup était précisément cette "matérialité" qui m'était donnée par les diverses matières que j'introduisais dans mex tableaux.'[1] In their appeal to the tactile senses, the new materials represented an extension of a certain aspect of *collage* and *papier collé*, and like the fragments of paper, the gravel, sawdust and so on served to emphasize the material existence of the pictures to which they were

[1] *Braque, la Peinture et Nous*, p. 17.

applied.[1] They represented, too, a reaction against traditional media and facility of technique, while contributing at the same time to the new sensuous appeal that was beginning to find its way back into the work of Picasso and Braque.

In many ways the discovery of *collage* and the invention of *papier collé* represent a climax and a turning point in the pre-war Cubism of Picasso and Braque. *Collage* was, to start with, the natural outcome of their concept of the work of art as an autonomous, constructed object. It seems to have given them a sense of certainty in that they were producing works of art which were part of external reality and not just representations of it. Considered simply as pictorial media, *collage* and *papier collé* effected a conclusive break with traditional means. Then *papier collé* enabled the painters to reintroduce colour directly into their work, as an independent pictorial element. It suggested, too, a new, more abstract and in a sense freer method of composition. Hitherto both painters had submerged their individualities in a common urge; the creation of a new pictorial language and the complete reassessment of traditional artistic values had involved a rigid discipline and an intense degree of concentration. Their work of 1913, on the other hand, has a feeling of relaxation; one gets the sensation that a tension has been broken. The differences between the personalities of Picasso and Braque begin to reassert themselves. The work of Picasso, who had suppressed his natural restlessness in his anxiety to master completely the mechanics of the new style, becomes increasingly more varied and inventive, combining a sense of wit with a new feeling of gaiety that occasionally reaches the point of exuberance. Braque's work remains more static, more calm and withdrawn, although he gives freer expression to his enjoyment of the physical properties of the different materials with which he was working. The relationship between the two painters remained as intimate as before, but they no longer found it necessary to rely on each other's resources and talents for support and stimulation. Although they continued to see each other frequently, after Picasso moved to the Left Bank in the autumn of 1912, they were no longer in almost daily contact as they had been during the previous years. In 1913 Picasso was in Céret for the spring and the early part of the summer, returning to Paris in June,[2] while Braque, who was in Céret for only a brief while,[3] spent the summer in Sorgues.

[1] This point is illustrated particularly well by Picasso's *Violon au Café* discussed above. Strips of cloth and paper have been incorporated into the picture, and are overpainted with forms that recall the cut-out shapes in *papier collé* but do not correspond to the shapes of the cloth and paper underneath. The bits of *collage* therefore have no representational or compositional value and serve primarily to convey a sense of solidity and materiality.

[2] Picasso-Stein correspondence.

[3] Kahnweiler says that Braque was in Céret for a while in 1913. This piece of information he transmitted to M. Jardot for the catalogue of the Picasso exhibition at the Musée des Arts Décoratifs, Paris 1955, p. 25.

Two contemporary figure pieces of the spring of 1913, Braque's *Woman with a Guitar* (Pl. 39) and Picasso's *Harlequin* (Pl. 18) show the way in which the two painters were moving apart in their work. Both paintings are still clearly related to *papiers collés* although Braque's painting differs from many of his contemporary still-lifes influenced by *papier collé* in that the exact nature and form of the subject were obviously established from the start. Both paintings are less tense and austere in mood than hitherto. But the *Woman with a Guitar*, although the planes that compose the figure are larger and fewer and in some cases quite self-contained, still relates to an earlier style in which form is built up of interlocking, transparent planes—indeed the painting is closer in many respects to Braque's *Female Figure* of 1910–11 than to his more hermetic figure pieces of the following winter. Picasso's *Harlequin*, on the other hand, is flatter and more stylized than anything that had preceded it. The shapes that build up the figure are for the most part clearly defined and the earlier sense of fluidity and interpenetration has disappeared. The combination of various views of the head is now accomplished by laying next to each other a series of stylized forms or symbols that represent its component parts: to the right of the central section is added a profile ear and beyond it a circular form which represents the back of the head. There is, too, an element of fantasy about the painting that is absent from Braque's, which has a feeling of calm enjoyment. Braque's incorporation of a perfectly drawn naturalistic mouth in the woman's head has an element of humour about it, but Picasso's reduction of the features of the face to small dots and sharp, thin lines (in addition to putting in the stylized moustache) is more frankly amusing. The legs of the harlequin accentuate this effect: one is stylized in an angular fashion, while the other is composed of curving, lumpy shapes. The theme of the harlequin was one which Picasso had abandoned four years earlier, before his work had become truly Cubist.[1] After 1914 it becomes a recurrent theme in Picasso's Cubist painting.

Many of the new elements in Picasso's work at this time, in 1913, can be accounted for by the fact that he had turned his attention to a particular Negro mask from the Ivory Coast, of a type called 'Wobé' that was in his collection.[2]

[1] See e.g. Z II (1), 138 and 145.

[2] In his preface to *The Sculpture of Picasso* (London 1949) Kahnweiler describes this type of mask, and states that Picasso owned an example. He also discusses this kind of Negro art at great length in his article *Negro Art and Cubism* which appeared in the December 1948 issue of *Horizon* (London). Kahnweiler, who minimizes any direct influence from Negro art in the creation of early Cubism, feels that it is only with Picasso's study of Wobé masks that Negro art begins to be an important influence on Cubism. He emphasizes the fact that this kind of African sculpture enabled the Cubists to break with 'imitation' and to achieve a more 'synthetic' kind of painting. It is interesting to note that in a drawing of Picasso's of 1917, which shows the interior of his house at Montrouge, a Wobé mask appears on the wall. I am indebted to Mr. Douglas

This kind of mask consists basically of a flat, oblong wooden board. From it, at the top, projects another smaller board or ledge to represent the forehead. The nose is a thin strip of wood running down from it. The eyes are indicated by projecting circular pegs, while the mouth is conveyed either by a crescent shape or by a rectangular block (Pl. 80E). The general effect is geometrical and very unnaturalistic, and the features only become identifiable by their suggestive or symbolic arrangement. The facial conventions in Picasso's *Harlequin* clearly derive directly from this type of African mask. The eyes are the same circular forms, but reduced almost to pin points, and there is the same line above them (here it has become a small black carnival mask), with another line running straight down from it to denote the nose. Picasso furthermore clearly appreciated and understood the principles of this type of Negro art. The harlequin's hands and feet, for example, are represented by completely unnaturalistic shapes that acquire a literal meaning only because of their placing in relation to each other and to the other parts of the figure. That is to say that if shown almost any one of the various elements of the body or the features of the face (the moustache is, of course, an exception) in isolation, one might well be unable to identify it, whereas by its placing in the painting each become immediately legible. In this sense all the shapes that compose the figure are, like the fragments of paper in the *papiers collés*, 'synthetic', self-contained shapes or forms that are given meaning only by the suggestive way in which they are assembled to depict some particular subject or given a specific pictorial meaning. The device of using the mouth as a focal point from which a second view of the face is opened out was one which Picasso had been exploring since 1910; now the new formal conventions he had developed enabled him to carry out this kind of displacement more freely.

From the first, Negro art had been an aesthetic revelation to Picasso, and he had been as much impressed by its 'reasonable' or conceptual qualities as by its formal, sculptural properties. But his interpretation of Wobé sculpture was perhaps still more intellectual and sophisticated. Besides realizing that the principles involved in it corresponded to the new elements which appeared in Cubist painting towards the end of 1912, Picasso seized at once upon the psychological possibilities inherent in this highly abstract kind of art, in which shapes bearing very little resemblance to the original parts of the body are used as conventional symbols for them. The reduction of the student's features in *L'Etudiant à la Pipe* to small circles, dots, crosses and crescents, together with the displacements

Cooper for calling my attention to this point. (This drawing is reproduced in *Portrait of Picasso*, London 1956, pl. 96.)

of the ears, produces a highly comic effect. In the *Femme en Chemise dans un Fauteuil* (coll. Dr. Pudelko-Eichmann, Florence), a work from the end of 1913, there is an element of satire in the way in which the features of the face are reduced in size and importance to an absolute minimum, while the breasts, each of which is duplicated, are unnaturally prominent (Pl. 20a). By comparison, Braque's *Woman with a Guitar* looks almost naturalistic, even though the colours in the *Femme en Chemise* are surprisingly life-like for the period. In some of the contemporary drawings and *papiers collés* the abstract, 'shorthand' treatment of the human head, traditionally considered to be a thing of nobility, in terms of a few insignificant pencil marks has a disquieting effect. In fact, in this respect a few of Picasso's Cubist heads of 1913 and 1914 foreshadow the bestiality of certain of his figures of the 1920's.[1]

The constructions in paper, wood, tin and other materials which Picasso was making at this period were also clearly influenced by the Wobé mask he owned. The part played by the constructions of Picasso and Braque in the development of Cubist painting is hard to assess; most of them were too fragile to survive. However, Picasso claims still to own some 1912 paper sculptures[2] and it is certain that he was experimenting with the medium during this year. None of the paper constructions which Kahnweiler recalls having seen in Braque's studio in the Hôtel Roma, rue Caulaincourt, still exist, although he, too, was experimenting with paper sculptures and constructions during 1912; some of these may even have been a prelude to the discovery of *papier collé* that autumn. Certainly Braque's constructions must have helped him to achieve the kind of spatial definition that exists in his *papiers collés* and paintings of 1913. Certain later paintings by Braque, such as *Music* of 1914 (Pl. 40a), seem to have been even more directly influenced by these constructions. *Music* looks almost as if it had been constructed from paper or cardboard forms, attached to the background at their lower ends and inclined forwards at the top, casting shadows behind them. A large number of Picasso's drawings of 1913 and 1914 are undoubtedly projects for sculptures in paper or cardboard.

The more solid, predominantly wooden constructions by Picasso which have survived are important because they are so intimately connected with the paintings of the period and because they serve to establish many of the principles of Cubist sculpture. The debt to Wobé art is obvious. The forms, which are often unnaturalistic and unrepresentational, are, by their arrangement, endowed with the quality of symbols which enable the spectator to reconstruct the sub-

[1] See Picasso Catalogue, Musée des Arts Décoratifs, 1955, nos. 69 and 72.
[2] Information received from Mr. Douglas Cooper.

ject matter. Thus in the *Bouteille et Guitare* (a work which no longer exists) the bottle was composed of a strip of wooden moulding which represents the neck and top; the level of the liquid was shown by a small projection of wood or cardboard. (Pl. 19a.) The circular opening of the guitar was replaced by a projecting cone of wax. In other examples the hole of the guitar is given by a projecting circular form. This method of representing part of an object by a shape that is the reverse of its counterpart in real life, and of replacing voids by solids and solids by voids, becomes one of the distinguishing features of Cubist sculpture. In the same way the dice that appear in some of Picasso's constructions are tubular or cylindrical forms rather than cubes, and are covered with dots that act as keys or clues, enabling the spectator to identify them. This method of work enabled Picasso, in both his paintings and his sculptures, to work in a direct, easily legible manner, while at the same time avoiding all traditional forms of realism or imitation. By 1913 Archipenko was also producing polychromed 'sculpture-constructions' (he called them 'sculpto-paintings') which while they are not particularly Cubist in appearance or spirit, were created in much the same way as Picasso's constructions. Thus an assortment of cones, cylinders and cubes of wood, celluloid, tin and so on were imaginatively assembled to represent human figures. When during the war Laurens and Lipchitz began to produce Cubist sculptures[1] it was the *papiers collés* and constructions of Picasso and Braque and the work of Archipenko that they used as their starting point. It is interesting to note that while the principles of their Cubist sculpture were derived from the constructions and *papiers collés* and ultimately from the Cubist painting of Picasso and Braque, towards the end of the war the bas-reliefs of Lipchitz and Laurens were in turn influencing the appearance of paintings by Picasso, Braque and Gris.[2]

The constructions account for the simplifications and distortions that begin to appear in Picasso's painting towards the end of 1913. In *L'Homme au Livre* (still in the collection of the heirs of Gertrude Stein), perhaps the only surviving figure construction, which is in paper and zinc, the man's arms are two long, thin strips of paper, the shoulders a projecting ledge shaped like the contours of the body of a guitar, and so on. The limbs of the *Homme Assis au Verre* (Pl. 22)

[1] Some of Lipchitz's small bronzes of 1913 and 1914 (e.g. the *Danseuse* in the Petit Palais, and the *Marin* in the Musée d'Art Moderne) make use of certain Cubist devices, such as representing convex forms by concave ones and so on, but it was not until the early war years that Lipchitz emerged as a fully mature, significant artist.

[2] See e.g. Picasso's *Still-Lifes*, Z III, 119–21, 146–8; Braque's *Still-Life with Bunch of Grapes*, 1918 (coll. Mr. D. Cooper); Gris' *Arlequin à la Guitare*, 1918, illustrated in the Cat. of the Berne exhibition, 1955 no. 65.

a large canvas of the summer of 1914, are conceived in much the same way, although working in a different medium the forms could be more freely conceived and more wildly distorted. The flat, oblong head with the peg-like eyes still relates clearly to the type derived from the Wobé mask the previous year. The effect of the whole is produced by bending and interweaving a few large planes into the representation of a human figure. The naturalism of the pose, however, suggests that at this date Picasso was already developing his figure paintings from more representational drawings, a method he was certainly using by the following year. In a work like this the element of fantasy that had begun to appear in Picasso's work during the past year reaches a climax.The colour has become frankly decorative; the background is emerald green and there are touches of bright blues, oranges and yellows. In 1914 both Picasso and Braque made free use of the decorative possibilities of a 'pointilliste' technique, covering large areas of their paintings with small, brightly coloured dots of paint. The idea may have suggested itself to Picasso through his use of stippled or patterned wall-papers in some of his contemporary *papiers collés*. During 1914 Picasso, who had during the past year often used ordinary enamel paints, began to experiment with other, less shiny types of cheap, commercially manufactured paints. These account for the unusually bright, rather metallic colour harmonies of some of his paintings.

The mood of gaiety and release is typical of Picasso's work of 1914. The *Seated Woman* (coll. M. Georges Salles, Paris), illusionistically painted to imitate *papier collé*, is almost a parody of Cubist techniques. It has been seen that in many of Picasso's and Braque's paintings there are forms which look like fragments of pasted paper, and there are several Picasso still-lifes that, like the *Seated Woman*, are completely painted in direct imitation of *papier collé*. This is one of the contradictions of the style: having dispensed with the need for illusionism by incorporating fragments of external reality into their pictures Picasso and Braque then occasionally replaced these fragments by *trompe l'oeil* effects. On the other hand, the style was highly sophisticated and open to all kinds of intellectual refinements, and having definitively broken with traditional concepts of painting the artists felt at liberty to play as many variations as possible on the themes that occupied them. Humour also played a considerable part in the later, more mature phases of the style, and many of Picasso's paintings of 1913–14 have the quality of being pictorial *jeux d'esprit*. The *Seated Woman*, which is based on a whole selection of cut out papers,[1] some of which are painted in imitation of elaborately patterned, commercially manufactured

[1] See Z II (2) 792–803.

wall-papers, is in fact a technical *tour de force* requiring a complete knowledge and command of academic and illusionistic techniques. (Pl. 20b.)

Braque painted no figure pieces during 1914, and a still-life of this year, *Nature Morte à la Pipe* (coll. Girardin, Petit Palais, Paris), shows only a steady and logical evolution from his work of the previous year. The objects are now kept almost completely intact; although none of the innovations and discoveries of the past years have been discarded, there is a sense of ease in the way in which they are incorporated into the picture. Every object combines aspects not visible from a single point of view, but in the dice, for instance, this is now accomplished simply by unfolding two adjoining sides of it on to the picture plane. The painting is essentially flat but the spatial relations between the objects are made clear and there is a definite sense of recession. A typical feature of the work of both Braque and Picasso at this time is the way in which objects are sometimes accompanied by flat, opaque shapes which seem to be a part of them and yet to stand behind them, like shadows or reflections. The wine glass in this picture is reinforced by two heavy, square shapes. This, and the fact that one side of the bowl is curving and the other straight, gives the impression that not only has Braque combined various views of the glass into a single image, but that he has also synthesized into it various different types of wine-glasses. Some of the shapes are built up of sand and some of gesso, while the whole painting is covered with pointilliste dots of bright blue; the resulting effect is one of great variety and richness. (Pl. 40b.)

By 1914 Picasso was working in several different ways so that it is necessary to compare two of his still-lifes to the single one by Braque in order to show the stages reached by the two artists when they were separated in the early autumn of that year, soon after the outbreak of the war. *Le Violon* (Pl. 21a) is flatter than Braque's *Nature Morte à la Pipe* and at first sight more abstract. The composition has been built up of large flat, overlapping shapes, like brightly-coloured strips of *papier collé*. Each of these, with the exception of the patterned strip down the centre is, however, given a specific meaning so that three musical instruments can be discerned: a violin, a clarinet (both placed horizontally across the canvas) and a guitar. In other words, the shapes become the objects; and here we have a rare instance of Picasso working in what Gris would have agreed was a completely 'synthetic' way. In contradistinction to Braque's painting, the spatial relationships between the objects here are not clearly defined and remain a sort of intellectual puzzle. The *Green Still-Life* (Pl. 21b), on the other hand, a later work of 1914, is simpler, more naturalistic and more obviously decorative than *Nature Morte à la Pipe*. It has the same brilliant colour scheme as the

128

Homme assis au Verre and the same feeling of spontaneous gaiety. In the *Homme assis au Verre* the poster behind the man and the table at which he is seated seem to become almost part of the figure. In the *Green Still-Life* every object gives birth to a series of shapes or planes that are fused with the background or projected into it, producing an effect almost of movement. The fusion of subject and background had, of course, been accomplished much earlier in Picasso's and Braque's work of 1909–10. In these works of Picasso of 1914, however, there is a new feeling of dynamic interaction between the subject and its surroundings which was to become one of the distinguishing features of much of his work of the following years.

While Picasso and Braque were moving, largely under the influence of *papier collé*, towards a flatter, simpler and more decorative kind of painting, Gris' work was becoming increasingly complex and more refined. Gris, who had always been an original painter, had during 1912 asserted himself as an important influence on the minor figures of the Cubist movement. Now, in 1913, he was executing works which match the contemporary paintings of Picasso and Braque in quality and invention. Gris began to use pieces of *papier collé* in his paintings during 1913, and this naturally conditioned the appearance of his work, but there is not the same fundamental change in his style at this time as there was in the case of Picasso and Braque, who were both deeply influenced in all their work not only by the appearance of *papier collé* but also by the new pictorial techniques which it involved. Gris' work of 1913 shows rather a steady progression towards an increasingly accomplished and commanding kind of painting. It is true that in 1913 a greater element of abstraction begins to make itself felt in Gris' work, but this, it will be seen, was not altogether due to the influence of *papier collé*. And it was not until later, in the series of elaborate *papiers collés* which he did in 1914 that Gris started to become really interested in the possibilities of a new kind of painting in which formal abstraction played a much greater part.

Glass of Beer and Playing Cards is built up of the same upright, oblong forms (strips of *papier collé* and other shapes derived from them) that characterize so much of Picasso's and Braque's contemporary work. (Pl. 45b.) But while the heavy, linear 'grid' effect of some of the paintings of the previous year has disappeared, the system of vertical shapes that is imposed on the subject is made to serve much the same purpose. Within each shape the subject is seen from a different point of view, as it had been earlier within each compartment of the linear framework laid over it. Now, however, each part of the object is rendered also in a different way. The main part of the glass is painted solidly

and naturalistically, while the fragments adjoining it are rendered flatly in different colours. Sometimes the contours are shown simply by opposing a light area to a dark one, but, in other cases, a dark line is drawn over a light background or, reversing the process, a white line is drawn over a dark background. What is new, too, in the work of Gris is the way in which the component parts of an object are often completely displaced: thus the left hand side of the glass in this painting is slipped several inches downwards on a vertical axis. While most of the vertical compositional forms have literal meanings, some are coloured in an arbitrary way, and the displacement of others (for example an area patterned in the same way as the wall-paper appears at the bottom left hand side) gives a feeling of greater freedom of invention. While the fundamental premises of Gris' art were calculated and intellectual he had, of course, also a strong intuitive pictorial sense. In the works of 1913, the inventive, empirical aspect of his talent becomes increasingly obvious. The difference between this sort of painting and a work like *Le Lavabo* of the previous year is that now one has the impression that the composition, in terms of vertical, oblong planes, was not suggested or conditioned to such a great extent by the subject. That is to say that the frame-work or background of the painting has begun to assume more importance, and can be considered independently of the subject with which it is fused and related.

It has always been known that in connection with his later work Gris made a large number of preparatory sketches and calculations of a mathematical nature. These he generally destroyed after the paintings were completed; on his death, and at his request, his wife and Kahnweiler destroyed the drawings of this type which remained in his studio. But recently a few of these preliminary studies, which somehow escaped destruction, have come to light.[1] Four of these relate stylistically to the paintings of 1913 and 1914—surprisingly early for this kind of 'mathematical' drawing. They provide, needless to say, a new insight into Gris' method of work at this time. The simplest and perhaps the earliest of the drawings is of a single guitar, executed in heavy pencil or charcoal. (Pl. 47b.) By using the thin, carefully ruled pencil lines underneath as a starting point, it is possible to reconstruct some sort of underlying geometric framework. But an analysis of the drawing shows that any 'geometry' involved amounts simply to the fact that all the main lines composing the guitar are either rigid verticals or else diagonals inclined at forty-five degrees from them. Strictly speaking, there

[1] Five drawings of this type (two are on the reverse side of others) are at present in the possession of Mr. Heinz Berggruen in Paris. I am indebted to Mr. John Richardson for having told me of M. Berggruen's discovery.

is nothing scientific about this or any of the other drawings of the series. Gris has neither used nor tried to formulate optical laws or theories about the nature of volumes in space. Neither, at this point, are the compositions established according to consistent geometrical systems. Rather Gris has used a series of unrelated, arbitrary, angular and modular relationships and proportions to carry out his Cubist displacements and his Cubist analysis of volumes with a feeling of greater explicitness and exactitude. In the drawing discussed above, the two sides of the guitar are of exactly the same thickness, the distance from the centre of the hole of the guitar to the ends of each of the two handles or necks is the same, and so on. The other, slightly later, drawings are all more complicated but they appear also to be based on sets of angular relations combined with various arbitrary, aesthetic or mathematical modules. In all the drawings there are free-hand lines (as opposed to the majority of lines which are drawn with rulers and compasses) which have been put down in a purely intuitive way and which do not fit into any kind of mathematical scheme.

This type of preparatory drawing explains the presence of the abstract areas which begin to appear in the work of Gris during 1913. In the *Violin and Guitar* in the collection of Mr. and Mrs. Ralph D. Colin in New York, a work stylistically very close to the first drawing of the guitar, most of the shapes or planes around the objects are given a literal meaning, but each of the three main sections of the violin carries next to it an abstract plane of bright colour, and in other contemporary still-lifes there are often important compositional areas which seem to have no literal meaning. The drawing of the guitar discussed above suggests that Gris originally used these studies in order to find a means of explaining more fully and accurately the formal properties of his subjects. Indeed, the naturalism and solidity of the objects in his paintings of this period, and his later condemnation presumably of this phase of his Cubism[1] as analytical and descriptive, both indicate that this was still one of his main concerns. However, the drawings of this series show that as he experimented with geometrical equipment, compasses, protractors, setsquares and so forth, his fascination with formal relationships and proportions led him to break down the space or areas around his subject, often in an arbitrary or abstract way. In the paintings some of these shapes are given a representational meaning, but others are retained for purely formal or pictorial reasons. This painting also serves to show the greater naturalism and the emphasis on three-dimensional form that become a characteristic of the later work of 1913. (Pl. 47a.)

Gris had never abandoned colour to the extent that Picasso and Braque had,

[1] See Kahnweiler, *Gris*, 144–5, The *Letters of Juan Gris*, pp. 25–6.

and when these two painters began to widen their palettes during 1913, Gris increased the intensity of his colour so that his works, which during 1912 had been more highly coloured, remain more brilliant than theirs. The colours in *Glass of Beer and Playing Cards*, a work of early 1913, are varied but still relatively subdued. In the slightly later paintings of the same year such as *The Guitar*,[1] (Colour Pl. C) colour reaches an intensity that is unequalled in the contemporary work of any other Cubist painter, even Delaunay's and Kupka's experiments in pure colour look subdued by comparison. Often Gris applied the colours directly as they came out of the tube, unmixed with white, and their brilliance is accentuated by the areas of black which appear in his work at this time. Although at this point Gris' desire to convey a detailed, exhaustive and precise account of the nature of his subjects prevented him from opening up the contours of objects and allowing them to merge with their surroundings to create the sense of spatial continuity found in Picasso and Braque, here, as in some of their contemporary work, the shapes and planes behind the objects help to convey an impression of great compositional and spatial complexity and sophistication.

During the latter part of 1911 and the first half of 1912 Gris had done a series of landscapes, views of Paris, that relate closely to Picasso's landscapes at Horta de San Juan. These paintings of Gris', however, despite their simplicity and the grasp they show of early Cubist principles of composition, still have a slight *art nouveau* quality about them: the decorative, curving outlines of the buildings in particular recall his earlier commercial illustration. At Céret, where he spent the summer of 1913, Gris painted a second series of landscapes, which are a great deal more assured and accomplished. Neither Picasso nor Braque had painted any landscapes since 1911. For these landscapes Gris adopts an abnormally high view-point. In *Landscape at Céret* (present whereabouts unknown to the author), for example, the spectator seems to look down on the foreground houses almost directly from above. The sides of the houses, the far sides of the roofs and the chimney-tops are arbitrarily folded outwards on to the picture plane. The furthest houses show no diminution of scale and are piled upwards, accentuating the effect of flatness; only the small, dot-like trees on the horizon give a sense of recession. Dealing with a lot of small, distant objects, Gris was not able to exercise the same intellectual control that he shows in his contemporary still-lifes, and compositional unity is achieved by two abstract diagonal shapes that are superimposed over the subject, or into which the sub-

[1] This painting was executed at Céret during the summer of 1913 and is referred to in a letter written to Kahnweiler on Sept. 17. *Juan Gris*, p. 8.

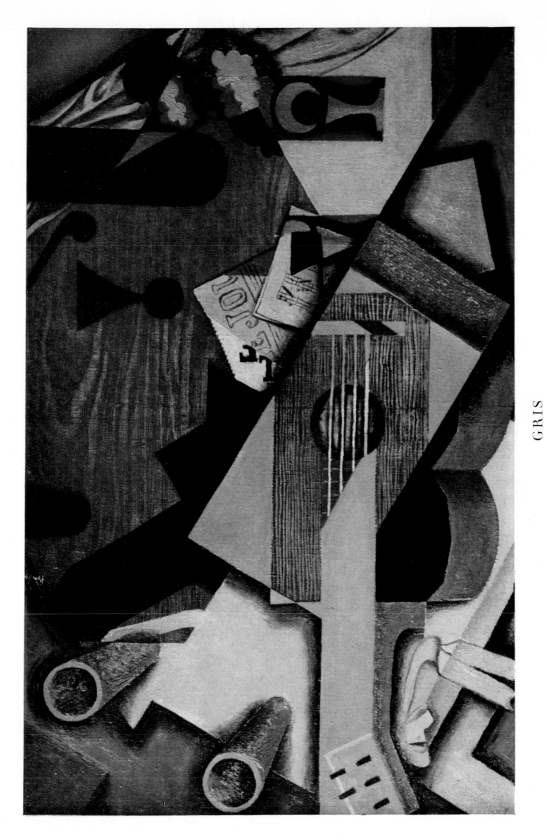

GRIS

c. The Guitar, 1913. Oil, 40" x 26"

Collection Mr. and Mrs. Jacques Gelman, Mexico City

ject is fitted. These paintings by Gris are important since they were to become the prototype for much subsequent Cubist landscape.[1] (Pl. 46.)

Whereas the last months of 1912 had marked a turning-point in the work of Picasso and Braque, 1914 was a more vital year in the evolution of Gris' art. *Papier collé* did not lead Gris to a simpler, more relaxed kind of painting as it did Picasso and Braque, and in the large series of *papiers collés* that he executed in this year Gris continued to exploit the literal, representational possibilities of the medium. Nevertheless, certain more abstract elements had begun to find their way into Gris' painting during 1913, and when he began to cover the entire surface of his canvases with pieces of paper of different sizes and shapes he undoubtedly started to become very aware of the possibilities of building up a composition in terms of large, abstract, coloured shapes over which a subject could be overlaid. The *papiers collés* mark the move, perhaps still unconscious, towards Gris' later 'synthetic' styles.

However, this is looking ahead. More immediately the *papiers collés* of 1914 represent the climax of Gris' exploration of the intellectual possibilities of Cubism and of the new techniques it had introduced. Clearly certain pieces of paper were introduced originally as pictorial shapes, to balance the composition, to pick up a note of colour, and so on, but almost every one of them can also be ascribed some literal meaning. In *Glasses and Newspaper* (Smith College Museum of Art, Northampton, Mass.), for example, the newspaper represents itself, the paper painted in a diamond pattern becomes the table cloth, while the piece of wood-grained paper in the middle of it relates to the legs of the table and tells the spectator the nature of the material that composes the table underneath the cloth. Pieces of this same imitation wood-graining are glued on to the chair behind the table, again informing the spectator of its properties. Over the pieces of paper, standing on the table, are two identical glasses, each seen from at least two points of view; as opposed to the way in which successive images were fanned out from below in many of the paintings of 1913, here in one of the glasses they are swung outwards to either side from a central point at the top. This same, detailed, intellectual analysis can be applied to every one of these *papiers collés* of Gris'. The harsh, often garish, colour schemes of the previous year give way to rich, sombre effects; blacks, browns and dark blues and greens predominate. (Pl. 48.)

By 1914 the principles of the Cubism of Picasso and Braque had been definitively established. At this point Braque's career was interrupted by the war. When he was able to resume his normal life in 1917, after a brief period of

[1] See e.g. the 1913–14 landscapes of Metzinger, Valmier, etc.

uncertainty he began to use his earlier discoveries to achieve a richer, more human and more completely personal style, which by the 1920's could no longer be classed as part of any general movement or style. Picasso painted on during the war, but the stylistic unity and continuity that had characterized the pre-war period was destroyed. By 1920 his Cubist works had been interspersed not only by a large number of naturalistic drawings and paintings but also by canvases in which he employed a variety of different forms of distortions, and even by a few experiments in a Divisionist technique. Detached from the rest of his work, however, Picasso's Cubist paintings executed during and immediately after the war represent a more or less straightforward progression from his earlier work. On the whole, he simplified his style and, as Braque was to do when he began painting again, he slowly widened his range of vision and subject matter. In 1915 and the succeeding years Picasso made relatively little use of *papier collé* and *collage*, and there are only a few constructions which can be ascribed to this period. On the other hand, after 1914 the purely pictorial possibilities suggested by these techniques are examined in a more detached and objective way. Generally speaking, the *trompe l'oeil* effects are abandoned; the ebullience and sardonic wit of the preceding years are held in check; the paintings become simpler, grander, one might almost say more structural or architectural. There is, however, no fundamental change in the method of Picasso's Cubism.

But in 1914 Gris' art was just entering one of its most crucial phases. And it is thus necessary to look ahead and give a brief summary of his work during the succeeding years in order to complete the picture of his evolution as a Cubist painter. Most immediately, in the series of large canvases finished in the early part of 1915, the complexity of his work of the previous years reached a climax. In paintings like *Livre, Pipe et Verres* (Pl. 50a) the number of objects that compose the still-lifes is increased; their fragmentation is more elaborate and the spatial relationships between them more intricate. There is, too, a greater skill and sophistication in the combination of various different techniques used to establish the nature of individual forms; in *Livre, Pipe et Journal*, for example, the central part of a coffee-pot is painted illusionistically (with the lid suspended above it), the right-hand side is indicated by a white line on a green ground, while the ground itself becomes the left-hand section by the application of a black shadow, which at once gives a sense of relief and conveys the contour of the spout and bowl. In this series of still-lifes the use of successive view-points is made particularly apparent by the bold repetition of the large forms of the table-tops, which are generally seen from slightly above, as in normal vision, and a second time as though from directly above.

The *Still-Life in front of an open window* (Pl. 49), a painting of the middle of this year, furthermore introduced a new factor into Cubism. Hitherto, although Braque had done paintings of scenes through open windows, the Cubists had avoided relating interior and exterior space. By placing his still-life in front of a landscape background, Gris was faced with the problem of introducing a new sense of depth and recession into his paintings. Gris, however, succeeds in conveying a very precise sensation of spatial definition. The still-life is intimately related to its surroundings—indeed it is inseparable from them—but each object retains its separate identity. Furthermore, the objects on the table stand well in front of the balustrade of the window, which in turn appears to be separated from the trees and houses behind by a considerable distance. There is a diminution of scale between foreground and background, lines at the sides of the picture lead the eye inwards, and the use of a paler tonality in the central section of the background is, in fact, a form of atmospheric perspective. But the sense of depth is conveyed primarily by less traditional methods. The objects and the areas to the sides and above them are encased by flat planes hung or placed in front of each other and given relief by shading around their outer edges; this was a method which Picasso and Braque in particular had been using for some time, but Gris' application of it to a more elaborate subject, treated in a wide range of colours, represents an extension and refinement of Cubist techniques. Many of the later works of this year and the first paintings of 1916 show Gris introducing into his work the pointilliste technique, favoured by Picasso and Braque during 1913 and 1914. And in works such as the *Blue Guitar on a Table* (Kröller-Müller Foundation, Otterlo) Gris produced some of the most strikingly decorative effects in all Cubist painting.

Gris' art, however, was at this time undergoing a much more fundamental change. In March 1915 he wrote to Kahnweiler: 'I think I have really made progress recently and that my pictures begin to have a unity which they have lacked till now. They are no longer those inventories of objects which used to depress me so much.'[1] It is true that the objects in Gris' paintings had always given the impression of having been derived from specific models, or at least of having an exact equivalent in the material world: in fact this was one of the characteristics of his Cubism that differentiated it from that of Picasso and Braque. Now, in 1915, while the objects in his paintings remain clearly defined, they begin to be much more generalized in appearance. This can be seen clearly in the *Still-Life in front of an open window*. The *compotier*, water-flask and glass no longer have the quality of being particular objects. The descriptive,

[1] *The Letters of Juan Gris*, pp. 25–6.

naturalistic details of the previous years are suppressed. Neither are the objects broken up into their component parts, dislocated and examined from different points of view. Instead Gris effects the same kind of optical synthesis in a single image that Picasso and Braque had evolved in the early years of their Cubism and that Gris had hitherto forced the spectator to accomplish for himself by piecing together the various fragments and views of the subject.

This new element in Gris' art was, as Kahnweiler has pointed out, the first step towards a more conceptual approach. The objects in Gris' paintings were now the products of his memory, or of some inner, mental vision of the world. The effect of this on his painting was an almost immediate move towards a more abstract method of composition. With the *papiers collés* of 1914, Gris must have been made increasingly aware of the possibilities of building up a composition in a purely abstract way, in terms of the 'flat, coloured forms' that he came to regard as the basic material of painting. Now that he was no longer conditioned or influenced to such a great extent by the appearances of objects in the material world surrounding him, Gris felt free to interpret or represent them in terms of fanciful, coloured shapes, provided that he could subsequently objectify them for the spectator by relating them in some way to their counterparts in real life. Technically, this enabled him to relate the subjects to the compositional planes around them in a much more intricate way, since all the component parts of a picture were now conceived primarily in terms of pictorial units. In the years following 1915, the objects in Gris' work became increasingly generalized, one might almost say increasingly abstract, in their conception. Many of the paintings of 1916 and the following years were clearly begun with specific subjects in mind but in other cases a geometrical proportion or the formal relations between a few coloured forms were the basis for his paintings, and the subject-matter only later suggested itself to Gris and was subsequently worked into the background. It is possible, too, that the sketches or calculations that preceded these paintings were by now more scientific, or at least more geometrically and mathematically consistent than earlier examples studied above. This is not to say that as Gris progressed towards the intellectual certainty he so desired he suppressed his more spontaneous, intuitive pictorial gifts. As the subject-matter was fused into the abstract substructure in these paintings, or emerged from it, Gris' eye, his instinctive pictorial sense, took over. The *pentimenti* in almost all his paintings after 1916 testify to the countless adjustments made before a work reached its ultimate conclusion. Nevertheless, the paintings executed between 1918 and 1920 have a precision and exactitude that mark the closest approach of Cubism to a mathematical science. (Pl. 50b.)

Gris has described both his aesthetic and his method of work with great clarity: 'It would be true to state that, with rare exceptions, elements of concrete reality have been rendered pictorial, a given subject has been made into a picture.

'My method of work is exactly the opposite. . . . It is not picture 'X' which manages to correspond with my subject, but subject 'X' which manages to correspond with my picture.

'I call this method a deductive method because the pictorial relationships between the coloured forms suggest to me certain private relationships between the elements of an imaginary reality. The mathematics or picture-making lead me to physics of representation. The quality or the dimensions of a form or a colour suggest to me the appellation or the adjective for an object. Hence, I never know in advance the appearance of the object represented. If I particularize pictorial relationships to the point of representing objects, it is in order that the spectator shall not do so for himself, and in order to prevent the combination of coloured forms suggesting to him a reality which I have not intended.

'I do not know if one can give to this aesthetic, this technique and this method the name of Cubism. . . .'[1]

All this amounts, of course, to a recapitulation of Gris' definition of synthetic Cubism. To his uncertainty as to whether 'this aesthetic, this technique and this method' could be given the name of Cubism, the answer is that they represented only certain aspects of Cubism pushed to their ultimate formal and intellectual conclusions. But because of his detachment, his refusal to deviate from the task he had set himself of analysing and defining the nature and aesthetic of Cubism, Gris remained in some ways its purest exponent. Years later, when he himself was still making use of the discoveries and principles of his Cubist years, Braque was able to say 'Le seul qui ait poussé les recherches cubistes avec conscience, à mon sens, c'est Gris'.[2]

[1] *Notes on my Painting*, addressed to Carl Einstein, published first in *Der Querschnitt*, nos. 1 and 2, pp. 77 and 78, Frankfurt-on-Main, summer 1923. Reprinted in Kahnweiler's *Juan Gris*, pp. 138–9.
[2] *Braque, la Peinture et Nous*, p. 19.

THE INFLUENCE OF CUBISM IN FRANCE
1910-14

In *Les Peintres Cubistes*, Apollinaire wrote of the rise of Cubism: 'cette esthétique nouvelle s'élabora d'abord dans l'esprit d'André Derain.'[1] Although Derain never became a Cubist, Apollinaire's statement is not as unreasonable as it might at first seem, for Derain has some place, albeit a very hard one to define, in the history of the movement. In 1906 he was certainly regarded as one of the three or four most significant young painters working in Paris, and because of his fundamental eclecticism he reflects better than almost any other painter the various influences that were at work at this time. In the first place, Derain turned seriously to Cézanne for inspiration just before Picasso and Braque. In this he was not, of course, a pioneer; at the advanced *Salons* of 1903 and 1904, the influence of Cézanne was everywhere.[2] However, in an isolated early example, a *Still Life* of 1904 (in the collection of Mme. C. Baron, Garches), Derain had seized on many of the aspects of Cézanne which were to influence the Cubists. In it he adopted Cézanne's high, informative viewpoint; forms are boldly simplified, and there is an interest in reconciling three-dimensional form with the flat picture surface. But characteristically, although Derain has emphasized some of the most important aspects of Cézanne's work, he reduces them to a rather obvious kind of formula. He avoids any intensive analysis of form, and his work lacks the concentration and structural precision of the paintings executed by Picasso and Braque when they in turn came under the influence of Cézanne. (Pl. 76a.)

Then, largely through his admiration for Gauguin (and this influence can be seen even in the Cézannesque still-life discussed above) in 1906 Derain began to explore the aesthetic possibilities of 'primitive' art just before Picasso did. Again

[1] p. 22. Ozenfant and Jeanneret in *Après le Cubisme*, Paris 1918, make almost exactly the same point as Apollinaire.

[2] See p. 22 above.

Derain was not alone in this. Matisse was certainly familiar with Negro sculpture by 1906, and Vlaminck knew it even earlier.[1] However, Derain was perhaps the first of these painters to appreciate Negro work in a more serious and thoughtful or intellectual way, and to absorb some of its formal qualities into his own painting. Apollinaire stressed this point in a little-known article entitled *Les Commencements du Cubisme*, which appeared in *Le Temps* on the 14th October 1912. Since this is the first purely factual account of the discovery of Negro art by the painters, it is perhaps worth summarizing it here. After describing the way in which Vlaminck first discovered African art,[2] when he chanced to come across some Negro masks in a curiosity shop in a village on the banks of the Seine, Apollinaire goes on to say, 'ces singuliers simulacres africains causèrent une profonde impression sur André Derain qui les considérait avec complaisance, admirant avec quel art les imagiers de la Guinée ou du Congo arrivaient à reproduire la figure humaine en n'utilisant aucun élément emprunté à la vision directe. Le goût de Maurice de Vlaminck pour les sculptures nègres et les méditations d'André Derain sur ces objets bizarres à une époque où les impressionnistes avaient enfin délivré la peinture des chaînes académiques, devaient avoir une influence décisive sur les destinées de l'art français.'

But what gives Derain a place as a true forerunner of Cubism is that he was the first painter to combine in a single work the influences of both Cézanne and Negro art. This he did in his large *Baigneuses* (coll. Joseph Muller, Solothurn) which was painted in the winter of 1906 and shown at the *Salon des Indépendants* of 1907. Vauxcelles, in his review of the exhibition, wrote: 'un mouvement que je crois périlleux se dessine. Une chapelle s'est constituée où officient deux prêtres impérieux, Derain et Matisse . . . cette religion ne me séduit guère.'[3] The movement to which Vauxcelles refers is, of course, Fauvism, but his remarks are puzzling since two years before he himself had given the movement its name, even if contemptuously, and had been a cautious supporter of Matisse and Derain for some time; he seems to have felt that there was some new element in their recent work. This was to a certain extent true. The paintings shown by both painters were less decorative and more structural than their most typically Fauve works of the previous years. Matisse was represented by his large *Blue Nude* (now in the Baltimore Museum of Art). After criticizing it for its crudity, Vauxcelles passed on to Derain's *Baigneuses*: 'les simplifications barbares de Monsieur Derain ne me heurtent pas moins: des marbrures Cézan-

[1] See p. 55 above.

[2] Apollinaire's account of all this is more or less confirmed by Vlaminck himself in *Portraits avant Décès*, Paris 1943.

[3] *Gil Blas*, 20 March 1907.

niennes verdoient sur les torses des baigneuses enfoncées dans une eau terrible-ment indigo.'[1] There were, however, significant differences between these two paintings. As opposed to the *Blue Nude* the colours in Derain's work are more naturalistic (although the background is a violent Prussian blue), and whereas the contours of Matisse's figure are free and sensuous, Derain's bathers are seen in terms of simple, angular, almost geometric forms that remind one of certain paintings by Cézanne. (Pl. 76b.)

The heads of Derain's figures, and particularly that of the central bather, are related to a type of Negro sculpture, found most commonly in the French Congo, in which the head is reduced to a simple spherical or block-like shape, and the features, except for the nose, are represented simply by indentations or concave planes.[2] Derain used this same type of Negro head, more directly, as a model for the faces of the central figures in his *Last Supper* (in the Art Institute of Chicago), a painting executed a year or two later.[3] Derain has not put either Negro art or Cézanne to particularly original ends as did Picasso in his *Demois-elles d'Avignon*, but the presence of these two influences in the *Baigneuses* serves to relate the two paintings and to prove that at any rate the two painters were closer artistically at this period than has been generally supposed. In *Les Commencements du Cubisme* Apollinaire discusses the relationship between Derain and Matisse during 1905 and then goes on to say: 'L'année suivante (1906) Derain se lia avec Picasso et cette liaison eut pour effet presqu'immédiat la naissance du Cubisme.' Apollinaire continues: 'Dès la fin de l'année, le cubisme avait cessé d'être une exagération de la peinture des Fauves dont les violents coloriages étaient de l'impressionnisme exaspéré. Les méditations nouv-elles de Picasso, de Derain et d'un autre jeune peintre, Georges Braque, aboutirent au véritable cubisme qui fut avant tout l'art de peindre des en-sembles nouveaux avec des éléments empruntés, non à la réalité de vision mais

[1] Ibid.

[2] Some of the heads in Derain's *Baigneuses* and several in the *Last Supper* are close to a Negro head reproduced by Carl Einstein in his *Neger Plastik*, Munich 1920, pls. 14 and 15. This head was in the collection of Frank Haviland, a friend of Derain's. It was reproduced for the first time in Maurice de Zayas' *African Negro Art and its Influence on Modern Art*, New York 1915. M. Charles Ratton believes that the mask sold to Derain by Vlaminck, which Vlaminck talks about in *Portraits avant Décès*, is one of the masks, now in the possession of Mr. J. J. Kleyman, N.Y. This mask was of a different type from the one discussed above, although there are certain com-mon characteristics. Haviland's collection was dispersed in 1936.

[3] This work is extremely hard to date. It was not shown publicly in Paris and did not pass through Kahnweiler's hands. Critics have dated it from 1907 (Salmon) to 1913 (Leymaire) and 1914 (Einstein). It seems most likely to have been executed in the years immediately following the *Baigneuses*. It might possibly be the picture subsequently referred to in a note in *Paris Journal* on 25 Oct. 1911: 'Derain, le collectionneur de statues nègres . . . avait presque décidé à envoyer un grand tableau d'une beauté certaine (au Salon d'Automne): *Le Déjeuner*. Or Derain barbouilla le tableau: la nature morte, disait-il, avait trop d'importance.' The following year, 1912, Derain entered his 'Gothic' period.

à la réalité de conception'.[1] While Derain had no such positive role in the creation of Cubism one can see how the concern with solid formal values and the presence of the influences of Cézanne and Negro art in his work would have led Apollinaire to associate him with the birth of the movement.

In a review of the *Salon des Indépendants* of 1914 Apollinaire looked back over the past years and once again emphasized Derain's role in the formation of Cubism: 'Il y a deux grands courants, dont l'un est issu du Cubisme de Picasso et l'autre du Cubisme d'André Derain, l'un et l'autre viennent de Cézanne.'[2] This time Apollinaire was obviously overstressing the importance of Derain to an absurd degree. In actual fact, in 1907, the same year that he exhibited the *Baigneuses*, Derain fell under the artistic dominance of Picasso and began to lose his place at the forefront of modern painting; *la Toilette*, which he showed at the *Salon des Indépendants* of 1908, was a lifeless painting derived directly from the *Demoiselles d'Avignon*. Nevertheless, during the years immediately following 1907 Derain continued to be a strong influence on many of the younger painters who were turning away from Impressionism and Fauvism towards a solider, more austere, form of expression. Furthermore, Derain was typical of a large number of artists (among whom were many of the painters of the *Section d'Or*) whose work had certain features in common with the early Cubism of Picasso and Braque, but who were unable or unwilling to break with traditional concepts of form and space.

During the years immediately following 1907 it became obvious that a general movement towards a more thoughtful and formal kind of painting was taking place. At the *Salon des Indépendants* of 1907 Fauvism was still a force (Vauxcelles counted some twenty-five painters whom he felt had been touched by it),[3] but the movement had lost much of its original impetus. In 1908, at the *Salon d'Automne*, Vauxcelles was able to say 'l'ère des ébauches semble donc près d'être close'.[4] By this time many of the former Fauves, painters like Braque, Dufy, Vlaminck and Friesz had renounced the unnaturally bright or arbitrary colours which had been one of the distinguishing features of the style and were turning for inspiration to the more structural aspects of Cézanne's work; the influence of Gauguin, on the other hand, was declining. With the exhibition at

[1] A note in *Gil Blas* on 8 Oct. 1912 about a proposed exhibition of Negro sculpture also links the name of Picasso with those of Derain and Matisse: 'On sait que Matisse, Derain et Picasso furent les premiers à remplacer les moulages grecs par les simulacres d'une beauté barbare mais souvent saisissante. Ils les étudièrent et les imitèrent même, imitation qui marqua le déclin du fauvisme et l'aurore du Cubisme.'
[2] *L'Intransigeant*, 26–8 February 1914.
[3] *Gil Blas*, 20 March 1907.
[4] *Gil Blas*, 30 Sept. 1908.

Kahnweiler's in 1907 and the paintings he showed at the *Salon des Indépendants* of 1909, Braque had emerged as a controversial and original painter; the influence of Cézanne could still be seen in his work, but it was obvious that he had achieved something new and important. Derain, who continued to be influenced by Picasso, Cézanne and primitive art, was producing works that were becoming increasingly austere and archaistic. Only Matisse had followed up the decorative and sensuous aspects of Fauvism to produce a highly individual style of his own, and he, it is true, remained an important influence. His disciples, however, were almost all foreign painters (mostly Germans and Americans), and their work belonged to a conscious 'school' of painting, rather than to a spontaneous movement. The work of Van Dongen, who had been associated with the Fauves and had been singled out as an important and promising young painter, had become frankly journalistic and commercial.

Another important indication of the direction in which contemporary painting was moving was the fact that for the first time the work of the Douanier Rousseau was being taken seriously by a large number of people. Rousseau had been exhibiting regularly at the *Salon des Indépendants* since 1886, but for a long time had received encouragement only from a few individual painters such as Signac, Luce and Lautrec. Shortly before the turn of the century, his original personality attracted the attention of Alfred Jarry and the circle around him; Apollinaire later became a close friend. Nevertheless, Rousseau's literary friends seem to have regarded his painting with a certain amount of amusement, and it was only towards the end of the first decade of the twentieth century that his painting began to enjoy a success with the serious critics. Vauxcelles reviewed his work favourably for the first time in 1909,[1] and in his review of the *Salon des Indépendants* of the following year, Apollinaire dedicated a long and enthusiastic passage to Rousseau's large painting *Le Rêve*.[2] In fact, though, the new taste for Rousseau's work was one which was dictated by the painters rather than by the critics. In 1908 Picasso had bought Rousseau's *Portrait of Yadwriga* (still in his possession), and in the same year he honoured the old painter with a banquet in his studio in the *Bateau Lavoir*, which was attended by many of the most advanced painters and poets in Montmartre and by a few distinguished visitors from the left bank as well; the influence of Rousseau can, perhaps, be seen in some of Picasso's landscapes executed at La Rue-des-Bois in the autumn of 1908. At the same time, other painters were being drawn to Rousseau's work independently. By 1909 both Léger and Delaunay were friendly

[1] *Gil Blas*, 25 March 1909.
[2] *L'Intransigeant*, 18 March 1910.

142

with Rousseau and used to frequent his musical *soirées*; the *Snake Charmer*, which was shown at the *Indépendants* of 1907, had been commissioned by Delaunay's mother. It is not strange that a generation of artists who had discovered the aesthetic worth of Negro sculpture should also have felt sympathy for the art of this old 'primitive'. For as in African and other primitive art they found in Rousseau directness of vision and formal simplicity, unperverted by the over-refinement and sophistication with which so much traditional art had become over-laid. Although he dealt with elaborate literary and allegorical themes of the most hackneyed kind, the freshness and uncompromising realism of his vision gave the impression of an artist who was seeing the world for the first time and revealing in his work only its most essential formal and human qualities. In other words, the naiveté of his approach had the effect of deflating these subjects of their pretensions. Then with his painstaking approach and his refusal, or inability, to conceal technical difficulties and problems, he seemed to be 'redoing' painting from the beginning. To this extent he, too, was a 'pure' painter. Rousseau died in 1910. The following year a large retrospective exhibition of his work was held at the *Salon des Indépendants*. The exhibition was hung in the hall between the two rooms occupied by the paintings of the Cubists and their friends.

By 1909 the work of some of the future Cubists, apart from Picasso and Braque, was beginning to attract attention. In the same review of the *Salon des Indépendants* in which he referred to Braque's 'bizarreries cubiques', Vauxcelles attacked the work of Le Fauconnier and Metzinger. Metzinger had abandoned Divisionism the previous year, after Max Jacob had introduced him into the circle that revolved around Picasso. 'Que Metzinger galope à la suite de Picasso ou de Derain ou de Braque,' wrote Vauxcelles of the paintings Metzinger showed at the *Indépendants*.[1] Le Fauconnier was criticized for his extreme simplification of form; he exhibited a portrait of a child and a landscape which he had executed at Ploumanach in Brittany during the previous year when he had been working under the influence of Derain. In 1909, however, Le Fauconnier developed a more personal style, and at the *Salon d'Automne* of this year he exhibited a *Portrait of Jouve* (Pl. 66a) a work that was to have a profound effect on the work of another of the future Cubists. Albert Gleizes wrote of this painting in his *Souvenirs* 'J'en tirai tout de suite une leçon'.

To-day it seems hard to think that the *Portrait of Jouve* could have been regarded as a progressive and revolutionary work. It is weakly constructed, and has an *art nouveau* flavour that reminds one that as a student Le Fauconnier

[1] *Gil Blas*, 25 March 1909.

had been an admirer of the Nabis and in particular of Maurice Denis.[1] On the other hand, the picture has certain features in common with more advanced paintings of the period. It is executed in severe harmonies of browns and greys, similar to those used by Picasso and Braque at this time, and there is a simplicity about it which is equalled only in contemporary canvases by Matisse and, perhaps, in the decorative frivolities of Marie Laurencin (Pl. 77a) and Van Dongen. Furthermore, there is an attempt (however unsuccessful) to deal with the figure in terms of elementary geometric shapes that serves to relate the painting in a very general way to Picasso's and Derain's work of the previous years. Gleizes was particularly impressed with the way in which Le Fauconnier deliberately suppressed all inessential details and used colour merely as a support for the 'armature' of the design: 'Le dessin qui m'était apparu comme possédant la clé de mes aspirations et que je ne parvenais pas à dominer, m'avoua dans le portrait de Jouve la véritable direction'.[2]

At the *Salon d'Automne* of 1909, where Le Fauconnier showed the *Portrait of Jouve*, Léger was represented by a Corsican seascape and a landscape entitled *Le Jardin*.[3] These paintings were executed in Léger's early style, which was a fusion of elements borrowed from Impressionism, Neo-Impressionism and Fauvism. *La Couseuse* (coll. Kahnweiler, Paris), however, a work of the summer of 1909, marks a break in Léger's art (Pl. 51). In it colour is reduced to a scheme of blue-greys and pale buffs, while the human body is interpreted in terms of simple, cylindrical or tubular forms, faceted in a simple, rather primitive fashion, that give the figure something of the appearance of a mechanical robot. In contrast to the basic flatness of Le Fauconnier's work, Léger's forms are so insistently modelled that their three-dimensional quality becomes almost aggressive. Léger always claimed that Cézanne was the starting point for his art. In a lecture entitled *Les Origines de la Peinture Moderne*, which he delivered at the Académie Wassilief in 1913[4] Léger said, 'un peintre parmi les impressionnistes, Cézanne, comprit tout ce qu'il y avait en elle [la peinture impressionniste] d'incomplet.' What Léger felt that Cézanne had restored to painting was, of course, a sense of form and structure and a feeling for volumes in space. Léger emphasized, too, the fact that Cézanne had seen the necessity of reintroducing

[1] Gleizes, *Souvenirs*.

[2] Ibid.

[3] The seascape is reproduced in Descargues, *Léger*, 1955, p. 11. The *Jardin* is the painting shown at the posthumous Paris exhibition of Léger in 1956 (at the Musée des Arts Décoratifs), cat. no. 3. This information from the artist was passed on to me by Mr. D. Cooper. The *Jardin* is, however, dated 1905 in the Paris Catalogue so that Léger was exhibiting in 1909 a painting done four years earlier.

[4] The lecture was delivered on 5 May 1913, and was published in the issues of 29 May and 14 and 29 June 1913 of *Montjoie*.

the use of lines or contours as a means of expressing visual reality. This was an aspect of Cézanne that had escaped the attention of many of Léger's contemporaries, who, although they all admired the solidity and formal clarity of Cézanne's art, tended to take the opposite point of view and to stress the fact that he had broken the contours of objects and had thus given painting a greater sense of fluidity and freedom. There was a certain amount of truth in both views. As opposed to the Impressionists, Cézanne was always anxious to delineate each object in his painting as fully and clearly as possible, while at the same time the contours of the objects in his paintings are constantly broken and rebroken in an attempt to expand volumes as much as possible and to reconcile them with the two-dimensional picture plane. What is significant is that Léger should have seized on the element of definition in Cézanne's work. Nevertheless, in *La Couseuse* any debt to Cézanne is of a very intellectual or generalized kind. Indeed, the colour, the smoothness of the modelling and the simple, rounded forms suggest that Léger had been influenced as much by the art of the Douanier Rousseau as by that of Cézanne.

The painting of Delaunay, with whom Léger was becoming particularly friendly at this time, was moving in a similar direction. In 1908 Delaunay was still working in a Divisionist technique, but in the first of his paintings of Saint Séverin, begun early in 1909,[1] and in most of his *Eiffel Towers* painted later in the same year, the influence of Cézanne began to assert itself strongly; in the case of the *Eiffel Towers* the choice of subject-matter may have been inspired by the Douanier Rousseau whom Delaunay greatly admired. In one of the first of this series (Pl. 60a), in the Arensberg Collection in the Philadelphia Museum of Art, the treatment of the foliage in terms of a few clearly defined shapes is a feature obviously derived from Cézanne; indeed, the painting recalls some of Braque's Cézannian landscapes of the previous year, although Delaunay's work has a bluntness and crudity that still relates it to his earlier Divisionist work. Like Léger, Delaunay at this point was striving for a very precise definition of form, and the outlines of the Tower are carefully preserved. As opposed to Léger, however, Delaunay did not limit his use of colour, and this painting is executed with a full palette. In his notebooks, under a photograph of one of his contemporary Saint Séverin pictures, Delaunay wrote: 'période de transition de Cézanne au Cubisme. . . . Dans *Saint Séverin* on voit la volonté de construire, mais la forme est traditionnelle. . . . La couleur est encore clair-obscure, malgré le parti pris de ne pas copier objectivement la nature, ce qui fait encore perspec-

[1] For the problems involved in dating Delaunay's work and the ways of solving them see footnote to p. 155 below.

tive. . . . Comme chez Cézanne, les contrastes sont binaires et non simultanés.[1] Les réactions de couleurs conduisent à la ligne. La modulation est encore l'expression classique dans le sens du métier expressif. Cette toile marque bien le désir expressif d'une forme nouvelle mais n'aboutit pas. Grande influence sur l'expressionnisme, sur le film Caligari, sur le théâtre russe.'[2]

By 1910 Metzinger had known Delaunay and Léger for some time, and he saw that, like Picasso and Braque, these two painters were using the discoveries of Cézanne to new ends. Although Metzinger was a painter of very little imagination or originality, he was one of the first people to realize that Picasso and Braque were evolving a completely new style of painting, and he was anxious to organize the efforts of his friends into a modern school of painting with a clearly defined aesthetic. When his own paintings were hung by chance next to those of Gleizes and Le Fauconnier at the *Salon d'Automne* of 1910 he was quick to notice the similarities between them. In his *Note sur la Peinture* which was written in September of 1910, after the opening of the *Salon d'Automne*, Metzinger proclaimed the birth of a new movement in painting, which was neither romantic nor decorative, and which had as its foundation a concept of form which was the result of a peculiarly modern sensibility. 'Pour nous les Grecs ont inventé la forme humaine; nous devons la réinventer pour d'autres. . . . La forme, prise depuis trop de siècles pour le support inanimé de la couleur, recouvre enfin ses droits à la vie, à l'instabilité.' This new art, Metzinger felt, was represented in the work of Picasso, Braque, Delaunay and Le Fauconnier.

Metzinger was one of the leading spirits in the campaign to reform the laws about the hanging of paintings in the *Salon des Indépendants*.[3] The result of this was, as we have seen, that he and his friends were able to show together as a group at the *Indépendants* of 1911, the first of the Cubist *Salons*. Metzinger himself was represented by four works; the largest and most important of these was a painting of two nudes against a background of trees (present whereabouts unknown). The figures in this painting with their featureless faces and faceted bodies, lit from a single, strong light source, are derived directly from Picasso's figure pieces executed in Paris after his return from Spain in the autumn of

[1] For Delaunay's definition of 'simultaneous' colour contrasts see pp. 173–4 below.

[2] These manuscript notebooks, now in the possession of Madame Sonia Terk Delaunay, consist of random jottings, and are full of mistakes of grammar and orthography. It is not clear when they were written but they appear to date from the later years of Delaunay's life. They are freely quoted from by Gilles de la Tourette in his *Delaunay*, Paris 1950, although often reinterpreted and very inaccurately transcribed. I have chosen to use the original even when the sense is not always completely clear.

[3] See p. 25 above.

1909. Metzinger therefore took as his starting point works in which Picasso's analysis of solid forms was at its most intensive. However, if Metzinger was able to appreciate intellectually the importance of Picasso's art, in his own painting he was influenced only by its most superficial aspects. In the *Two Nudes* Metzinger has learned from Picasso how to reconcile three-dimensional form with the picture plane, by placing the subject in shallow depth and fusing it with its surroundings, but there is no real interest in analysing solid forms. In his early, analytical Cubism Picasso distended and distorted form, seeking to convey a sense of solidity and to synthesize as much information as possible into a single image. Metzinger, on the other hand, elongates his figures in a mannerist fashion, denying their sculptural solidity. His vision is still fundamentally naturalistic, and he views his subject from the single, static point of view of traditional painting. In short, the *Two Nudes* is only Cubist in the most superficial and obvious sense of the word, in that there is a deliberate 'cubification' of volumes. (Pl. 64a.)

Léger's major painting at this exhibition was a large canvas entitled *Nus dans un Paysage* (Pl. 52a), which he had begun as early as the autumn of 1909,[1] while Delaunay showed three Parisian landscapes, one of which was a painting of his *Eiffel Tower* series. The work of both painters was much more interesting than what they had been producing a year earlier. The *Nus* can, however, be regarded as a perfectly logical development of the *Couseuse*. For like the *Couseuse* it shows Léger investigating the nature of solid, geometrical forms and exploring the pictorial relationships between them. The *Nus* is, of course, a much more ambitious and complex painting. 'Je voulais pousser les volumes aussi loin que possible,' Léger later recalled.[2] There is a great deal more subdivision within the basically simple forms of the figures, and whereas the *Couseuse* stands out against the background in sharp relief, here Léger has retained a balance between solid forms and the two-dimensional picture plane by reducing everything, figures, trees, landscape and background, to geometrical shapes of more or less equal size, as Picasso and Braque were doing in many of their paintings of 1909. Indeed, the faceted, elaborate and analytical treatment of the bodies in the *Nus* reminds one of Picasso's work of the Horta period. But, unlike Picasso, Léger shows no interest in summarizing or synthesizing various views of his models into a single image. And this, it will be seen, remained one of the fundamental differences between Léger's Cubism and

[1] Information received from Mr. D. Cooper.
[2] Quoted in the Catalogue for the Léger exhibition at the Musée des Arts Décoratifs in 1956, p. 78.

that of Picasso and Braque, even after he dispensed completely with traditional linear perspective. Here perspective is suggested by the abrupt foreshortening of the lower limbs of all three figures; these are the sort of poses that Picasso and Braque deliberately avoided. Neither is Léger's painting conceptual in the sense that theirs was. He does not express his idea of the human body but uses his subject rather as a starting point for a geometric, cubistic experiment. And Léger was faced with a different problem from Picasso and Braque, that of retaining the geometric solidity, the sculptural quality of his figures and yet conveying the sense of motion that is implied in the active poses of the figures. This he has done simply by the vigorous, muscular subdivision of the forms of the bodies and by building up the composition by a series of short, emphatic diagonal movements; even the verticality of the tree-trunks is destroyed. For the *Couseuse* Léger had used a consistent, bright and direct form of illumination. Here he has substituted a generalized, 'sous-bois' effect. The forest setting, the solid, tubular forms, and the grey-green tonalities recall once again the work of the Douanier Rousseau. Léger, discussing this painting, has said, 'on a dit qu'il y avait dans cette toile des influences du Douanier. C'est peut-être vrai parce qu'à cette époque je voyaise Douanier, mais c'est inconscient. . . . Les *Nus dans la forêt* (the painting subsequently became known by this name) pour moi, n'étaient qu'une bataille de volumes. J'avais senti que je ne pouvais pas faire tenir la couleur. Le volume me suffisait.'[1] The dispassionate, almost brutal way in which Léger was attacking the problem of analysing solid forms disturbed Apollinaire who, in his review of the exhibition, wrote: 'Léger a encore l'accent le moins humain de cette Salle. Son art est difficile, il crée, si l'on ose dire, la peinture cylindrique et n'a point évité de donner à sa composition une sauvage apparence de pneumatiques entassés. N'importe! La discipline qu'il s'est imposée mettra de l'ordre dans ses idées et l'on aperçoit déjà la nouveauté de son talent et de sa palette.'[2]

Delaunay's *Eiffel Tower* (Guggenheim Museum, New York)[3] which was not begun until nearly a year after the *Nus* is a more assured, less experimental work (Pl. 56). In the spring of 1910 Kahnweiler had bought the *Couseuse*[4] and had begun to become seriously interested in Léger's work. Soon Léger was frequenting the gallery in the rue Vignon. 'Là, nous avons vu, avec le gros Delaunay, ce que les cubistes faisaient. Alors Delaunay, surpris de voir leurs

[1] Ibid., p. 78.
[2] *L'Intransigeant*, 20 April 1911.
[3] There are several similar versions of the *Eiffel Tower*, and it is impossible to discover which of them was shown at the *Indépendants* of 1911. There are two versions in the Guggenheim Museum and a third in the Kunstmuseum in Basle.
[4] Information received from Mr. D. Cooper.

toiles grises, s'est écrié: "Mais il peignent avec des toiles d'araignées, ces gars!". '[1] This remark must have been inspired by Picasso's and Braque's most recent canvases in which they were evolving the linear, grid-like kind of composition that enabled them to suggest form and space more freely than when they were still working with closed contours. At any rate, both Léger and Delaunay were immensely impressed by what they saw, and the *Eiffel Tower* by Delaunay bears witness to the fact that he looked at the work of Picasso and Braque in a very intelligent if subjective way. Unlike Picasso, Braque and Léger (and for that matter unlike almost all Cubists), Delaunay was never interested in analysing, or even in portraying, solid forms. On the other hand, he realized at once (and more fully than any of the other painters showing at the *Salon des Indépendants* of 1911 in Room 41) that by dismissing traditional perspective Picasso and Braque had revolutionized traditional ideas of pictorial form, and, more important from his point of view, pictorial space. In this painting the lower part of the Eiffel Tower is seen diagonally, while the upper part is seen as though from in front. However, in the top half, three sides of the tower are seen simultaneously (as opposed to one side that would be seen in normal vision), and below fragments of a third side of the base are scattered through the houses clustered at its foot, so that Delaunay is in fact achieving the same kind of optical synthesis which was one of the most important features of the Cubism of Picasso and Braque. Furthermore, by pushing the middle of the tower inwards, away from the spectator (or by bending the upper part of it forwards towards the spectator), Delaunay creates a new spatial effect whereby the structure of the painting cannot be grasped at a single glance but has to be read in two sections;[2] many of Braque's later works produce the same visual sensation.[3] As in works by Picasso and Braque, forms are opened up into each other and into their surroundings. As opposed to Léger, Delaunay felt that Cézanne's importance lay in the fact that he had broken the contours of forms and had thus given painting a greater sense of mobility. Delaunay later referred to this phase in his own art as 'l'époque destructive'. In his notebooks, accompanying a reproduction of one of his *Eiffel Towers*, he wrote this comment: 'Cézanne est définitivement brisé par nous les premiers cubistes. Après avoir brisé le compotier on n'a pas pu le recoller.' But whereas in the contemporary work of Picasso and Braque space is made concrete and fused with material objects, the

[1] Catalogue cit., p. 27. Delaunay had met Picasso several years before this, and may even have seen some of his early Cubist paintings before he went with Léger to Kahnweiler's.

[2] This is an aspect of Delaunay's work that is discussed by de la Tourette.

[3] For a discussion of the spatial inventions in Braque's later works see J. Richardson, *The Ateliers of Braque* in the *Burlington Magazine*, June 1955.

work of Delaunay gives one the sensation that forms have been forcibly shattered, and this produces a sensation of energy and movement. In his *Note sur la Peinture* Metzinger had written that Delaunay's paintings seemed to sum up the 'paroxysm' of a disordered and restless age.

Le Fauconnier and Gleizes represented the more conservative faction in Room 41, although Le Fauconnier's *Abondance* received a great deal of critical attention. This was strange since there was nothing revolutionary about Le Fauconnier's work, which was less Cubist than that of Léger, Delaunay, and Metzinger, or even that of Gleizes. Despite the squat, broad proportions of the figures in *L'Abondance*, Le Fauconnier shows no interest in going very deeply into any kind of analysis of solid form. In fact, he has simply seized upon the most accessible aspect of Cubism, that is to say the treatment of forms in terms of simple, angular facets, as an easy way of dealing with a monumental subject. There is no atmospheric recession, but the perspective is completely traditional. The houses and road have a more or less consistent vanishing point (the road undoubtedly leads the eye inwards, into depth) and there is a logical diminution of scale from one background plane to the next. Gleizes' *La Femme aux Phlox*, on the other hand, although it derives from Le Fauconnier, is a more honest attempt to come to grips with the problem of reducing figures and objects to their simplest, most elementary shapes. The picture is, however, full of inconsistencies; for example, Gleizes had dealt with the flowers and the woman's surroundings in a bold, rather drastic fashion, but the figure itself is treated in an angularized but completely naturalistic way. At the same exhibition Gleizes also showed a *Landscape*, now in the Musée d'Art Moderne in Paris, and this, while it had superficial similarities with Braque's paintings executed at L'Estaque in 1908, showed that Gleizes was still unable to impose satisfactorily his own geometric vision on the natural scene. (Pls. 65 and 62a.)

In Room 43, which was separated from Room 41 by the retrospective exhibition of the Douanier Rousseau, the Cubists placed the works of painters whom they felt had aims similar to their own. The most important of these painters was Roger de la Fresnaye, who showed a large canvas called *Le Cuirassier* (Musée d'Art Moderne, Paris), based on Géricault's painting in the Louvre; La Fresnaye had turned to military subjects during 1910 when he was working on the illustrations for Claudel's *Tête d'Or*. Stylistically the *Cuirassier* relates most closely to Derain's work of the previous years; indeed it has much in common with both the *Baigneuses* and the *Last Supper*. Any reference to primitive or archaic art forms is, however, less direct, and La Fresnaye uses the simple forms and expressionless faces to achieve a tasteful, consciously classical effect

that is far removed from the aims of true Cubism. The work of the other painters in this room, artists like Luc Albert Moreau, André Lhote and Segonzac was, like that of La Fresnaye, related to Cubism only in so far as it showed an emphasis on simple, clearly defined volumes and a corresponding limitation of colour. The *Cuirassier*, for example, is in greys, browns and a muted russet-red; only a year earlier La Fresnaye had been painting with the Gauguinian palette of greens, purples, blues and crimsons. (Pl. 73a.)

Reconstructing the Cubist section of the *Salon des Indépendants* of 1911 one is struck by how little it had to do with the work of Picasso and Braque, the creators of true Cubism. Léger, it is true, had devoted himself to an intensive analysis of form, making a sincere effort to extract structural, geometric properties from the visual world. Delaunay had appreciated the fact that Picasso and Braque had revolutionized traditional concepts of form and space, but he had already turned their discoveries to purely personal ends. Of all the painters from Room 41 and Room 43 Metzinger's work resembled most the Cubism of Picasso and Braque, but he was copying the superficial appearances of their art without any real appreciation of the problems which had gone to create it and those which it was still facing. Moreover, taken as a group, the Cubists at the *Indépendants* had found no genuine iconography as Picasso and Braque had done. In their creation of a new pictorial idiom, Picasso and Braque had found it necessary to limit themselves in almost every way. Their subject-matter was severely restricted to the things which played a part in their everyday life; their vision and their art were essentially realistic. Because of the conceptual nature of their art they had been able to detach themselves from external reality without lessening a sense of realism. It was an interior, classical and often extremely personal vision that they were imposing on the world immediately around them. The other Cubists were, on the contrary, painting large, elaborate works, many of which were deliberately painted as *Salon* pieces; their choice of subject-matter ranged from the literary allegory of Le Fauconnier's *Abondance* to the consciously heroic classicism of La Fresnaye's *Cuirassier* or Delaunay's brilliant but disturbing visions of the Parisian scene. Whereas the total effect of the Cubist rooms at the *Indépendants* had been sombre, by 1911 Picasso and Braque had gone further and had discarded colour completely, and only Gleizes' *Femme aux Phlox* and Léger's *Nus* matched their work in sobriety and restraint, although Metzinger was in fact working in what amounted to a decoratively tinted *grisaille*. And whereas the Cubism of Picasso and Braque was born out of some inner necessity, at the *Indépendants* the general impression was one of a much more superficial and contrived form of painting.

151

Metzinger, in an article entitled *Cubisme et Tradition*, which appeared in *Paris Journal* in September 1911, selected the work of Delaunay and Le Fauconnier as marking the two limits of the style, which, if passed, would lead on one side to 'esotérisme' and on the other to 'académisme'. Just from looking at the display at the *Indépendants* in 1911 this was a fair statement of the case. However, when Léger exhibited the *Nus dans un Paysage*, early in that year, it was not wholly representative of his artistic development at that time. In September 1910, when he moved from the Avenue du Maine to a new studio in the rue de l'Ancienne Comédie, Léger began an important series of landscapes or cityscapes, which represent a very different and in some ways more revolutionary aspect of his work. The first of these is almost certainly the small *Fumées sur les Toits* (coll. R. Weil, St. Louis), (Pl. 52b) which Léger gave as a wedding present to the bride of his friend the painter André Mare (the wedding took place towards the end of 1910). In the *Couseuse* and the *Nus* the emphasis is on solid forms; here, on the other hand, the houses are sketched in in a purely linear fashion and the painting is composed of flat, clearly defined planes of different colours, which are arranged in a limited space. And Léger has clearly been influenced by the 'cobweb' type of Cubism of Picasso and Braque which he and Delaunay saw at Kahnweiler's gallery. Indeed, the organization of the picture surface in terms of a loose framework or grid suggests that Léger may have seen the paintings and drawings which Picasso brought back to Paris from Cadaqués in the autumn of 1910. Léger's painting differs, however, from the contemporary work of Picasso and Braque in that it is quite brightly coloured (in blues, reds and pinks). His use of perspective, too, while it is obviously inconsistent, is still much more conventional. These features are due to the fact that in this painting Léger was still relying much more on the visual stimulus of his subject or model, as opposed to Picasso and Braque whose art was more conceptual and thus more detached from visual appearances. Then as opposed to them Léger was always much more interested in the life outside his studio. It is this that makes his art at once more impersonal and less contemplative than theirs. It is interesting to note that he found he had little in common with Apollinaire and Max Jacob, two of Picasso's closest friends, but that he felt at once drawn to Cendrars whom he also came to know at this time. For, 'il est comme moi, il ramasse tout dans la rue. On s'est enchevêtré avec lui sur la vie moderne. . . .'[1]

In these first cityscapes Léger was instinctively developing a pictorial theory which was to affect almost all of his subsequent work. Looking at the urban landscape from his studio window, Léger was fascinated by the way in which the

[1] Catalogue cit., p. 27.

inert masses of the buildings were brought to life by the contrast of the billow-
ing smoke coming out of the chimney tops. The round evanescent forms ac-
quired a special pictorial meaning in relationship to the square, solid cubes of the
houses. And from his high view point the triangular forms of the pitched red
roofs made further contrasts of colour and form. When in 1914 Léger delivered
his second lecture at the Académie Wassilief,[1] he stressed the fact that a painting
must be built up of a series of deliberate contrasts, not only of colour but of
forms as well. To illustrate his point Léger took as an example exactly such a
scene as he had painted in the *Fumées sur les Toits*: 'Concentrez vos courbes avec
le plus de variété possible, mais sans les désunir; encadrez-les par le rapport dur
et sec des surfaces des maisons, surfaces mortes que prendront de la mobilité par
le fait qu'elles seront colorées contrairement à la masse centrale et qu'elles
s'opposent à des formes vives: vous obtenez un effet maxime.' The sense of
dynamism and movement which is implicit even in an early work like *Les
Fumées sur les Toits*, and which Léger developed in his work of the following
years, is in sharp contrast to the classical balance and stability found in the con-
temporary Cubism of Picasso and Braque. In this respect Léger's landscapes
relate more closely to Delaunay's *Eiffel Towers*, in which solid forms are broken
or interrupted by cloud-like forms in much the same way, and it is possible that
Léger may have been influenced by Delaunay. Léger's work was, however,
more structural and solid than that of Delaunay and had none of that explosive
quality which had led Apollinaire, before he became converted to Delaunay's
art, to say: '(ses) toiles ont l'air malheureusement de commémorer un tremble-
ment de terre.'[2]

Léger used the puffs of white smoke again in a literal way in *Les Fumeurs*
(Guggenheim Museum, New York), a work painted in the latter part of 1911
and shown at the *Salon des Indépendants* in 1912. As in the cityscapes this device
served to give a sense of movement and formal variety, and this effect has been
further enhanced by the fact that Léger now contrasts flat forms with three-
dimensional forms as well; the strong linear quality of the *Fumées sur les Toits*
has been retained, but is combined with the same emphasis on solid volumes
that had characterized the *Couseuse* and the *Nus dans un Paysage*. The figures
are consciously 'cubified' or reduced to cylindrical and block-like shapes, while
the open linear framework around them allows Léger to attain a sense of precision
and fluidity at the same time. In this respect Léger's work resembles that of

[1] This lecture was published in the June 1914 issue of the *Soirées de Paris* under the title
Réalisations picturales actuelles.
[2] *L'Intransigeant*, 18 March 1910.

Picasso and Braque at this period. The line of trees in the background, which runs back into depth, still gives a sense of recession, but apart from this Léger has by now also abandoned traditional perspective. Léger, however, used a variable view-point not so much as a means of combining different aspects of a figure or an object into a single image but as a means of manipulating pictorial forms more freely in order to create a sense of pictorial dynamism. Occasionally individual objects are foreshortened in an orthodox, traditional way, but they are likely to be placed next to others in which the perspective is either divergent or has been disregarded completely. (Pl. 53.)

La Noce (Musée d'Art Moderne, Paris), a painting probably also of late 1911 or early 1912, represents the next stage in Léger's development. Here the round, billowing white forms in the centre of the painting have no literal meaning, and are simply abstract pictorial elements which unify the composition and enliven the picture surface. The system of contrasts is further developed since these central forms are contrasted not only in shape but also in size with the more elaborately worked forms of the figures behind them. This phase in Léger's art reaches a climax in *La Femme en Bleu* (Kunstmuseum, Basel) (Pl. 54), exhibited at the *Salon d'Automne* of 1912. In this painting the whole composition is organized in terms of large flat or slightly rounded shapes, some of which are completely abstract, while others have been suggested by the forms of the figure seated in the centre of the painting; the figure itself and the setting can be reconstructed only with the help of the smaller areas which contain details such as the hands and the objects on the two tables (or the table and stool). Léger achieves a sense of movement and variety not only by contrasting the large bold shapes with the smaller rounded forms between them but by contrasting them with each other as well. Some are curving and have a suggestion of shading at the edges, others are completely flat and angular; the predominant colour is blue, but there are areas of black, white, red, green and yellow. This type of painting by Léger resembles the slightly later paintings of Braque, which had been influenced by the techniques of *papier collé*, in that two distinct approaches, one completely abstract and the other more naturalistic or representational, are fused together in a single painting. This was a method of work that Léger never abandoned, and it can be seen in its most obvious form in paintings of the 1930's and 1940's in which objects and figures are drawn over a background pattern of abstract coloured shapes, which become intimately related to them, but which at the same time continue to exist independently. However, whereas in a work like the *Table au Musicien* Braque worked in a 'synthetic' way, first juggling with strips of paper, abstract pictorial elements, in order to

establish a compositional substructure, and then subsequently individualizing and objectifying certain shapes by making them represent specific objects, Léger, on the other hand, begins with a fully developed idea of the subject-matter, which is elaborated with considerable detail and care, while the large abstract and semi-abstract shapes are subsequently developed from it or superimposed over it. That is to say, in the Cubist period occasionally Braque works from abstraction to representation, but Léger invariably starts with representation and works towards abstraction.

During 1911 Delaunay, whose *Eiffel Towers* had been exciting but formally slightly precarious, was trying to find a more stable basis for his art. *La Ville* (Pl. 57), now in the Guggenheim Museum in New York, is one of the first of a series of views of Paris, seen from an open window, that Delaunay began in this year'[1] Here Delaunay has strictly limited his use of colour, and has concentrated on building up the picture surface in a pattern of small black and grey planes; to control the tonal distinctions between them Delaunay has resorted to a schematic technique of square or rectangular brushstrokes, each distinct from the ones around it, so that the effect is of a *grisaille* Divisionism. The areas between the houses are, however, a dull, dark green, while the *Eiffel Tower*, which can be seen in the background, is orange. Superficially this painting has something in common with certain Cubist landscapes by Picasso and Braque (it recalls Braque's *View of Montmartre*, painted from his studio in 1910 and now in the collection of M. Jean Masurel in Roubaix), and it seems likely that in these paintings Delaunay had again been directly influenced by what he saw at Kahnweiler's gallery. On the other hand, there is none of the subtlety of spatial definition that is found in the work of Picasso and Braque, and despite the disregard of any conventional system of perspective one has the impression that these paintings were systematically evolved from more naturalistic sketches. Unlike Léger in his treatment of similar scenes, Delaunay makes no use of contrasts of form and he avoids any kind of linear emphasis. His vision of Paris is less immediate and direct than

[1] Delaunay, like Picasso and Braque, did not sign and date his work of this period until long afterwards. The dates he then inscribed on his paintings are often misleading, and the situation is complicated by the fact that he developed a habit of ascribing the paintings to the date of the phase of his development to which he felt they belonged. The catalogue to an exhibition which he held at the Galerie Barbazanges from 28 February until 13 March 1912, enables one to establish a sequence for his work up to this time, as dates are given, and many of the works are illustrated, so that it is possible to place exactly paintings of a series which have the same title. For example the first, more 'grisaille', *Ville* which is dated 1911 on the painting is dated in the same way in the catalogue, but the example from the Musée d'Art Moderne which is signed and dated 1910 is illustrated in the Catalogue and dated there 1912. It must, however, have been begun in 1911 as it undoubtedly precedes the Laon paintings which were done in the first months of 1912 and were included in the exhibition. The preface to the catalogue is by Maurice Princet; unfortunately it does not tell us much about the author's personality.

Léger's, and by contrast more poetic and mysterious. Delaunay himself claimed that the inspiration for these paintings of scenes through open windows came to him on reading a poem by Mallarmé.

Delaunay spent January of 1912 in Laon. The *Villes* (there are some four paintings in the series)[1] had been painted in his studio in Paris (unlike comparable paintings by Léger they do not represent a particular view from his window) but now, working from nature, he produced a series of paintings in a different style. In these paintings Delaunay seems to have turned back once again to the work of Cézanne, although he now interprets Cézanne in a freer, more casual way. The buildings in *Les Tours de Laon* (Musée d'Art Moderne, Paris) are rendered in terms of planes loosely hinged together and opened up into each other, while the sky is subdivided into facets of more or less equal size in order to unify the picture surface. Once again there is no rigid system of perspective, although in the avenue of trees in the lower right-hand corner the perspective is perfectly conventional. In one of the last of the *Villes* (another, oblong canvas, also in the Guggenheim Museum, New York), Delaunay had begun to cover some of the small grey planes with strokes of bright colour applied in accordance with Divisionist technique. The Laon paintings are once again executed with a full palette, and the importance of this series lies in the fact that it was at this time that Delaunay first became excited with the possibility of dealing with large pictorial surfaces in terms of flat, interpenetrating planes of colour. The concepts of form and space latent in the work of Cézanne had been seized on, simplified and exaggerated by the Cubists. Now Delaunay was to do the same thing with Cézanne's painstaking juxtaposition of contrasting or complementary warm and dark tones. (Pl. 58a.)

On his return to Paris Delaunay painted *La Ville de Paris* (Museé d'Art Moderne, Paris), a vast canvas that dominated the Cubist section at the *Salon des Indépendants* of 1912 (Pl. 58b). It was intended by Delaunay to synthesize all his researches of the past years. It is in fact composed of three separate paintings, joined together in a mosaic-like frieze of small, coloured shapes; the mannerist central figures were evolved from a photograph of an antique statue of three Graces in the Louvre. The elegant, elongated proportions and the insistence on obvious geometric shapes recall Metzinger's *Two Nudes* painted a year earlier, and since Delaunay was not essentially a figure painter it is likely that in this painting he turned to another artist for guidance. Delaunay, however, once again differs from the other Cubists in his refusal to use line as a

[1] One of these is in the Musée d'Art Moderne, two are in the Guggenheim Museum, and one unfinished example is in the collection of Madame Sonia Terk Delaunay.

means of defining or suggesting form. The forms of the three women in this painting are broken up into small planes of colour ranging from light areas of pale pinks and yellows into shadows of light blues, mauves and greens. The subject-matter of the landscape on the left recalls Delaunay's enthusiasm for Rousseau. Indeed, this section of the painting is close to the background of Rousseau's *Self-Portrait* (Prague) and to a landscape entitled *La Tour Eiffel* (reproduced in *Action* no. 7, May 1921). The right-hand section is a re-interpretation of the earlier *Eiffel Towers*. Apollinaire, impressed by the size of the painting, wrote in a review of the exhibition: 'Décidément le tableau de Delaunay est le plus important de ce Salon. *La Ville de Paris* est plus qu'une manifestation artistique: ce tableau marque l'avènement d'une conception d'art perdue peut-être depuis les grands italiens. Et il résume tous les efforts du peintre qui l'a composé, s'il résume aussi et sans aucun appareil scientifique tout l'effort de la peinture moderne.'[1] Later, Delaunay came to feel that this marked the end of the 'destructive' or Cubist phase in his art since after this he abandoned all idea of fragmenting solid forms in a Cubistic manner (he had never been interested in showing volumes in any case), and devoted himself to his researches into the nature of pure colour.

In 1911, to the general public, who did not know the achievements of Picasso and Braque, the work of Delaunay, Léger, Metzinger, Gleizes and Le Fauconnier, represented Cubism in its most advanced and developed form. However, even at the *Salon des Indépendants* of 1911 Delaunay's *Eiffel Tower* had stood apart from the work of the other painters as an individual and independent variant of the style. Personally, too, Delaunay began to drift away from the other painters almost immediately after Cubism had been launched as a recognized movement, and he retained a close friendship only with Léger and Le Fauconnier. Léger himself, while he continued to frequent Cubist gatherings,[2] was in 1911 also beginning to assert himself as an independent personality to whom the group activities of the remaining painters meant very little. At the *Salon d'Automne* of 1911 his independence was noticed by Apollinaire, who wrote: 'Léger est à la recherche de sa personnalité.'[3] And Gleizes, who reviewed the same exhibition in *Les Bandeaux d'Or*, was slightly disturbed by the most recent trends in Léger's art: 'la volonté absolue de ne se réaliser que plastiquement donne à sa composition un aspect à l'abord quelque peu inquiétant'.[4] Only Gleizes, Metzinger and Le Fauconnier, excited by the sensation caused by Room

[1] *L'Intransigeant*, 20 March 1912.
[2] See pp. 23, 28–9 above.
[3] *L'Intransigeant*, 30 Sept. 1911.
[4] *Les Bandeaux d'Or*, Nov. 1911.

41 at the *Indépendants*, were still anxious to consolidate Cubism into a cohesive and militant movement. Metzinger had begun to write about painting in 1910, and by 1911 Gleizes was doing critical work also; in the summer of this year these two painters began their collaboration on *Du Cubisme*. Together with Le Fauconnier, they planned to publish a review dedicated to the plastic arts which would serve as a platform for the expression of their ideas about contemporary painting and sculpture.[1]

In accordance with his desire to codify the laws which governed Cubist painting, Metzinger exhibited at the *Salon d'Automne* of 1911 a highly schematized painting entitled *Le Goûter* (Arensberg Collection, Philadelphia Museum of Art), his most famous Cubist painting; because of the smile on the face of the woman this painting became known as 'la Joconde du Cubisme'.[2] Although as early as 1910 Metzinger had written of the way in which Picasso and Braque had dismissed traditional perspective, his *Two Nudes* shown at the *Indépendants* of 1911 had shown that he did not understand what it really was that Picasso and Braque were getting at in their painting. This is still fundamentally true of *Le Goûter*, which has the same sort of academic 'cubification' as the earlier work. In the head, however, Metzinger has schematically combined a profile and a full-face view, while half the teacup is seen from above and the other half exactly at eye level. Since this kind of optical synthesis is found only in these two areas, and since Metzinger shows no real interest in analysing and expanding solid forms, the effect is highly contrived. Indeed, one is reminded at once of Princet's theoretical discussions about Cubism; Metzinger certainly knew this 'mathematician', and it is very likely that Princet had an influence on his art. In his *Note sur la Peinture* written the previous year he went so far as to say, 'Picasso . . . fonde une perspective libre, mobile, *telle que le sagace mathématicien Princet en déduit toute une géométrie*' (the italics are my own). One is left with the impression that Metzinger's Cubism is the result more of intellectual influences than of a genuine new vision of the world. (Pl. 64b.)

A contemporary work by Gleizes such as the painting that was originally entitled *Passy*[3] but which is now known as *The Bridges of Paris* (Pl. 61), shows that Gleizes' painting was developing along slightly different lines. When he was collaborating with Metzinger in writing *Du Cubisme*, Gleizes had objected to the dryness of Metzinger's theorizing,[4] and this painting is cer-

[1] See p. 29 above.
[2] The painting is first referred to in this way in a note signed 'la Palette', in *Paris Journal* on 30 Oct. 1911.
[3] The painting is reproduced under this title in the first editions of *Du Cubisme*.
[4] *Souvenirs*.

tainly freer and more imaginative than Metzinger's *Le Goûter*. The canvas is broken down into a few large, transparent planes, into which the different elements of the landscape are fitted. The new breadth of handling in this work and the presence of the small circular cloud forms in the centre of the composition suggest that Gleizes was beginning to study the work of Léger. A comparison of this painting with the *Femme aux Phlox* which Gleizes had shown at the *Indépendants* a few months earlier shows that Gleizes was maturing rapidly as a painter. In turning to the work of Léger for inspiration, Gleizes was once again following Le Fauconnier's lead, for Le Fauconnier, after returning to Paris from Italy where he had spent the summer of 1911, had fallen completely under the influence of Léger's art. His *Chasseur* (Pl. 66b), which he showed at the *Salon des Indépendants* of 1912 is clearly derived from the type of painting Léger had created in *La Noce* and *Les Fumeurs*. However, Le Fauconnier had never at any point shown any real understanding of the problems which faced Cubism, and now he failed to appreciate the fact that the strength and vitality of Léger's work of this period derived from the very careful balance that Léger maintained between abstraction and representation. Le Fauconnier turns the hard, dynamic precision of Léger's art into a bland, amorphous, badly organized and highly abstract kind of painting which has little or nothing to do with Cubism. At this time Le Fauconnier's friendship with Gleizes and Metzinger also came to an abrupt end, and for this reason his work was not illustrated in *Du Cubisme* when it appeared in March of 1912. During 1913 and 1914 Le Fauconnier's work became more representational again, and though at the advanced *Salons* his work continued to be shown with that of the Cubists, in actual fact after the *Salon des Indépendants* of 1911 he had ceased to be of any interest or importance as a painter. On the other hand, Le Fauconnier was an influence in encouraging young painters to look at Cubist painting and to adopt a Cubist form of expression; he was in a position to do this, since in February of 1912 he was appointed to succeed Jacques Emile Blanche as director of one of the teaching studios at the *Académie de la Palette*. Metzinger was made a teacher there at the same time.

The *Section d'Or* exhibition, held at the Galérie de la Boétie in October 1912, marked the climax of Cubism as a movement. In the year-and-a-half since the first Cubist manifestation at the *Salon des Indépendants* of 1911, the style had spread with astonishing speed. More than thirty painters showed at the *Section d'Or*, and while not all of them were Cubist, each of them had to some extent been influenced by the style. Delaunay and Le Fauconnier, two of the original Cubists from Room 41 of the 1911 *Indépendants*, both abstained from showing,

but the exhibition was given added weight by the fact that Gris had contributed two paintings, one the very large *l'Homme au Café*, now in the Arensberg Collection in the Philadelphia Museum of Art. Gris had exhibited publicly for the first time at the *Salon des Indépendants* of this year (1912) and his work had attracted a great deal of attention;[1] his paintings, however, had been hung separately from those of the other Cubists. Furthermore, in the intervening months between that exhibition and the *Section d'Or*, Gris had evolved a much more personal and assured style, and in the absence of paintings by Picasso and Braque, his work represented Cubism in its purest and most uncompromising form.

Even before the opening of the *Section d'Or*, Gris had begun to have an influence on the minor figures of the movement. At the *Salon d'Automne* which opened a week or so before the exhibition at the Galérie de la Boétie, Metzinger had shown a large painting, *La Danseuse au Café* (Pl. 63) (coll. Sidney Janis, New York), in which he had adopted Gris' technique of superimposing a thick linear grid over his figures, although what had been evolved by Gris as a means of synthesizing different aspects of an object or a figure into a single image became in Metzinger's hands a decorative or schematic, mannerist device. This painting is, however, interesting in that it is one of the few Cubist pictures in which the influence of Seurat, a painter much admired by the Cubists, can be seen in a direct and obvious form; the flat, stylized forms of the lamp-brackets, and for that matter the entire subject-matter, suggest that Metzinger had been looking at works like the *Chahut* or *Parade*. Metzinger may have been led to a closer study of Seurat by Severini, a painter with whom he was friendly, and who was at this time reinterpreting Seurat in Futurist terms. Each of the painters of the *Section d'Or* showed several paintings, chosen to illustrate their development over the previous years. Metzinger's most recent work was *La Plume Jaune* (now in the collection of Mr. & Mrs. Ingersoll, Philadelphia) which is in the same style as the *Danseuse au Café*. Both paintings are brighter than Metzinger's work of the previous year, although until 1914 he continued to favour pale, silvery colour schemes. In all Metzinger's work of this period there is a strong emphasis on decorative detail: Apollinaire referred to the drawing which Metzinger showed at the *Salon d'Automne* of 1913 as 'une délicieuse chinoiserie'.[2]

At the *Section d'Or* Gleizes showed *Les Moissonneurs* (Guggenheim Museum), (Pl. 62b), one of the largest Cubist paintings ever executed, which occupied a

[1] See p. 97 above.
[2] *L'Intransigeant*, Nov. 14.

whole wall at the Galerie de la Boétie. During the months before the exhibition Gleizes had come increasingly under the artistic domination of Léger. In a work like *L'Homme au Balcon* (now in the Arensberg Collection in Philadelphia Museum of Art), Gleizes deliberately contrasts angular and curved shapes, while the tubular, block-like forms of the figure and head are derived directly from works by Léger such as *Les Fumeurs*. In *Les Moissonneurs* the circular white forms in the centre of the painting recall the clouds of smoke that Léger had introduced into his slightly earlier works. However, while Léger was moving towards a more dynamic kind of painting in which abstract and representational elements are contrasted or juxtaposed, Gleizes' vision remained, for the time being, more naturalistic; the circular shapes in this painting, for example, represent specific things, trees, clouds and the sacks or baskets of the gleaners. As in the contemporary work of almost all Cubist painters, there is a strong linear quality about Gleizes' work. And in *Les Moissonneurs* and *L'Homme au Balcon* Gleizes also felt the need to use brighter colours again.

Another of the *Section d'Or* painters who had felt the influence of Léger was Picabia. Picabia, a Spanish painter who was a few years older than most of the Cubists (he was born in 1878), had during the early years of the century gained a considerable reputation for his landscapes executed in a highly coloured, richly impasted Impressionist style. By 1909, however, his work was becoming flatter and more decorative, and he began to become interested in the formal relationships between simple, brightly coloured masses. Shortly after the *Salon des Indépendants* of 1911 he came into personal contact with some of the Cubists, through Apollinaire, who had become a close friend. He showed with the Cubists for the first time in the summer of 1912, when he was invited to join them at the *Salon de Juin* in Rouen. At the *Salon d'Automne* of this year he became recognized as an advanced and controversial painter.[1] Picabia was represented at the *Section d'Or* by *Danseuses à la Source* (Arensberg Collection, Philadelphia Museum of Art), a work for which the closest prototype is perhaps Léger's *Nus dans un Paysage*, although there may also be some influence from Marcel Duchamp's contemporary figure work. Picabia's dancers have the same wooden, rough-hewn quality as Léger's *Nus*, and the landscape background is dealt with in a similar, though more drastic fashion. But whereas Léger's interest lay primarily in examining the relationships between solid forms, Picabia reduces the whole picture surface to intricate patterns of coloured shapes (the painting is in oranges, creams and browns) with only an occasional suggestion of volume or depth; the flatness of the canvas is stressed, for example, by the way

[1] See p. 35 above.

in which the further and nearer legs of the foremost figure are joined together by planes of colour which seem to belong to them both. Picabia, like many of the painters of the *Section d'Or*, could be considered a Cubist only if the term is interpreted in a broad sense, in that he took superficial aspects of Cubism and used them for different ends. (Pl. 74a.)

The abstractions which Kupka showed at the *Section d'Or*, on the other hand, had nothing to do with Cubism at all. In the year-and-a-half immediately preceding the exhibition, Kupka had completely abandoned the *art nouveau* style in which he had been working, and had produced a series of paintings which although they had a starting point in nature were highly abstract in appearance. *Nocturne* (Galerie Louis Carré, Paris) a work of late 1910 or early 1911, is composed of a system of vertical slabs of paint which diminish in size towards the top of the canvas; the darker areas at the bottom suggest the horizon of a landscape, but without the aid of a title the subject would be hard to reconstruct. The effect is, so to speak, midway between Whistler and De Staël. At the *Salon d'Automne* of 1911 Kupka exhibited a painting entitled *Plans par Couleurs*, which was wholly abstract; this painting may even have been the study for *Le Langage des Verticales* (now in the Galerie Louis Carré, Paris), a painting of 1912. During 1912 and 1913 Kupka executed a series of brightly coloured abstract paintings, some of which are organized in terms of the same upright, vertical shapes, while in others the curving, decorative rhythms of *art nouveau* reasserted themselves. Kupka, who was born in 1871, was older than any of the Cubists, and he must have been stimulated by the discussions between the young painters whom he used to meet in Jacques Villon's studio at Puteaux;[1] indeed, the contact with a younger generation of revolutionary painters may have encouraged him to make the final break with representation. His aims, however, were never at any point those of the Cubists. (Pl. 74b.)

Louis Marcoussis, on the other hand, was as close to true Cubism as any of the painters at the *Section d'Or*, except for Gris, and, in a particularized way, Léger. Marcoussis (whose real name was Markous) was a Polish painter, who in 1910 met Apollinaire, and through him Picasso and Braque; he had given up painting, but took it up again after meeting them. A still-life of 1912 entitled *Nature Morte au Damier* (Pl. 75) shows that Marcoussis was up to date in some of the latest if most superficial developments in Picasso's art. The flat, rather insubstantial quality of this painting may owe something to the fact that it was originally executed as part of a scheme for the decoration of the Café Azon, a Montmartre restaurant frequented by the Cubists and their friends. Mar-

[1] See p. 29 above.

162

coussis contributed little or nothing of his own to Cubism, but his work at the *Section d'Or* was of some importance since it reflected something of what Picasso and Braque were doing at this time. Apollinaire wrote in his review of the exhibition, 'Marcoussis est très moderne,'[1] and certainly his work must have seemed advanced beside that of painters like Lhote (Pl. 78a), Luc Albert Moreau, Marchand and Segonzac. La Fresnaye, whose work belonged to the same general category as that of these painters, had, it is true, cautiously developed a more Cubist form of expression. In his still-lifes of 1912 such as the *Nature Morte aux Trois Anses* (Pl. 73b) the objects are all seen from a high, generalized view-point, and are opened up into a background of large, flat, interlocking planes. La Fresnaye refused, however, to break completely with traditional ideas about perspective, and his work remained primarily formal and decorative.

The work of Marcel Duchamp and of Jacques Villon, who had been largely responsible for the organization of the *Section d'Or*, represented an aspect of Cubism that was different both from that of the groups dominated by Gris and Léger, and from that of the more conservative wing which was headed by La Fresnaye and Lhote. The adherence to Cubism of these two painters and of their brother, the sculptor Duchamp-Villon, was an event of importance in the history of the movement. All three were intelligent, open-minded men, interested in the intellectual possibilities of contemporary painting and anxious to relate Cubism to some of the movements which surrounded it. Duchamp-Villon had been instrumental in persuading the selection committee of the *Salon d'Automne* of 1911 to accept the work of the Cubists, and the entries of both his brothers had been placed in the Cubist section of this exhibition. During 1911 the studio at Puteaux, which was shared by Jacques Villon and Duchamp-Villon, became an important meeting-place for Cubist painters. It was here that the plans for the large exhibition at the Galerie de la Boétie were formulated.[2]

While most of the Cubist painters claimed to have evolved from the art of Cézanne, Marcel Duchamp saw himself rather as an artistic descendant of Redon.[3] The influence of Redon is clearly seen in *Yvonne et Magdeleine Dechiquetées*, dated September 1911 (Arensberg Collection, Philadelphia Museum of Art), in the strong, rather mysterious use of chiaroscuro and in the way in which the heads float, bodiless, in an undefined space. The faces of Duchamp's sisters are each seen twice, rendered each time in a different way.

[1] *L'Intransigeant*, 10 Oct. 1912.
[2] See p. 31 above.
[3] Information received from M. Duchamp, May 1956.

So that here it does seem to have occurred to Duchamp that it was possible to combine various views of a subject into a single painting, though not into a single image. In the Cubist section of the *Salon d'Automne* of 1911 he exhibited a painting entitled *Portrait* (now in the Arensberg Collection, Philadelphia Museum of Art), which showed the same sitter in five different positions. In this work, Duchamp was coming more directly under the Cubist influences. This can be seen also in a contemporary work, *The Sonata* (Arensberg Collection, Philadelphia Museum of Art) in which the figures are treated in an angular way and occasionally opened up into their surroundings; in the standing figure there is a crude attempt to combine a profile and a full face view. However, the painting, which is executed in pale pastel colours, lacks any sense of precision or discipline, and the forms remain vague and indistinct.

The first real turning point in Marcel Duchamp's art came towards the end of 1911, when he became interested in the problem of rendering figures in successive stages of motion. In December of 1911 Duchamp was engaged in painting a picture of two chess players, each of which is seen in two different positions as he bends forward over the chess-board,[1] and at the same time he was working on the first version of his famous *Nude Descending a Staircase* (Arensberg Collection, Philadelphia Museum of Art). In these paintings Duchamp severely restricted the range of colours on his palette and reduced his subject to a few simple, geometric shapes; in short, Duchamp's intellectual interest in solving a new pictorial problem forced him to come to grips with one of the fundamental problems of painting that he had hitherto ignored, that of representing three-dimensional forms on a two-dimensional surface. The result is that these works are much closer in spirit to Cubism than anything else he ever produced. The colour scheme of blacks and browns, the fusion of the subjects and their surroundings, and the linear framework which shows through underneath the solid forms, recall similar features in the work of Picasso and Braque; Duchamp was in fact introduced to Picasso and Braque at about this time by his friend Maurice Princet. In the final version of the *Nude Descending a Staircase* (Arensberg Collection, Philadelphia Museum of Art), which was shown at the *Salon des Indépendants* in April of 1912, the forms have been elaborated, multiplied and fused together in a fashion that suggests more convincingly the downward motion of the figure as it moves from step to step. (Pls. 70a, b.)

This painting has, of course, affinities with certain aspects of Futurism. Mar-

[1] The study for this painting is in the Musée d'Art Moderne in Paris, and is dated December 1911. The finished painting in the Arensberg Collection in the Philadelphia Museum of Art is also dated 1911.

cel Duchamp was above all else an intellectual, and he cannot have failed to be aware of developments in Italy, even before the Futurist painters descended on Paris in the autumn of 1911. The Futurist Manifesto was published in France in *Le Figaro* of the 20th of February, 1909. The technical manifesto on painting was issued in Milan in April 1910 and was printed in French; it appeared subsequently in a French periodical, *Comoedia*. Later Duchamp may even have met the Futurist painters on their visit to Paris, since Severini took them on an extensive tour of the studios of advanced French painters.[1] On the other hand, when Duchamp began work on the *Chess Players* and the *Nude Descending a Staircase* he could have seen no Futurist painting to influence him. Even if the Italian painters had brought examples of their work with them to Paris, it was only in the paintings executed after their return to Italy that they evolved a definite style of their own. Severini, who at this time was the main link between the Italian painters and the Cubists, was dealing with the problem of motion in his contemporary work, but while he was dislocating and displacing the limbs of his figures to achieve this effect, he had as yet made no attempt to indicate successive stages of motion in the same logical, schematic way as Duchamp. Duchamp's painting at this time was thus an independent and original variation of Cubism, and was part of the logical development of his intellectual desire to show several aspects of a model in a single painting. Duchamp was at this time also interested in the techniques of the cinema, and this also undoubtedly had an influence on his painting.

Nevertheless, the *Nude Descending a Staircase* provides one of the most obvious and schematic illustrations of the well-known passage in the manifesto of the Futurist painters, 'En effet, tout bouge, tout court, tout se transforme rapidement. Un profil n'est jamais immobile devant nous, mais il apparaît et disparaît sans cesse. Etant donnée la persistance de l'image dans la rétine, les objets en mouvement se multiplient, se déforment en se poursuivant, comme des vibrations précipitées dans l'espace qu'ils parcourent. C'est ainsi qu'un cheval courant n'a quatre pattes mais il en a vingt et leurs mouvements sont triangulaires.' The first Futurist exhibition in Paris was held in February 1912 at the Galerie Bernheim, and when the *Nude Descending a Staircase* was seen a few weeks later at the *Indépendants* the analogies between it and the work of the Futurists must have been clearly apparent, although Balla, whose solution to the problem of depicting figures in movement was closest at this time to that evolved by Duchamp, was not represented at the Futurist exhibition. But the *Nude* of Duchamp is linked to Futurism only in the most superficial way, and

[1] See pp. 42–3 above.

Duchamp's vision differed fundamentally from that of the Futurists. Futurism was a dynamic, romantic movement. Duchamp's work, on the other hand, was cold and detached, and the *Nude Descending a Staircase* reflects none of the Futurist's enthusiasm for contemporary life, but was rather a satire on mechanical civilization. This painting violates, too, the final demand of the manifesto of the Futurist painters: 'Nous exigeons pour dix ans la suppression totale du nu en peinture.'

Duchamp showed the *Nude Descending a Staircase* a second time at the *Section d'Or*, together with a more recent painting *Le Roi et La Reine entourés de nus vites* (now also in the Arensberg Collection in the Philadelphia Museum of Art). *The Bride* (Pl. 69) is a contemporary work and belongs to the same series. In the *Nude* Duchamp had conceived the idea of reducing the human figure to semi-mechanical forms. Then, late in 1911, Duchamp-Villon had asked a group of artists including Léger, Metzinger, La Fresnaye, Gleizes and his brother Marcel Duchamp, to make pictures for the decoration of his kitchen, and Duchamp produced a picture of a *Coffee-grinder* (collec. Mme. Yvonne Liguières, Paris) in which its mechanical aspect is burlesqued or treated in a semi-humorous fashion. Duchamp became fascinated with the mechanics of the coffee-grinder, and assimilated them to those of the human form, so that he began to interpret the figures in his paintings in terms of more obviously mechanical forms; metal cylinders, pistons, cog-wheels, rubber tubes and so on. The colour scheme of *The Bride* is still that of the *Nude*, but the forms that compose the figure are varied and each is fully modelled and carefully distinguished from the shapes around it. Once again, in the emphasis on commercially manufactured, machine-like forms, there is a parallel with the Futurists. However, while the Italians exalted the machine as one of the most glorious features of the dynamic civilization in which they lived, Duchamp uses it as a means of passing a very different kind of comment on modern life. Duchamp's attitude to contemporary civilization was aloof, coldly humorous and basically cynical and negative. *The Bride* and the paintings and sketches surrounding it, culminated in *The Bride stripped bare by her bachelors* (Arensberg Collection, Philadelphia Museum of Art), a work executed on glass, which was begun in 1915 and finished eight years later, but which had been partially conceived as early as 1913. André Breton has described this work as a 'mechanistic and cynical interpretation of love; the passage of woman from the state of virginity to that of non-virginity taken as the theme of a fundamentally a-sentimental speculation, almost that of an extra-human being training himself to consider this kind of operation'.[1] *The Bride* has practically nothing that recalls Cubism, and there is

[1] 'Lighthouse of the Bride', *View* Series V, New York, Jan. 1945.

an element of destructive humour about it that already relates it to the spirit of Dada. At the *Salon des Indépendants* of 1912 *The Nude Descending a Staircase* had not been hung with the work of the Cubists, who probably sensed that Duchamp's aims were at variance with their own. At the *Section d'Or* Vauxcelles, who had bitterly opposed the Cubists, was now frankly shocked and disgusted by Duchamp's work.[1] Even Apollinaire, for all his thirst for novelty, found it disquieting.[2]

Jacques Villon was drawn to Cubism largely through the enthusiasm of his younger brother, Marcel. Except for Kupka (who in any case was never really a Cubist) Villon was the oldest of the figures associated with the movement. When he began to paint seriously in 1910 at the age of thirty-five, Villon had already been working for over ten years as a commercial illustrator for various Parisian periodicals such as *l'Assiette au Beurre* (to which Gris also contributed). Because of his age and experience, Villon's approach to Cubism was cautious, and his methodical temperament furthermore led him to search for a scientific basis for the style. His first Cubist paintings, like the *Portrait of his brother, Duchamp-Villon* (Musée d'Art Moderne, Paris) which was exhibited together with four other portraits at the *Salon d'Automne* of 1911, show an analytical treatment of form that may have been inspired in a very general way by the work of Cézanne or possibly even by that of Picasso and Braque. In this portrait his desire to investigate and explain the solid mass of the head has led him to distend it abnormally, so that, as in certain early Cubist paintings by Picasso, the far side of the face can be seen in what is basically a three-quarter view. As opposed to Picasso and Braque, however, Villon never abandoned the use of colour, and in this painting there is still a very strong impression of atmospheric light. Eluard quotes Villon as having said in recent years, 'je fus le cubiste impressionniste, et je crois que je le suis resté.'[3] (Pl. 68a.)

Jacques Villon was represented at the *Section d'Or* by four canvases. One of them, *Jeune Femme* (Arensberg Collection, Philadelphia Museum of Art), when compared to the portraits painted a year earlier, shows how rapidly Villon had moved to a more abstract and sophisticated form of expression. At this time, Marcel Duchamp was experimenting with geometry, but not applying it directly to his painting. Jacques Villon, on the other hand, who had suggested the *Section d'Or* as a title for the exhibition, was actually introducing mathematical and geometrical calculations into his work; Marcel Duchamp has been quoted

[1] *Gil Blas*, 14 Oct. 1912.
[2] *L'Intransigeant*, 10 Oct. 1912.
[3] Eluard and René Jean, *Jacques Villon ou l'Art Glorieux*, Paris 1948, p. 61.

as saying that his brother was familiar with the work of geometricians from Pythagoras to Dom Verkade.[1] In the *Jeune Femme* the underlying geometrical framework is fairly simple. As the basis for his composition Villon has joined the corners of the canvas by two clearly marked diagonals, while two large circles meet at their point of intersection; one of these is transformed into the section of the woman's body from her waist to her knees, while her shoulders and head are inscribed into the second. The geometrical severity of the composition is subsequently disguised and refined by a series of more instinctive pictorial adjustments: the two major diagonals are broken and shifted very slightly so that they do not coincide exactly with the four corners, and the circular forms are lost, or at least made less insistent, in the left-hand side of the picture. The intellectual quality of Villon's painting relates it to that of Gris, but while Gris was interested in exploring the intellectual possibilities opened up by the new Cubist concepts of form and space, and only subsequently became interested in establishing a mathematical basis for his art, Villon was from the first primarily interested in the scientific possibilities of painting, and was drawn to Cubism largely because he saw that it was a type of painting that could be interpreted in these terms. (Pl. 67.)

As in the case of Marcel Duchamp, there are analogies between Villon's work and that of the Futurists. Indeed, a work like the *Jeune Femme* is in many ways more Futurist than anything produced by his brother. By repeating the forms of the shoulder Villon creates the impression that the young woman can be seen in successive stages of motion as she bends forward, and instead of simply opening the subject up into its surroundings as the Cubists would have done, here Villon suggests that the figure is vanishing into the background in a more dynamic way. The insistence on diagonal lines gives a sensation of movement which could be interpreted as a manifestation of the Futurists' theory of universal dynamism. The colour scheme in this picture, too, is hot and smouldering like so many Futurist paintings such as, for example, Carra's *Funeral of the Anarchist Galla* (Museum of Modern Art, New York). A painting of 1913, *Soldats en Marche* (coll. Galerie Louis Carré, Paris) is more specifically Futurist. (Pl. 68b.) Here the composition is established by a series of vigorous diagonal 'lines of force', which indicate the forward motion of the marching soldiers; the subject-matter also is one which would have appealed to the Futurists who constantly exalted the virility and healthiness of war. It is interesting to compare this painting with contemporary works by Balla, such as his painting of a *Speeding Automobile* (Museum of Modern Art, New York). While in the work of Balla the

[1] Jerome Melquist, 'Jacques Villon Maître de Puteaux,' *Art Documents*, Geneva, no. 3, Dec. 1950.

diagonal, wedge-shaped force lines become more jagged and pointed as they progress towards the edges of the canvas, in order to give a sense of increasing velocity, in Villon's painting the marching motion is arrested by a strong counteracting diagonal at the extreme right of the composition. Villon's art remains more controlled and withdrawn than that of the Futurists, and his insistence on the more formal, classical aspects of painting gives his art of this period a place half way between Futurism and Cubism. In his work of 1914, however, Villon reverted to a highly coloured Cubistic form of expression.

At the time of the *Section d'Or* exhibition, Duchamp-Villon, the third of the brothers, was the most active of the sculptors attached to the Cubist movement; a review of the *Salon d'Automne* of 1913 stated that, 'la sculpture cubiste a pour principal représentant Duchamp-Villon.'[1] In actual fact, in 1912 no truly Cubist sculpture existed except for the bronze head by Picasso and the experimental constructions which he and Braque were executing to supplement their researches into pictorial form and space. However, by 1911 several sculptors were developing styles which corresponded to the Cubists' shift towards a more sober, formal kind of painting. The names of the four sculptors, Brancusi, Agero, Archipenko and Duchamp-Villon became associated in a general way with those of the Cubist painters who were exhibiting at the advanced *Salons*. All these sculptors had been influenced to a certain extent by Negro art or by other primitive and archaic forms of sculpture, and their work had in common an insistence on large, simple and clearly defined volumes.[2] Archipenko, who by 1910 was already employing a very simple and vigorous form of stylization in his work, showed at the Brussels exhibition in 1911 where Apollinaire accepted the name 'Cubists' on behalf of the exhibitors.[3] Both Archipenko and Agero showed at the *Section d'Or*. Little is known of Agero's work of this period, but on the 24th of January 1912 *Paris Journal* referred to a portrait of Braque executed under the influence of Negro sculpture. Shortly after the exhibition in the Galerie de la Boétie had closed, Archipenko declared formally to the press that he had broken completely with the Cubists whose principles he rejected.[4] Brancusi never became involved with the Cubists, and his work of this period was related to that of Archipenko and Duchamp-Villon only in its basic simplicity.

Duchamp-Villon's early sculpture was purely naturalistic, but after 1910 his

[1] Review by Henri Revers, *Paris Journal*, 14 Nov. 1913.
[2] As early as 1906 Derain had begun to execute sculptures in stone under the combined influences of Gauguin and Negro art. Salmon, in *La Jeune Peinture Française*, which was written before the war, although it did not appear until 1919, wrote: 'En sculpture comme en peinture l'influence d'André Derain est chaque jour plus sensible,' p. 85.
[3] See pp. 25–6 above.
[4] *Gil Blas*, 14 Dec. 1912. See p. 37 above.

work became increasingly simple and stylized. The cubistic phase of his sculpture reached a climax in a series of bas-reliefs which he showed at the *Salon d'Automne* of 1913, and which showed the influence of Archipenko. In one of the bas-reliefs, *l'Amour* (one cast is in the Museum of Modern Art, New York and another in Paris), the puppet-like figures have been distorted and reduced to a few bold and suggestive shapes, while all the subtlety of modelling which could still be found in his earlier work was suppressed. Just as the Cubist painters had revolted against the Impressionists' concern with fleeting and momentary appearances, so sculptors like Duchamp-Villon, Archipenko and Brancusi were reacting against over-elaborate surface modelling and the ephemeral effects of light, which Rodin and Medardo Rosso had introduced into sculpture. Duchamp-Villon, asked by the review *Montjoie* to comment on the sculptures shown at the *Salon d'Automne* of 1913, said: 'Malheureusement presque toutes participent du domaine du modelage, fort éloigné de celui de la sculpture.'[1]

Le Cheval (Museum of Modern Art, New York), Duchamp-Villon's most important single sculpture, which was executed in 1914 from studies begun in the previous year, shows that, like his brothers, he was strongly attracted to Futurism. Even in the preliminary *maquette* which is now in the Gemeente Museum in Amsterdam, the anatomy of the horse is reduced to semi-mechanical forms which serve to give a sense of power and strength. The finished work is more abstract, and the machine-like quality of the forms has been deliberately exaggerated. The spatial effects that Duchamp-Villon uses are Futurist, too: the hind quarters of the animal, for example, are treated in terms of spiral forms which seem to bore their way into the interior structure of the horse. During June of 1913 the Galerie de la Boétie held an exhibition of Futurist sculptures by Boccioni, and Duchamp-Villon must have been influenced by what he saw there. As opposed to the sculpture of Boccioni, however, in Duchamp-Villon's work there is no feeling of solid forms being decomposed by motion or light. Nevertheless, a letter written by Duchamp-Villon to Walter Pach at this time is a purely Futurist statement: 'The power of the machine imposes itself, and we can scarcely conceive living beings any more without it. We are strangely moved by the rapid brushing by of men and things, and accustom ourselves without knowing it to perceive the forces of the former through the forces they dominate. From that to an opinion of life in which it appears to us simply under its form of higher dynamism, there is only a step, which is quickly made.'[2] (Pl. 71.)

[1] *Montjoie*, Nov.–Dec. 1913.
[2] This letter of 16 Jan. 1913 is quoted, in an English translation, in Pach's *Queer thing, Painting*, New York 1938, p. 145, and again in an abridged form and in a different translation in the catalogue to the exhibition of works by the Duchamp brothers, organized by the Guggen-

At the time of the *Section d'Or* exhibition, however, Duchamp-Villon's major work was the facade which he designed for the '*maison cubiste*' at the *Salon d'Automne* of 1912. In 1910 the *Salon d'Automne* had included a large exhibition of decorative art from Munich, and the superiority of the Germans in this field had led the President of the *Salon*, Franz Jourdain, to launch an appeal asking French artists to take a greater interest in the applied arts. The call was answered by André Mare, a young painter whom Léger had known at the Académie Julien (they did their military service together) and with whom he shared a studio until 1908. Mare persuaded Duchamp-Villon, who was interested in architecture, to co-operate with him in the project for a '*maison cubiste*'. Mare himself was in charge of the interior decoration. The 'house' was decorated with paintings and wall panels by Jacques Villon, La Fresnaye, Marie Laurencin and Paul Vera and other *Section d'Or* painters. Both Villon and Vera were working in a Cubist idiom, but La Fresnaye and Laurencin were never more than peripheral figures in the movement. Marie Laurencin had been influenced by Picasso's Negroid work, and later adapted some of the devices of Cubism to her own decorative and feminine style, but her work was included in the Cubist exhibitions and manifestations mainly because she was a friend of Apollinaire, who was devoted to her and was anxious to encourage her as much as possible. Other artists who worked on the '*Maison Cubiste*', like Ribbemont Dessaignes and the sculptor Desvalliers, had nothing at all to do with Cubism. Judging from photographs, the general effect of the interiors was decidedly un-Cubist, and must have been reminiscent of earlier *art nouveau* ensembles executed by the Nabis for the theatrical productions of Lugné-Poë and Paul Fort in the 1890's. Warnod complained of the over-elaborate colour schemes and the general feeling of unnecessary complication.[1] The facade itself was basically perfectly traditional. It consisted of a flat wall, subdivided symmetrically by the openings of the door and windows, and surmounted by a small pitched roof. The only novelty lay in the heavy, angular, rather mannerist decoration that was applied in large quantities around the door and windows. Unfortunately the project was not completed in time for the opening of the exhibition, so that it was not noticed much by the critics in their reviews;[2] and shortly after the opening of the *Salon d'Automne* all critical attention was focused on the *Section d'Or*.

heim Museum and the Museum of Fine Arts, Houston, 1957. The second, later, version is used here.

[1] *Comoedia*, 20 Oct. 1912.

[2] Apollinaire commented only on the sense of comfort which the interior of the *Maison Cubiste* gave. *L'Intransigeant*, 30 Sept. 1912.

These manifestations of 1912, while they demonstrated the existence of a powerful new movement, also served to show how divergent the aims of the self-styled Cubists had become. Apollinaire attempted to clarify the situation in a lecture entitled *le Cubisme Ecartelé*, which he delivered at the Galerie de la Boétie on the 12th of October 1912, a few days after the opening of the *Section d'Or*.[1] He distinguished four types of Cubism; two of these, 'Scientific' Cubism and 'Orphic' Cubism, he felt to be pure developments. Scientific Cubism Apollinaire defined as 'l'art de peindre des ensembles nouveaux avec des éléments empruntés, non à la réalité de vision, mais à la réalité de connaissance'.[2] The artists whom Apollinaire placed in this category were Picasso, Braque, Metzinger, Gleizes, Laurencin and Gris, that is to say (if one excepts Marie Laurencin), the painters who were working in a Cubist style. About Orphic Cubism Apollinaire was slightly vaguer, but he implies that its goal is abstraction and its purpose is to convey some sort of absolute truth. The artists in whom Apollinaire saw Orphist tendencies were simply those whom he sensed were breaking away from Cubism as it had been originally created by Picasso and Braque. These artists were Delaunay, Léger, Picabia and Marcel Duchamp. Picasso was placed in this category too, but only because of his use of light, and (one suspects) because Apollinaire realized his importance and could not bear to exclude him from any significant new movement. A third category, Physical Cubism, was invented to cover the work of all the peripheral figures who were working in a more naturalistic idiom but who belonged to Cubism because of the 'discipline' they showed in the construction of their work. A fourth denomination, Instinctive Cubism, is applied to artists whose inspiration was not drawn from visual reality, and whose work was related to that of the Orphists, but lacked lucidity and any definite aesthetic principles. At first one might be tempted to think that Apollinaire was referring to painters like Kandinsky, who were formulating an abstract style of their own, but he goes on to say that this movement had already spread throughout Europe, and in a note at the end of *Les Peintres Cubistes* he generously extends the term to cover all the developments in twentieth-century painting from Fauvism to Futurism.

The term Orphism was originally invented by Apollinaire to describe the most recent developments in Delaunay's art. The paintings by Delaunay that so impressed Apollinaire were a series of canvases which Delaunay brought back from the Valley of the Chevreuse where he had spent the summer of 1912, and which he called *Fenêtres*. These paintings by Delaunay did in fact mark the

[1] See p. 32 above.
[2] *Les Peintres Cubistes*, p. 24.

beginning of a new phase in his art which broke fundamentally with the principles of Cubism proper. Delaunay later came to feel that the series marked the beginning of the 'constructive' phase in his art which he opposed to the 'destructive' or Cubist period which preceded them; in his notebooks he wrote: 'les Fenêtres appartenaient à toute une série qui ouvre vraiment ma vie artistique.'

Delaunay had begun his artistic career as a Divisionist painter, and as a student had read Chevreul and Rude on the theory of colour. Now, with the *Fenêtres*, colour once again became the principal element of his art. In some notes on painting written in the autumn of 1912 and published in the December issue of *Soirées de Paris* under the heading *Réalité, Peinture Pure*, Delaunay tried to make his position clear.[1] He stressed the importance of El Greco and 'certain English painters' (presumably Turner and Constable) whose interest in light had anticipated the researches of the Impressionists. The work of the Impressionists, Delaunay continues, was carried to its logical conclusions by Seurat, whose importance could not be overemphasized, since, 'de la lumière (il) a dégagé le contraste des complémentaires.' On the laws of complementary colours Delaunay based all his own art. His own aesthetic, he goes on to say, differed from that of Seurat and the Divisionists in that, while they used colour contrasts as a technique to record their vision of nature, for him the painting of light had become an end in itself. And while the Impressionists and Divisionists had covered their canvases with small strokes or dots of colour which were intended to be blended by the eye of the spectator, Delaunay conceived of a type of painting in which the colours used to produce a sensation of light would not blend but would retain their separate identities; by their interaction these colours could furthermore be made to produce a sensation of depth and movement. Since movement implies duration, time was also an element of this new art. Using the terminology of Chevreul, Delaunay called these colour contrasts 'simultaneous' to distinguish them from the colour contrasts used by the Impressionists and their successors, which were 'binary' and tended to fuse together when seen at a distance.[2]

Delaunay's writings are, unfortunately, illogical and contradictory, so that one is forced to reinterpret them in the light of his paintings. For example, in *Réalité, Peinture Pure* he stresses the importance of studying nature, and talks about the necessity of a subject in painting, but presumably he felt (as Apollinaire did) that his own work was 'pure' painting because it was tending towards

[1] The article was published with an introductory note by Apollinaire.

[2] The work of Chevreul that Delaunay read was *De la Loi du Contraste Simultané des Couleurs* a book which was first published in 1839; a revised edition appeared in 1889. The chapter from which Delaunay seems to have derived his theories is entitled *Définition du Contraste Simultané.*

abstraction. Light and reality were for some reason inexplicably related to each other in his mind, and for this reason he felt that his art was an art of realism. Nevertheless, Delaunay would have been the first to admit that the kind of metaphysical reality he was striving for in his work had no connection with the realism of Cubism as it was created by Picasso and Braque. Writing of this period in his notebooks, Delaunay described the new developments in his art in a much simpler way: 'à ce moment, vers 1912, j'ai eu l'idée d'une peinture qui ne tiendrait techniquement que de la couleur, des contrastes de couleurs, mais se développant dans le temps et se percevant simultanément. J'employais le mot scientifique de Chevreul, "les contrastes simultanés" .'

Although the *Fenêtres* do mark a new departure in painting, looked at in retrospect Delaunay's evolution seems perfectly logical. With the series of *Eiffel Tower* paintings, begun in 1910, Delaunay had broken with traditional perspective and had investigated the possibilities of a new pictorial space. By his dislocation of objects he had also produced a sensation of movement in his paintings. Next, in the *Villes* he had submitted himself to a more purely Cubist discipline by virtually abandoning colour and organizing his canvases in terms of small planes or shapes arranged in shallow depth. The last of these paintings had become increasingly abstract and difficult to read; in them touches of bright colour were introduced in a tentative way. The paintings executed at Laon, although they are some of his most nearly Cubist works, lie somewhat outside the main stream of Delaunay's development. However, at this time, colour re-asserted itself strongly in his art, and he abandoned the chequered, square brush-strokes he had used in the *Villes*. The *Ville de Paris*, as has been seen, was an attempt to incorporate all the researches of the previous years into a monumental *Salon* piece. The *Fenêtres* which represent the next step in his development are simply a reinterpretation of the earlier *Villes* in terms of brilliant colours, and without the Divisionist brush-strokes. The rainbow-like effects produce a new sense of light and transparency, as Delaunay had intended that they should, and there is a greater sense of depth and movement; these canvases, however, are still composed of a series of small, flat or tilted, inter-locking planes. This serves to relate them, superficially at least, to the canvases of Picasso and Braque of the period between 1910 and 1912. Indeed, at first glance, the paintings of the *Fenêtres* series look like brilliantly coloured Cubism. (Pl. 59.)

However, if in the last of the *Villes* the subject-matter had become of second-ary importance, in many of the *Fenêtres* it counts for almost nothing at all. In almost all the paintings of the series the Eiffel Tower can be seen in the back-

ground, in the centre of the composition, and some of the larger paintings of the series show ferris-wheels and houses as well, but these forms are used by Delaunay merely as the starting-point for the break-up of the picture surface in terms of transparent, interacting coloured shapes. The real subject-matter of these paintings is, as Delaunay himself said, light itself. Nevertheless, despite Delaunay's interest in colour theory, his approach remained to a large extent intuitive and empirical, and the disposition of colours in the *Fenêtres* is not governed by any very rigid system, although there is generally a careful balancing of the parts of the spectrum. In the example in the Guggenheim Museum, Delaunay uses the three primary colours (blue, yellow and a pinky-red) and three secondary colours (purple, orange and green), but they are not placed on the canvas in a logical order; they are not arranged according to the spectrum, neither is there a systematic juxtaposition of complementaries. A long horizontal *Fenêtre* in the Gallatin Collection in the Philadelphia Museum of Art, is divided into three sections, the first predominantly yellow, the second blue and the third red, but each of these basic areas is broken by planes of various different colours that are introduced in a spontaneous and instinctive fashion. The earth colours and blacks of the *Villes*, however, are completely discarded.

The *Fenêtres* broke the balance between abstraction and representation that Cubism had always sought to maintain. The next stage in Delaunay's development is represented by a series of paintings which he executed at Louveciennes during the summer of 1913, and which are all composed of circular motifs inspired by celestial bodies. Despite their astronomical appearance, these paintings have no real subject-matter, and Delaunay himself regarded them as 'non-figurative'.[1] With the circular forms Delaunay was able to achieve a greater sense of movement, and he felt, furthermore, that they enabled him to eliminate the last vestiges of any linear element from his art. Line, he felt, was detrimental to the free interaction of colour. On the other hand, these paintings still had a 'faceted' appearance that related them to his more Cubist work, and Delaunay was dissatisfied, too, with the gradations which he had to employ to achieve a transition from one area to another. Later in the year he produced his first *Simultaneous Disk* (presaged by a spectral disk on the floor of one of his *Saint Séverins*), a round terra-cotta plaque covered with concentric bands of bright, unmodelled colour, and almost immediately he began to introduce these harder, disk-like forms into his paintings as well. With these works the final break with Cubism was completed. (Pl. 60b.)

Apollinaire classified Léger as an Orphist, both in the lecture that he gave at

[1] *Notebooks.*

the Galerie de la Boétie and in his review of the *Salon des Indépendants* of 1913,[1] in which he tried to promote and organize the new movement which he had invented. Léger and Delaunay had worked together closely during the previous years, and during 1913 it is true that in certain aspects Léger's art, like that of Delaunay, was becoming more abstract. On the other hand, the fundamental differences between the painters were also becoming more apparent. Whereas Delaunay was evolving a lyrical and poetic kind of painting with a hazy, illogical aesthetic, Léger's aims were much more concrete and realistic. And while Delaunay indulged in metaphysical speculation, Léger was primarily concerned with creating a form of painting that reflected modern life. In one of the two lectures which he delivered at the Académie Wassilief at this time Léger said, 'on n'a jamais été autant réalisté et collé à son époque comme aujourd'hui.'[2] This is a point which he stressed again and again. Modern life, he felt, differed from that of other periods in that it was swifter, more compressed, and more complicated than anything that had preceded it. These qualities could best be captured by a more dynamic, vigorous and abstract form of art: 'La conception moderne n'est donc pas une abstraction passagère bonne pour quelques initiés seulement, il est l'expression totale d'une génération nouvelle dont il subit les nécessités et répond à toutes les aspirations.'[3]

Léger's thought was clearly influenced by the theories and propaganda of the Futurists. He constantly refers to the dynamic quality of modern life; he praises the new, swift means of locomotion and derides the ridiculous reactionaries who wish to preserve the landscape by forbidding the erection of large, commercial posters along the highways. Like the Futurists, and in opposition to the Cubists, Léger expresses his admiration for the Impressionists. 'Les Impressionistes', he insisted, 'sont les grands novateurs du mouvement actuel.'[4] However, his attitude differed from that of the Futurists in many respects. Whereas they had approved of the Impressionists because they had concerned themselves with a representation of contemporary life in a lively and direct way, Léger, on the contrary, felt that their importance lay in the fact that they had taken the first step towards a kind of painting in which formal, pictorial values predominated, while the subject itself was only of secondary importance: 'Les impressionnistes les premiers ont rejeté la valeur absolue du sujet pour ne plus en considérer que la valeur relative.'[5] Delaunay admired the

[1] *L'Intransigeant*, 18 March 1913.
[2] *Les Réalisations Picturales Actuelles.*
[3] *Les Origines de la Peinture et sa Valeur Représentative.*
[4] Ibid.
[5] Ibid.

Impressionists, too, but only because their canvases produced a sensation of light. While Léger sympathized with the Futurists in their glorification of contemporary life, he was untouched by their highly romantic and literary approach. He was anxious to produce a painting that would reflect the modernity and vitality of his age, but he felt that this could best be achieved by the creation of a more abstract style, and not simply by the painting of movement in a schematic way or by the adoption of mechanical or up-to-date subject-matter: 'les réalisations mécaniques modernes tels que la photographie en couleurs, le cinématographe, la profusion des romans plus ou moins populaires, la vulgarisation des théâtres, remplacent efficacement et rendent désormais parfaitement inutile, en art pictural, le développement du sujet visuel, sentimental, représentatif et populaire.'[1] Léger's art thus remained more visual than that of the Futurists, and the problems with which he concerned himself were, in the last analysis, purely pictorial. Finally, to the intense chauvinism of the Futurists he opposed the concept of a new, universal pictorial idiom.

Léger repeatedly stressed the fact that his was an art of realism; so did the Cubists and the Futurists, and, for that matter, so did Delaunay. The Cubists, as has been seen, were realists in the true sense of the word. They were intent on interpreting the world around them in new pictorial terms; their vision was untouched by any literary or romantic considerations, and they ignored all forms of metaphysical speculation. The Futurists, on the other hand, felt that they were realists because their work reflected the most up-to-date aspects of life in the twentieth century; in actual fact, their outlook, like that of all anarchists, was highly emotional and over-coloured. Delaunay saw himself as a realist simply because he felt that his work embodied a higher metaphysical truth than that of other painters. While in some of his work of 1913 and 1914 Léger moved away from Cubism, his claim to realism was more justified than that of either Delaunay or the Futurists. Unlike the Futurists, his view of contemporary life was objective and unromantic, and unlike Delaunay, even at his most abstract, he was concerned with relating his art to external reality by his conscious attempt to parallel the sense of immediacy and directness of modern life in his own paintings. And while at this period in his career Léger was advocating a more abstract form of expression he never excluded all the representational possibilities of art. He was to prove, too, the underlying realism of his vision by the fact that total abstraction satisfied him only for very brief periods.

The concrete, forthright nature of Léger's aesthetic was reflected in his paintings. In the years before 1913, Léger had evolved a type of painting which was

[1] *Les Origines de la Peinture et sa Valeur Représentative.*

based on a system of pictorial contrasts. A few bright colours had been juxta-posed, representational elements had been contrasted with abstract elements, solid forms with flat forms and curving or rounded shapes with angular ones. Now, during 1913, Léger produced a series of paintings which he called simply *Contrastes de formes* (or, occasionally, *éléments géométriques*) in which the representational element is completely absent. Contemporary with these paint-ings, however, and closely related to them, are others which have specific sub-jects, although even these paintings are less immediately legible than most of Léger's work that had preceded them. The *Contrastes de Formes* are composed of contrasting shapes, some cylindrical and solid, others flat and angular; some are large and others small. All are outlined boldly in black, and are brightly coloured, generally in primary colours. There is no consistent source of illumina-tion, but the use of vigorous white highlights enhances the solidity of the cylindrical and tubular mechanical shapes. These contrasts produce a dynamic sense of movement which was one of the aims of Léger's art; as opposed to the Futurists, however, Léger achieves this sensation by purely pictorial means, and never resorts to the device of showing a solid form in successive stages of movement. The more figurative paintings of the period are treated in exactly the same way; indeed, the *Soirées de Paris* of August 1914 reproduced a paint-ing of Léger's of a seated woman, which had as a subtitle, *application des con-trastes au sujet*. Moreover, the *Contrastes de Formes* usually seem to be derived fairly directly from the other, less abstract, paintings. Some of the horizontal *Contrastes* relate to paintings of figures on balconies or staircases, and the up-right canvases are similar in composition to those of seated figures, while the smaller panels seem to derive from still-lifes. It is uncertain whether Léger had abandoned abstraction completely by 1914, but many of his large figure com-positions belong to this year. Examples, like the *Escaliers* (Pl. 55), however, are still constructed on exactly the same principles as the *Contrastes*. (Colour Plate D.)

While Léger's experiments in abstraction were related to his more representa-tional work, and while his art continued to have a starting point in visual reality, Delaunay, on the other hand, during 1913 had developed a completely abstract form of painting which had no connection whatsoever with the external world. Disagreements began to arise between the two painters. Léger had al-ways been more interested in the representation of three-dimensional forms and in linear design than Delaunay had, and in his second lecture at the Académie Wassilief[1] he specifically stated that he thought it wrong for painters to rely

[1] *Les Réalisations Picturales Actuelles.*

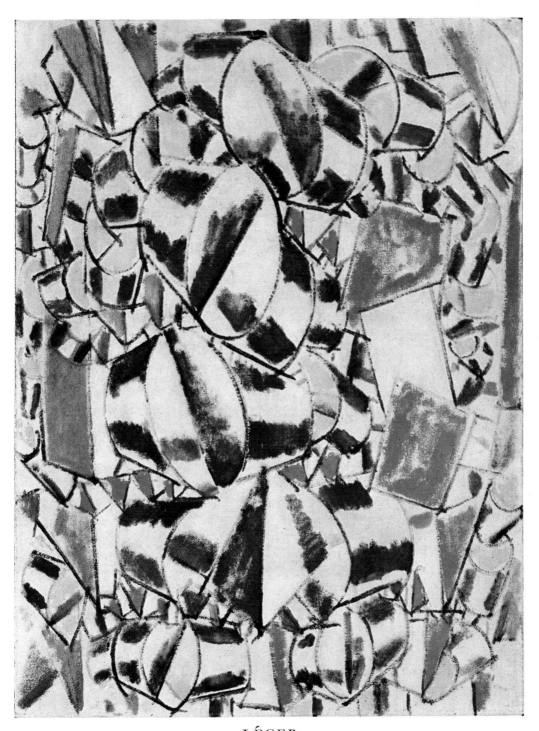

LÉGER

D. Contrastes des Formes, 1913. Oil, $51\frac{3}{8}'' \times 38\frac{3}{8}''$.
Philadelphia Museum of Art, Arensberg Collection

only on the interaction of colouristic elements to produce their effects. Léger felt that the work of Delaunay and his followers was simply an extension of the theories of Neo-Impressionism, and in his lecture he went on to say that their style was not suited to paintings of large proportions such as they had shown at the *Indépendants* of 1914: 'C'est ce que j'appelerai la peinture additionnelle au rebours de la peinture multiplicative.' The term 'multiplicative' Léger applied to his own work in which he stressed the importance of line and solid form as well as that of colour. Delaunay, infatuated with colour, complained that Léger was developing along the wrong lines. In his notebooks, under the reproduction of one of his *Disks*, he noted: 'influence sur Léger qui n'a pas compris son influence. (Ici) la couleur est le seul dessin. Il n'y a pas comme dans Léger un dessin et de la couleur dessus, aussi [*sic*] que chez Cormon ou le reste.'

In retrospect, and particularly in the light of their subsequent developments, it becomes clear that the aims of both these artists, Léger and Delaunay, were never quite those of the pure Cubists, Picasso, Braque and Gris. Like these three painters, and independently of them, in his paintings of 1909 and 1910 Léger had purged his art of all inessentials and had tackled squarely the problem of creating a more classical, structural sort of art, in which simple volumes played the leading role. But the sense of movement implicit in his *Nus*, the vigorous foreshortening of the poses, the very subject itself, indicated that Léger's talent and aesthetic were of a more dynamic, less subtle and personal nature than theirs. And despite their complexity, his most purely Cubist works, paintings like *La Femme en Bleu*, remained in a sense less sophisticated and more easily accessible than the contemporary work of Picasso and Braque. What he admired in their Cubism was the dismissal of what he, too, felt to be outmoded pictorial conventions. It has been seen how through their example he was led to break with traditional perspective. This gave him the freedom to manipulate pictorial forms in a new, more abstract, highly dynamic and original way, and eventually to evoke the spatial and formal sensations that enabled him to adapt his art to what he felt were the needs of twentieth-century society. In his painting there is always a feeling for the reality and significance of objects that derives, ultimately, from Cubist aesthetic. Delaunay, on the other hand, despite his pretensions to establishing a universally significant art form, remained a much more purely subjective painter. The earliest paintings of his pre-Cubist phases already showed that colour, which was only one of the many pictorial factors that concerned the Cubists, was to be the all-important factor in his art. From the Cubists he learned how to organize a painting independently of perspectival considerations, and when he began to re-introduce pure, prismatic colours into

179

his work, he came to feel almost at once that Cubism was merely the starting point for a more popular, more abstract kind of painting. He slipped almost imperceptibly, but very quickly, into the formalism and abstraction that the Cubists had been aware of but had deliberately avoided. His *Villes* and his *Laon* paintings can justifiably be called Cubist, but by 1913 he had made a complete break with Cubist aesthetic. While by 1914 Léger, like Delaunay, had moved away from Cubism in his abstractions, in most of his work he remained as close to Cubism, both in technique and in spirit, as he had been for the past four years.

So, although Cubism was daily making new converts, of the original painters who had launched Cubism as a movement only Gleizes and Metzinger continued to work in a strictly Cubist style. By 1913 Metzinger had fallen completely under the artistic domination of Gris, and during the following year he followed Gris' development in so far as he was capable of doing so. Gleizes in 1913 had begun to feel the influence of Gris, and also that of Delaunay, although he continued to refer to Léger's earlier Cubist work as well. Both painters occasionally introduced lettering and stencilled numbers into their paintings, but always in a literal or representational way, and never with any true understanding of what had led Picasso and Braque to do so. What is most remarkable is that in the period before the war, of the Cubist painters only Picasso, Braque and Gris made any extensive use of *collage* and *papier collé*. In 1909, 1910 and 1911 Léger and, to a lesser extent, Delaunay, had submitted themselves to an intense pictorial discipline and in this their Cubism was related to that of Picasso and Braque, but both saw in Cubism only the starting-point or the means towards a very different art. When they had extracted what they thought was most important from Cubism, they passed on to something else. Gleizes and Metzinger, painters whose development did not follow an inner necessity, saw intellectually the importance of Cubism, and were content to follow the development of the style at second-hand without being able to see it through to its logical conclusions, either instinctively as Picasso and Braque had done, or on Gris' high intellectual level. Never having undergone a period of profound analysis and concentration in their work, they lacked the technical discipline to evolve for themselves, as Picasso and Braque did, a form of painting which was at the same time freer and more concise. By 1914, when Cubism was widely known, they had ceased to have any importance in the movement. And even they, the academic representatives of the style, could not stand out against the disruptive influences, both personal and artistic, which the war was to produce.

CONCLUSION

'On peut déjà prévoir le jour prochain où le terme CUBISME n'aura plus qu'une valeur nominative pour désigner dans l'histoire de la peinture contemporaine certaines recherches des peintres entre les années 1907–14.' So Blaise Cendrars wrote in 1919 in an article entitled *Le Cube s'effrite*.[1] To the majority of people this obituary of Cubism must have seemed rather premature. For Cubism, it was obvious, had survived the war. Léonce Rosenberg, the dealer who had temporarily taken over Kahnweiler's role as the chief patron and supporter of the movement, had by 1919 presented at his *Galerie de L'Effort Moderne* large one-man exhibitions by five well-known Cubists, and was busily encouraging newcomers to the school.[2] Exhibitions by Picasso and by Severini, who had by this time abandoned Futurism in favour of a purely Cubist idiom, were scheduled for the following year. Then, in January 1920, a second exhibition of the *Section d'Or* was held at the *Galerie de la Boétie* with the intention of demonstrating the continued vitality and coherence of the movement.[3] Almost all the Cubists, with the important exception of Picasso, showed at the *Salon des Indépendants* of this same year. After the opening Gris was able to write to Kahnweiler: 'the *Salon des Indépendants* opened with something of a success for the Cubists, who were taken seriously by the whole—or almost—of the press. Even Monsieur Vauxcelles admits that he has wronged us.'[4]

But if at the end of the war Cubist activity was resumed on a large scale, the character of the movement was deeply changed. The great revolutionary days were past. In art, as in politics, things which had seemed outrageous in 1914 were accepted almost without a murmur in 1919. As far as Cubism goes, this is proved by the fact that Vauxcelles, who before the war had been its bitterest opponent, was now able, as Gris noted, to look at it in a more detached and objective way. And in fact, as Kahnweiler has pointed out in his book on Gris, the

[1] In *La Rose Rouge*, no. 3, 15 May 1919.

[2] By 1919 there had been exhibitions of Braque, Léger, Metzinger, Herbin and Gris, Rosenberg had also shown Laurens and was planning a Hayden exhibition, two new recruits to Cubism.

[3] Yet a third exhibition called *La Section d'Or* was held at the Galerie Vavin Raspail in 1925.

[4] *The Letters of Juan Gris*, p. 75. Letter of 31 Jan. 1920. Kahnweiler was in Switzerland.

united front presented by the Cubists in 1920 was not based on any very solid foundations. Gleizes, who was one of the organizers of the 1920 *Section d'Or* and had seen the exhibition as a conscious attempt to revive the spirit and principles of pre-war Cubism, was forced to admit that it served only to show how 'l'idée (du Cubisme) en se développant avait fait éclater la mince enveloppe du mot Cubisme'.[1]

As a movement, then, Cubism had lost the quality of unity and concentration which had made it seem so vital and revolutionary in the years before the war. During the war most of the painters were physically separated from each other, and many of them were temporarily forced to abandon their work.[2] When they were able to resume their normal lives they found that they had lost a sense of continuity in their art. Some, like Braque, hesitated for a while before recovering their sense of direction. Others, like Gleizes and Villon, were immediately drawn towards a more abstract form of expression. For a few painters, such as Léger for example, the war itself provided an intense and positive experience that had an immediate and lasting effect on their artistic development. Then those artists who, like Picasso and Gris, had been in a position to keep Cubism alive during the war, had been forced to work in comparative isolation, and this had served to accentuate the differences between them. New figures, most notably the two sculptors Laurens and Lipchitz, were giving the style a new interpretation.

Nevertheless, although after 1918 Cubism was more diffuse than it had been four years earlier, it is dangerous to overestimate the part played by the war in the disintegration of the school. During 1913 and 1914 Picasso and Braque had already been moving apart stylistically. Gris was asserting himself more and more as an individual artist who was giving the style a different emphasis. In his *Contrastes de Formes*, Léger's researches into the pictorial properties and possibilities of form had reached a point of individuality that placed them outside any category. The Orphism of Delaunay was growing steadily further away from its parent movement. La Fresnaye, who had in any case never been a central figure in the movement, had fallen under the influence of Delaunay and was moving out of the Cubist orbit. The Duchamp brothers, and most especially Duchamp-Villon, had adapted Cubism to the principles and aesthetic of Futurism. By 1914 both Marcel Duchamp and Picabia, whose allegiance to Cubism had in any case always been rather doubtful, were completely Dada in

[1] 'L'Epopée' in *Le Rouge et le Noir*, June-July 1929.
[2] Léger, Braque, Gleizes (very briefly), Marcoussis, Metzinger, Jacques Villon and Duchamp-Villon were in the army as were La Fresnaye, Lhote and the majority of the peripheral figures who had been attached to the movement.

spirit. Lhote and a large number of painters like him, who were referred to as 'Cubist', had really only seized on the most superficial aspects of the style and were using them to create an up-to-date academicism; indeed, applied to their work, Vauxcelles' definition of Cubism as 'un retour offensif à l'école' was apt enough.

It is true that as the original nucleus of the movement was breaking up, the style was constantly attracting new figures. By 1914 a host of minor painters, many of whom have long since been forgotten, had become Cubist or had been touched in a positive fashion by the movement. These were the painters who were, perhaps, most affected by the war. For like Gleizes and Metzinger and the other hangers-on of Cubism, it was they who felt the conscious need to be part of an organized, revolutionary movement. When the major Cubists were physically separated by the war and Paris was temporarily abandoned as the home of the artistic *avant-garde*, Cubism lost the impetus that was necessary to sustain the efforts of the lesser artists. After the painters were able to reassemble again, new forces were making themselves felt; many artists experienced a sense of disillusion and disorientation that prevented them from taking up where they had left off. Although much pre-war Cubism had a strong intellectual flavour, its origin had been notably unscientific; it offered no hard and fast rules, no signposts to artistic security and success. Many of the lesser painters began to search for some definite pictorial certainty in the realms of abstraction or in coldly didactic movements such as Purism. Others turned to forms of expression more suited to an emotional and disturbed state of mind. The fact that Picasso, who was still generally regarded as the central figure of the Cubist movement, was working in a naturalistic as well as in a Cubist idiom must have made many people doubtful about the future of the style. In short, Cubism no longer held out the possibilities of a universal pictorial idiom.

And although even before 1914 Cubism had spread with unprecedented rapidity to almost every part of the Western world, it was never to become an international style. For, just as many of the painters who had been originally attached to the school used Cubism as a point of departure for the realization of totally different ends, so artists in Holland, Russia and Germany reinterpreted, indeed occasionally even misinterpreted Cubism to found a whole succession of schools and pictorial idioms that were completely divorced from its ideals. This, it has been seen, was exactly what had been done first of all by the Futurists when they had seen in the pictorial techniques evolved by the Cubists the means of expressing their own violent ideologies. By 1914 abstraction was already a force in European art, and during the war more and more painters became

attracted to it. An increasing number of artists, painters like Mondrian, Malevitch, Rodchenko, and even at one point, it appeared, Klee, had come to see in Cubism only the first step towards a completely abstract form of painting.

It is easy to understand how such an interpretation could be placed on Cubism. With Cubism, painting had become further removed from ordinary visual appearances than ever before; the Cubist painters were acutely aware of the formal or abstract side of their art. And we have already seen how from an interest in reducing objects and figures to their simplest basic forms, Léger had passed on to an interest in those forms for their own sake, endowing them with a life and independent existence of their own. Delaunay, by introducing what was really a traditional use of colour (as opposed to a Cubist use of it) into Cubist painting, had become fascinated by the spatial and formal interaction between planes of pure colour, and had soon come to feel that there was no need for a subject, since these formal problems were really the theme of his art. Mondrian, without entering deeply into the spirit and significance of Cubism, had seized at once on the methods of composition evolved by the Cubists, and fascinated by the superficial patterns in the work of Picasso and Léger (whom, as he himself admitted, he most admired) he embarked on a series of formalized experiments that resulted eventually in the aesthetic of *De Stijl*.

The fact that Cubism gave birth to so much abstract art may be one of the reasons why it has been so consistently misunderstood by the public, and even occasionally by serious critics and historians. Cubism, it must be stressed again, was an art of realism, and it was even further removed from abstraction than from, for instance, Futurism. All the true Cubists had at one time or another come near to complete abstraction, but each of them had almost immediately retracted and reasserted the representational element of their art. After the Cadaqués paintings Picasso produced the comparatively legible portrait of Kahnweiler, and devised a system of pictorial 'keys' that would render his paintings more accessible to the spectator. When in the winter of 1911–12 Braque's fascination with the tactile qualities of pictorial space had resulted in a complicated, highly hermetic group of paintings, he hastily reverted to a more comprehensible idiom. In 1915 Gris' dissatisfaction with the descriptive quality of much of his earlier work led him to produce the most abstract of all his works, a still-life (now in a private collection in Paris) in which it is impossible to reconstruct with any certainty the nature of most of the objects that compose it; this painting, however, did not solve the problems he was facing and remained an isolated phenomenon in his work. It was in his *Contrastes de Formes* that Léger first detached himself from Cubist aesthetic, although he paralleled these

paintings with other, more figurative work, and soon abandoned abstraction altogether. Indeed, it is perhaps not altogether fortuitous that the naturalistic portraits executed by Picasso in the second half of 1915 were more or less contemporary with some of his most hermetic Cubist canvases since those done at Cadaquès five years earlier.

But whatever the future of the movement might have been if it had not been for the war, it is certainly true that by 1914 the fundamental principles of Cubism had been established and all the most important discoveries and innovations had been made. To the system of perspective which had governed European painting since the Renaissance the Cubists had opposed the right of the painter to move freely around his subject and to incorporate into his depiction of it information gathered from previous experience or knowledge. For the first time in the history of art, space had been represented as being as real and as tangible, one might almost say as 'pictorial', as the objects which it surrounded (here one must distinguish between an Impressionistic depiction of atmosphere and the painting of empty, clear space, such as is found before Cubism only in the late work of Cézanne). While the Cubists had not denied the interrelation of colour and volume, they had formulated a means of allowing them to exist independently of each other in a single painting; that is to say they were using various pictorial elements in their simplest, purest form, allowing each to retain its separate identity while contributing at the same time to the total effect. Partly in order to solve the pictorial problems that had confronted them in their creation of a completely new pictorial idiom, and partly as a natural result of their concept of the painting as an independent organism, a constructed object with a life of its own rather than as a traditional 'work of art', the Cubists had evolved two revolutionary pictorial techniques: *papier collé* and *collage*.

Finally, in their desire to take stock afresh of the world that surrounded them, the Cubists had effectively stripped bare many of the problems that had underlain painting and sculpture since the beginning of time. Artists, except those intent only on duplicating their subject in an illusionistic way, had always been aware of the need to reconcile their representation of it with the abstract demands of the aesthetic medium in which they were working; forms must be balanced to achieve a satisfactory composition, in painting volumes in depth must be arranged to produce also a harmonious surface pattern, and so on. The outlook of the Cubists, it has been seen, was intensely realistic, and a true appreciation of their painting depends ultimately on the spectators' ability to reconstruct or identify its subject-matter. But because they were less

directly conditioned by visual appearances than any other school of painting since the Renaissance, they were able to evolve more abstract pictorial and sculptural techniques to solve the problems of recreating or reinterpreting the material world through an artistic medium. Never before had the duality between representation and abstraction been so clearly stated as it was in the Cubist paintings of Picasso, Braque, and Gris, in the years immediately preceding the war. In these paintings one is aware at once of the presence of an easily identifiable subject, but the eye is simultaneously stimulated by the presence of an equally obvious underlying abstract pictorial structure with which the representational elements are fused and related. Had any of the problems facing the Cubists remained unsolved before the painters were physically separated by the war, they might have found it necessary to come together again in the same spirit of co-operation that had given the movement such intensity and concentration in the pre-war years. But because the nature of the style had been so firmly established during these years preceding 1914, the history of Cubism after the war is largely the history of the artistic development of a series of individual artists who used its principles as the foundation for the creation of their own particular idioms.

In so far as Cubism was a new concept of form and space, involving new pictorial techniques, it is still alive to-day. Picasso has never relinquished the right to synthesize into his subjects any amount of information or detail, gained by using a variable viewpoint, that he felt necessary to convey more forcefully his vision or ideas of them. *Guernica* is not a Cubist painting, but equally obviously it could not have come into being without Cubism behind it. In Braque's late *Ateliers* there is much the same feeling of spatial materiality and continuity as there is in the works of his classical Cubist period. At the end of his career, when Gris' work could no longer be classified as strictly Cubist, he was still using a 'synthetic' Cubist procedure, working from abstraction to representation, marrying a subject to an abstract pictorial substructure. This same process has been used at different times and in modified ways by Braque, Léger and even Picasso. *Papier collé* and *collage* have long since been accepted as recognized methods of work. There is even a reflection of the concept of the *tableau objet* in the aesthetic beliefs of the most radical American painters of the 1950's.

Indeed, the continued life of Cubism, the fact that its influence can be seen around us everywhere to-day, in painting, sculpture, and even, though less directly and obviously, in architecture and the applied or commercial arts, makes it difficult, perhaps even impossible to assess with complete detachment and objectivity its ultimate role in the history of art. But there can be no doubt

that to the historian of the future it will appear as one of the major turning points in the evolution of Western art, a revolution comparable in its effects to any of those which have altered the course of European art, and one which has produced a series of works capable of holding their place amongst the great masterpieces of the past.

BIBLIOGRAPHY

I. UNPUBLISHED MATERIAL

Delaunay, R. *On Futurism*, 1912. (This essay takes the form of an open letter to Marinetti.)

 Notebooks, written over a long period of years before his death in 1941. (Extracts from these notebooks appear, often in an altered form, in *Delaunay* by Gilles de la Tourette.)

Delaunay, Sonia Terk. Biographical data on R. Delaunay, definitive version 1950.

Gleizes, A. *Souvenirs*, written in the years before his death in 1953.

Picasso, P. Letters to Gertrude and Leo Stein, 1906–14. In the Stein correspondence, Yale University Library.

II. NEWSPAPERS AND PERIODICALS

Important articles are listed under the author's name
in the general section below.

Abstraction Création, Art non-Figuratif, Paris 1932.

Action (l'), Paris, 25 February–24 March 1912; February 1920.

Autorité (l'), Paris, 27 November 1912.

Art Libre (l'), Lyons, November 1910.

Bandeaux d'Or (les), Paris, November 1911.

Blast, London 1914–15.

Bulletin de l'Effort Moderne, Paris 1924–35.

Bulletin de la Société de l'Histoire de l'Art Français, Paris 1912.

Comoedia, Paris, 27 June 1911; 30 September 1912; 13 October 1912; 18 March 1913; 1 April 1914; 15 April 1914; 2 June 1914.

Cote, Paris, 19 March 1912; 20 March 1912; 30 September 1912; 12 October 1912.

Ecrits Français (les), Paris, 5 April 1914.

Elan (l'), Paris 1915–16.

Esprit Nouveau (l'), Paris, 1920–5.

Excelsior, Paris, 4 March 1914.

Festin d'Esope (le), Paris, November 1903–August 1904.

Figaro (le), Paris, 20 September 1909; 24 September 1911.

Gazette des Beaux Arts, Paris, November 1910.

Gazette de la Capitale, Paris, 23 April 1911.

Gil Blas, Paris 1906–14.

Intransigeant (l'), Paris 1906–14.

Je sais tout, Paris, April 1913.

Journal, Paris, 22 March 1912.

Journal Officiel de la Chambre des Députés, Paris, 3 December 1912.

Lacerba, Florence, 1 and 15 August 1913.

Matin (le), Paris, 1 December 1913.

Mercure de France (le), Paris 1906–14.

Montjoie, Paris, February 1913–June 1914.

Nord-Sud, Paris 1917–18.

Nouveau Spectateur (le), Paris, 25 May 1919.

Opinion (l'), Toulouse, 7 April 1912; 3 May 1913.

Paris Journal, Paris 1906–14.

Paris Midi, Paris, 10 October 1912; 21 February 1914.

Petit Bleu, Paris, February 1912.

Petit Parisien, 19 March 1912; 30 September 1912; 30 October 1912.

Petite Gironde (la), Bordeaux, April 1912.

Poème et Drame, Paris, January 1913.

Presse (la), Paris, 1–2 October 1910.

Revue de France (la), Paris, March 1912.

Revue Française (la), Paris, June 1912.

Revue Indépendante (la), Paris, August 1911.

Rue (la), Paris, April 1911.

Section d'Or (la), Paris, 9 October 1911.

Soirées de Paris (les), Paris, February 1912–August 1914.

Sturm (der), Berlin 1910–15.

Télégramme (le), Toulouse, 5 January 1909.

Temps (le), Paris, 14 October 1912.

Vers et Prose, Paris 1907–12.

Voce (la), Florence, 24 August 1911; 7 December 1911.

III. CATALOGUES
(of exhibitions and sales)

Only contemporary catalogues are listed below. Later catalogues containing important critical or historical material are included in the general section.

Armoury Show (International Exhibition of Modern Art), New York 1913.

Braque, at the Galerie Kahnweiler, Paris, 9–28 November 1908.

Delaunay, at the Galerie Barbazanges, Paris, February–March 1912.

Gleizes, Metzinger, Léger at the Galerie Berthe Weill, Paris, January 1913.

Herbin, at the Galerie Moderne, Paris, March 1914.

La Fresnaye, at Galerie Levesque, Paris, April–May 1914.

Les Indépendants, Cercle d'Art, VIIIème Salon, Brussels, 10 June–3 July 1911.

Kahnweiler Sales, at the Hôtel Drouot, Paris, Part 1, June 1921; Part 2, 17 and 18 November 1921; Part 3, 4 July 1922; Part 4, 7 and 8 May 1923.

Le Salon d'Automne, Paris 1906–14.

Le Salon des Indépendants, Paris, 1906–14.

Uhde Sale, Hôtel Drouot, Paris, 30 May 1921.

IV. GENERAL

Allard, A. 'Au Salon d'Automne de Paris,' in *L'Art Libre*, Lyons, November 1910; 'Quelques Peintres,' in *Les Marches du Sud-Ouest*, June 1911; 'Léger,' in *Les Soirées de Paris*, Paris 1913; Preface to an exhibition of works by La Fresnaye at the Galerie Levesque, Paris, April–May 1914; 'L'Avenir de la Peinture,' in *Le Nouveau Spectateur*, no. 1, Paris, May 1919; *Marie Laurencin*, Paris 1921; *R. de la Fresnaye*, Paris 1922.

Apollinaire, G. Preface to the Catalogue of the Braque Exhibition at the Galerie Kahnweiler, Paris, 9–28 November 1908; *L'Hérésiarque et Cie*, Paris 1910; 'Mes Prisons,' in *Paris Journal*, Paris, 14 September 1911; Preface to the Catalogue of *Les Indépendants, Cercle d'Art*, 8me Salon, 10 June–3 July 1911, Brussels; 'Les Commencements du Cubisme,' in *Le Temps*, Paris, 14 October 1912; *Les Peintres Cubistes, Méditations Esthétiques*, Paris 1913; 'Pablo Picasso,' in *Montjoie*, 14 March 1913; *L'Antitradition Futuriste*, Milan and Paris 1913; 'Simultanisme, Librettisme' in *Soirées de Paris*, Paris, June 1914; 'Pablo Picasso' in *Sic*, Paris, May 1917; *L'Esprit Nouveau et Les Poètes*, *Le Mercure de France*, Paris 1917; *Sculptures Nègres*, Paris 1917; *Peintures de Léopold Survage*, Paris 1917 (introduction to a catalogue).

Apollinaire. Special issue of *L'Esprit Nouveau*, 26 October 1924 (with essays by Salmon, Roche Grey, Picabia, etc.).

Aragon, L. *La Peinture au Défi*, Paris 1930.

Archipenko, A. *Sturm-Bildebücher*, Berlin 1923.

Arp, H. and Neitzel, L. H. *Neue Französische Malerei*, Leipzig 1913.

Barr, A. *Cubism and Abstract Art*, The Museum of Modern Art, New York 1936; *Picasso*, The Museum of Modern Art, New York 1946; *Matisse*, The Museum of Modern Art, New York 1951.

Barr, A. and Soby, J. T. *Twentieth Century Italian Art*, The Museum of Modern Art, New York 1949.

Barzun, H. 'Après le Symbolisme,' in *Poème et Drame*, Paris, May 1913; 'Manifeste sur le Simultanisme Poétique,' in *Paris Journal*, Paris, 27 June 1913.

Billy, A. *Max Jacob*, Paris 1947; *Appollinaire*, Paris 1947.

Bissière, R. 'Georges Braque' in *Bulletin de l'Effort Moderne*, Paris, March 1920.

Blaue Reiter (der). Munich 1912.

Boccioni, U. Introduction to his exhibition of Futurist Sculpture at the Galerie de la Boétie, Paris, June–July 1913; 'Il Dinamismo Futurista e la Pittura Francese,' in *Lacerba*, Florence, 1 August 1913; *Pittura Scultura Futuriste*, Milan 1914.

Braque, G. Special issue of *Cahiers d'Art*, nos. 1–2, Paris 1933; *Cahiers de Georges Braque*, 1917–47, Paris 1948.

Breton, A. *Francis Picabia*, Barcelona 1922.

Brielle, R. *Lhote*, Paris 1931.

Buffet-Picabia, Gabrielle. 'Some Memories of Pre-Dada, Picabia and Duchamp,' in *The Dada Painters and Poets* (the Documents of Modern Art), New York 1951.

Bulletin de la Vie Artistique, Enquête sur le Cubisme, Paris 1924–5. (A questionnaire about the nature of Cubism with answers from Gleizes, Metzinger, Jacques Villon, Angel Zarraga, etc.)

Carco, F. *Du Montmartre au Quartier Latin*, Paris (?) 1929.

Carrà, C. and others. *Nous Les Peintres Futuristes*, Milan 1910. (This pamphlet is not to be confused with the more important manifestoes of Futurist painting); *Guerra-Pittura*, Milan 1915; *Derain*, Rome 1924.

Carrieri, R. *Pittura, Scultura d'Avanguardia*, 1890–1950, Milan 1950.

Cendrars, B. and Delaunay, S. T. *La Prose de Transsibérien et de la Petite Jehanne de France*, Paris 1913.

Cendrars, B. 'Essai' in *La Rose Rouge*, Paris, 19 June 1919; 'Le Cube s'effrite,' in *La Rose Rouge*, Paris, 15 May 1919.

Cézanne, P. 'Letters to Emile Bernard,' in *Le Mercure de France*, Paris, 1 and 15 October 1907. (The letters, and Bernard's accompanying articles, later appeared as *Souvenirs sur Paul Cézanne, et Lettres*, Paris 1920.)

Chadourne, M. 'R. de la Fresnaye,' in *Cahiers d'Art*, Paris 1928.

Chamot, M. 'The Early Work of Goncharova and Larionov' in *The Burlington Magazine*, London, June 1955.

Chevreul, M. E. *De la Loi du Contraste Simultané des Couleurs*, Paris 1839. (A revised edition appeared in 1889.)

Circi-Pellicer, A. *Picasso avant Picasso*, Geneva 1950.

Cocteau, J. 'Autour de la Fresnaye,' in *L'Esprit Nouveau*, no. 3, Paris, December 1920; *André Lhote*, Paris 1920; *Picasso*, Paris 1923; *Le Rappel à l'Ordre*, Paris 1926.

Cogniat, R. 'Le Cubisme Méthodique: Léger et l'Effort Moderne,' in *Amour de l'Art*, vol. 14, Paris 1933.

Cooper, D. *Braque: Paintings* 1909–47, London 1948; *Fernand Léger et le Nouvel Espace*, Geneva 1949. 'Preface' to the Léger Exhibition at the Tate Gallery, London 1950; *Fernand Léger, Dessins de Guerre 1915–16*, Paris 1956; Catalogue to the Gris Exhibition at the Berne Kunstmuseum, October 1955–January 1956; Preface and Notes to the Braque Exhibition at the Tate Gallery, London 1956.

Coquiot, G. *Cubistes Futuristes et Passéistes*, Paris 1914; *Les Indépendants* 1884–1920, Paris 1920.

Courthion, P. *André Lhote*, Paris 1926; 'Ateliers et Académies,' in *Nouvelles Littéraires*, Paris, 19 November and 3 December 1932.

Les Créateurs du Cubisme. Catalogue to an exhibition at the Galerie des Beaux Arts, Paris, March 1935.

Le Cubisme 1911–18. Catalogue to an exhibition at the Galerie de France, Paris, May 1945.

Le Cubisme. Catalogue to an exhibition at the Musée d'Art Moderne, Paris, January 1953.

Dasburg, A. 'Cubism, its Rise and Influence,' in *The Arts*, Vol. 4, New York 1923.

Delaunay, R. 'Réalité Peinture Pure,' in *Les Soirées de Paris*, Paris, December 1912 (Prefaced and edited by Apollinaire); Letter to H. Rouveyre (undated) published under the title of 'Elément pour l'Histoire du Cubisme', in *Art-Documents*, Geneva, January 1951 (The letter discusses Delaunay's

relations with Apollinaire and the birth of Orphism.); *Album*, produced in connection with an Exhibition of Delaunay's work at Der Sturm in Berlin, 1913, Berlin (?) 1913 (the album is prefaced by Apollinaire's poem 'Les Fenêtres'); 'Uber das Licht' in *Der Sturm*, Berlin, January 1913 (translated by Paul Klee); 'Lettre ouverte au Sturm' in *Der Sturm*, Berlin, January 1914 (The letter, written to Hermath Walden, is dated 17 December 1913.); *Le Simultanéisme* reproduced in Arp and Lissitzky *Les Ismes*, Zurich 1925, and in Raynal's *Anthologie de la Peinture en France de 1906 à nos Jours*, Paris 1927.

Delaunay. Catalogue to an exhibition at the Musée d'Art Moderne (edited by Guy Habasque), Paris 1957.

Delaunay, Sonia Terk. Preface to a programme of the *Comédie des Champs Elysées*, Saison 1926–7.

Derain. Catalogue to an exhibition at the Musée d'Art Moderne, Paris 1954.

Dermée, P. 'Quand le Symbolisme fut mort,' in *Nord-Sud*, 1, Paris, March 1917; 'Jean Metzinger—Une Esthétique,' in *Sic*, Paris, March–April 1919; 'Lipchitz,' in *L'Esprit Nouveau*, Paris, November 1920.

Duchamp, Marcel. In *View*, New York, March 1945. Special issue devoted to M. Duchamp with essays by André Breton, Gabrielle Buffet-Picabia, James Thrall Soby, etc.

Duchamp, M. Preface to a Picabia exhibition at the Galerie de Beaune, Paris, November–December 1957.

Duthuit, G. *Les Fauves*, Geneva 1949.

Eddy, A. J. *Cubists and Post-Impressionism*, Chicago 1914, London 1915.

Einstein, C. *Negerplastik*, Munich 1920; 'Notes sur le Cubisme,' in *Documents*, Paris 1929; *Georges Braque*, Paris 1954.

Eluard, P. and René Jean. *Jacques Villon ou l'Art Glorieux*, Paris 1948.

'Enquête sur l'Art Nègre.' In *Action*, Paris, April 1920, with answers by Gris, Paul Guillaume, etc.

Fauconnier, Le. Catalogue for an exhibition at the Neumann Gallery, New York 1948–9 (the preface contains a photograph of the galley proof of a page, subsequently altered, of *Les Peintres Cubistes*).

Fierens, P. 'R. de la Fresnaye,' in *Art Vivant*, Paris, February 1931.

Fillia. *Il Futurismo*, Milan 1932.

Flechter, P. *Der Expressionismus*, Munich 1914.

Fleuret, F., Preface to the Catalogue of the Marie Laurencin Exhibition at the Galerie Barbazanges, Paris, February–March, 1912.

Forthuny, P. *Conférence sur les tendances de la Peinture Moderne*, Nantes 1910.

Fresnaye, R. de la. 'Paul Cézanne,' in *Poème et Drame*, Paris, January 1913.

Fresnaye, La. Catalogue to a retrospective exhibition at the Galerie Barbazanges, Paris, December 1926.

Fumet, S. *Braque*, Paris 1945 (in *Couleur des Maîtres* series); *Braque*, Paris 1945 (in *Collection des Maîtres* series).

Futurism. Manifestes Futuristes 1909–23, Milan 1923 (printed in English, French and Italian).

Garcia y Bellido, A. *La Dama de Elche y el conjunto de piezas arqueológicas reingresadas en España 1941*, Madrid 1943.

Geiser, B. *L'Oeuvre Gravé de Picasso*, Lausanne 1955.

Georges, W. 'Le Cubisme,' review of the *Salon des Indépendants*, in *L'Esprit Nouveau*, no. 5, Paris, February 1921; 'Braque,' in *L'Esprit Nouveau*, Paris, no. 6, March 1921; Preface to an exhibition of Constructivist sculpture by Gabo and Pevsner at the Galerie Percier, Paris, June–July 1924; *Fernand Léger*, Paris 1929.

Georges-Michel, G. *Peintres et Sculpteurs que j'ai connus*, New York 1942.

Gleizes, A. 'Jean Metzinger,' in *Revue Indépendante*, Paris, September 1911; 'Le Fauconnier et son Oeuvre,' in *Revue Indépendante*, Paris, October (?) 1911.

Gleizes, A. and Metzinger, J. *Du Cubisme*, Paris 1912.

Gleizes, A. 'Le Cubisme et la Tradition,' in *Montjoie*, Paris, February 1913; 'Opinion,' in *Montjoie*, Paris, November–December 1913; *Art Européen, Art Américain*, New York 1919; 'Choses Simples, à propos du Salon d'Automne de 1920,' in *La Vie des Lettres et des Arts*, Paris 1920; *Du Cubisme et les Moyens de le Comprendre*, Paris 1920; 'Originalité Collective, l'Art Moderne et la Société Nouvelle,' in *Cahiers Idéalistes*, Paris (?) 1921; *La Peinture et ses Lois. Ce qui devait sortir du Cubisme*, Paris 1924; 'A Propos de la Section d'Or,' in *Les Arts Plastiques*, no. 1, Paris 1925; *Tradition et Cubisme*, Paris 1927; 'L'Epopée' in *Le Rouge et le Noir*, Paris, June–July 1929; *Vers une Conscience Plastique*, Paris 1932; *Homocentrisme*, Sablons 1937.

Albert Gleizes, Hommage. Atelier de la Rose, Lyons 1954. With essays, statements and fragments of works by Gleizes, Metzinger, André Beaudin, Severini etc.

Gleizes, 50 Ans de Peinture. Catalogue to an exhibition at Lyons 1947.

Golding, J. 'Les Demoiselles d'Avignon' in *The Burlington Magazine*, London, May 1958.

Goldwater, R. J. *Primitivism in Modern Painting*, New York 1938; *Artists on Art*, New York 1945; *Lipchitz*, Berlin 1954.

Gomez de la Serna, R. 'Completa y Veridica Historia de Picasso y el Cubismo,' in *Revista del Occidente*, Madrid, July–August 1929 (These articles appeared in book form in Turin 1945 under the title *Picasso*).

Granié, J. Preface to an exhibition of works by Gleizes, Metzinger and Léger at the Galerie B. Weill, Paris, January 1913.

Grey, C. *Cubist Aesthetic Theories*, Baltimore 1953.

Gris, J. Collected Writings—Reprinted in *Juan Gris* by D. H. Kahnweiler, translated by D. Cooper, London 1947; *Letters* compiled by D. H. Kahnweiler, edited by D. Cooper, London 1956.

Gris. Special issue of *Cahiers d'Art*, Paris 1933, published on the occasion of a Gris exhibition at the Zurich Kunsthaus, Texts by Apollinaire, Ozenfant, Salmon, etc.

Guillaume, P. *A Propos de l'Art des Noirs* (with a preface by Apollinaire), Paris 1917; *Sculptures Nègres*, Paris 1917.

Guillaume, P. and Munro. *Primitive Negro Sculpture*, New York 1926.

Gybal, A. *Le Fauconnier*, Amiens 1922.

Habasque, G. 'H. Laurens, le Taciturne,' in *L'Oeil*, Paris, January 1956.

Herkovits, S. *African Art*, Denver 1945.

Hildebrandt, H. *Alexander Archipenko*, Berlin 1923.

Hire, M. de la. *Francis Picabia*, Paris 1920.

History of Modern Painting. Geneva 1956. With texts and documentation by Raynal, Jacques Lassaigne, Werner Schmalenbach, Arnold Rudlinger, and Hans Bolliger.

Hope, H. R. *Braque*, The Museum of Modern Art, New York 1949.

Hourcade, O. 'La Tendance de la Peinture Contemporaine,' in *La Revue de France et des Pays Français*, February 1912; 'Enquête sur le Cubisme,' organized by Hourcade, in *L'Action*, Paris, 25 February–24 March 1912; 'Le Mouvement Pictural, vers une Ecole Française,' in *Revue Française*, June 1912.

Huntingdon-Wright, W. *Modern Painting*, New York 1915.

Huyghe, R. *Histoire de l'Art Contemporain*, Paris 1935.

Isarlov, G. *Picabia Peintre*, Paris 1929; *Georges Braque*, Paris 1932.

Jacob, M. *Le Cornet à Dés*, Paris 1917.

Jaffé, H. *De Stijl 1917–31*, Amsterdam 1956.

Jakovski, A. H. *Herbin*, Paris 1933; *A. Lhote*, Paris 1947.

Janneau, G. *L'Art Cubiste*, Paris 1929.

Jourdain, F. *Le Salon d'Automne*, Paris 1928.

Judkins, W. O. 'Towards a Reinterpretation of Cubism,' *Art Bulletin*, New York, December 1948.

Kahnweiler, D. H. *Der Weg zum Kubismus*, Munich 1920; *Juan Gris*, translated by D. Cooper, London 1947; 'Negro Art and Cubism,' in *Horizon*, London, December 1948; *The Sculptures of Picasso*, London 1949.

Kirchner, L. *Chronik der Brücke*, 1913 (reprinted in *The College Art Journal*, New York, Fall 1950).

Kupka, F. 'Les Peintres et la Lutte pour le Pain,' in *Opinion*, Paris, 3 May 1913.

Kupka. Catalogue to an exhibition at the Galerie Louis Carré, New York, June 1951.

Kuppers, P. E. *Der Kubismus*, Leipzig 1920.

Laporte, P. 'Cubism and Science,' in *Journal of Aesthetics*, Cleveland, March 1949.

Larrande, C. 'André Lhote,' in *Revue Française*, May 1912.

Lassaigne, J. *Jacques Villon*, Paris 1950.

Laurens, M. *Henri Laurens*, Paris 1955.

Léger, F. 'Les Origines de la Peinture et sa Valeur Représentative,' in *Montjoie*, Paris, May–June 1913; 'Les Réalisations Picturales Actuelles,' in *Les Soirées de Paris*, Paris, June 1914; 'Pensées,' in *Valori Plastici*, Rome, February–March 1919 and in *Selection*, Antwerp, 15 September 1920; 'L'Esthétique de la Machine,' in *Bulletin de l'Effort Moderne*, Paris, nos. 1–2, 1924; Answer to a questionnaire 'Où va la peinture moderne?' in *Bulletin de l'Effort Moderne*, Paris, no. 2, 1924; Correspondence with Léonce Rosenberg in *Bulletin de l'Effort Moderne*, Paris, no. 4, 1924; 'Le Spectacle,' in *Bulletin de l'Effort Moderne*, no. 7, 1924.

Léger. Cahiers d'Art, Paris 1933, Special issue published on the occasion of a Léger Exhibition at the Zurich Kunsthaus. Texts by Giedion, Cendrars, Salmon etc.

Léger. Catalogue to a retrospective exhibition at the Musée d'Art Moderne, Paris 1949.

Léger. Catalogue to an exhibition at the Musée des Arts Décoratifs, Paris 1956.

Lemaître, G. E. *From Cubism to Surrealism in French Literature*, Cambridge Mass. 1945.

Leymarie, J. *Derain*, Paris 1949.

Level, A. *Picasso*, Paris 1928.

Lhote, A. 'Le Cubisme est-il Mort?' in *Les Feuilles Libres*, Paris, April–May 1922; *La Peinture, le Coeur et l'Esprit*, Paris 1933; *Cézanne*, Lausanne 1949.

196

Longhi, R. *Scultura Futurista, Boccioni*, Florence 1914.

Lozowick, *Modern Russian Art*, New York 1925.

MacOrlan, P. *Chronique de la Vie Contemporaine*, Paris 1928; *Montmartre*, Brussels 1946.

Marcoussis. Essays by Apollinaire, Tzara, etc., Antwerp 1920.

Marinetti, Benedetta. 'Marinetti,' in *Cahiers d'Art*, Paris 1950.

Marinetti, F. T. 'Fondation et Manifeste du Futurisme,' in *Figaro*, 20 February 1909; *Le Futurisme*, Paris 1911; *A bas le Tango et Parsifal*, Milan 1914.

Marinetti, F. T. (and others). *Noi Futuristi*, Milan 1917; *Les Mots en Liberté Futuristes*, Milan 1919; *I Manifesti del Futurismo*, Milan 1920.

Marx, R. *L'Art Social*, Paris 1913; *Maîtres d'hier et d'aujourd'hui*, Paris 1914.

Mauclair, C. *Trois Crises de l'Art Actuel*, Paris 1906.

Melquist, J. 'Jacques Villon, Maître de Puteaux,' in *Art-Documents*, no. 3, Geneva, December 1950.

Messens, E. and Melville, R. *The Cubist Spirit in its Time*, London 1947.

Metzinger, J. 'Note sur la Peinture,' in *Pan*, Paris, October–November 1910; 'Alexandre Mercereau,' in *Vers et Prose*, Paris, October–December 1911; 'Le Cubisme et la Tradition,' in *Paris Journal*, 15 (?) September 1911; 'Art et Esthétique,' in *Lettres Parisiennes*, Paris, suppl. 9, April 1920; 'L'Evolution du Coloris,' in *Le Bulletin de l'Effort Moderne*, Paris, 1925; 'Un Souper chez G. Apollinaire,' in *Apollinaire*, Paris 1946.

Mondrian, P. *Plastic Art and Pure Art 1937 and Other Essays 1941–43*, New York 1945.

Montaigne, N. 'G. Braque, sa Vie Racontée par lui-même,' in *Les Amis de l'Art*, Berne, nos. 4–7, January–April 1949.

Nebelthau, E. *Roger de la Fresnaye*, Paris 1935.

Olivier, Fernande. *Picasso et ses Amis*, Paris 1933.

Ozenfant, A. and Jeanneret. *Après le Cubisme*, Paris 1918; 'Le Purisme,' in *L'Esprit Nouveau*, no. 4, January 1921; *La Peinture Moderne*, Paris 1925.

Ozenfant, A. *Art*, Paris 1929 (translated as the *Foundations of Modern Art*, London 1931).

Pach, W. *Queer Thing, Painting*, New York 1938.

Papini, G. *Il Mio Futurismo*, Florence 1914.

Paulhan, J. *Braque le Patron*, Paris 1945.

Penrose, R. *Portrait of Picasso*, London (I.C.A.) 1956.

Picasso. Catalogue to an exhibition at the Musée des Arts Décoratifs, Paris 1955.

Picabia, P. *Cubism by a Cubist*, preface to the Catalogue of a Picabia exhibition in New York 1913; 'Francis Picabia et Dada,' in *L'Esprit Nouveau*, no. 9, June 1921.

Piot, R. 'A Propos les Cubistes,' in *Bulletin du Salon d'Automne*, special no. 1917

Princet, M. Preface to the Catalogue of the Delaunay Exhibition at the Galerie Barbazanges, Paris, February–March 1912.

Raynal, M. 'Qu'est ce que . . . le Cubisme?' in *Comoedia Illustré*, Paris, December 1913; *Quelques Intentions du Cubisme*, Paris 1919; *Lipchitz*, Paris 1920; 'F. Léger,' in *L'Esprit Nouveau*, Paris, no. 4, January 1921. The article was subsequently expanded in the *Bulletin de l'Effort Moderne*, nos. 18–19, Paris 1925; *Juan Gris*—Paris 1920 (reprinted in the *Bulletin de l'Effort Moderne*, no. 16, Paris, June 1925); 'Juan Gris,' in *L'Esprit Nouveau*, Paris, February 1921; *Picasso*, Paris 1922; *G. Braque*, Rome, Paris 1923; *Anthologie de la Peinture en France de 1906 à nos Jours*, Paris 1927.

Reverdy, P. 'Sur le Cubisme,' in *Nord-Sud*, Paris, March 1917; 'Le Cubisme, Poésie Plastique,' in *L'Art*, Paris 1919; 'L'Esthétique et l'Esprit,' in *L'Esprit Nouveau*, Paris, no. 6, March 1921; *Picasso*, Paris 1924; *Le Gant de Crin*, Paris 1926.

Rewald, J. *Paul Cézanne, Correspondance*, Paris 1937.

Rey, E. *Picabia*, Paris 1908.

Richardson, J. 'The Ateliers of Braque,' in the *Burlington Magazine*, London, June 1955.

Roger-Milés, L. Preface to a Picabia Exhibition at the Galerie Haussmann, Paris, February 1905; Preface to a Picabia Exhibition at the Galerie Georges Petit, Paris, March 1909.

Romains, J. *Le Fauconnier*, Paris 1921.

Rosenberg, L. *Cubisme et Tradition*, Paris 1920; *Cubisme et Empirisme*, Paris 1921.

Sabartés, J. *Picasso*, Milan 1937. English edition, London 1949; *Picasso—Documents Iconographiques*, Geneva 1954.

Salmon, A. *La Jeune Peinture Française*, Paris 1912; *La Jeune Sculpture Française*, Paris 1919; 'Les Origines et Intentions du Cubisme,' in *Demain*, Paris, April 1919; *L'Art Vivant*, Paris 1920; *Propos d'Atelier*, Paris 1922; *Derain*, Paris 1924; *Derain*, Paris 1929; *L'Air de la Butte, Souvenirs sans Fin*, part 1, Paris 1945; *Souvenirs sans Fin*, part 2, 1908–20, Paris 1956.

Seligman, G. *R. de la Fresnaye*, New York 1954.

Seuphor, M. *Mondrian*, London 1956.

Severini, G. Preface to an Exhibition of his work at the Sackville Gallery, London, March 1912; *Du Cubisme au Classicisme*, Paris 1921; 'Vers une Synthèse Esthétique,' in *Bulletin de l'Effort Moderne*, October–November 1924; *Tutta la Vita di un Pittore*, Italy 1946.

Siblik, E. *Francis Kupka*, Prague 1929.

Soffici, A. 'Arte Francese,' in *La Voce*, Florence 1913; *Cubismo e Futurismo*, Florence 1914.

Stein, G. *The Autobiography of Alice B. Toklas*, New York 1933. *Picasso*, Paris 1938. English edition, New York, London 1939.

Stein, L. *Appreciation*, New York 1947.

Sweeney, J. J. *African Negro Art*, The Museum of Modern Art, New York 1935; 'Picasso and Iberian Sculpture,' in *Art Bulletin*, New York, no. 3, 1941; *Modern Art and Tradition*, New York 1948.

Tourette, G. de la. *Delaunay*, Paris 1950.

Trillo-Clough, R. *Looking Back on Futurism*, New York 1942.

Uhde, W. *Rousseau*, Paris 1913; *Picasso et la Tradition Française*, Paris 1928.

Ungaretti, G. 'La Doctrine de Lacerba,' in *L'Esprit Nouveau*, Paris, no. 2, November 1920.

Valensi. 'La Couleur et les Formes,' in *Montjoie*, Paris, November–December 1913.

Vallier, D. 'Braque, la Peinture et Nous,' in *Cahiers d'Art*, no. 1, 1954.

Villon, J. Special issue of *Cahiers d'Art*, 1951.

Villon, J. Catalogue to an exhibition at the Musée d'Art Moderne, Paris 1951.

Villon, J. Catalogue to an exhibition at the Musée Toulouse-Lautrec, Albi 1955.

Villon, J., Duchamp, M., and Duchamp-Villon. Catalogue to an Exhibition at the Guggenheim Museum, New York 1957.

Vitrac, R. *Jacques Lipchitz*, Paris 1929.

Vlaminck, M. *Tournant Dangereux*, Paris 1929; *Portraits avant Décès*, Paris 1943.

Warnod, A. *Les Berceaux de la Jeune Peinture*, Paris 1925.

Werth, L. *Quelques Peintres*, Paris 1923; *La Peinture et la Mode*, Paris 1924.

Wiese, E. *Alexander Archipenko*, Leipzig 1923.

Wilenski, R. *The Modern Movement in Art*, London 1927.

Zayas, M. de. *African Negro Art, its Influence on Modern Art*, New York 1915.

Zervos, C. *Picasso, Cahiers d'Art*, Paris, Vol. 1, 1932; Vol. 2, 1942; Vol. 3, 1949; Vol. 4, 1951; Vol. 5, 1952; Vol. 6, 1954; *Histoire de l'Art Contemporain*, Paris 1938.

INDEX

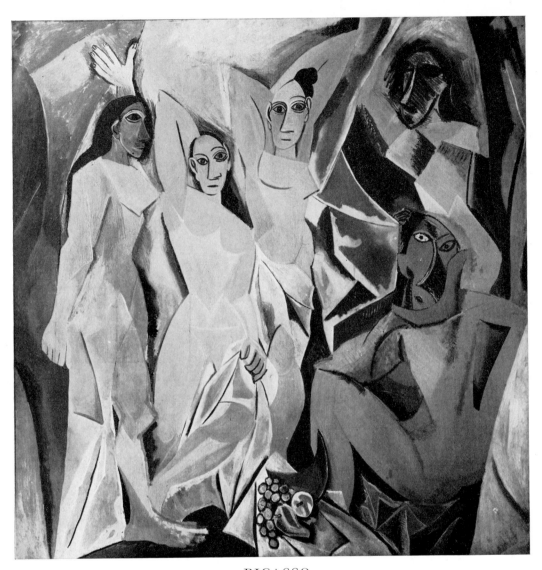

PICASSO
1. Les Demoiselles d'Avignon, 1907. Oil, 96″ × 92″.
The Museum of Modern Art, New York

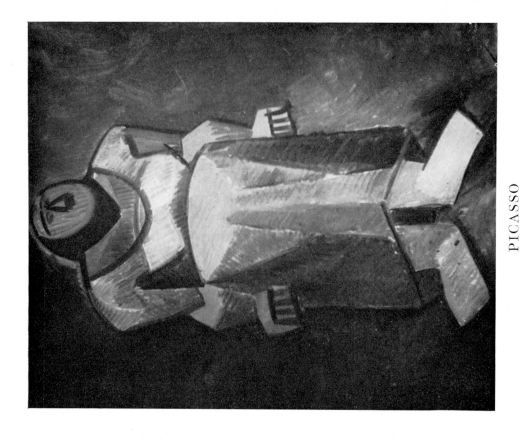

PICASSO

2B. La Paysanne, 1908. Oil, $55\frac{1}{2}'' \times 22\frac{1}{8}''$.
Museum of Modern Western Art, Moscow

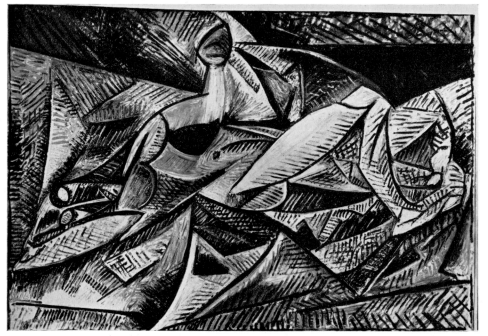

PICASSO

2A. Nu à la Draperie, 1907. Oil, $60\frac{3}{4}'' \times 40\frac{1}{2}''$.
Museum of Modern Western Art, Moscow

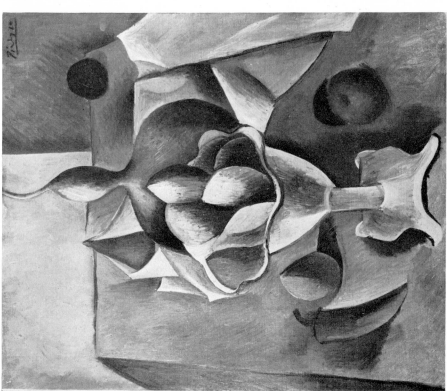

PICASSO

5B. Le Compotier, 1908–9. Oil, $29\frac{1}{4}'' \times 24''$.
The Museum of Modern Art, New York

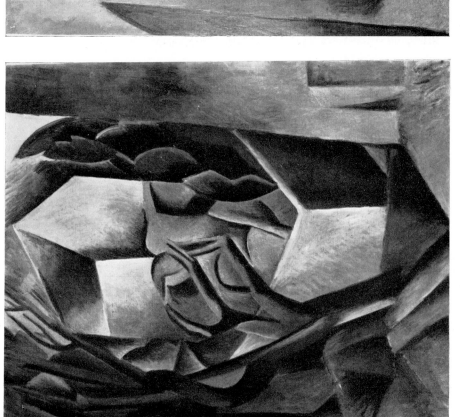

PICASSO

5A. Landscape, La Rue des Bois, 1908. Oil, $36\frac{1}{2}'' \times 29\frac{1}{4}''$.
Museum of Modern Western Art, Moscow

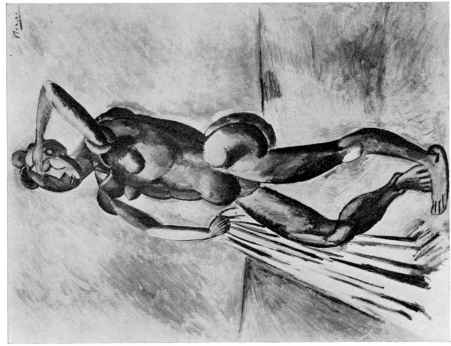

PICASSO
4B. Baigneuse, 1908–9. Oil, $51\frac{1}{4}'' \times 38\frac{1}{4}''$.
Private Collection

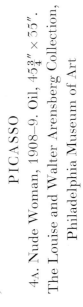

PICASSO
4A. Nude Woman, 1908–9. Oil, $45\frac{3}{4}'' \times 35''$.
The Louise and Walter Arensberg Collection,
Philadelphia Museum of Art

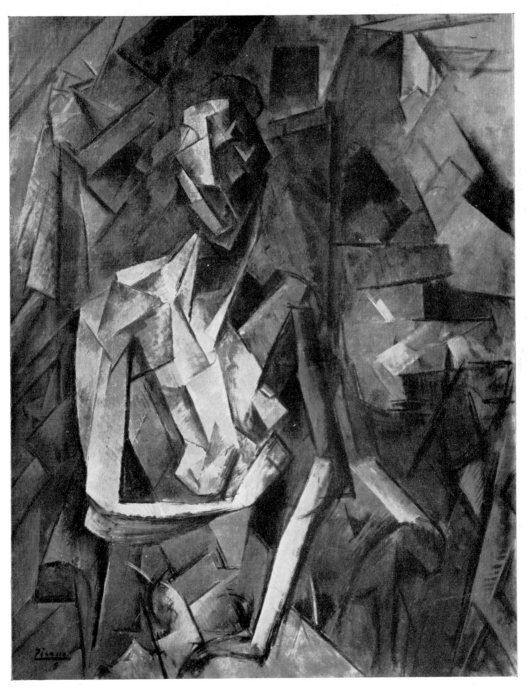

PICASSO

5. Seated Woman, 1909. Oil, $36\frac{1}{2}'' \times 24\frac{1}{4}''$. The Tate Gallery, London

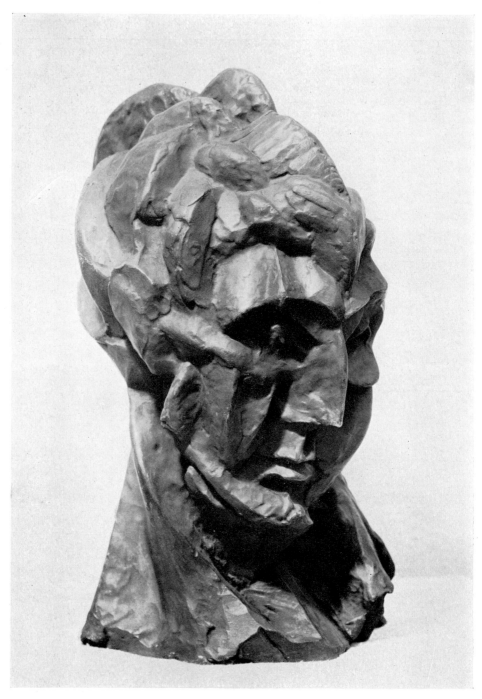

PICASSO

6. Head, 1909. Bronze, $16\frac{1}{4}''$ high. The Museum of Modern Art, New York

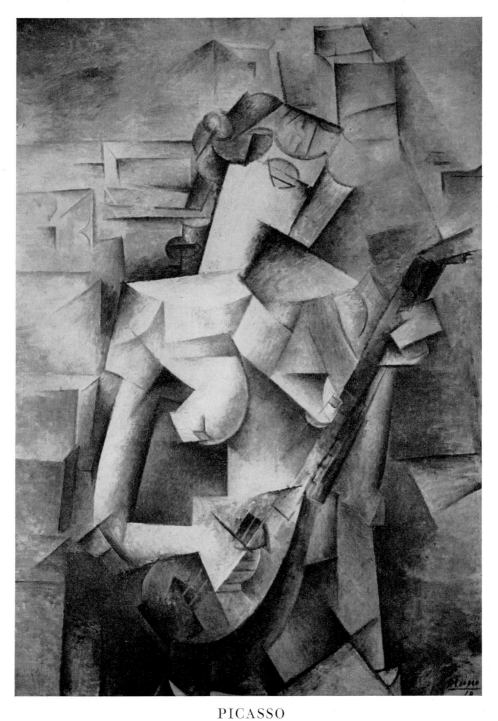

PICASSO

7. Girl with a Mandolin (The Portrait of Fanny Tellier), 1910.
Oil, $39\frac{1}{2}'' \times 29''$. Private Collection, New York

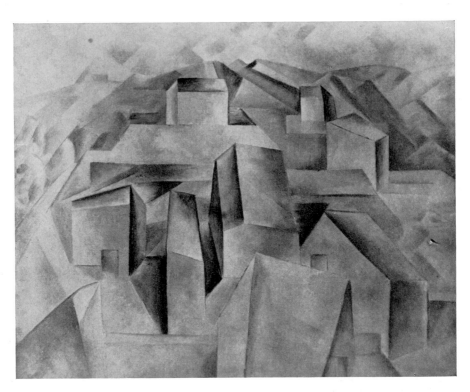

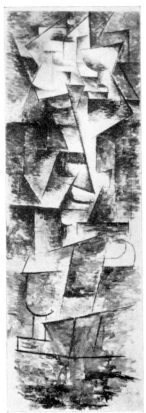

PICASSO

8A. Landscape, Horta de San Juan, 1909.
Oil, $24\frac{1}{2}'' \times 31\frac{3}{4}''$.
Collection the Heirs of Gertrude Stein

8B. Nude (Cadaquès), 1910.
Oil, $73\frac{5}{8}'' \times 24''$. Private Collection, Milan

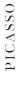

PICASSO

9B. Mademoiselle Léonie, 1910. Etching.
The Museum of Modern Art, New York

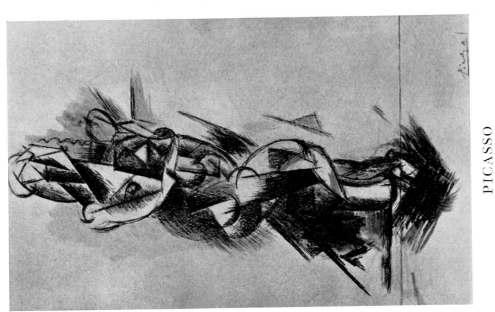

PICASSO

9A. Nude, 1910. Ink and wash, $29\frac{1}{8}'' \times 18\frac{3}{8}''$.
Collection Pierre Loeb, Paris

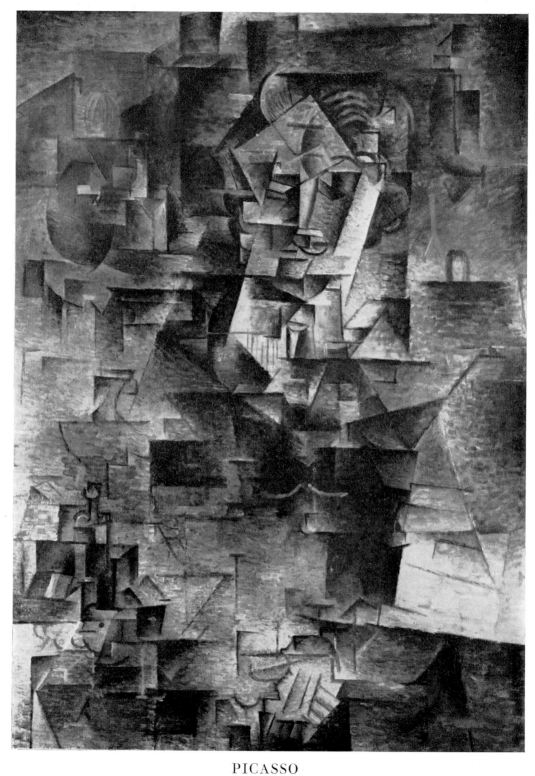

PICASSO
10. Portrait of Monsieur Kahnweiler, 1910. Oil, $39\frac{1}{4}'' \times 28\frac{1}{4}''$.
The Art Institute of Chicago, Collection Mrs. Gilbert Chapman

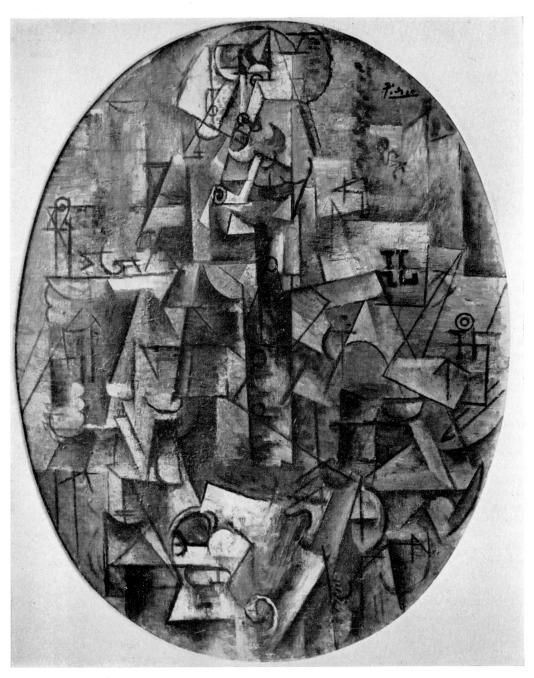

PICASSO
11. L'Homme à la Pipe, 1911. Oil, $35\frac{1}{2}'' \times 28\frac{1}{4}''$. Private Collection

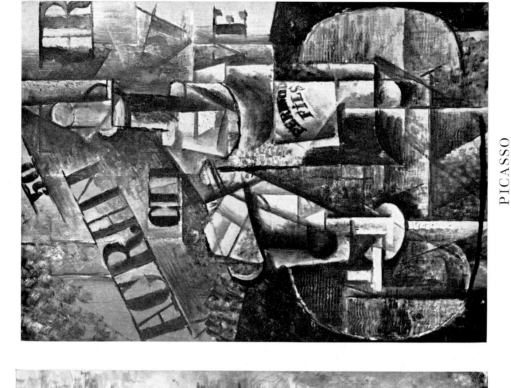

PICASSO

12B. Bouteille de Pernod, 1912. Oil, $18\frac{1}{2}'' \times 15\frac{1}{4}''$.
Museum of Modern Western Art, Moscow

PICASSO

12A. Bottle and Glasses, 1911. Oil, $26'' \times 24''$.
The Solomon R. Guggenheim Museum, New York

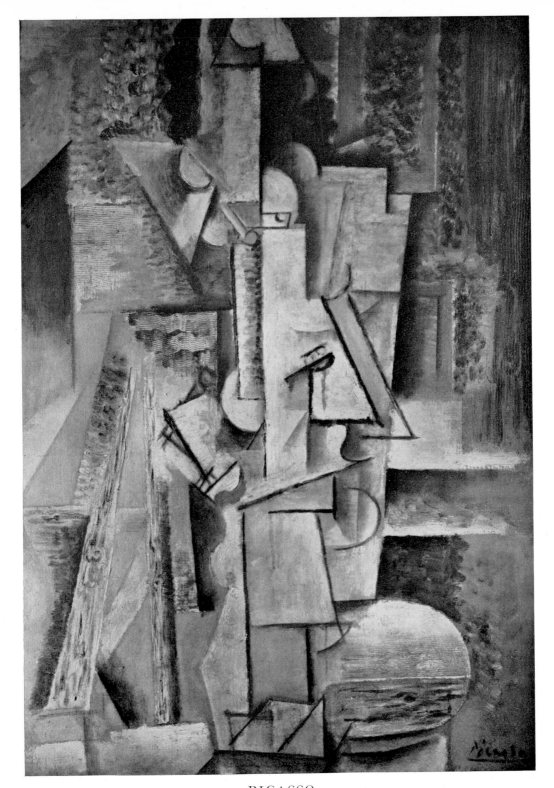

PICASSO

13. Le Modèle, 1912. Oil, $46\frac{1}{2}'' \times 36\frac{1}{2}''$. Collection Dr. H. Carey Walker, New York

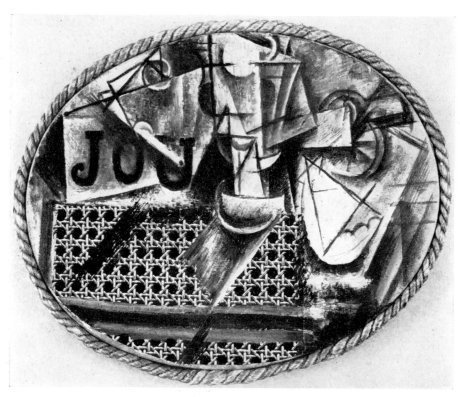

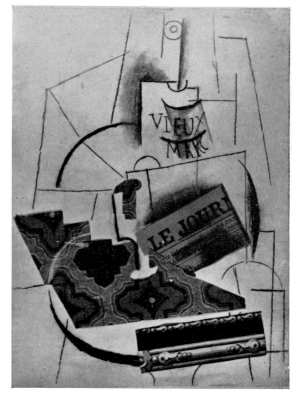

PICASSO

14A. Still Life with Chain-caning, 1912. Oil and pasted oil-cloth, $10\frac{5}{8}'' \times 13\frac{3}{4}''$. Collection of the Artist

14B. Bouteille de Vieux Marc, 1912. Papier collé, $30\frac{1}{2}'' \times 24\frac{1}{2}''$. Collection Madame Cuttoli, Paris

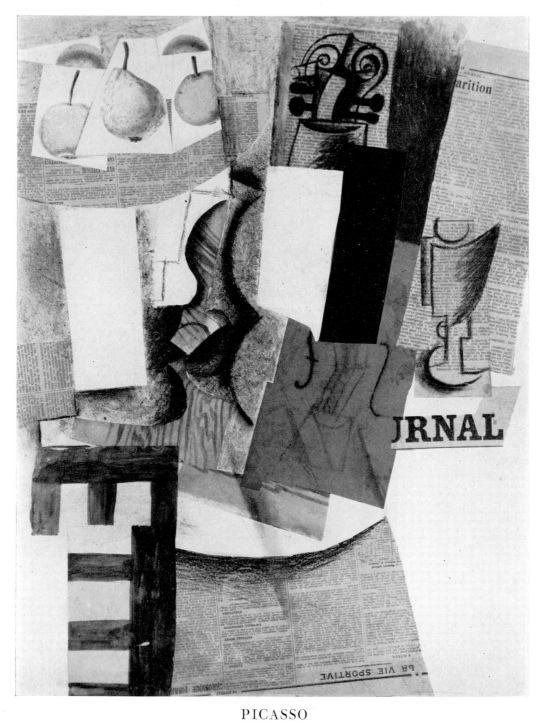

PICASSO
15. The Violin, 1913. Papier collé, 26″ × 20″. The A. E. Gallatin Collection,
Philadelphia Museum of Art

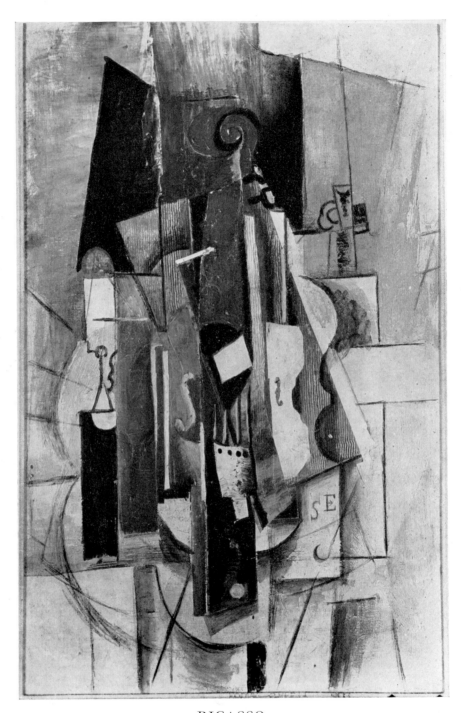

PICASSO

16. Violon au Café, 1913. Oil, 32″ × 18½″. Galerie Rosengart, Lucerne

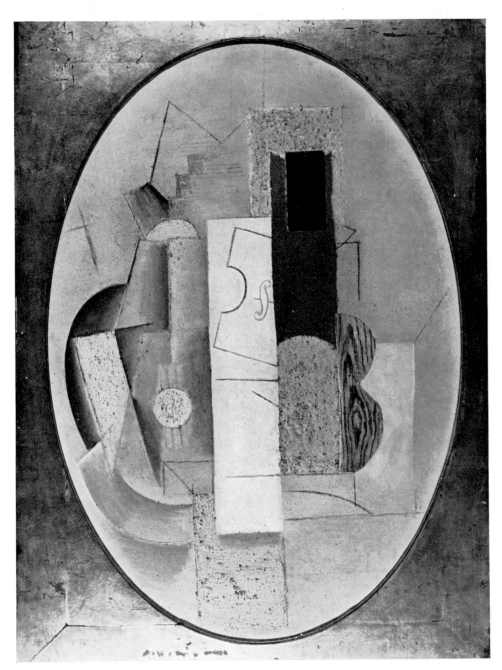

PICASSO

17. Violin and Guitar, 1913. Oil, pasted cloth, pencil and plaster, 36″ × 25″.
The Louise and Walter Arensberg Collection, Philadelphia Museum of Art

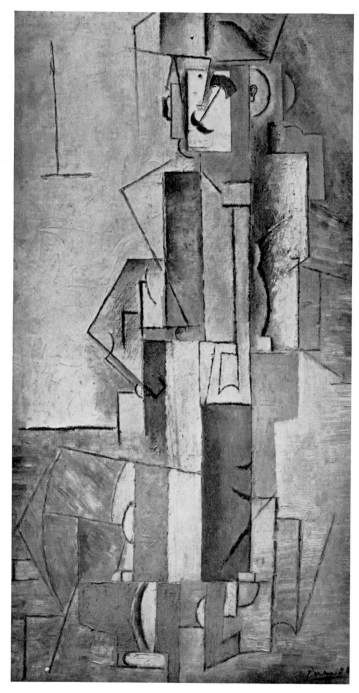

PICASSO
18. Harlequin, 1913. Oil, $33\frac{3}{4}'' \times 20\frac{1}{4}''$.
Galerie Rosengart, Lucerne

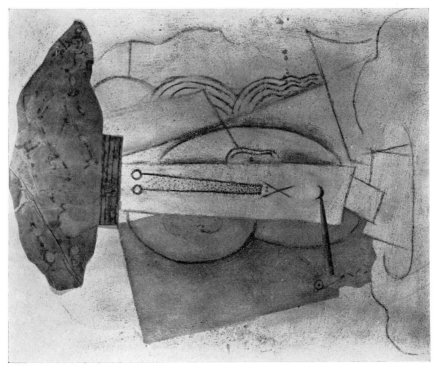

PICASSO

19B. L'Etudiant à la Pipe, 1913–14. Oil, $28\frac{1}{4}'' \times 24''$.

Collection the Heirs of Gertrude Stein

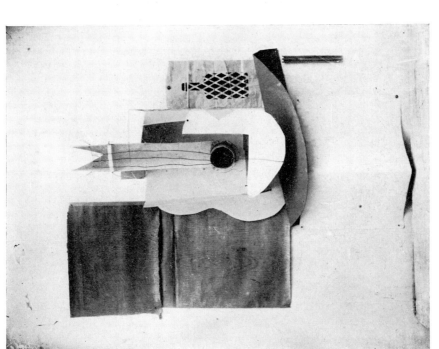

PICASSO

19A. Bouteille et Guitare, 1913. Construction.

No longer in existence

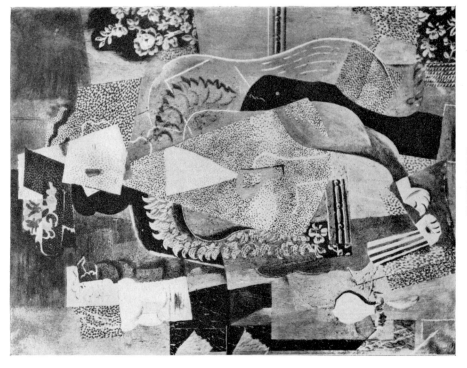

PICASSO
20B. Seated Woman (Portrait de Jeune Fille), 1914.
Oil, 51″ × 36¼″.
Collection Monsieur Georges Salles, Paris

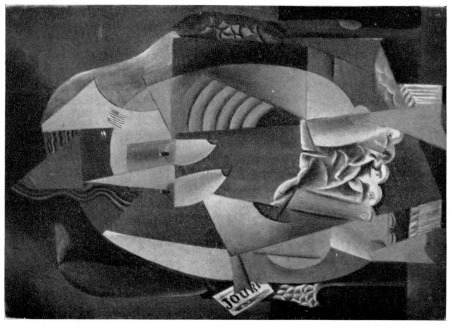

PICASSO
20A. Femme en Chemise assise dans un Fauteuil,
1913. Oil, 51″ × 39″.
Collection Dr. Ingeborg Pudelko Eichmann, Zurich

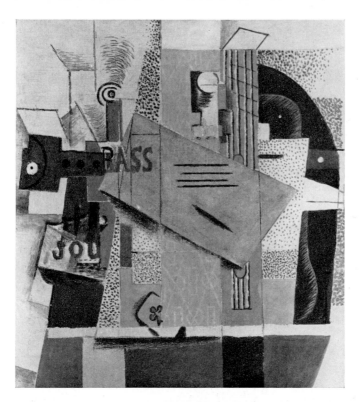

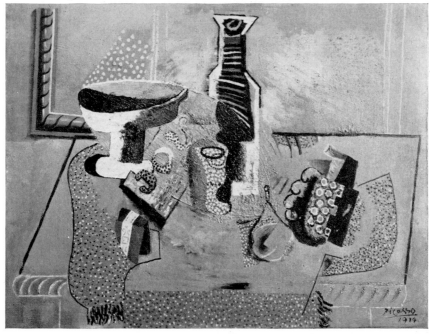

PICASSO

21A. Le Violon, 1914. Oil, $32\frac{3}{4}'' \times 28''$.
Musée National d'Art Moderne, Paris

21B. Green Still Life, 1914. Oil, $23\frac{1}{2}'' \times 31\frac{1}{4}''$.
The Museum of Modern Art, New York

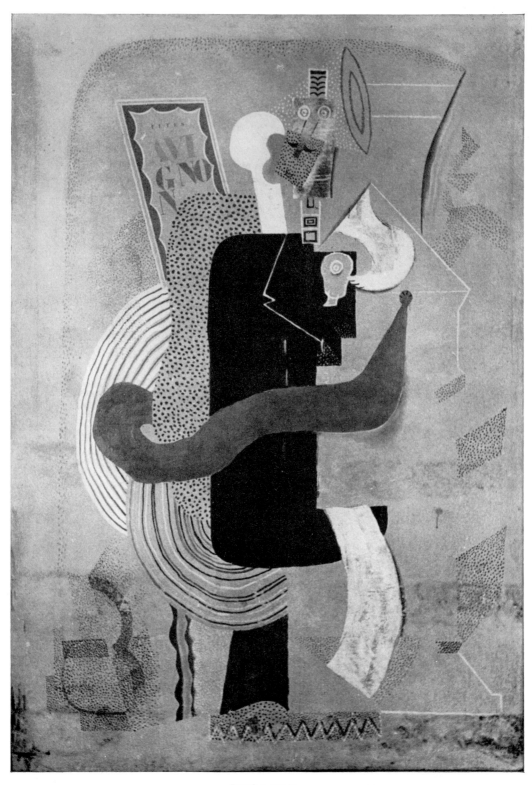

PICASSO

22. Homme Assis au Verre, 1914. Oil, $94\frac{1}{4}'' \times 65\frac{1}{2}''$.
Private Collection, Milan

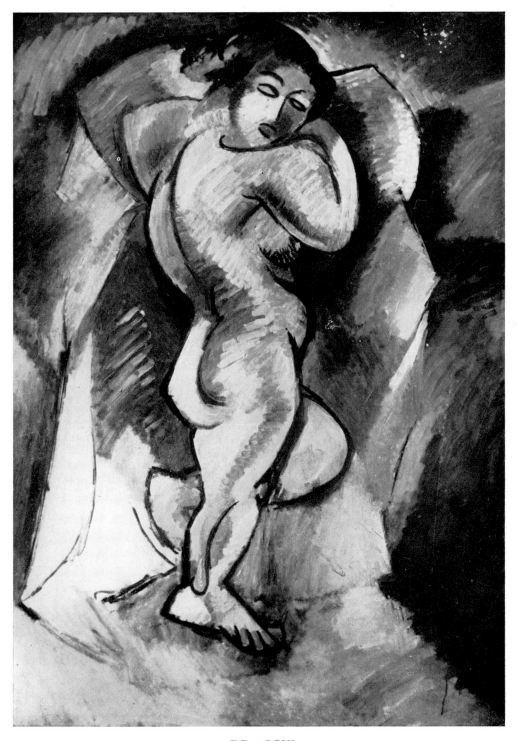

BRAQUE

23. Grand Nu, 1908. Oil, $55\frac{3}{4}'' \times 40''$. Collection Madame Cuttoli, Paris

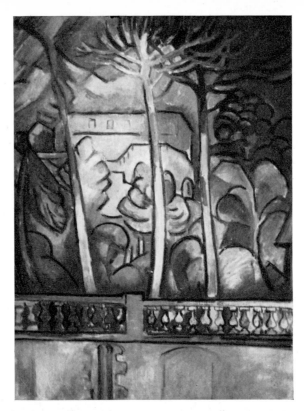

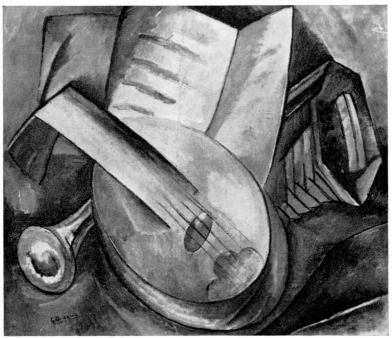

BRAQUE

24A. View from the Hotel Mistral, 1907. Oil, $31\frac{1}{2}'' \times 23\frac{1}{2}''$.
Collection Mr. and Mrs. Werner E. Josten, New York

24B. Still Life with Musical Instruments, 1908.
Oil, $19\frac{3}{4}'' \times 24''$. Collection of the Artist

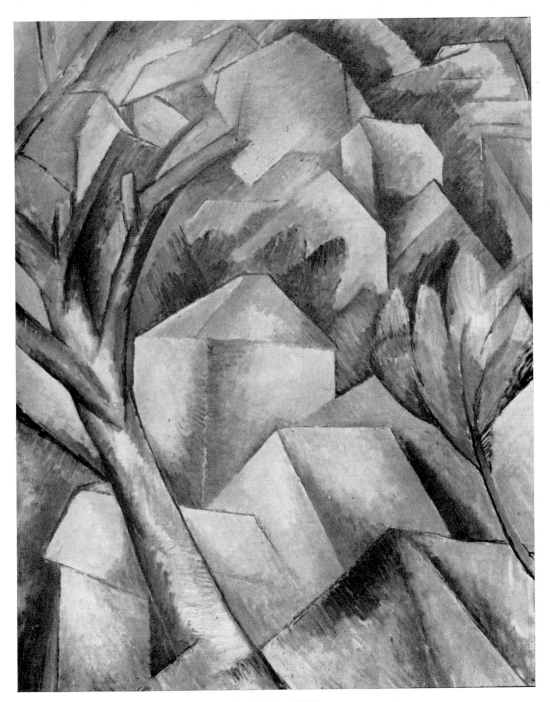

BRAQUE

25. Maison à L'Estaque, 1908. Oil, $28\frac{3}{4}'' \times 23\frac{3}{4}''$.
Collection Mr. Hermann Rupf, Berne

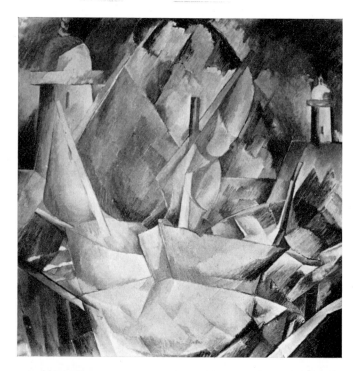

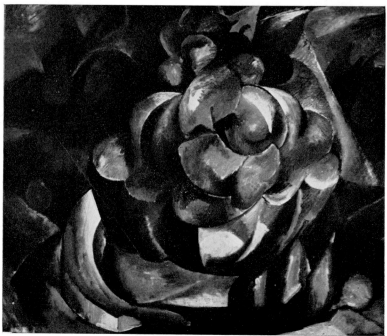

BRAQUE

26A. Le Port (Harbour in Normandy), 1909. Oil, 32″ × 32″.
Collection Mr. Walter P. Chrysler, Jr., New York

26B. Still Life with Fruit Dish, 1908–9. Oil, $20\frac{3}{4}$″ × $25\frac{1}{4}$″.
Collection Mr. Rolf de Maré, Stockholm

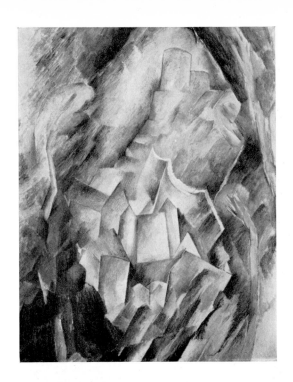

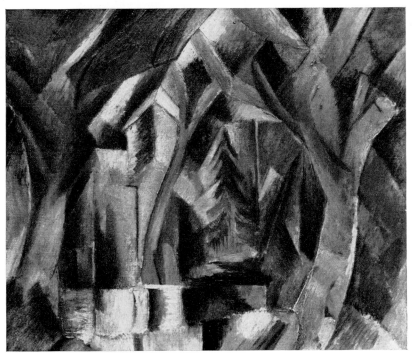

BRAQUE

27A. Landscape, La Roche Guyon, 1909. Oil, 65″ × 54″.
Collection Monsieur Jean Masurel, Roubaix

27B. Landscape, Carrières Saint-Denis, 1909. Oil, 16″ × 17⅞″.
Private Collection, New York

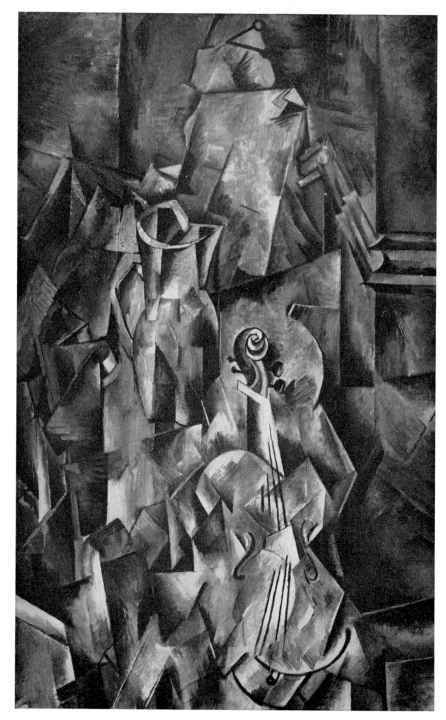

BRAQUE

28. Violon et Cruche, 1910. Oil, $46\frac{1}{2}'' \times 28\frac{3}{4}''$.

Kunstmuseum, Basle

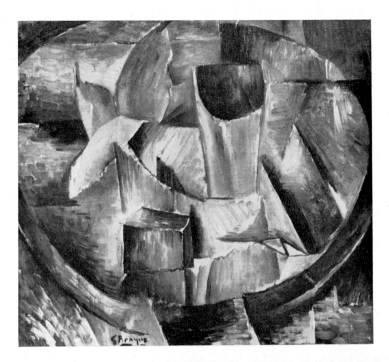

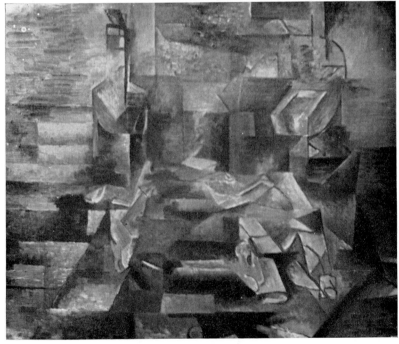

BRAQUE

29A. Glass on a Table, 1910. Oil, $13\frac{3}{4}'' \times 15\frac{1}{4}''$.
Collection Anthony Hornby Esq., London

29B. Les Poissons, 1910. Oil, $28\frac{1}{2}'' \times 23\frac{1}{2}''$.
Private Collection, Switzerland

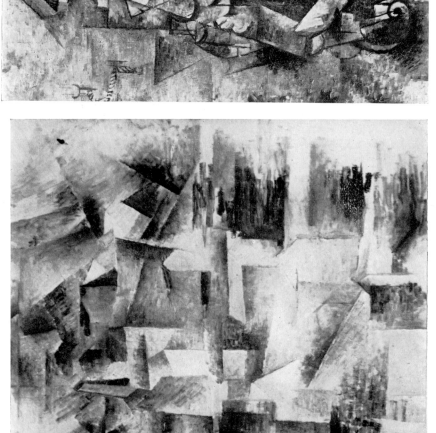

BRAQUE
30B. Man with Guitar, 1911. $45\frac{3}{4}'' \times 31\frac{7}{8}''$.
The Museum of Modern Art, New York

BRAQUE
30A. Les Usines de Rio Tinto, 1910. Oil, $25\frac{1}{2}'' \times 21''$.
Private Collection, Paris

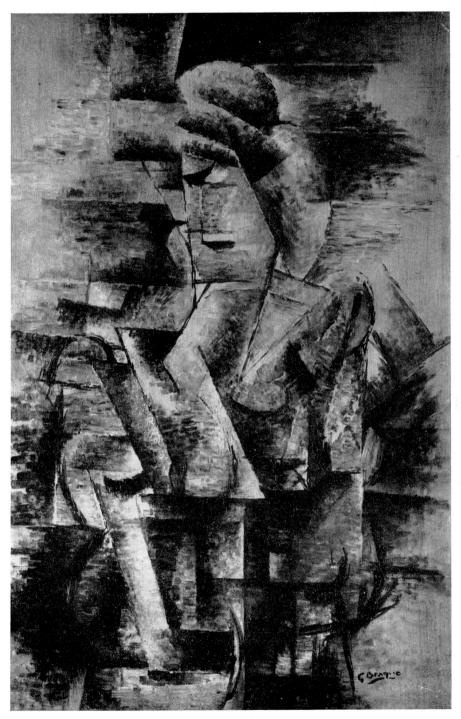

BRAQUE

31. Female Figure, 1910–11. Oil, $35\frac{1}{2}'' \times 23\frac{1}{2}''$.
Collection Dr. H. Carey Walker, New York

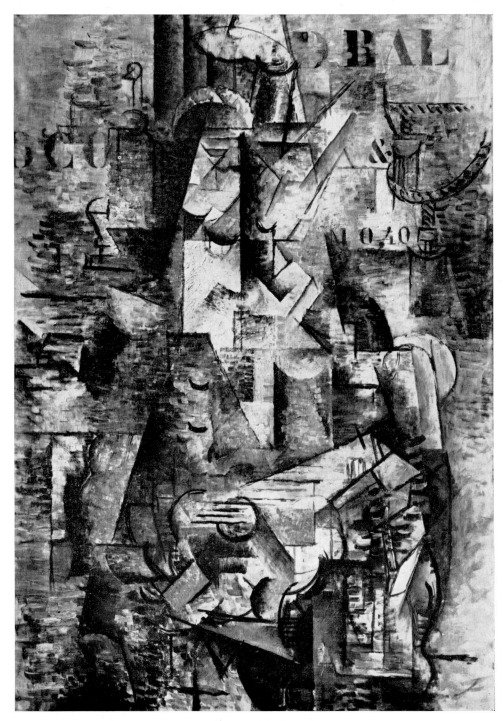

BRAQUE

32. Le Portugais, 1911. Oil, $45\frac{3}{4}'' \times 32''$. Kunstmuseum, Basle

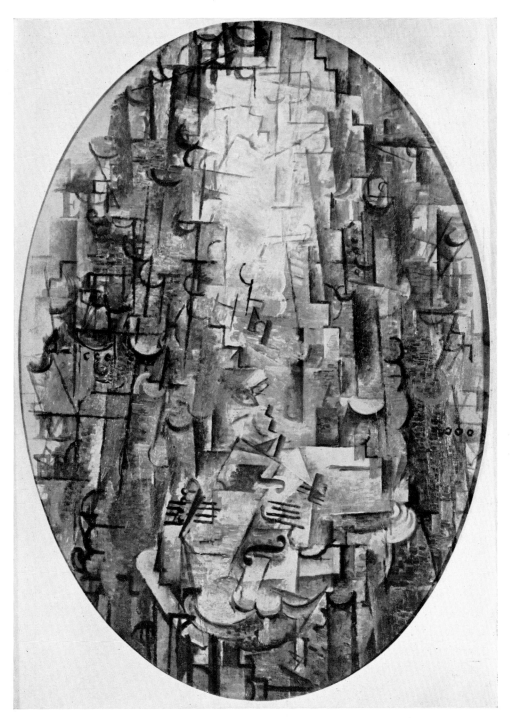

BRAQUE
33. Man with a Violin, 1911. Oil, $39\frac{1}{4}'' \times 28''$.
Bürhle Collection, Kunsthaus, Zurich

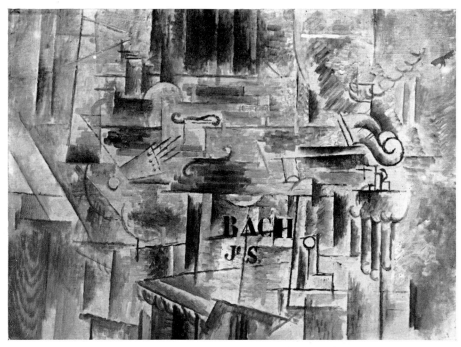

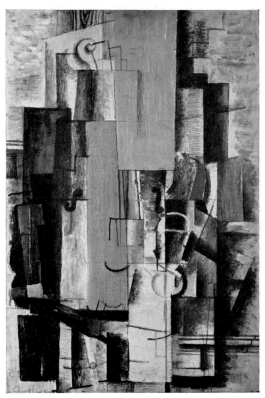

BRAQUE

34A. Hommage à J. S. Bach, 1912. Oil, $21\frac{1}{4}'' \times 28\frac{3}{4}''$. Collection Monsieur H. P. Roché, Paris

34B. Composition (The Violin), 1912. Oil, $31\frac{3}{4}'' \times 21\frac{1}{2}''$. Private Collection, New York

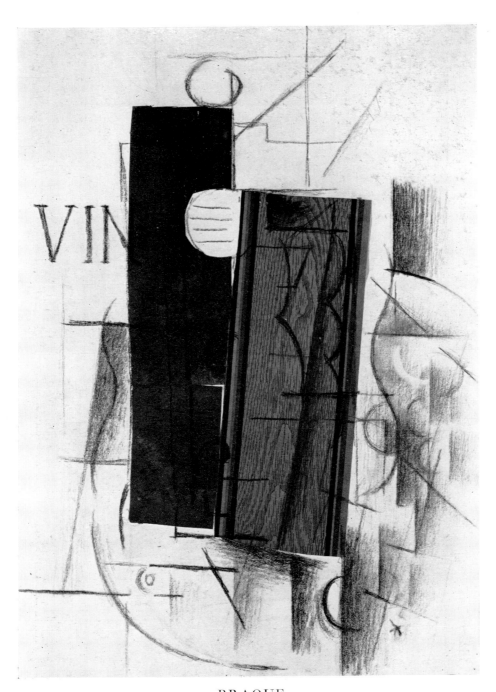

BRAQUE
35. Still Life with Guitar, 1912–13. Papier collé, $23\frac{1}{8}'' \times 17\frac{1}{4}''$.
The Louise and Walter Arensberg Collection,
Philadelphia Museum of Art

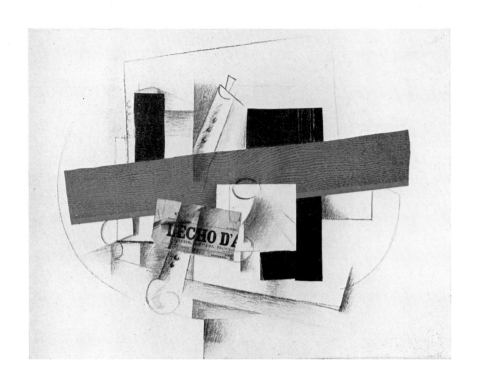

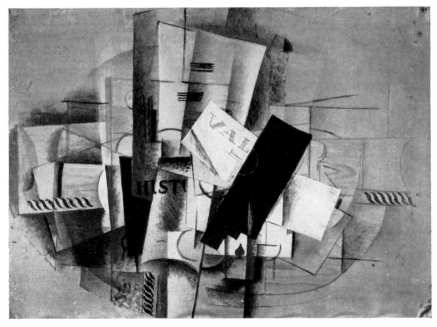

BRAQUE

36A. The Clarinet, 1913. Papier collé, $38\frac{1}{2}'' \times 51\frac{1}{4}''$.
Private Collection, New York

36B. La Table du Musicien, 1913. Oil and pencil, $25\frac{5}{8}'' \times 36\frac{1}{4}''$.
Kunstmuseum, Basle

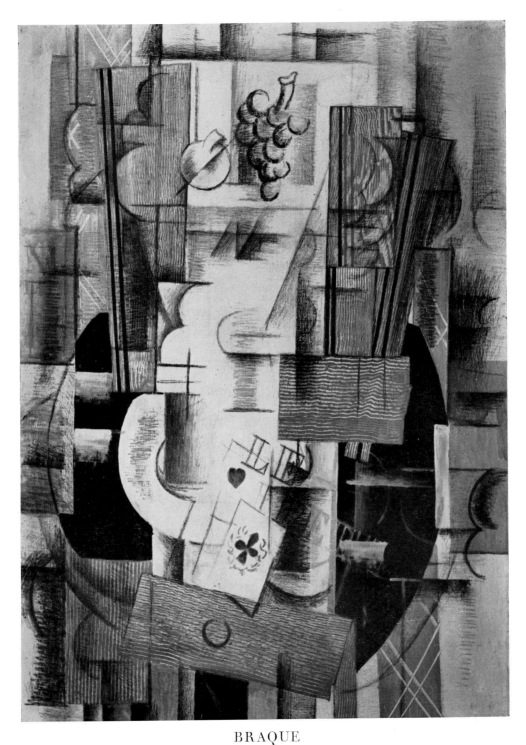

BRAQUE
37. Still Life with Playing Cards (Composition à l'As de Trèfle), 1913.
Oil and charcoal, 32″ × 23½″. Musée National d'Art Moderne, Paris

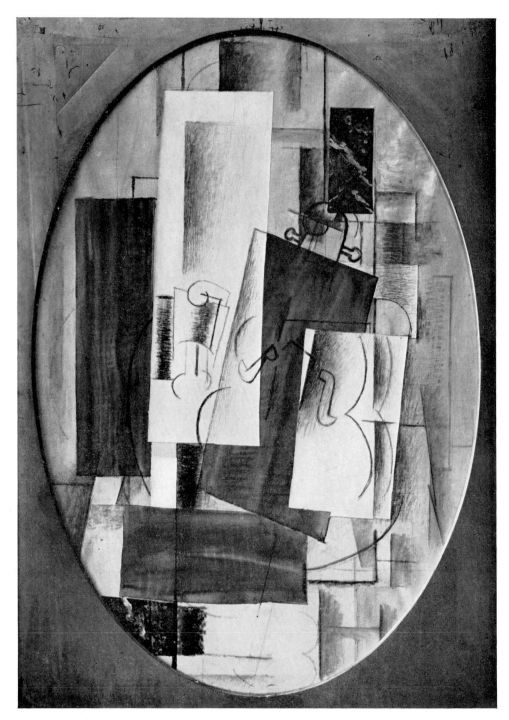

BRAQUE

38. Violon et Verre, 1913. Oil, $45\frac{3}{4}'' \times 31\frac{3}{4}''$. Kunstmuseum, Basle

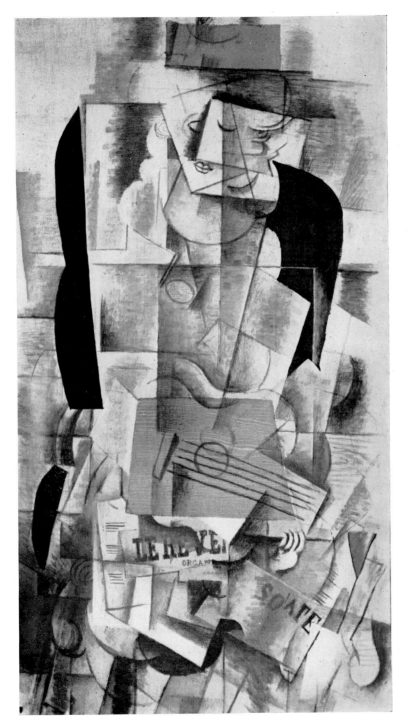

BRAQUE

39. Woman with a Guitar, 1914. Oil, $51\frac{1}{4}'' \times 29''$.
Collection Monsieur Raoul La Roche, Paris

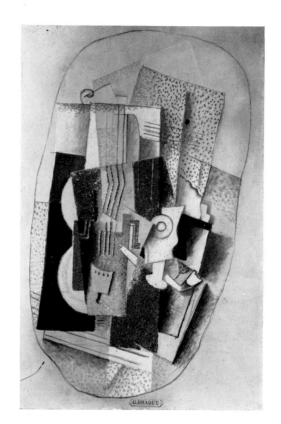

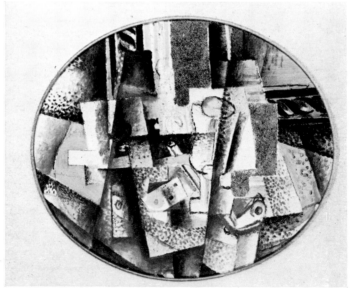

BRAQUE

40A. Music, 1914. Oil with gesso and sawdust, $36'' \times 23\frac{1}{2}''$.
The Philips Collection, Washington, D.C.
(Katherine Drier Gift)

40B. Still Life (Nature Morte à la Pipe), 1914.
Oil with sand and gesso, $15'' \times 18''$.
Girardin Collection, Petit Palais, Paris

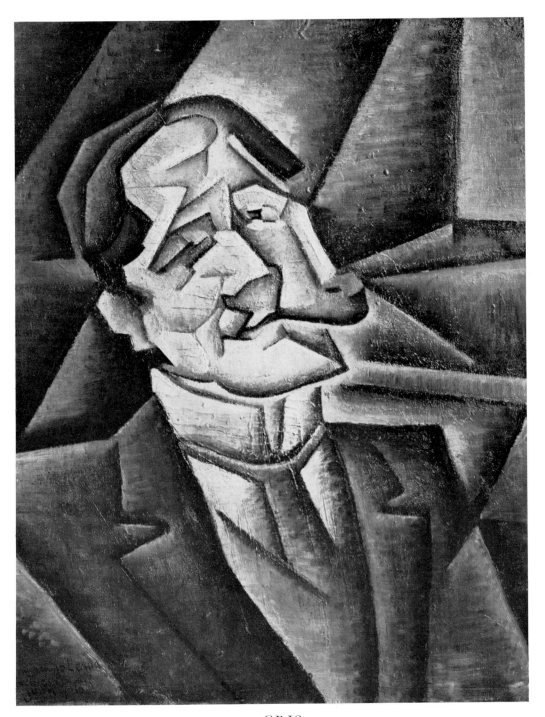

GRIS
41. L'Homme à la Pipe, 1911. Oil, 21″ × 18″.
Collection Mr. and Mrs. Jacques Gelman, Mexico City

GRIS

42A. Les Oeufs, 1911. Oil, $22\frac{1}{2}'' \times 15''$. Collection Clive Bell Esq., Firle, Sussex

42B. Still Life with Cylindrical Pot, 1911. Oil, $13'' \times 20\frac{1}{4}''$. Kröller-Müller Foundation, Otterlo

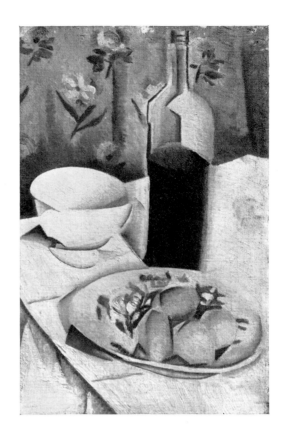

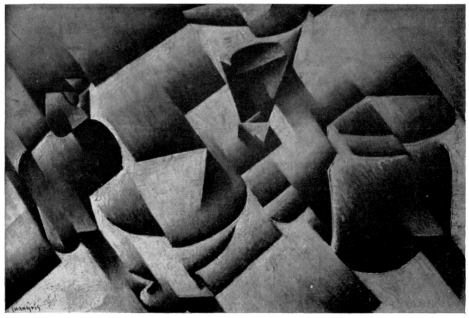

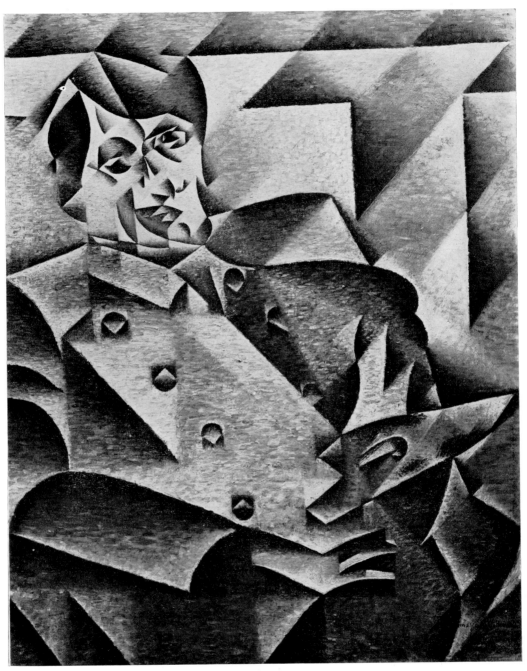

GRIS

43. Portrait of Picasso, 1911–12. Oil, $36\frac{1}{4}'' \times 28\frac{3}{4}''$.
Collection Mr. and Mrs. Leigh Block, Chicago

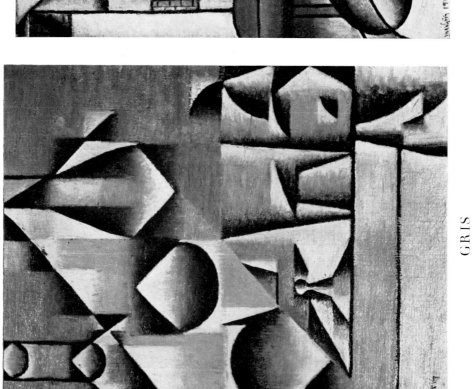

GRIS

44B. Portrait of Germaine Raynal, 1912.
Oil, 22″ × 14¼″. Private Collection, Paris

GRIS

44A. Grey Still Life, 1912. Oil, 15¾″ × 10″.
The Kröller-Müller Foundation, Otterlo

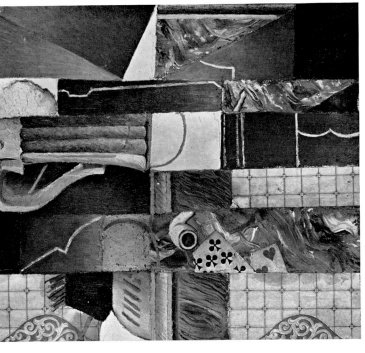

GRIS

45B. Glass of Beer and Playing Cards, 1915.
Oil and papier collé, $20\frac{1}{2}'' \times 14\frac{1}{2}''$.
Columbus Gallery of Fine Arts (Howald Collection),
Columbus, Ohio

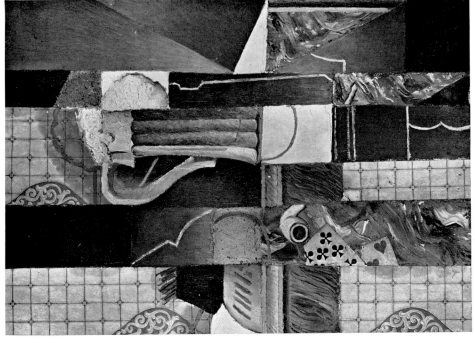

GRIS

45A. Le Lavabo, 1912.
Oil with mirror and papier collé, $52'' \times 55\frac{1}{2}''$.
Private Collection, Paris

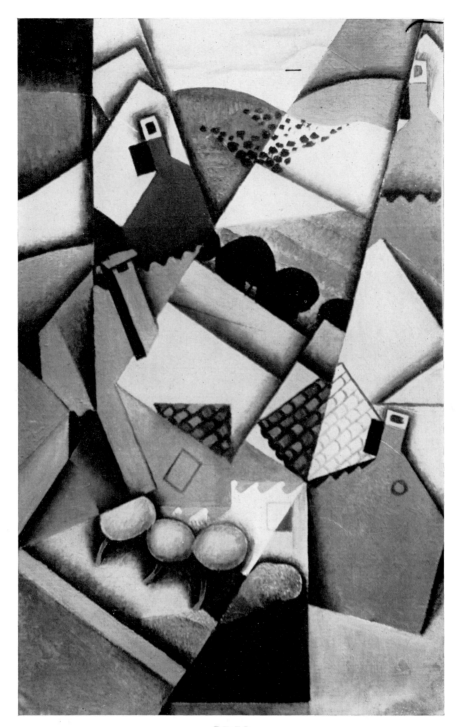

GRIS

46. Landscape at Céret, 1913. Oil, $39\frac{1}{2}'' \times 25\frac{1}{2}''$.
Present whereabouts unknown

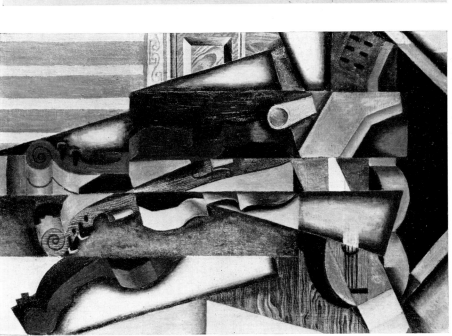

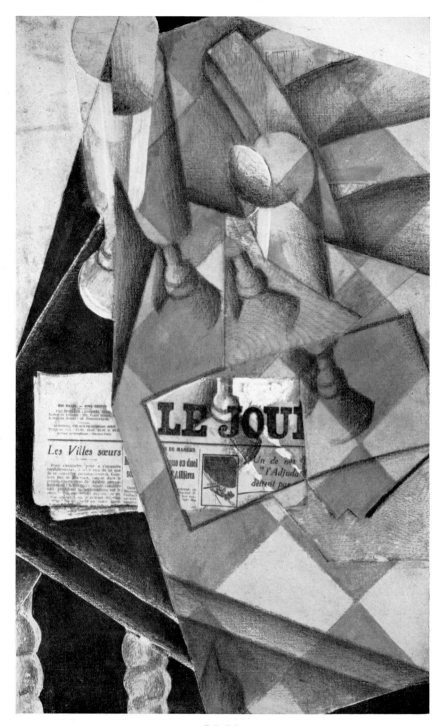

GRIS

48. Glasses and Newspaper, 1914. Papier collé, 24″ × 15″.
Smith College Museum of Art, Northampton, Mass.
(Gift of Joseph Brummer)

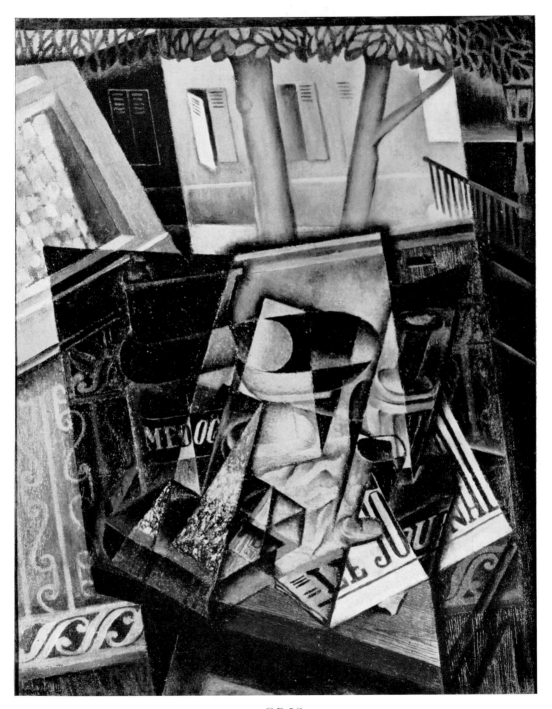

GRIS

49. Still Life in Front of an open Window, 1915. Oil, $45\frac{3}{4}'' \times 35''$.
Louise and Walter Arensberg Collection, Philadelphia Museum of Art

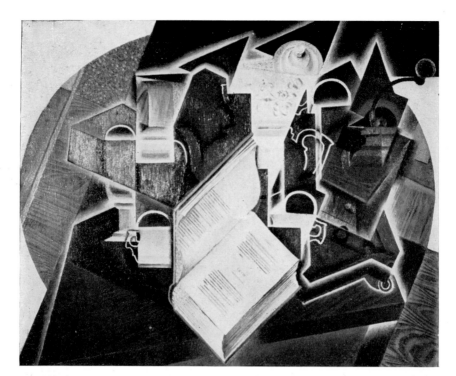

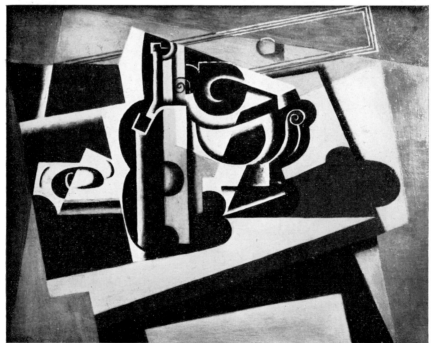

GRIS

50A. Livre, Pipe et Verres, 1915. Oil, $36\frac{3}{4}'' \times 29''$.
Collection Mr. and Mrs. Ralph D. Colin, New York

50B. Bouteille et Compotier, 1917. Oil, $36\frac{3}{4}'' \times 29''$.
Institute of Art, Minneapolis

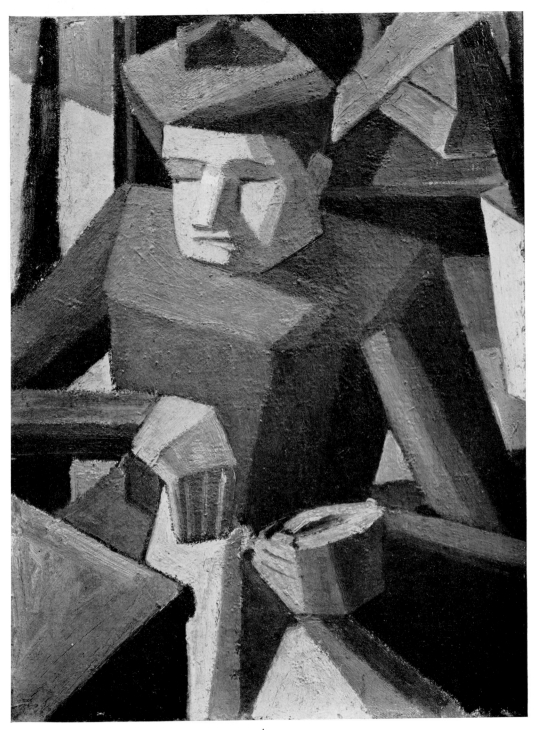

LÉGER
51. La Couseuse, 1909. Oil, $28\frac{3}{4}'' \times 21\frac{1}{2}''$. Private Collection, Paris

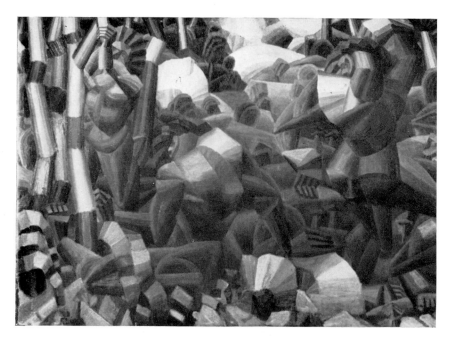

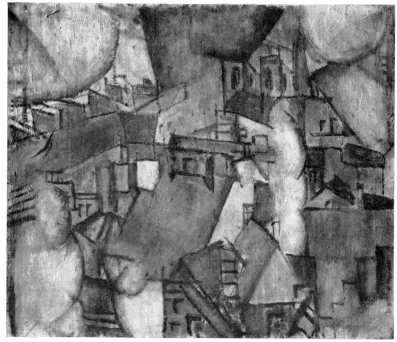

LÉGER

52A. Nus dans un Paysage, 1909–11. Oil, 48″ × 68″.
Kröller-Müller Foundation, Otterlo

52B. Fumées sur les Toits, 1910. Oil, $26\frac{1}{4}$″ × 2″.
Collection Mr. Richard Weil, St. Louis

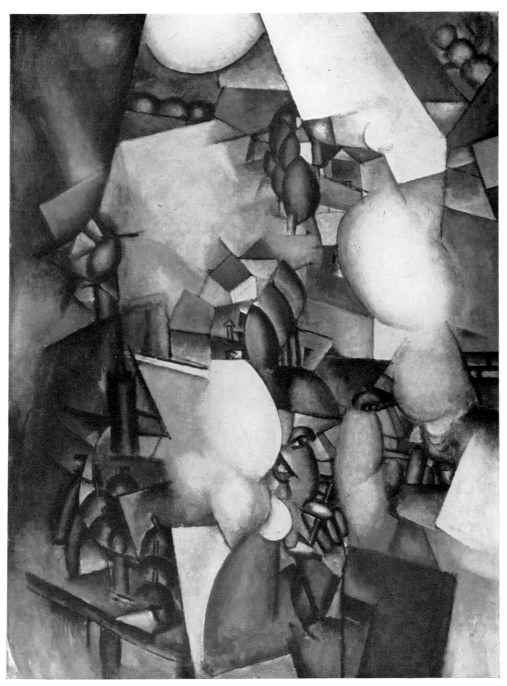

LÉGER
53. Les Fumeurs, 1911. Oil, $50\frac{7}{8}'' \times 38''$.
The Solomon R. Guggenheim Museum, New York

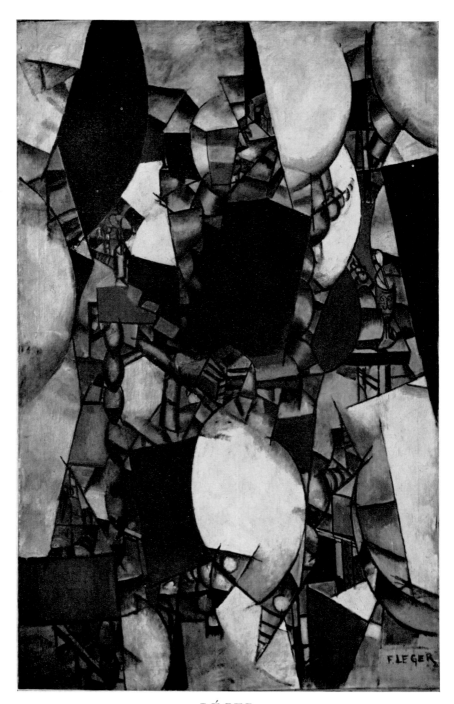

LÉGER
54. La Femme en Bleu, 1912. Oil, 76″ × 52″. Kunstmuseum, Basle

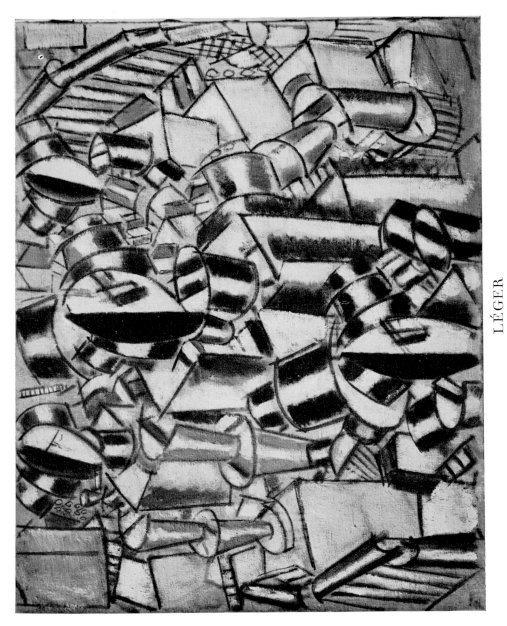

LÉGER

55. L'Escalier, 1914. Oil, 55″ × 49″. Kunstmuseum, Basle

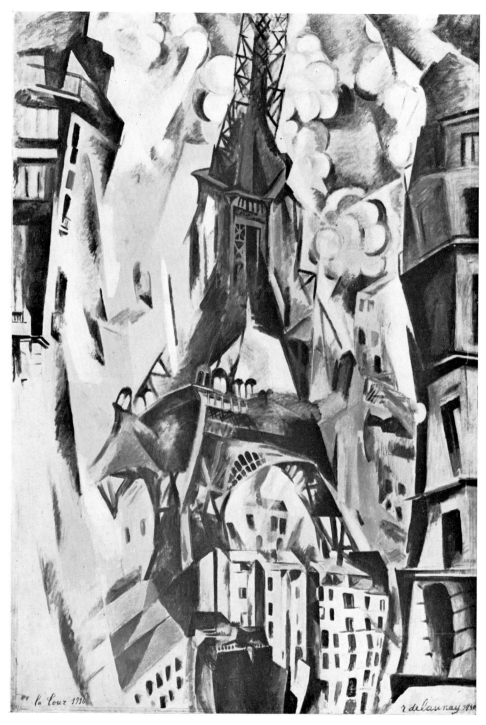

DELAUNAY
56. The Eiffel Tower, 1910. Oil, $79\frac{1}{2}'' \times 54\frac{1}{2}''$.
The Solomon R. Guggenheim Museum, New York

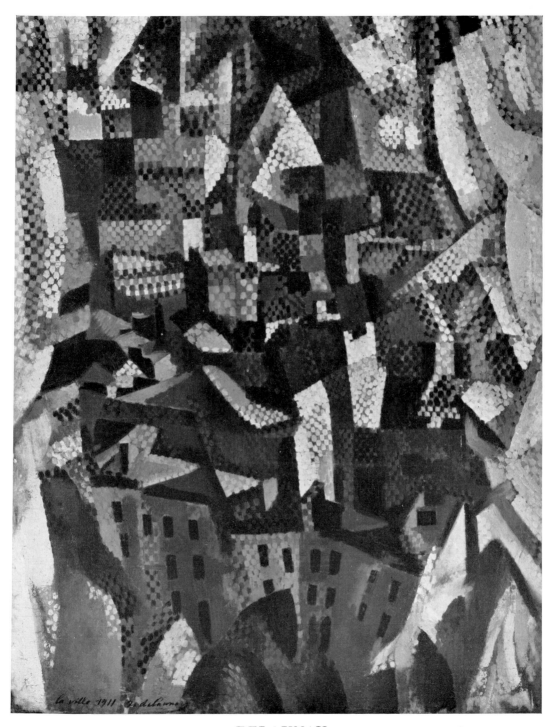

DELAUNAY
57. La Ville, 1911. Oil, 57″ × 44″.
The Solomon R. Guggenheim Museum, New York

DELAUNAY

58A. Les Tours de Laon,
1912. Oil.
Musée National d'Art
Moderne, Paris

58B. La Ville de Paris,
1912. Oil, $104\frac{1}{2}'' \times 158\frac{1}{2}''$.
Musée National d'Art
Moderne, Paris

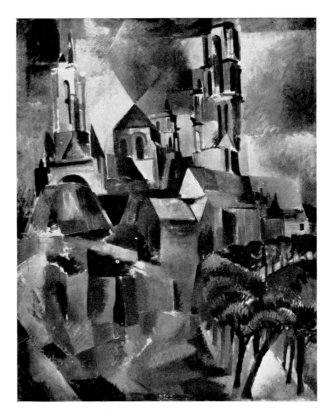

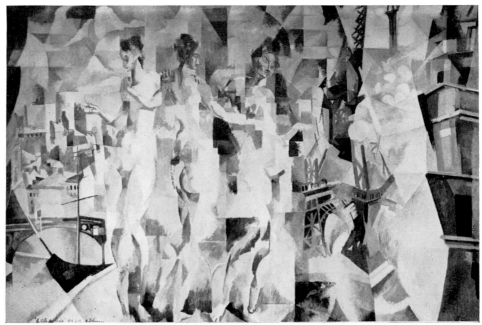

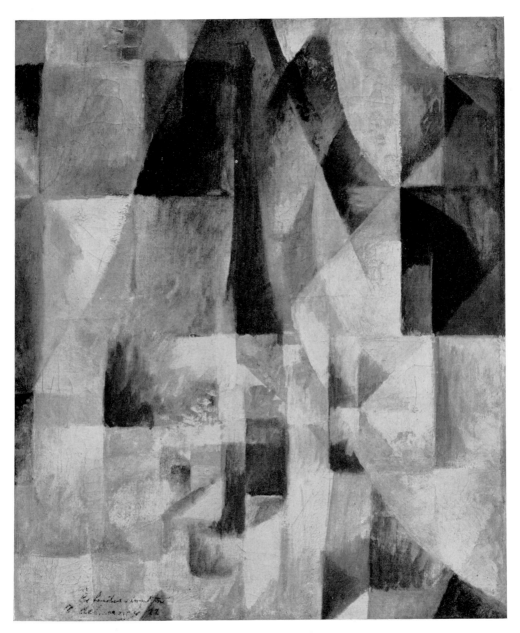

DELAUNAY

59. La Fenêtre, 1912. Oil, $21\frac{3}{4}'' \times 18\frac{3}{8}''$.

The Solomon R. Guggenheim Museum, New York

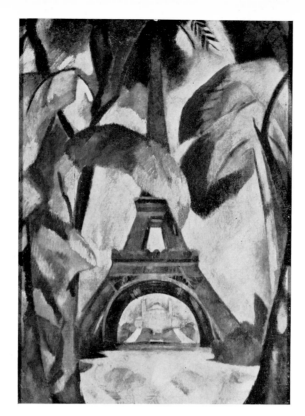

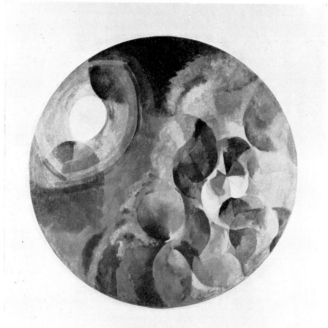

DELAUNAY

60A. The Eiffel Tower, 1909. Oil, 38″ × 27¾″.
The Louise and Walter Arensberg Collection,
Philadelphia Museum of Art

60B. Sun Disks, 1913. Oil, 52⅞″ × 53¼″ (diameter).
The Museum of Modern Art, New York

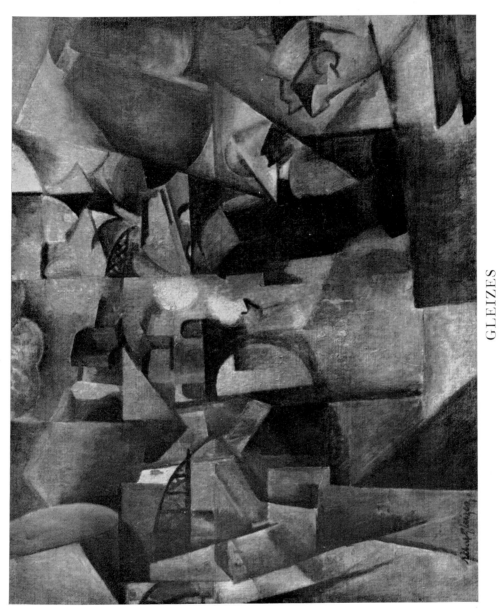

GLEIZES

61. The Bridges of Paris, 1912. Oil, $25'' \times 28\frac{1}{4}''$.
Collection Sidney Janis, New York

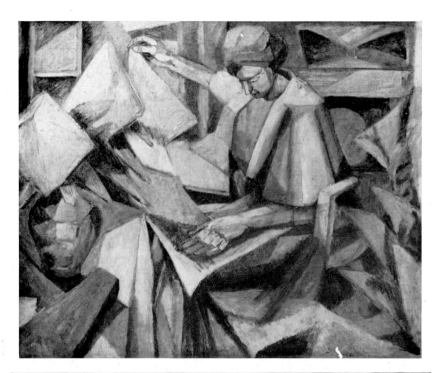

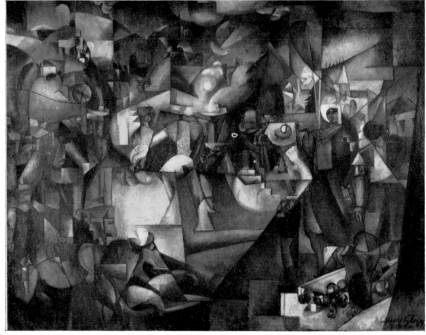

GLEIZES
62A. La Femme aux Phlox, 1910–11. Oil, $32'' \times 39\frac{3}{8}''$.
The Marlborough Gallery, London

62B. Harvesters, 1912. Oil, $106'' \times 138\frac{7}{8}''$.
The Solomon R. Guggenheim Museum, New York

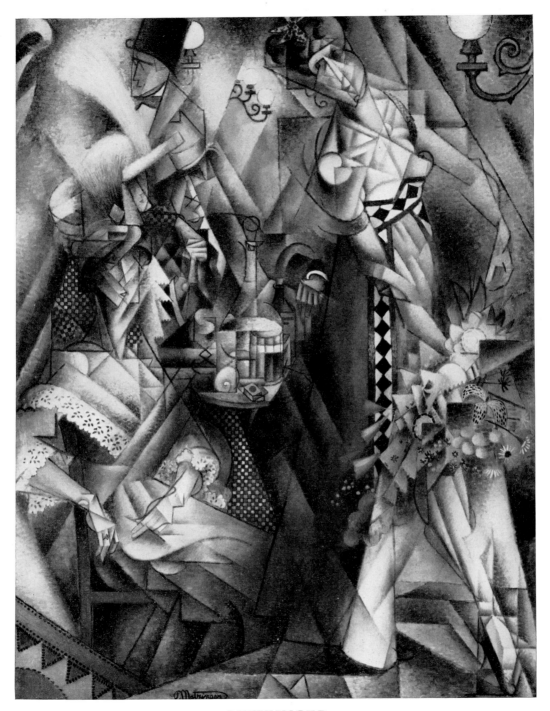

METZINGER

63. La Danseuse au Café, 1912. Oil, $57'' \times 44\frac{1}{2}''$. Collection Sidney Janis, New York

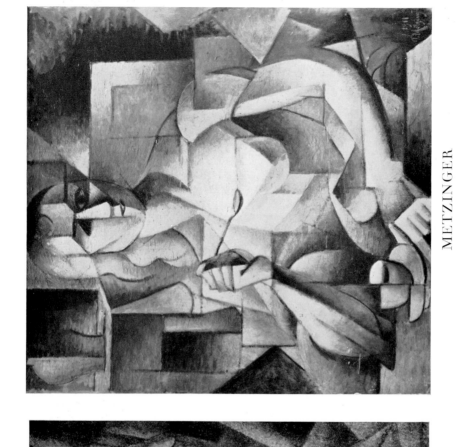

METZINGER
64B. Le Goûter, 1911. Oil, $29\frac{3}{4}'' \times 27\frac{7}{8}''$.
Louise and Walter Arensberg Collection,
Philadelphia Museum of Art

METZINGER
64A. Two Nudes, 1910–11. Oil.
Present whereabouts unknown

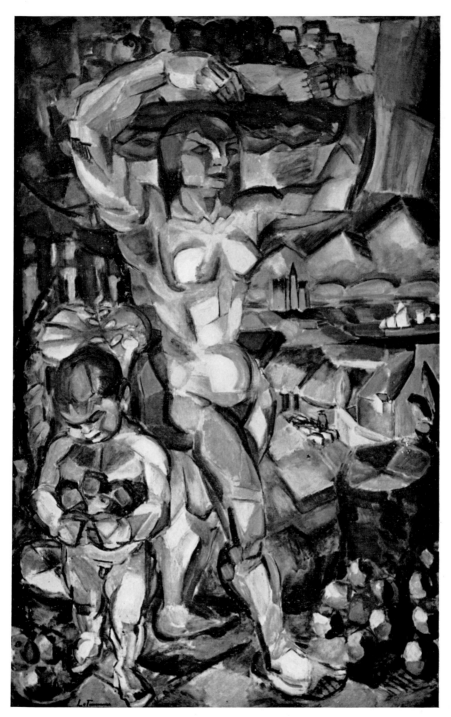

LE FAUCONNIER
65. L'Abondance, 1910–11. Oil.
Gemeente Museum, The Hague

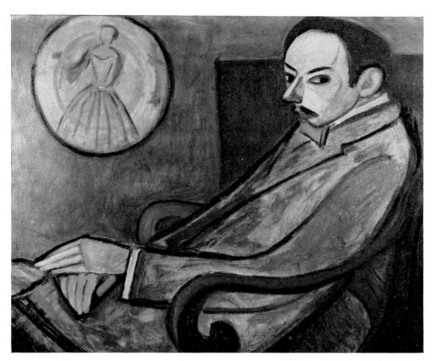

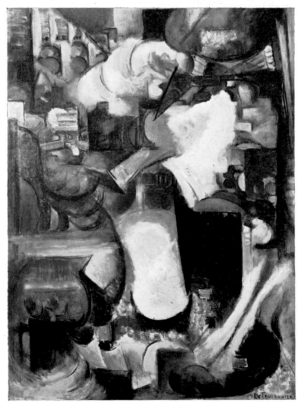

LE
FAUCONNIER
66A. Portrait of
Jouve, 1909. Oil.
Musée
National d'Art
Moderne, Paris

66B. The Hunts-
man (Chasseur),
1912. Oil,
$62\frac{1}{4}'' \times 46\frac{3}{8}''$. The
Museum of
Modern Art,
New York

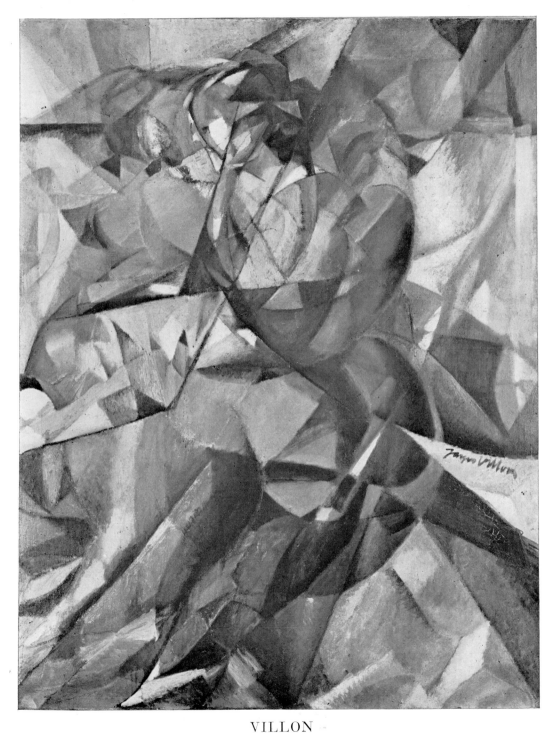

VILLON

67. Young Woman, 1912. Oil, $57\frac{3}{4}'' \times 45''$.

The Louise and Walter Arensberg Collection, Philadelphia Museum of Art

VILLON

68A. Portrait of
Duchamp-Villon. Oil,
$13\frac{3}{4}'' \times 10\frac{1}{2}''$. Musée
National d'Art Moderne,
Paris

68B. Soldats en Marche,
1913. Oil, $25\frac{1}{2}'' \times 36''$.
Collection Galerie Louis
Carré, Paris

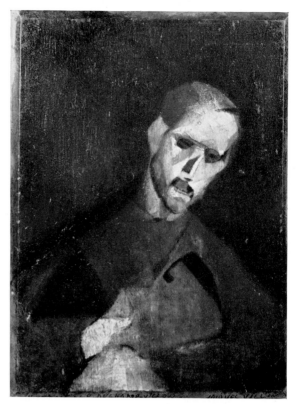

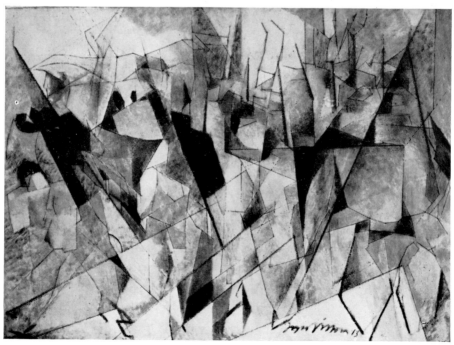

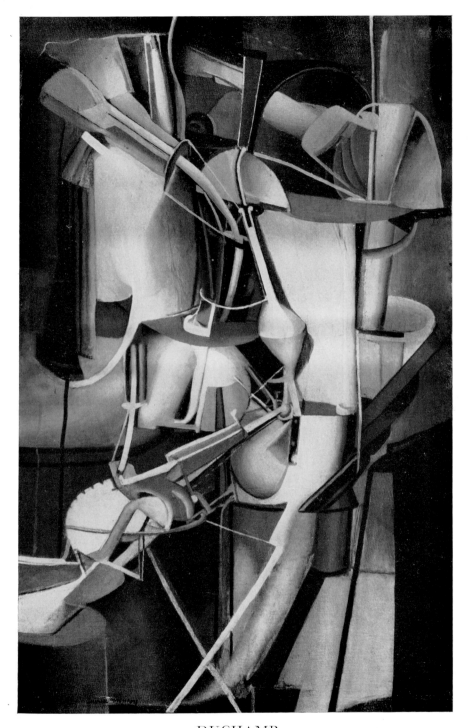

DUCHAMP
69. The Bride, 1912. Oil, 55″ × 21¾″.
Louise and Walter Arensberg Collection, Philadelphia Museum of Art

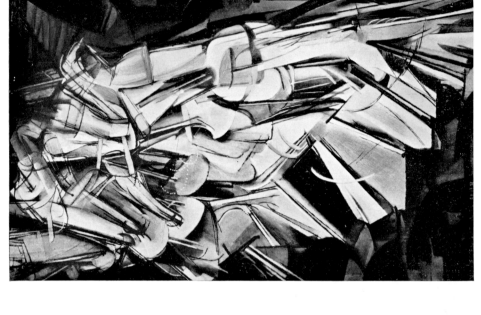

DUCHAMP

70B. Nude Descending a Staircase, 1912.
Oil, 58″ × 55″.
Louise and Walter Arensberg Collection,
Philadelphia Museum of Art

DUCHAMP

70A. Nude Descending a Staircase, no 1,
1911. Oil, $57\frac{3}{4}″ \times 25\frac{1}{2}″$.
Louise and Walter Arensberg Collection,
Philadelphia Museum of Art

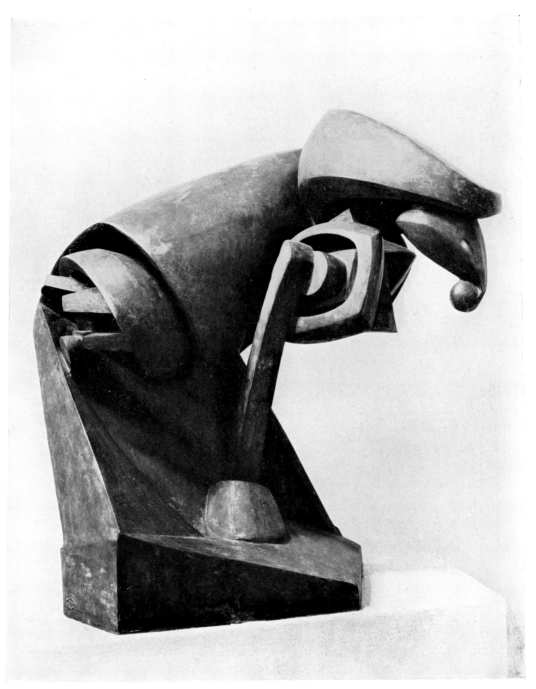

DUCHAMP-VILLON
71. The Horse, 1913–14. Bronze, 40″ high.
The Museum of Modern Art, New York

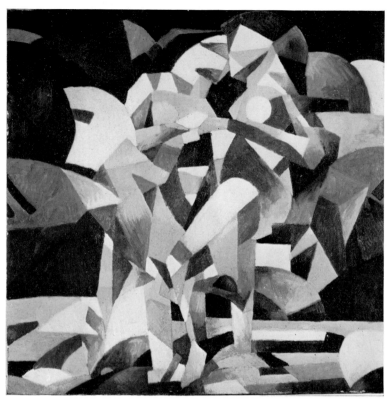

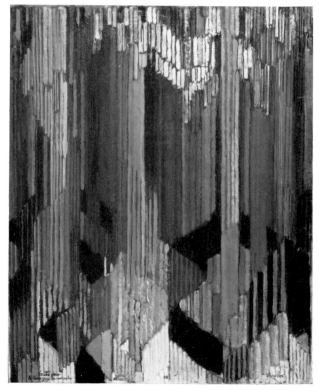

PICABIA
74A. Danseuses à la Source,
1912.
Oil, $47\frac{1}{2}'' \times 47\frac{1}{2}''$
Arensberg Collection,
Philadelphia Museum
of Art

KUPKA
74B. La Langage des Verti-
cales (study), 1911.
Oil, $30\frac{1}{2}'' \times 24\frac{3}{4}''$.
Collection Galerie Louis
Carré, Paris

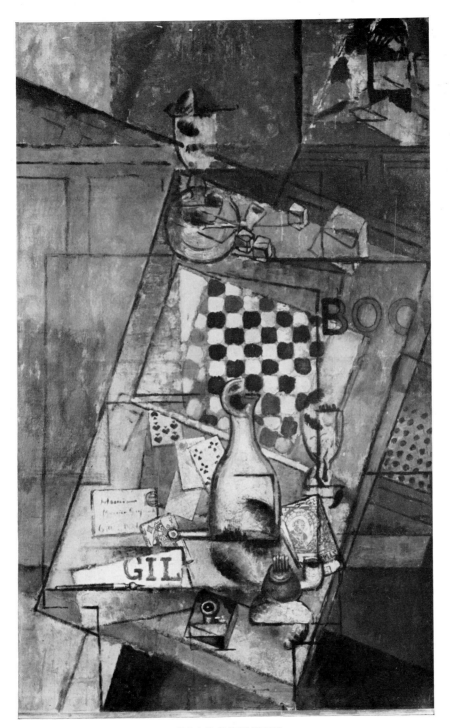

MARCOUSSIS
75. Nature Morte au Damier, 1912. Oil.
Musée National d'Art Moderne, Paris

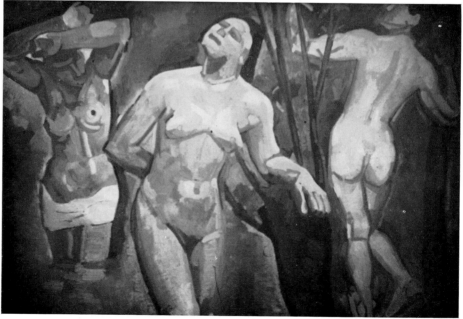

DERAIN

76A. Still Life, 1904. Oil. Collection Madame C. Baron, Garches

76B. Baigneuses, 1906. Oil. Private Collection, Switzerland

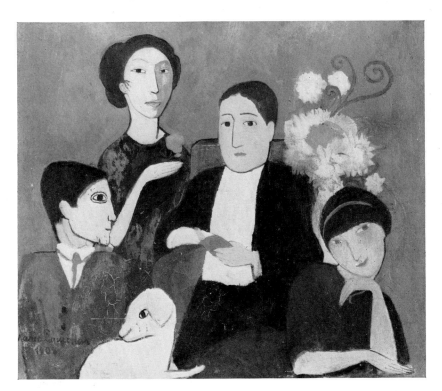

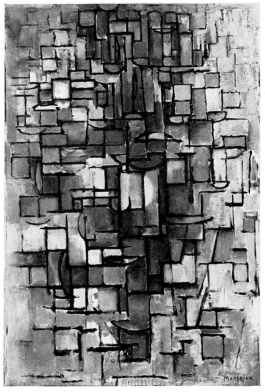

LAURENCIN
77A. Group of Artists, 1908 (Self portrait with Apollinaire, Picasso and Fernande Olivier). Oil.
Cone Collection, Baltimore Museum of Art

MONDRIAN
77B. Composition, 1913.
Oil, $37\frac{3}{4}'' \times 25\frac{1}{4}''$.
The Kröller-Müller Foundation, Otterlo

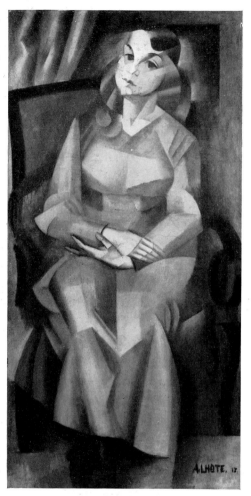

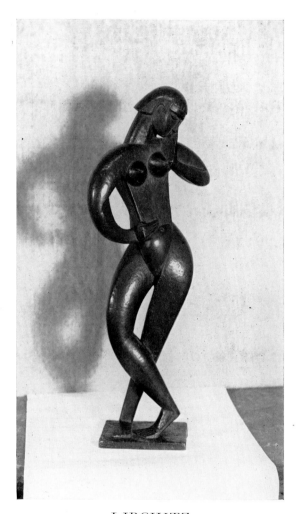

LHOTE
78A. Portrait of Marguerite, 1913.
Oil, 64″ × 36¼″.
The Marlborough Gallery, London

LIPCHITZ
78B. Danseuse, 1913–14. Bronze.
Girardin Collection, Petit Palais, Paris

Please renew/return this item by the last date shown.

So that your telephone call is charged at local rate,
please call the numbers as set out below:

	From Area codes 01923 or 0208:	From the rest of Herts:
Renewals:	01923 471373	01438 737373
Enquiries:	01923 471333	01438 737333
Minicom:	01923 471599	01438 737599

L32b

L.32